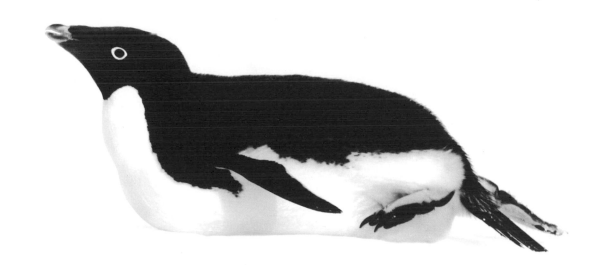

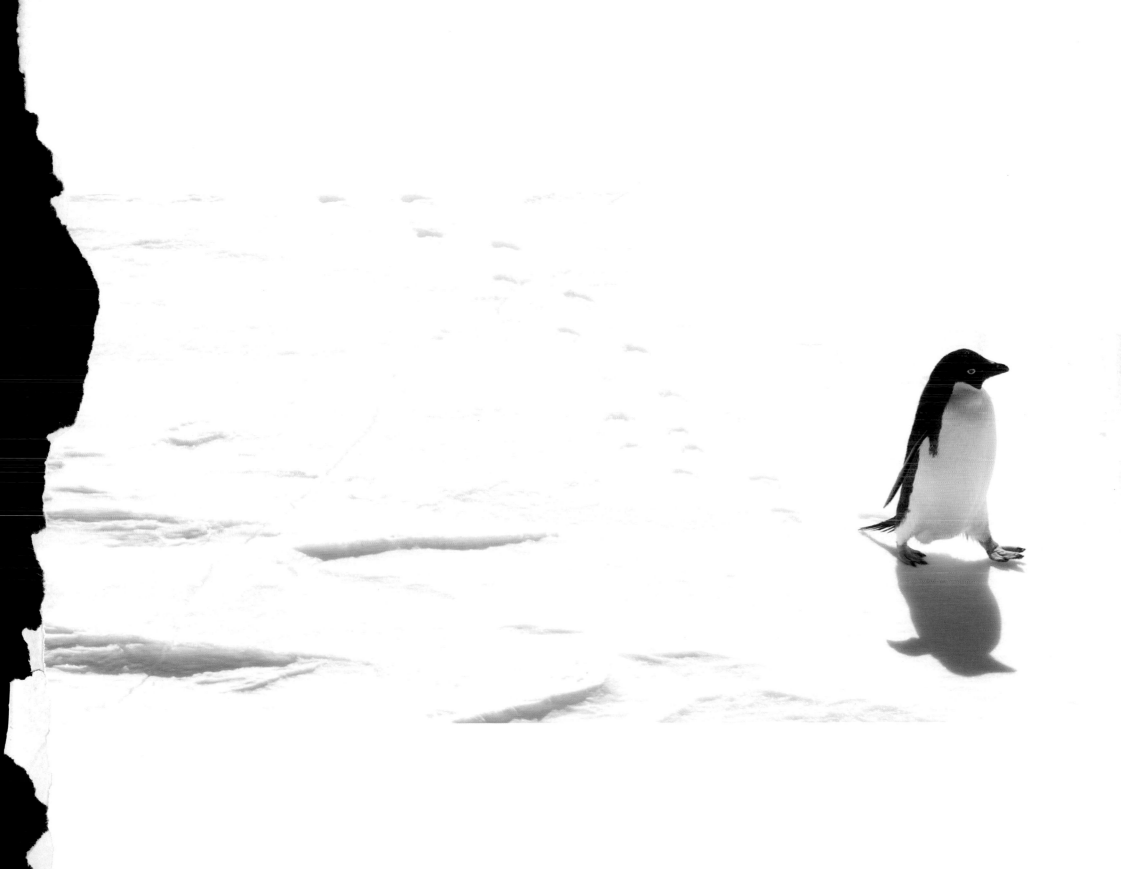

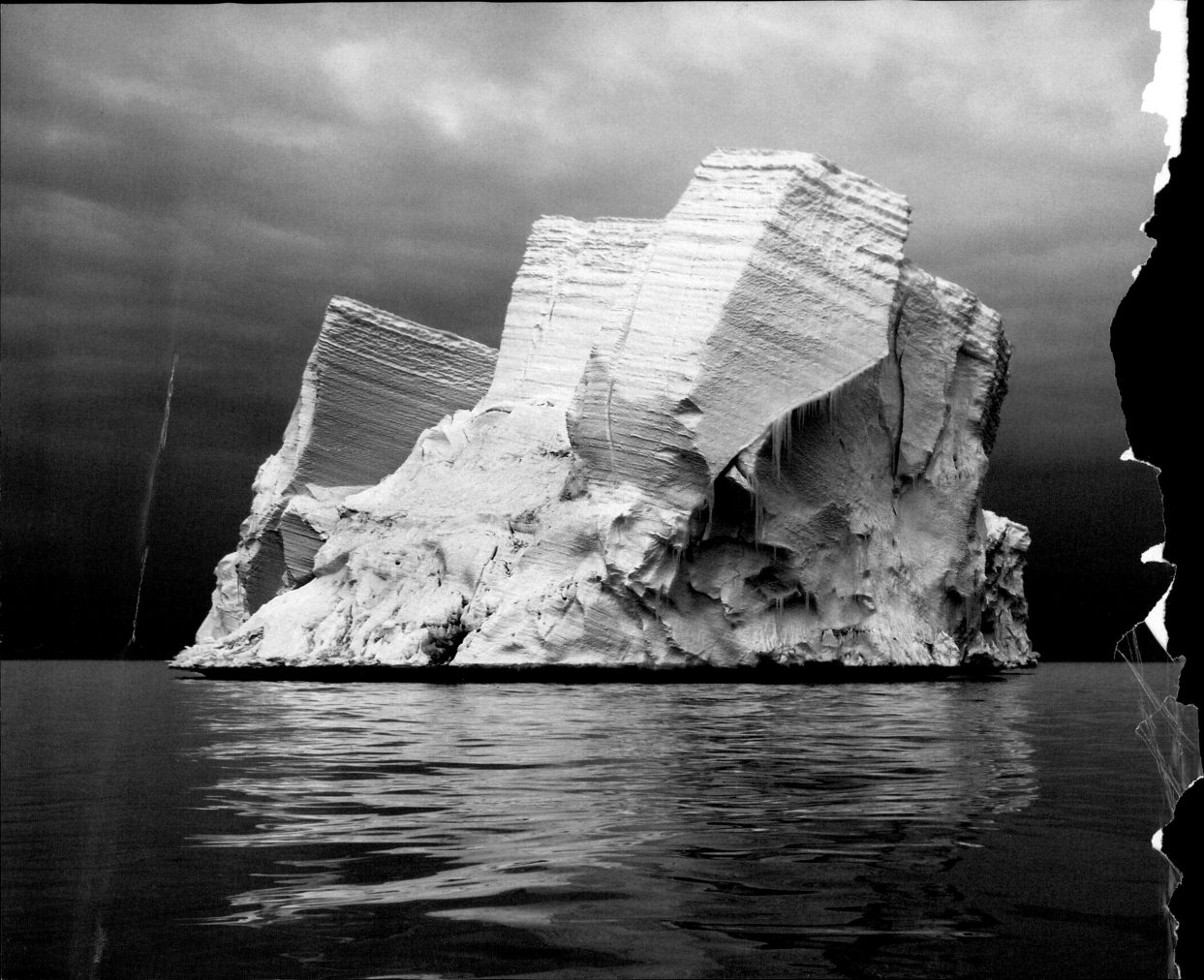

THE LAST OCEAN

ANTARCTICA'S ROSS SEA PROJECT | SAVING THE MOST PRISTINE ECOSYSTEM ON EARTH

JOHN WELLER Foreword by **CARL SAFINA**

RIZZOLI
NEW YORK

New York · Paris · London · Milan

THIS BOOK IS DEDICATED TO ALL THOSE WHO WORK TO PROTECT OUR NATURAL WORLD.

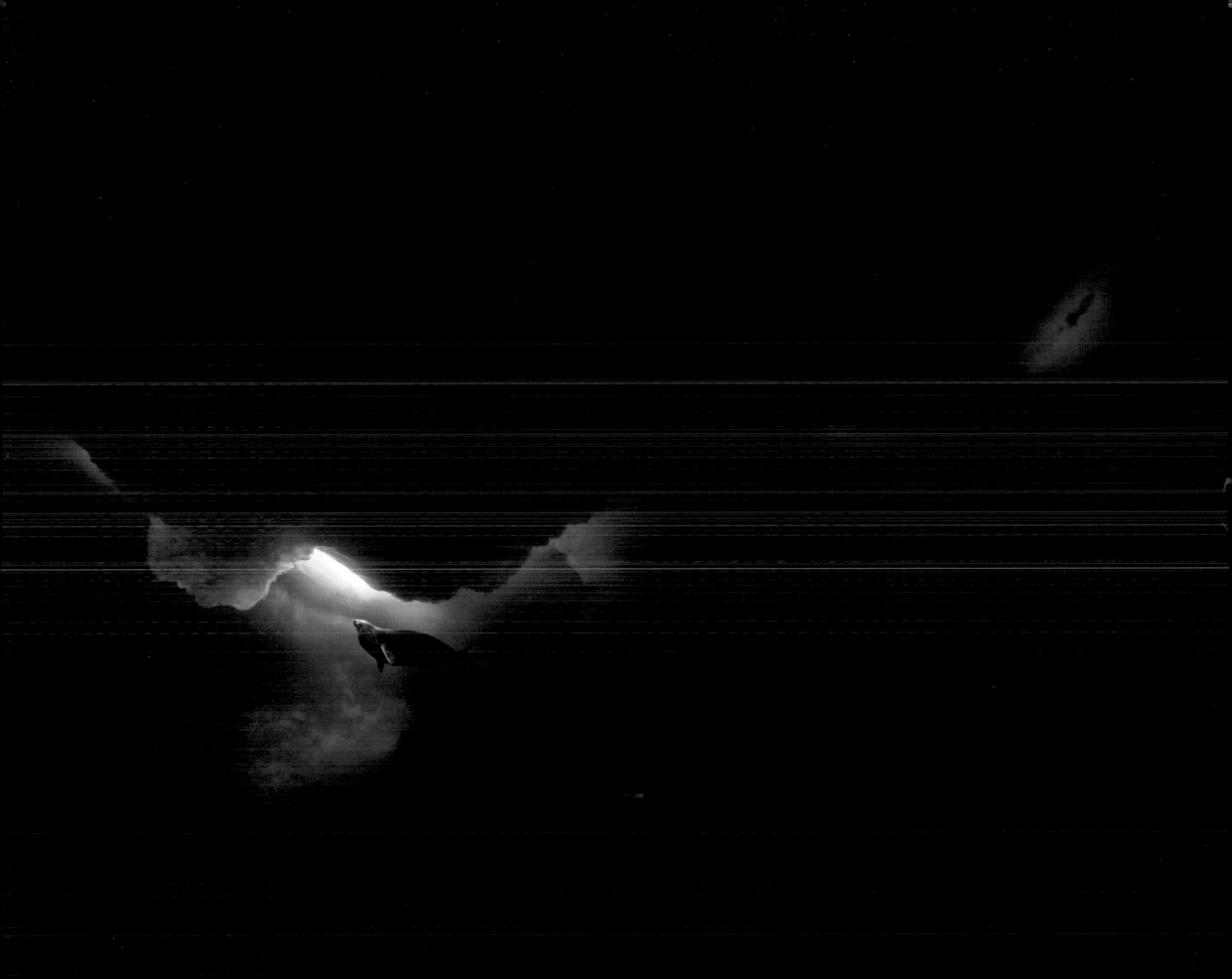

CONTENTS

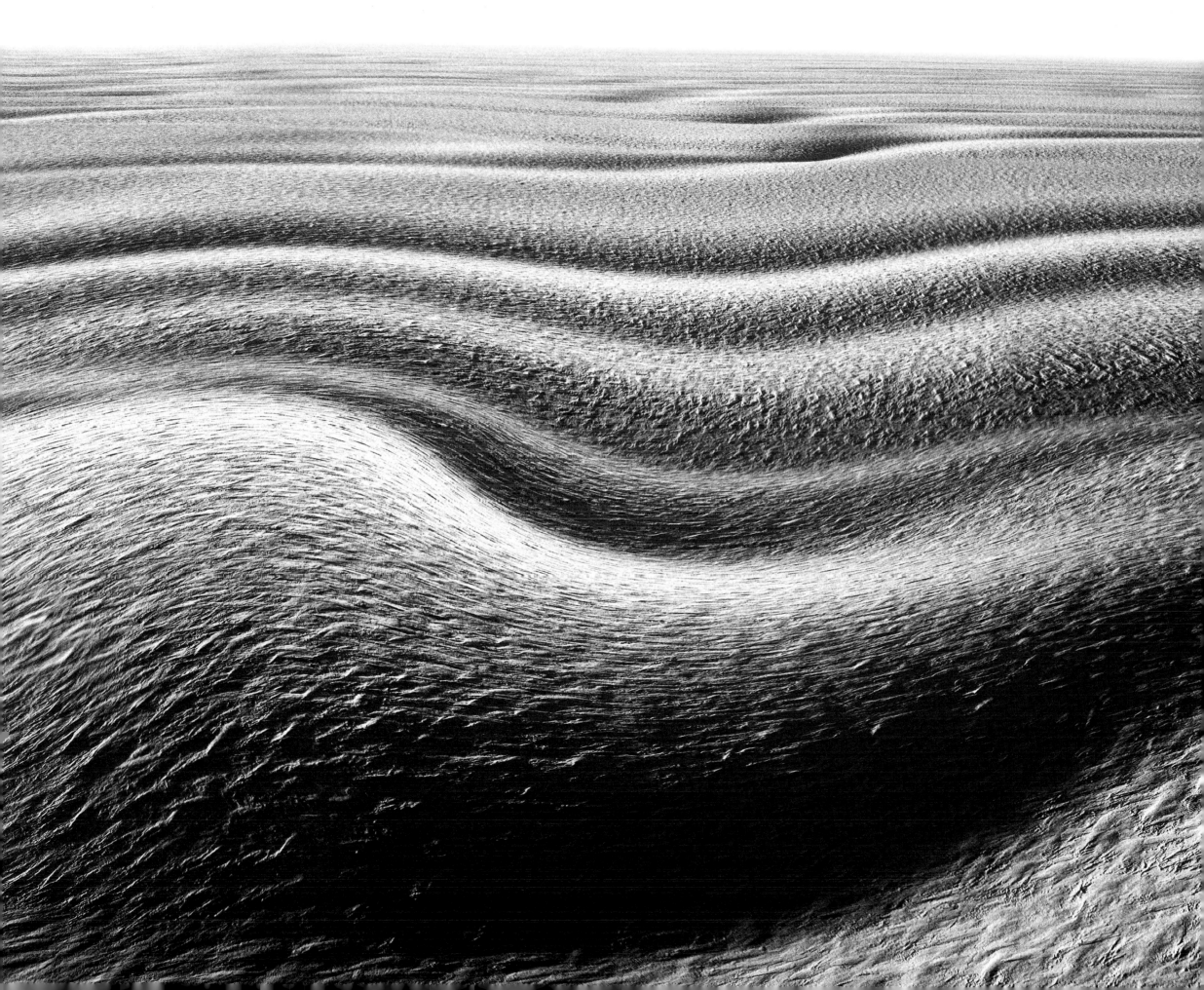

"In every deliberation, we must consider the impact on the next seven generations." — THE GREAT LAW OF THE IROQUOIS

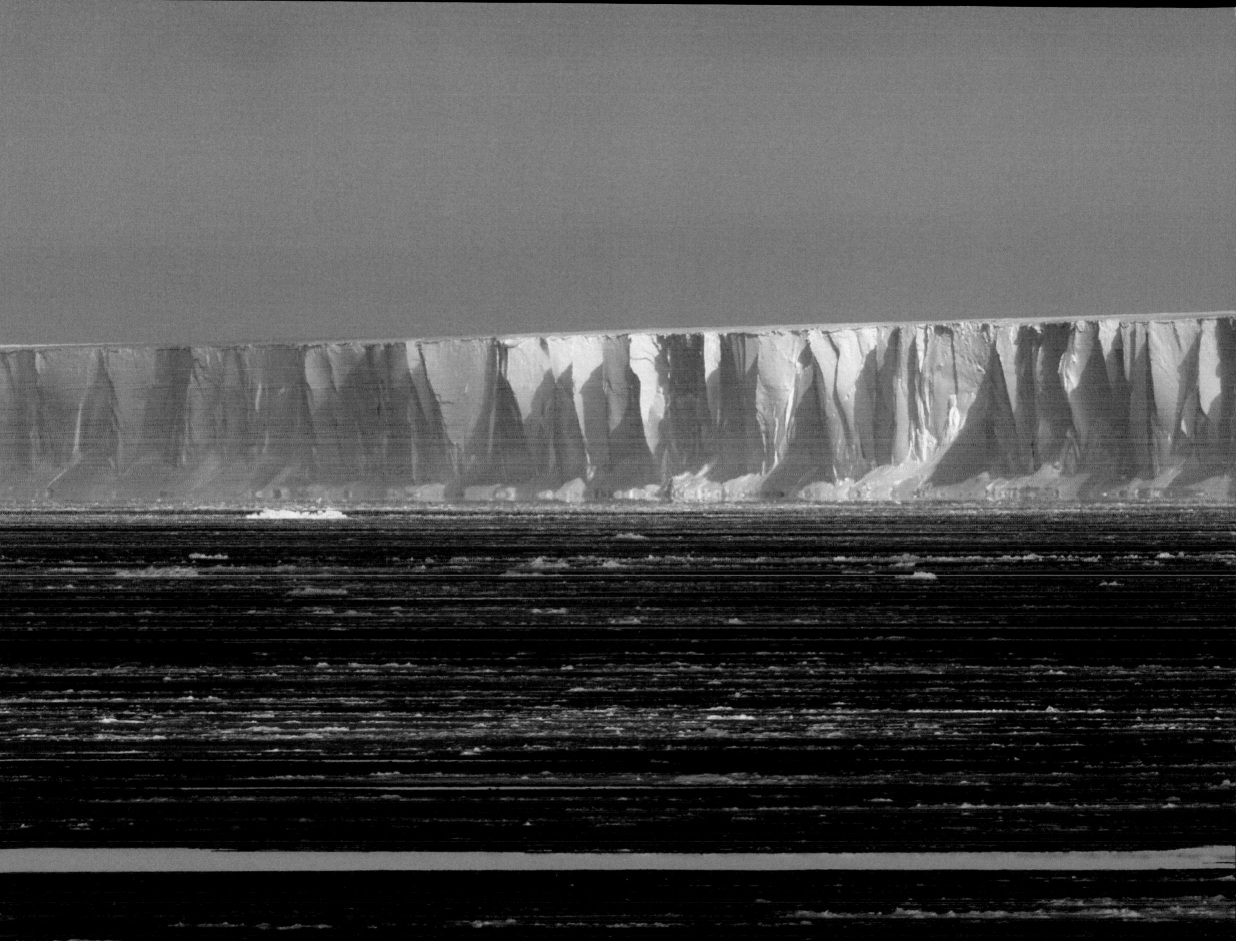

FOREWORD

by **CARL SAFINA**

John Weller's eye has a kind of divine penetration to it, a majestic sweep that somehow achieves and delivers much more than meets the eye. In other words, the images in this book are fabulous.

But imagery is only half the book. The ambitious narrative takes the reader on an in-depth journey into the Ross Sea. With clear, decisive prose, steeped in science and anchored in personal experience, Weller celebrates the astounding inhabitants and extreme environment of this most southern place.

The book reads like an adventure, revealing the drama in everything from the diving physiology of Weddell seals to the evolution of Antarctic fishes, from the formation of sea ice to the physical oceanography of the Southern Ocean. Moreover, the book weaves these highly detailed accounts into an overall story about the ecosystem, the effects of climate change and human industry, the history of marine conservation, and the uncertain fate of our global ocean.

I have always sought what was beneath the exterior of things. And in no earthly realm is the exterior so misleading as the sea. Out of sight for many, out of mind for most, the sea seems to many people *irrelevant* of all things, though without it our planet would be dead. Not only does the sea mask the enormity of life within, it also hides the hurts. As I wrote in my first book, and if anything it is truer now, "While the ocean may look the same as it has for millennia, it has changed, and changed greatly."

Fishermen and scientists all over the world confirm that extreme ocean degradation is now fact—fish depletion, coral reef degradation, loss of wetlands, etc. And while we work for further details, we already more than understand that we must act. As ocean health declines, people suffer. We are fundamentally tied to the ocean. Weller understands the issues in this way.

The good news is that people are waking up to these realities, and starting to take action. As a result of changes in law enacted in the 1990s, for instance, the United States has more recovering ocean fish populations than anywhere else in the world. Whales that were near extinction are strongly recovering. Protections work. Marine protected areas, especially no-take areas, recover rapidly. The ocean can heal itself if we let it. Will we? Why wouldn't we?

Thus far, as Weller points out, our response has not been fast enough, or bold enough, to outpace our destruction. Our nations must act as one if we are to stop the downward spiral of ocean health and begin the general recovery of great ecosystems. Our children and children not yet born will face the consequences or reap the benefits of what we do next.

So why pay attention to Antarctica when there is so much work to be done close to home? The Ross Sea is one of the most, if not *the* most, untouched parts of the world ocean. It is the best we have left, the cream of the crop. And for this reason alone it deserves our special consideration. But of perhaps even more importance, as Weller points out, the Ross Sea is an international place. Protection would require the agreement of 25 nations. And in an age when we must forge international collaboration in decisive defense of the global ocean, the Ross Sea is the right place to start.

Weller presents a message that is willfully hopeful, but not naive. He believes that we can change the course of history, and of course we can. We always have, and we do so daily.

Let this book be not a memorial, but a signpost on the road to the recovery of the ocean. And, of course, a celebration of one of the most beautiful places in the world.

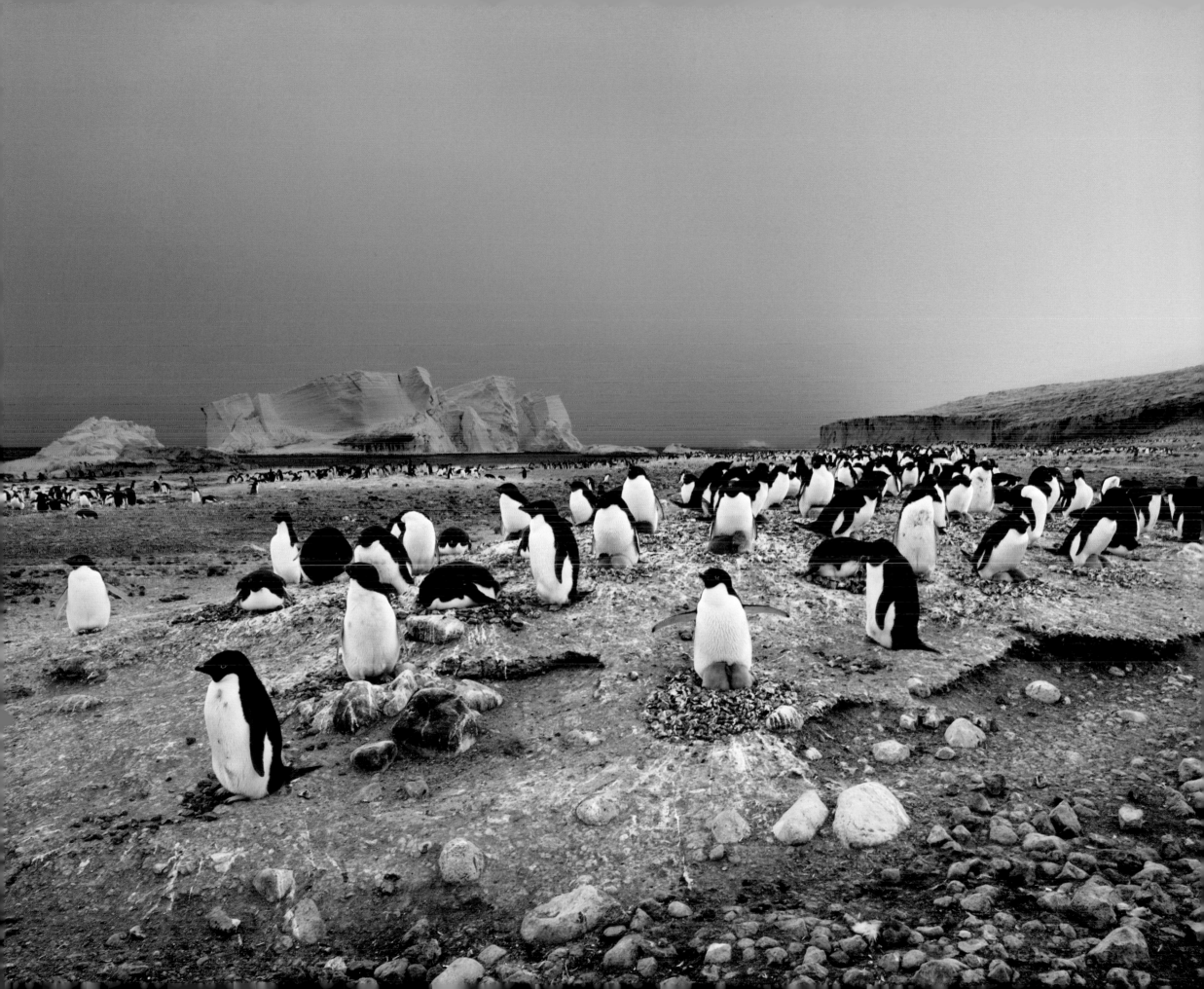

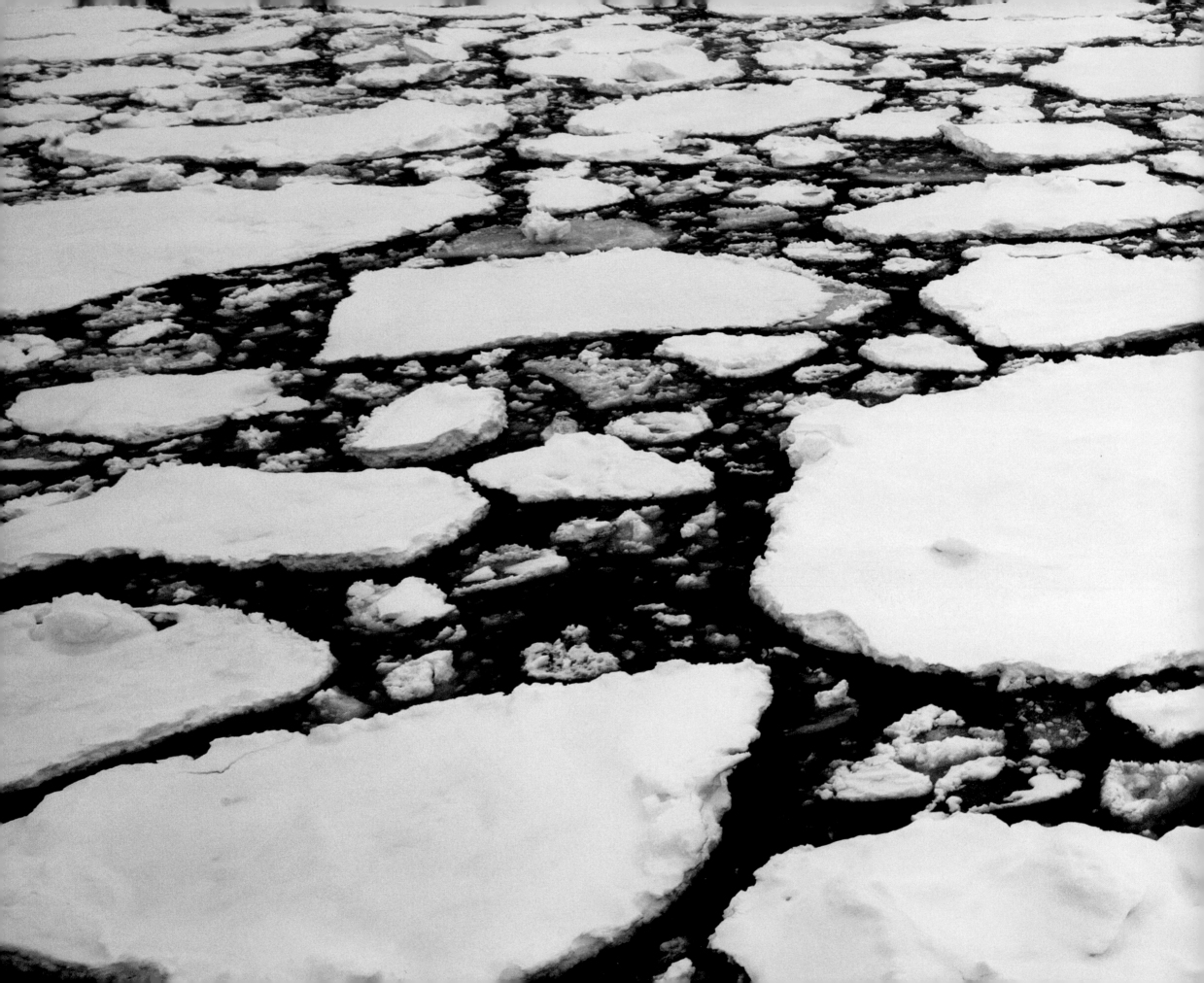

THE ICE

JOURNEY SOUTH

The water stretched outward to the edge of my imagination.

In a pocket between towering 10-meter swells, the 120-meter-long icebreaker rolled 35 degrees to the left. It rolled back on the way up the face of the swell, reaching dead center at the crest. As the swell dropped away, the ship continued to roll another sickening 35 degrees to the right, corkscrewing down into the next pocket until the bow slammed another swell, sending an angry curtain of salt-white spray 15 meters into the air. On the extremes of the worst rolls, I could almost walk on the walls.

I climbed steep outdoor stairs to the very top deck and stood alone just within reach of a handrail, teaching my body to counteract the rolling ship with my own inertia. My muscles loosened as I found my balance and became the fulcrum of the continuous movement. In that strange sense of stillness, the raw power of the waves and spray and bouncing ship sent my heart racing, and I couldn't help but throw my hands into the air as I rode the great green and yellow chariot south from New Zealand toward the southernmost body of water in the world.

But the seriousness of my mission tempered my excitement, and I reflected. My journey south had actually started two years earlier with a surprise visit from a childhood friend.

STARTING IN 2001, my friend Heidi Geisz worked seasonally at Palmer Station, Antarctica, on a penguin research team. In her time off, she traveled. She rarely made it home. Heidi's visits were always welcomed and never planned. She would blow into town like a warm wind, bubbling with stories and cheer. But when I opened my door in November 2004, her eyes were sad and serious. By way of greeting, she handed me a small stack of well-worn pages. She said simply, "This is something everybody needs to read." And so I did. As I reached the end of the document, the pages were suddenly heavy in my hands. I put them down and bolted outside, needing to walk away from the words, to put physical distance between my racing thoughts and the obscure scientific paper on my desk.

Antarctic ecologist Dr. David Ainley started his paper by presenting evidence that the Ross Sea, Antarctica, is the last large, intact marine ecosystem left on Earth, illuminating the devastating assessment by the United States National Science Foundation—"A more sobering discovery is that little if any of the ocean remains unaffected by fisheries, agricultural runoff, sewage, aquaculture and industry." David went on to conclude that a fast-expanding toothfish fishery in the Ross Sea is likely to cause irreparable harm in this last place. Toothfish are the largest predatory fish in the Southern Ocean, and the removal of top predators in other parts of the world's oceans has been proven to critically damage ecosystems all over the globe.

The idea struck hard. The last intact marine ecosystem? It was a lot to swallow. Could there really be only one place left undamaged in the entire ocean?

Over the course of the next few months I read about oceans, and what I learned was not just sobering; it was terrifying. Our ocean practices are marked by reckless overuse and indefensible waste. Fisheries are bulldozing the ocean floor with massive trawls, strip mining top predators with purse seine nets that can ensnare entire schools of oceanic tuna, and crisscrossing the ocean with enough fishing line to encircle the globe more than 550 times. Of the fish we capture, 40 percent are unwanted and thrown back into the water dead. Major fisheries have bloomed and withered over and over in sadly predictable patterns of overuse and abuse. The scariest estimates are that we've eaten our way through 90 percent of the world's top predatory fishes—tunas, groupers, and sharks—since 1950. The most optimistic estimates aren't much better.

And what we take out of the ocean is only half of the problem. Sewage, fertilizers, toxins, oil, and plastic debris all end up in the ocean. We produced roughly as much plastic in the last 10 years as we did in the entire 20th century, and plastics take hundreds to thousands of years to break down. Even then they don't disappear. Tiny pieces of plastic, smaller than grains of sand, are found on beaches, in deep-sea sediments, and in the bodies of ocean animals around the world.

In addition to the sheer size of the fishing industry, the massive amount of wasted bycatch, and the poisons of pollution, we also subject marine systems to some of the most egregious and barbaric rituals imaginable—fishing with dynamite, and cutting the fins off of live sharks, which are then dropped back into the water to die slow, hopeless deaths.

Industry, pollution, and destructive practices are pushing ocean systems to the brink of collapse worldwide—and at a time when ocean systems are already struggling to keep up with climate change, which is fundamentally transforming the ocean in innumerable ways, down to the very chemistry of the water itself. And let's be perfectly clear: more than a billion people depend directly on fish for their protein. They live mostly on fish with little opportunity for other industry or sustenance. These people are all at risk. We are in a global crisis, and yet it is almost completely hidden from our daily lives.

With Heidi's introduction, I wrote to David Ainley and requested a meeting. Two weeks later, I met him at his home in California. He spun tales of a pristine place—where Adélie Penguins build nests from the same stones that their ancestors have used for thousands of years; where Weddell seals keep holes in the ice open with their teeth in winter temperature extremes of -60°C; and where minke whales, sequestered in a nearly impenetrable fortress of floating pack ice, have fully recovered from industrial whaling while the great whales have failed in the rest of the global ocean.

He explained in sharp detail how the mass removal of toothfish would trickle down through the ecosystem, changing it forever. He stressed again and again that the Ross Sea was the world's last pristine place and no one was paying attention. As we talked, I realized I was already committed. We

enlisted each other to tell the Ross Sea story, and though we shook hands on it, we made the pact with our eyes. I knew that I needed to see this last place for myself.

Over the next two years, I talked with scientists all around the United States and beyond. I sat down with media executives, members of Congress, business people, educators, filmmakers, and other artists. I told the story again and again, trying to raise awareness, and trying to find a way down to Antarctica. I raised money, addressing my entire community and collecting incredible support from friends, family, and friends of friends. Finally, I cold-called Francesco Contini of Quark Expeditions, who was sending an icebreaker to the Ross Sea. He offered me passage, finally putting me en route to the ice for the first time.

MY FIRST DAY on the Southern Ocean, I stood alone on that top deck for seven hours, through dinner and late into the night, as the glowing green curtains of the southern lights swept across the sky.

I awoke the next morning from a short, uneasy sleep, still strapped into my bunk with a sling I had rigged during the night. I dressed quickly and went outside. Instead of climbing back to the top deck, I headed down more steep outdoor stairs to the lowest. Again, I was alone. I secured myself to the handrail on the port side of the ship with a rope and climbing harness, and hung on for the ride. The top deck was a chariot, but the experience on the bottom deck was more like being in a kayak, engulfed by the raw power of water. When the ship was level, the deck was three meters above the water. When the ship rolled, I was either looking at the sky, or face-to-face with a monstrous wave.

The water was almost black, but flexing waves revealed glimpses of delicate pastels beneath the tortured surface—cyan, blue, and aquamarine—and those secret colors only hinted at the complexity below the ship. The ocean is not homogeneous, but instead a complex assemblage of distinct water masses, each with a unique temperature, salinity, and mix of suspended organic and inorganic materials. Density varies with temperature and salt load. The colder and saltier the water, the more dense it is, and when water masses with different densities meet in the ocean, the denser of the two sinks underneath, forcing the lighter water mass toward the surface. Colliding masses of water mix together only at their boundaries, remaining largely intact as they push past each other, and these masses can maintain their integrity over long distances and periods of time. Some of the water deep below the ship had originated not in Antarctica, but in the Arctic, more than 15,000 kilometers away.

In the North Atlantic, wind-driven surface currents move salty water northward toward the pole. The polar air cools the mass of water until, just about level with Greenland, the cold, salty surface water sinks, a slow river of dense water that hugs the east coast of the Americas as it flows southward near the ocean floor. But this deep ocean current—which moves 15 million cubic meters of water per second, 15 times the combined flow from all the terrestrial rivers in the world—is only a tributary of the current that flows

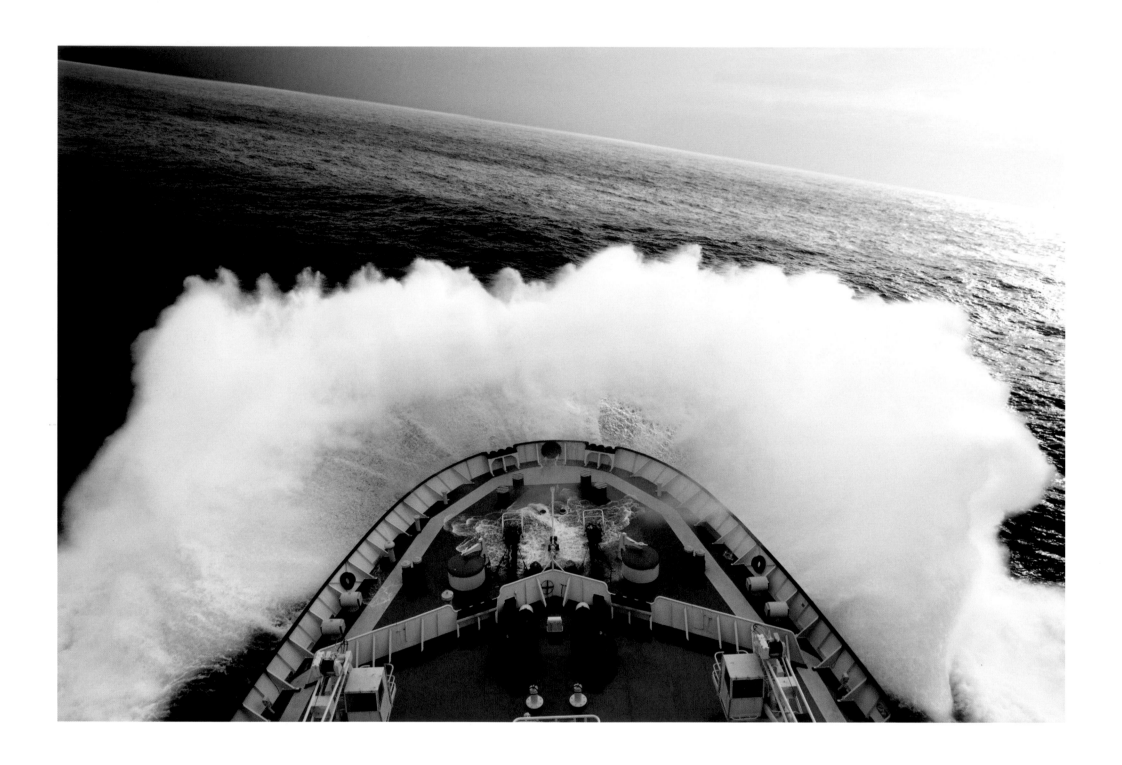

Above: *Kapitan Khlebnikov* in high seas | Opposite: **Wave in the Southern Ocean**

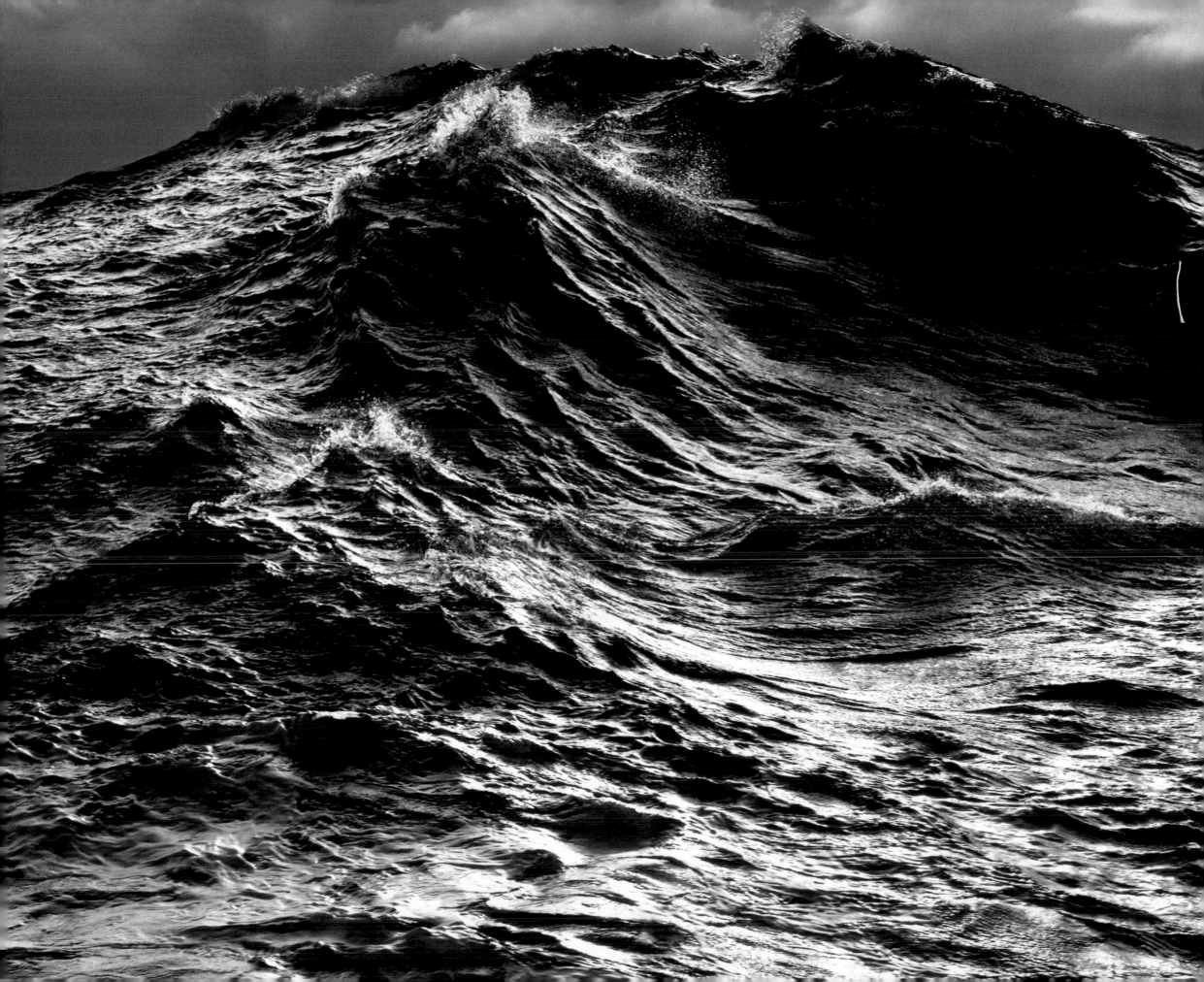

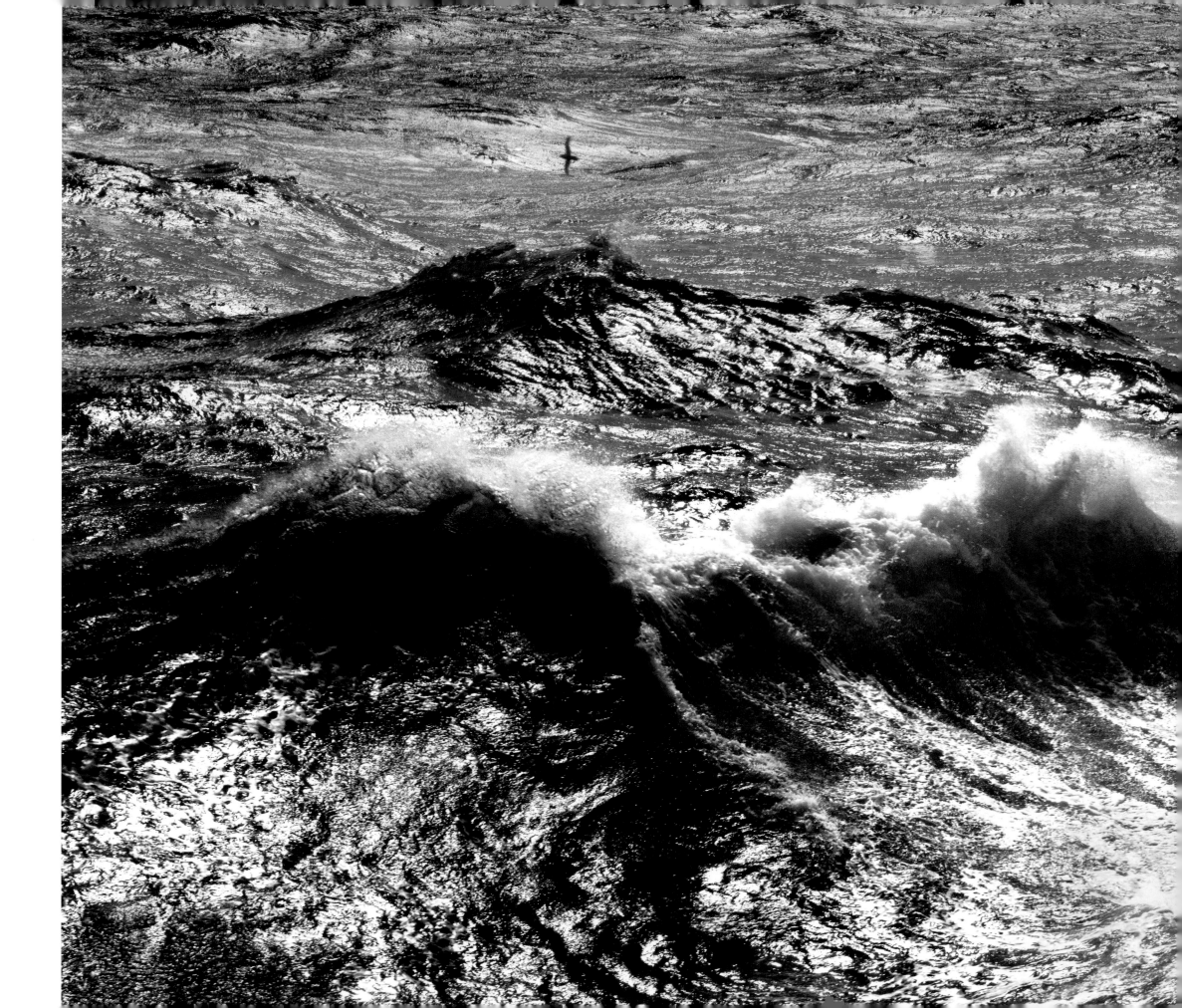

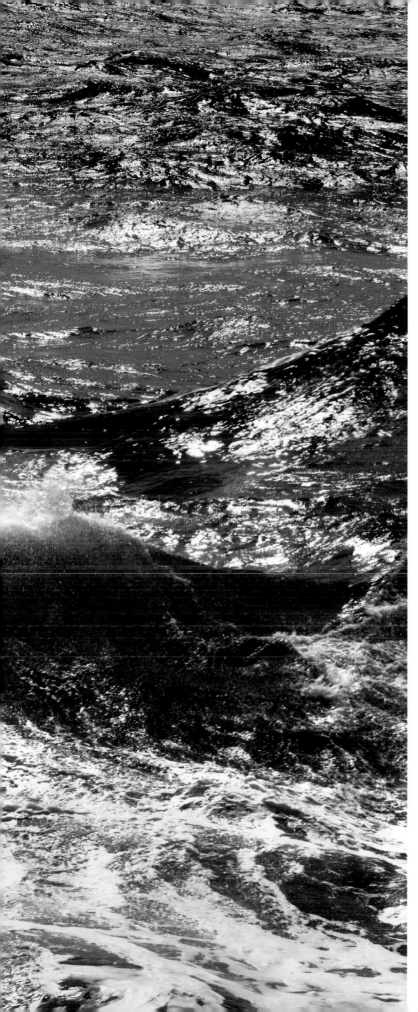

deep in the Southern Ocean. The Antarctic Circumpolar Current, or ACC, encircles the entire continent in a continuous loop. The current is up to 2,000 kilometers wide and flows at 100 million cubic meters per second as it spins east around Antarctica.

The ACC itself is also made up of different water masses, delivered by the other tributaries that flow into the great circular current, each with different properties. A cross section of the ACC would look like layered sandstone extending down from the surface to more than 4,000 meters, with the deep, dense water from the North Atlantic forming most of the bottom layer. On the northern edge of the ACC, the moving wall of water acts as a barrier to warm subtropical and subantarctic water masses, isolating Antarctica both climatically and biologically. Northern animals stay to the north. Southern animals stay to the south.

In the middle of the ACC, however, sinking Antarctic Surface Water forces nutrients to the surface in a thin ring encircling Antarctica at roughly 60° south latitude. With its upwelling of nutrients, the Antarctic Convergence is a primary biological boundary of the Southern Ocean, supporting large blooms of phytoplankton and thus aggregations of zooplankton and small fish. We knew when we had reached it because of the birds.

From the edge of the swollen gray sky, a single shaft of light exploded across the inky water, painting a channel of molten silver. Suddenly, a Southern Royal Albatross, with its four-meter wingspan, appeared above a cresting swell, slicing the fierce gusts with nonchalant precision, one pterodactyl wingtip nearly dragging a lazy arc in the wave. The bird glided, weaved, tacked, and wheeled, but rarely flapped its wings. A pair of Black-browed Albatross and numerous small flocks of Cape Petrels joined the aerial dance, all sweeping, crossing, and coasting up and over the vast silver-black mountains of water. Nesting on lonely subantarctic islands, some species of albatross make regular foraging trips of more than a month, covering distances of up to 13,000 kilometers and relying entirely on the famous Southern Ocean winds to make the journeys possible. The birds ushered the ship south toward the ice for hours. Then the ocean flexed again, and they were gone.

I didn't want to skip a fourth meal in a row, so I went inside to eat.

Days farther south, the air and water were almost still, and we left the great birds of the Southern Ocean behind to ride the wind. We crossed the Antarctic Circle, passed an iceberg, and soon left the night behind as well. The midnight sun glowed orange, balanced just above the black waves. At the splitting of sea and sky, it illuminated a thin white band stretching across the entire southern horizon.

Finally, I could see the edge of the ice.

Opposite: **Waves in the Southern Ocean** | Following Spread: **Black-browed albatross** (left); **light on water** (right)

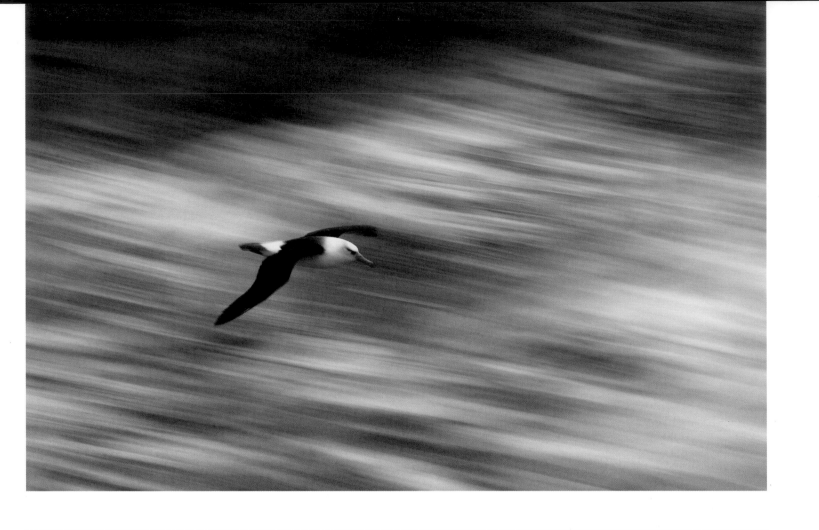
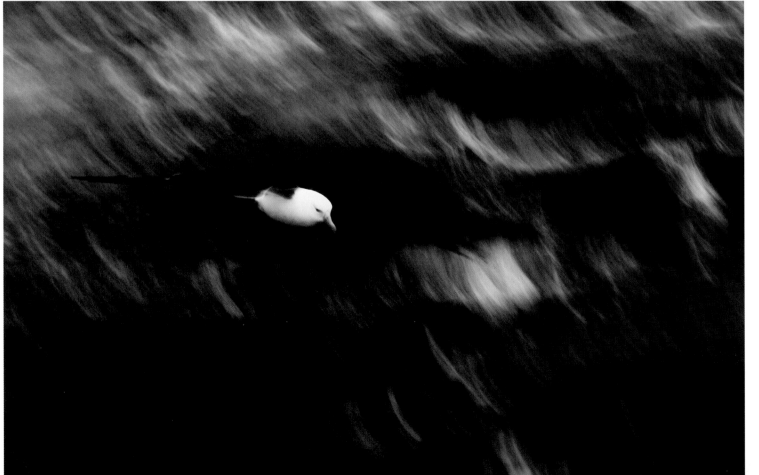

Opposite: **The edge of the pack ice and the midnight sun** | Following Spread: **Iceberg in the Southern Ocean**

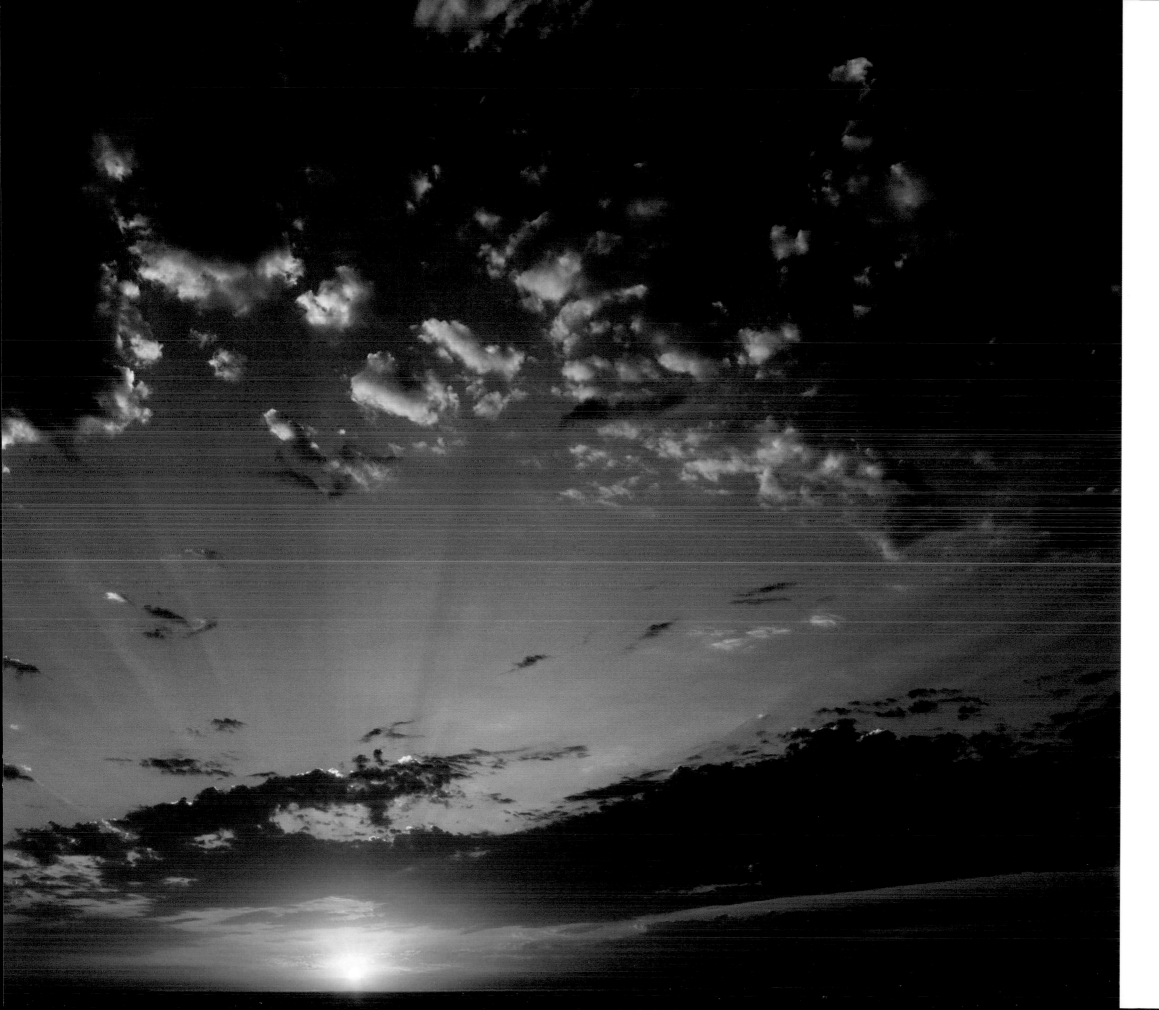

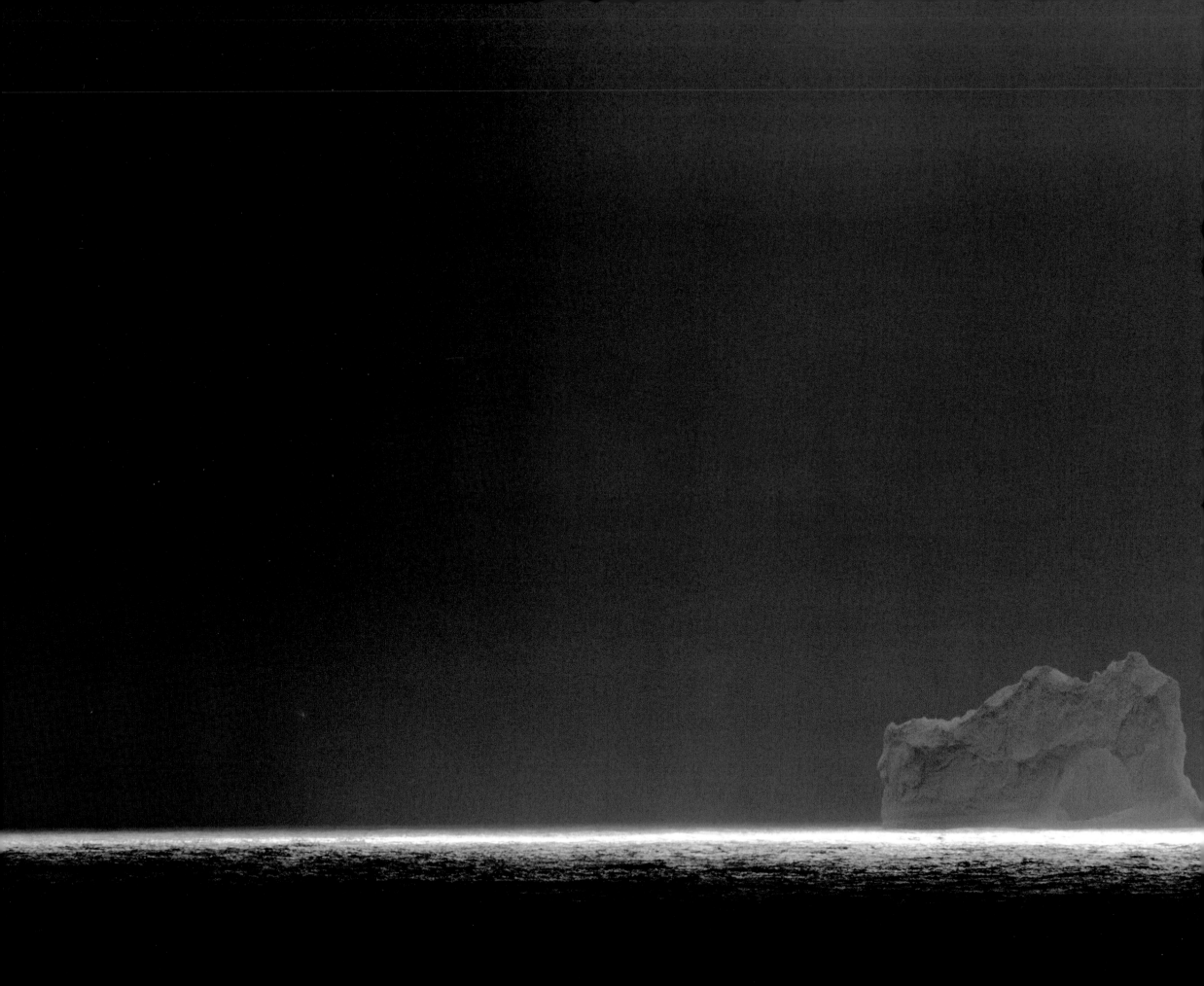

the freeze and the melt, this desert of drifting ice forms the basis for one of the largest, richest, and most dynamic ecosystems on Earth.

As sea ice freezes, it traps and concentrates nutrients from the seawater below. Thus, as the ice moves, it brings along its own fertilizer. This concentration of critical nutrients would be useless if the ice were flat, glassy, and completely solid. Sea ice is not. The solid layer of sea ice is sandwiched between a thick layer of loosely packed ice platelets below and a layer of snow above. The assemblage of platelets provides a haphazard complex of tiny caves and passages, protected from rough water by the weight of the ice, and from harmful ultraviolet rays by the snow above. Fertilized and sheltered, phytoplankton blooms in the platelets, limited only by the amount of light radiating through the layers of ice and snow. Displaced by the ship's passage, overturned rafts of sea ice release a dark brown soup of tiny plants into the icy water.

This wealth of food attracts a five-centimeter-long crustacean, the most important animal in the entire Southern Ocean. With an estimated total biomass of 600 million tons, Antarctic krill may be the most prolific animal on Earth. Krill mate in the early summer, and each female can release up to 10,000 eggs. The eggs are heavier than seawater, and thus they sink for five days as they develop, finally hatching at depths of 700 meters or more. The trip back to the surface takes three weeks, and during that time the larval krill complete several other stages of development, finally arriving at the sea ice, ravenous for their first real meal.

Krill must eat quickly to put on weight and prepare for winter, when phytoplankton will be in very short supply. At the surface, they are easy prey; thus, the animals have developed sophisticated defensive strategies. In the bright light of midday, they migrate downward, reaching depths of 200 meters, where they are harder to see in the lower light. There they form swarms—several hundred meters across and with densities of up to 30,000 animals per cubic meter—that continually shift shapes as the animals move in concert, confusing potential predators. Despite these tactics, krill cannot avoid being eaten. They are the primary food source for the majority of predators in the Southern Ocean, all of which come to the pack ice to feed.

Hauled out on a raft of ice in front of us, a crabeater seal raised its head to inspect the approaching ship. It reared back, obviously unhappy at the prospect of being disturbed from its resting place, but waited until the inevitable was absolutely necessary, finally abandoning its position seconds before the steel hull ripped the raft of ice in half.

The narrow escape left me wondering about the effect even this one vessel was having on the animals that live in the drifting ice. Our understanding of the Ross Sea ecosystem—of any marine ecosystem, for that matter—is only in its infancy. Scientists are just starting to unravel the web of entanglement, the DNA of the ecosystem itself. In a place where life is molded by the ice, already balanced at the edge of possibility, it is critical that we truly know the consequences of our actions before we act. But despite my uneasy conscience, I couldn't quell my building excitement as we moved farther into the ice, closer and closer to the Ross Sea.

I couldn't sleep. Every time I tried, I imagined what I was missing outside, and I would bolt out of the bunk, hurriedly donning my layers of clothing to get back out on deck. Finally, I just kept my clothes on, shedding only my outer layer to catch 30-minute naps when I literally couldn't hold my eyes open. I went on like this for four days before my exhaustion finally demanded an extended rest.

OUR JOURNEY SOUTH was marked by occasional wandering mountains of ice, chiseled into the sky like jagged teeth, their 60-meter-tall spires and cleaved cliffs brought into perspective only in comparison to South Polar Skuas: the birds' two-meter wingspans were almost invisible against the looming bergs.

Icebergs start off as light snow falling on the Antarctic continent. The snow compresses, becoming more and more compacted over thousands, if not millions, of years, eventually forming glacial ice. The glacial ice is viscous and plastic, moving under its own immense weight from the center of the ice cap out to the coast, where the ice rivers are pushed off the continent and out to sea. The floating fronts of ice tongues and ice shelves can be hundreds of miles long. The fronts calve into the ocean, releasing large, white, tabular icebergs. Wind, sun, waves, and currents then unleash their forces on the bergs, sculpting in infinite variety. Older icebergs can be identified by color. The older the ice, the denser it becomes, and the more wavelengths of light it absorbs. The oldest layers are so dense that they glow pure blue, green, or black.

An Adélie Penguin surveyed the scene from a high perch on the exposed underbelly of an old berg, the cupped divots of the icy surface betraying the fact that the berg had eroded unevenly, become unbalanced, and rolled over. In the distance, more icebergs stretched out in a line, likely 100 kilometers long. As I watched, the top of one berg suddenly started to bulge up in the same way that a drop of oil bulges down, just as it is about to fall. The analogy continued, and the berg-drop pulled off into the sky and hung, suspended in midair. I rubbed my eyes hard. Maybe I really needed some more sleep. But when I looked again, the bizarre airborne iceberg was still there, though it had changed and was connected in a thin line to other morphing bergs.

The mirage lasted for more than 20 minutes, but it lost hold of my attention as a pair of pure white Snow Petrels flashed overhead, glowing against the overcast skies. They banked hard left and right on delicately pointed origami wings, like flecks of paper suspended in temperamental winds.

Spying underwater movement between the rafts of ice, they entered steep dives—surprise attacks on unsuspecting krill. They looked impossibly small and fragile against the ice and clouds, but in fact they are the southernmost breeding animals in the world. They make their nests on exposed rock cliffs, 100 kilometers into the Antarctic continent itself. Many of their sites are as yet unseen by human eyes.

Deep into the pack ice, out of reach from even the largest swells, the floating puzzle pieces were huge—600 square kilometers—but even those great plates of ice were still in motion, moving along with the rest of the pack ice at up to 20 kilometers per day. Jumbled piles of ice defined the edges of slowly colliding plates, and where they were spread apart, the seascape looked strangely like an aerial map of lakes and connecting rivers. These leads and pools are ephemeral, though, constantly opening and closing as the pack ice shifts. Surrounded on all sides by hundreds of kilometers of floating ice, they are perhaps the most inaccessible pockets of water in the world, and yet they team with life.

Numerous small groups of Adélie Penguins eyed the ship, resting on the edges of the transient lakes. Seals dotted the ice—crabeaters, misnamed, as they hunt krill almost exclusively; leopard seals; and even the rare Ross seal itself. Flocks of Antarctic Petrels took flight, cruising low along the edges of the pools. A sudden blast of air announced the presence of a minke whale, and a misty cloud drifted across the ice as it filled its huge lungs with another breath and slid smoothly through the water and out of sight. The ship followed the seams of open water between the plates of ice, the path of least resistance, zigzagging from one magnificent oasis to the next.

Suddenly, a killer whale rose from a dive right next to the ship, directly in front of me. The water bent and stretched around its head in the instant before it broke through. In that split second, the whale was nothing more than a ghostly shape beneath the water—an errant wave—and the ocean had eyes. Pods of killer whales, sometimes 100 strong, patrol the ice edges. The males are easy to pick out. Two-meter-tall dorsal fins cut through the water, black knives against the ice.

There are actually three types of killer whales in the Ross Sea. Type A killer whales primarily hunt minke whales, while type B killer whales mainly hunt seals. Doug Allen, a BBC photographer, told me that he once witnessed type B killer whales making coordinated attacks on crabeater seals hauled out on rafts of ice. Doug saw five whales swim fast in tight formation, just below the surface, directly at the raft of ice, creating a bow wave in front of them. As the whales dove under the raft, the wave rocked the ice, tipping it severely. The seals started to slide, but frantically regained ground toward the middle of the raft. In the subsequent repeated attempts by the whales, the seals were less successful. Eventually, the whales were able to tip the seals over the edge of the raft and into the water. The rest of the job was easy.

Types A and B whales live all the way around Antarctica in the summer months, traveling great distances to hunt in the ice. A third type of killer whale, type C, lives more permanently around Antarctica, and primarily in the Ross Sea. Many researchers consider these whales to be a distinct species, and they are commonly known as Ross Sea killer whales. These orcas are much smaller and tend to gather in large groups to hunt toothfish and other fish deep in the pack ice, finding holes scarcely large enough for a single whale to poke its nose above water to breathe. Demonstrating this agility, a whale broke the surface in a pocket of water that I would have otherwise not noticed, its misty breath catching the low pink light as it slid backward into the water and out of sight.

We broke ice farther and farther south. Eventually, we ran out of open water leads, and the ship was forced to cut directly through the thick ice, nearly slowing to a standstill. The ice was compressing around us, quickly filling in the channel that we had just broken. Then we were stuck. The ship maneuvered to slowly work its way out of the jam. In addition to its great power and strength, the ship is equipped with unique systems to work in the ice. First, it can actually break ice in reverse. Analogous to the ice knife under the prow, the ice horn under the stern splits the ice when the ship moves backward and protects the rudder as it does. In addition, deep in the bowels of the ship, massive water tanks and a pumping system allow the ship to shift its center of gravity left, right, front, and back. Finally, deep below water level, a long line of nozzles in the hull can actually release high-pressure air, which forms a skirt of bubbles around the hull as it rises to the surface, fizzing. The ship blew bubbles and sallied back and forth, ramming the ice forward, then backward, and then forward again. Finally, after a full day, it wiggled its way free.

The currents shifted again, releasing the crushing pressure of ice around the ship, and we cut more quickly south. On the southern horizon was yet another thin white line.

Pack ice in the Ross Sea

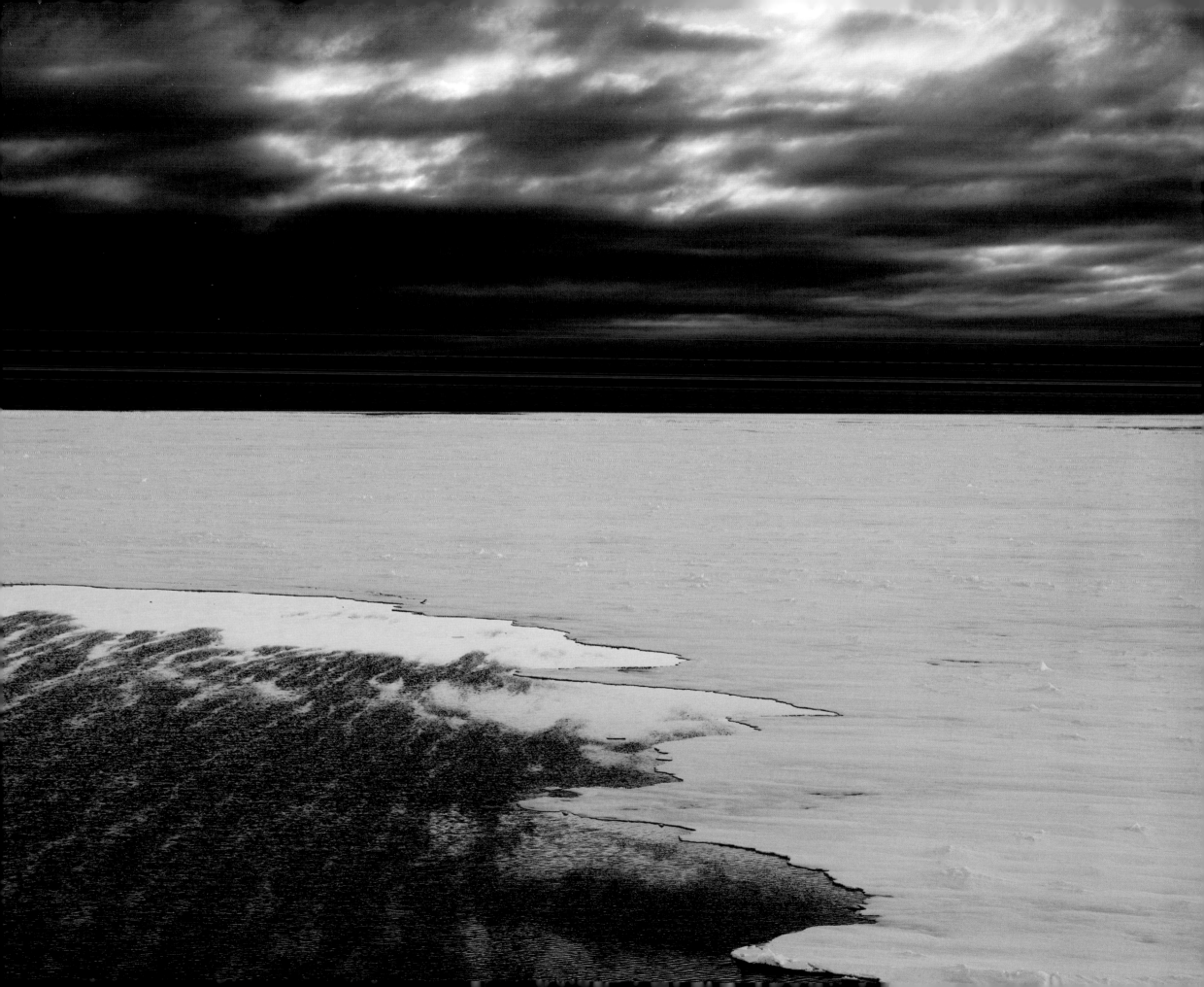

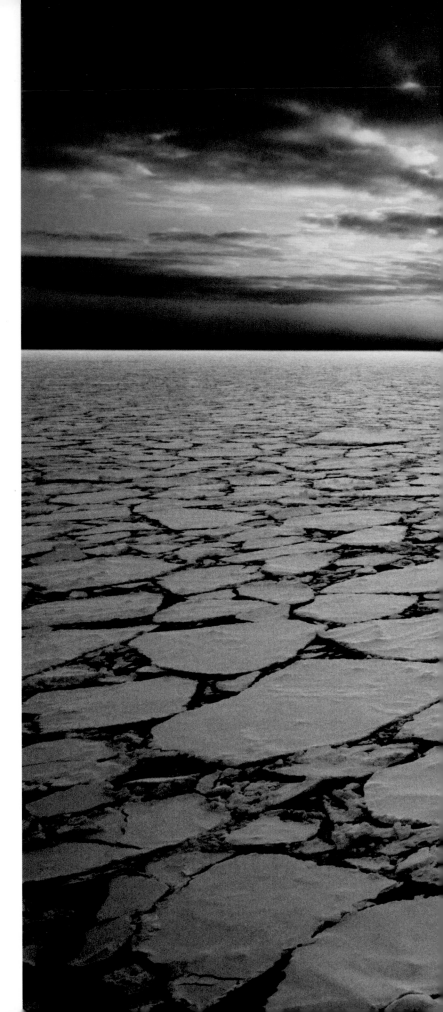

Midnight sun over pack ice

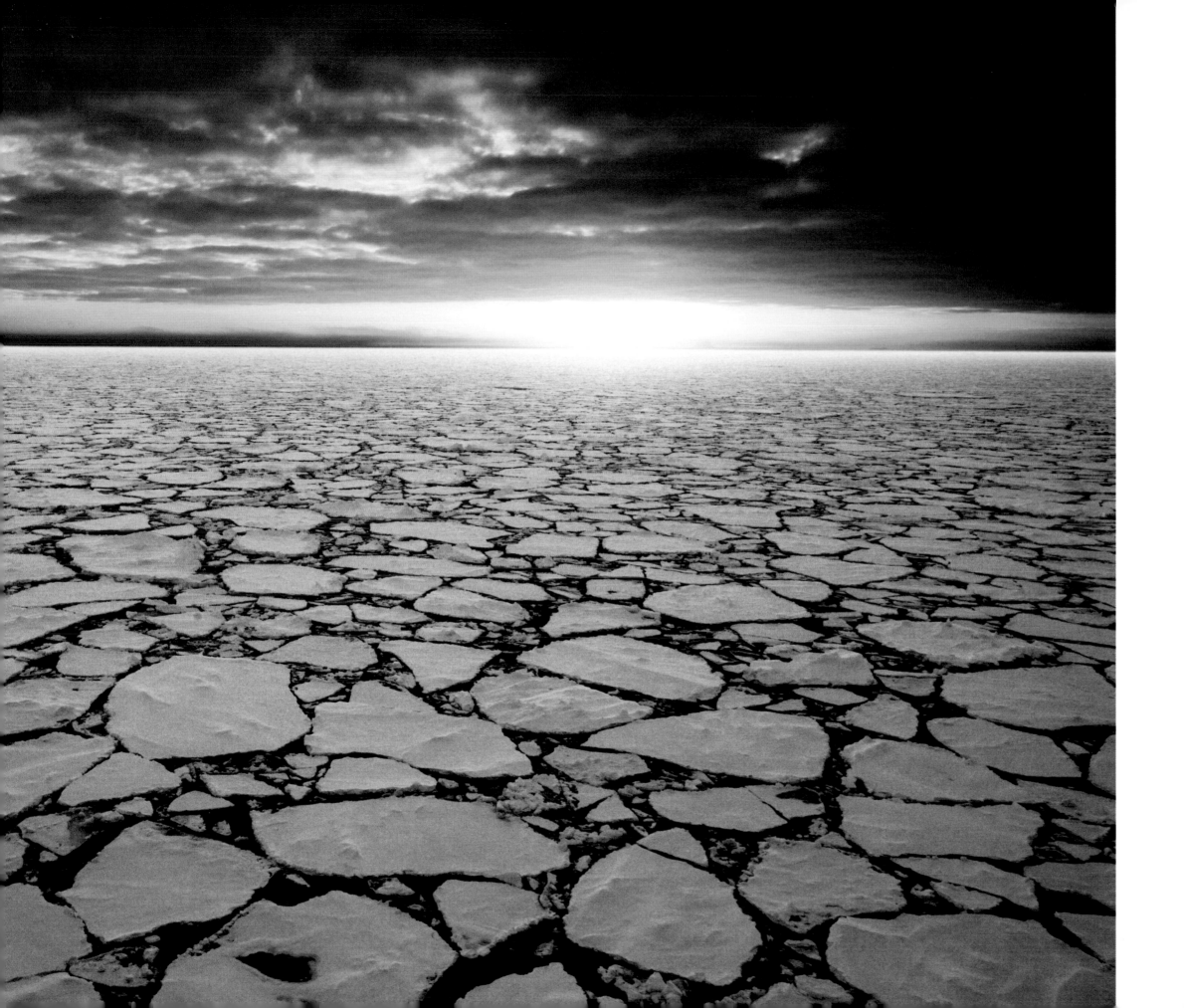

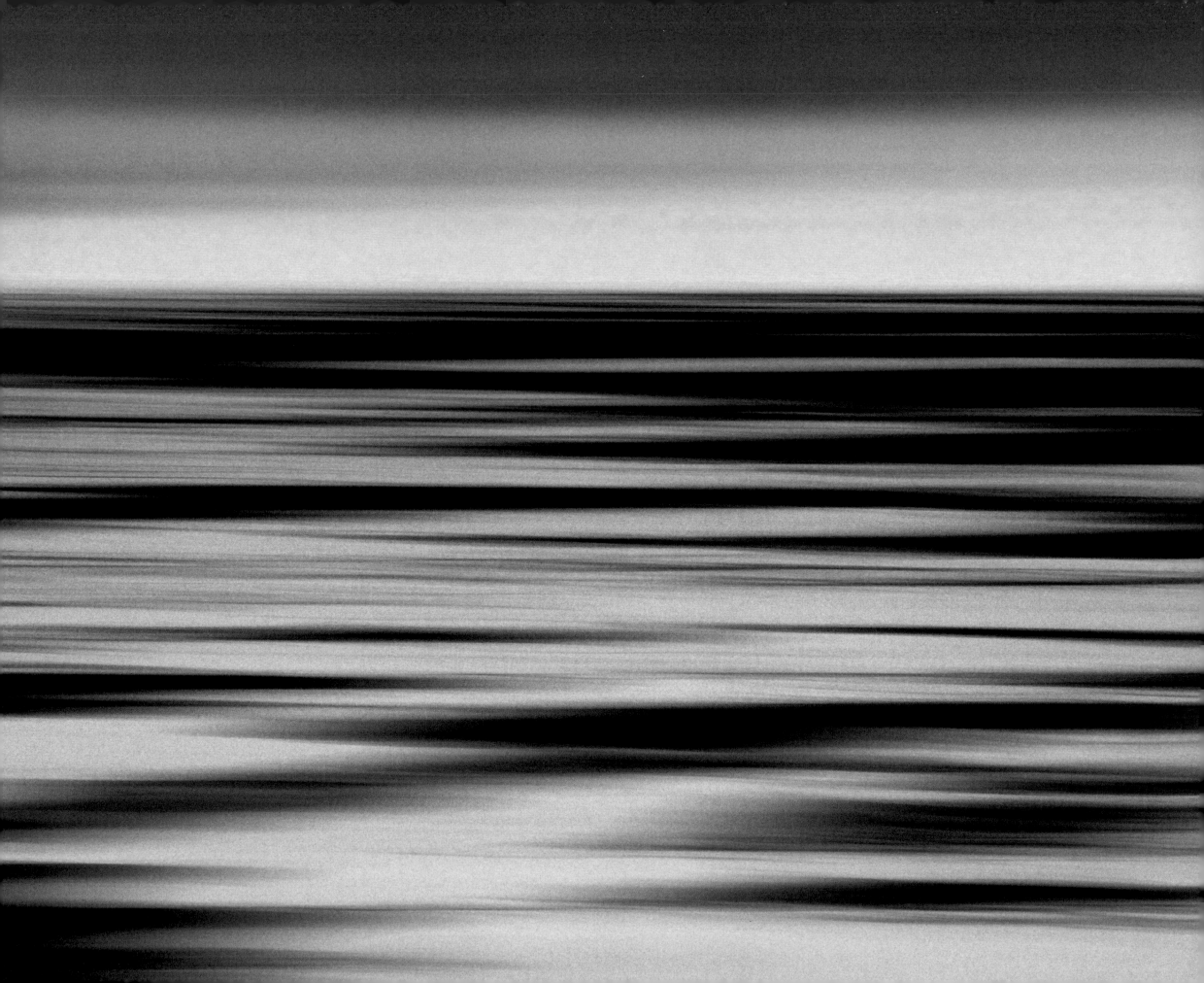

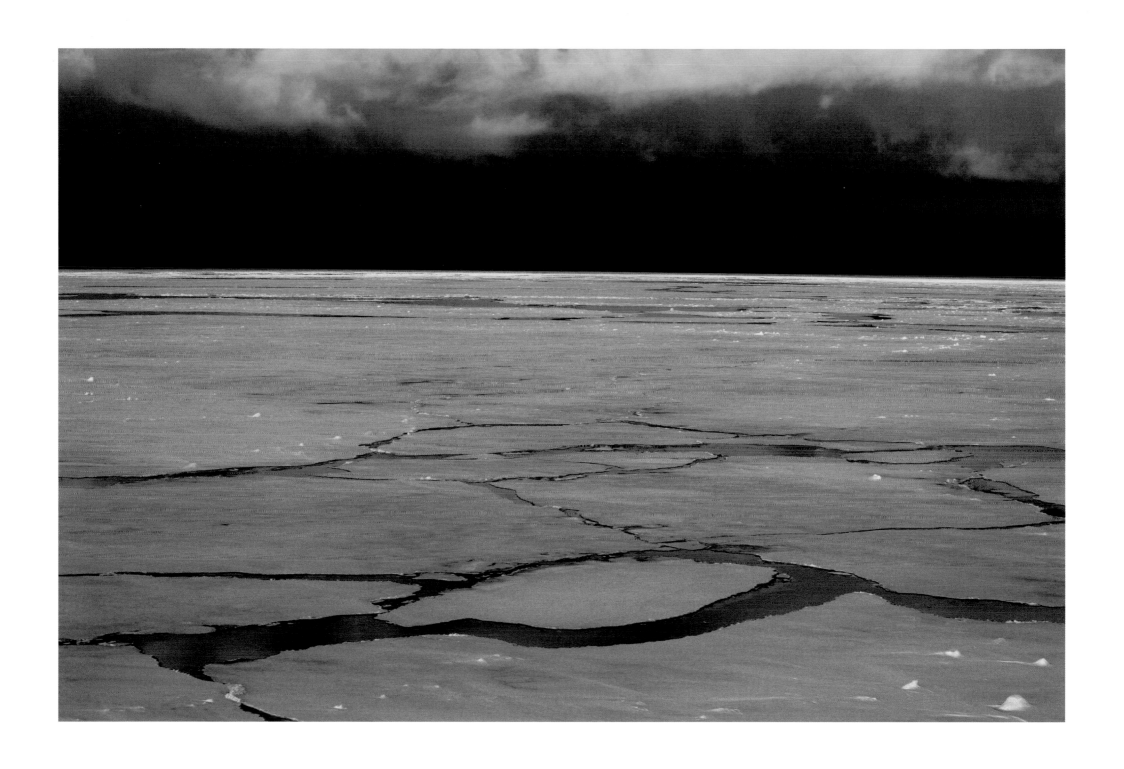

Opposite and Above: **Pack ice in the Ross Sea**

South Polar Skua and tabular icebergs

34

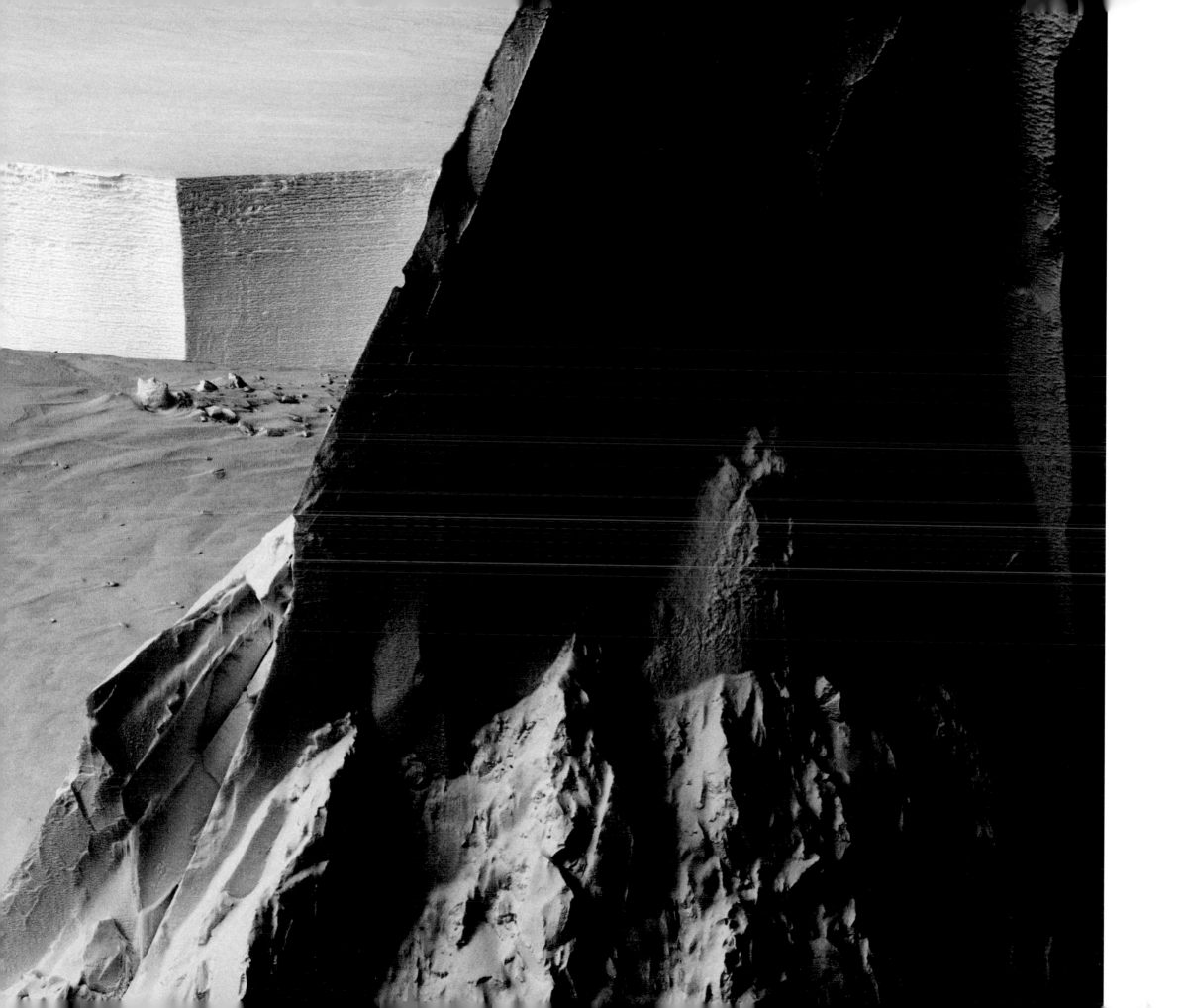

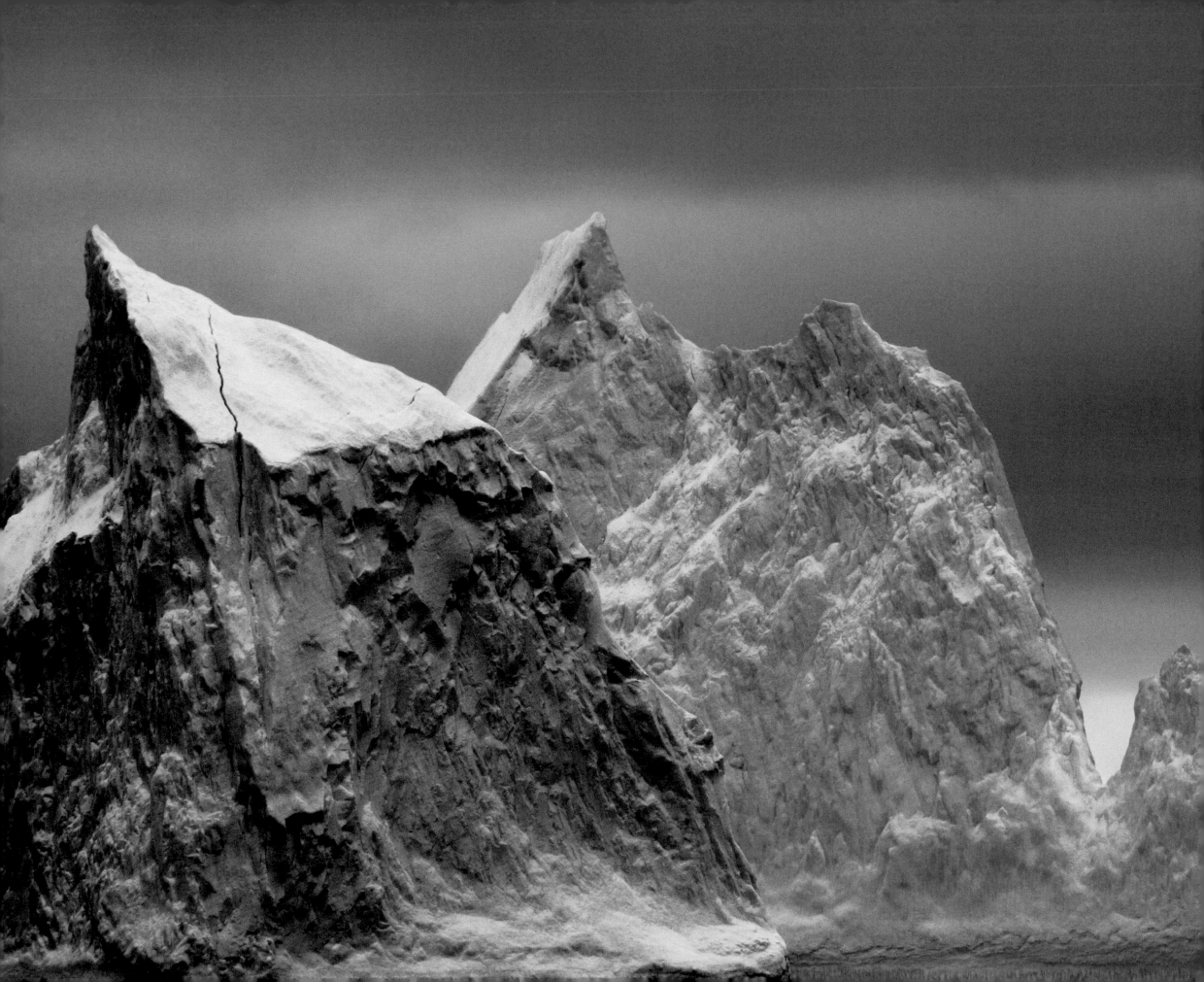

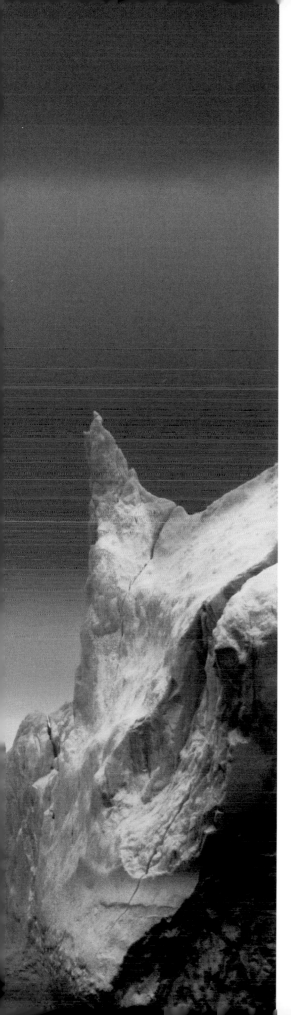

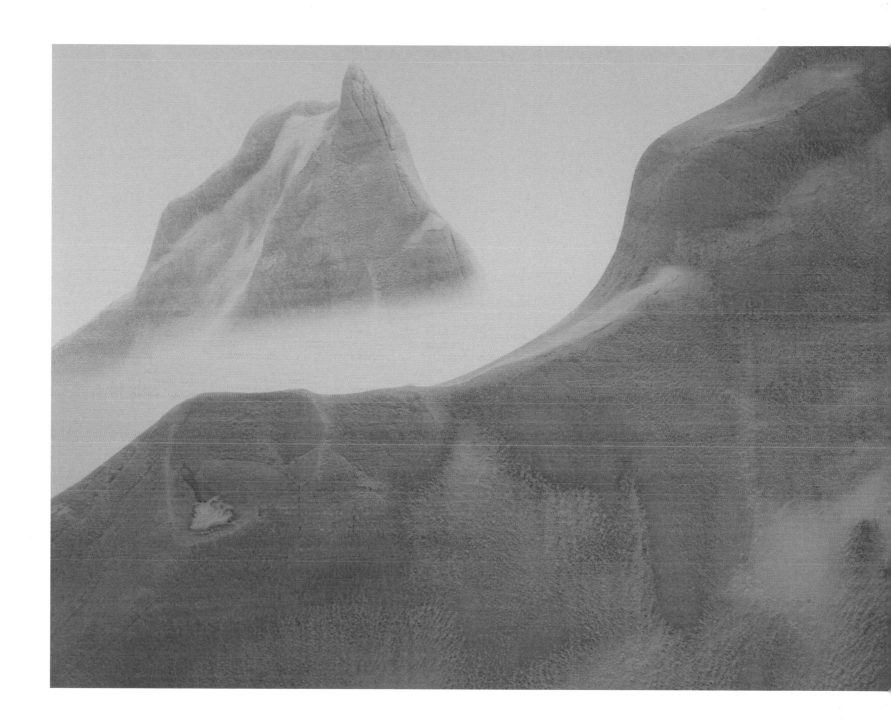

Opposite: **Icebergs** | Above: **Icebergs in ground fog**

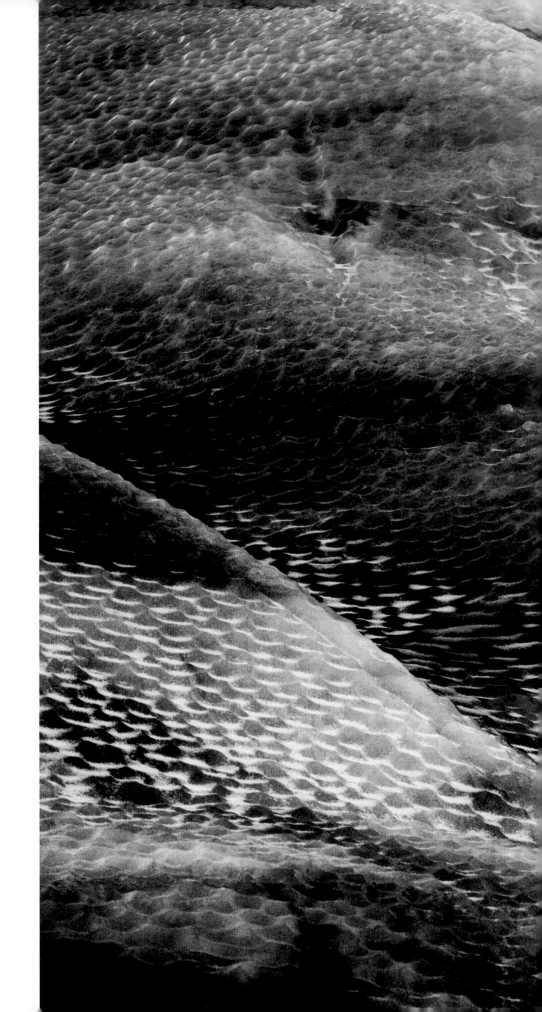

Adélie Penguin and blue iceberg

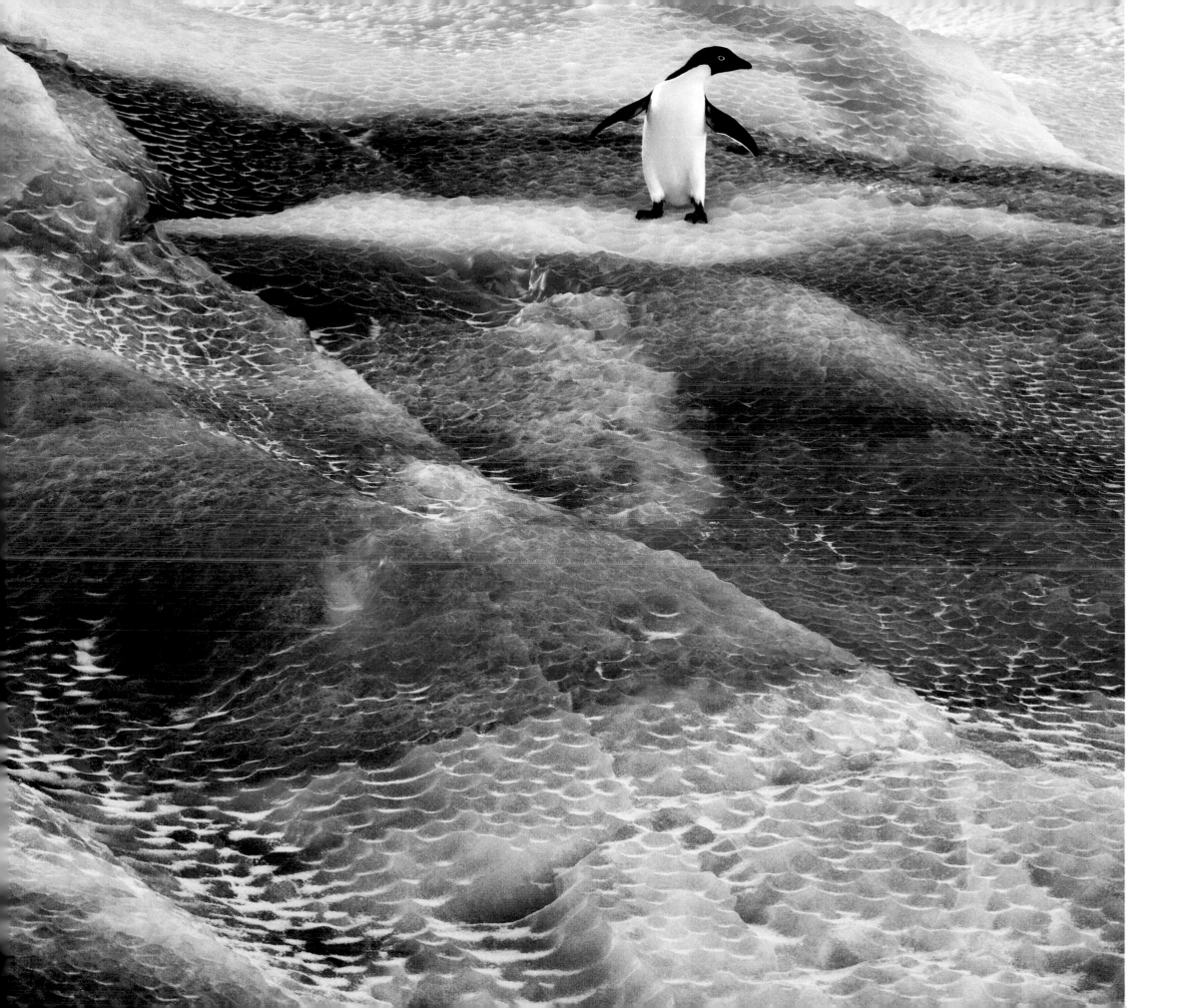

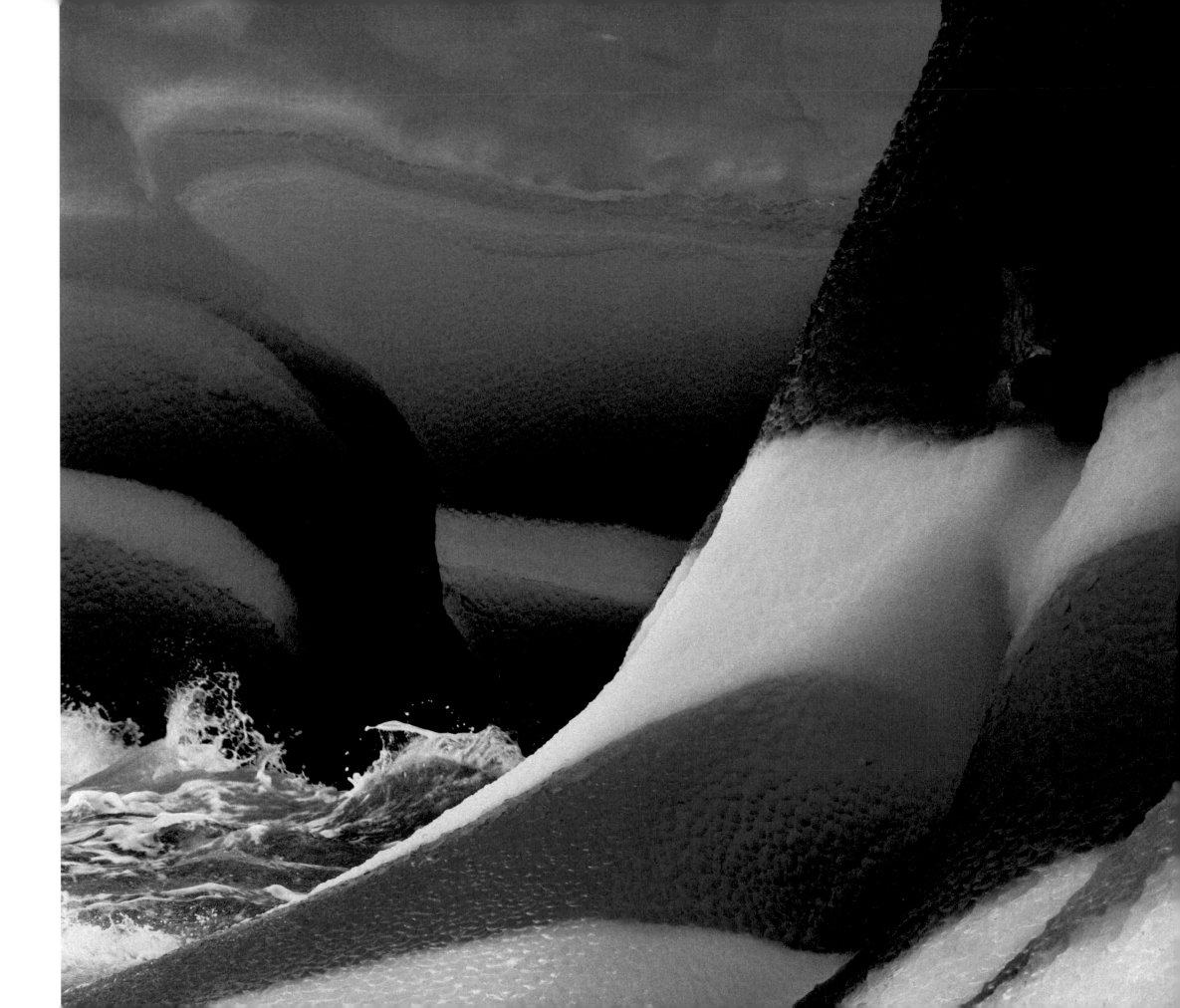

Blue iceberg

Snow petrels and iceberg

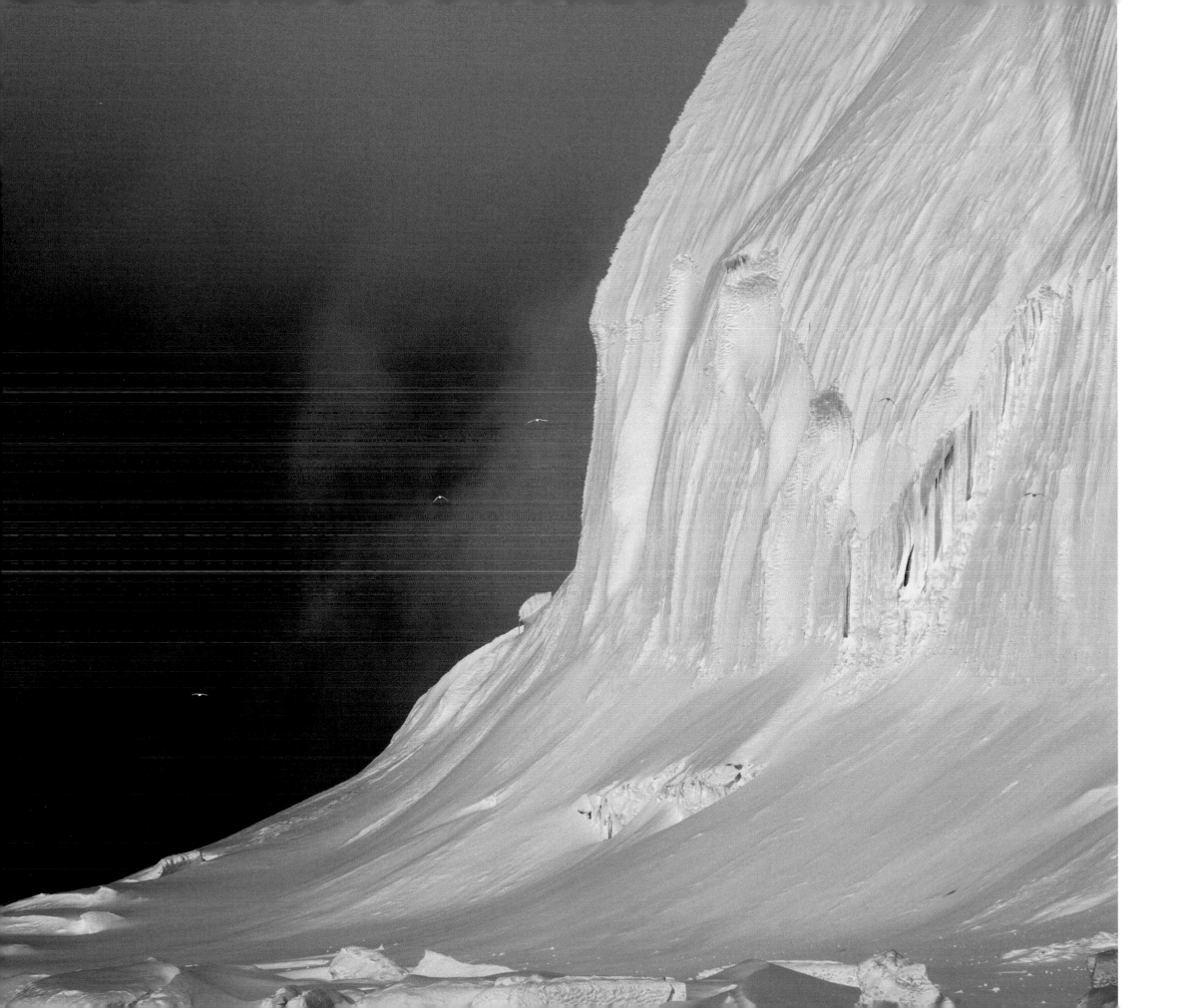

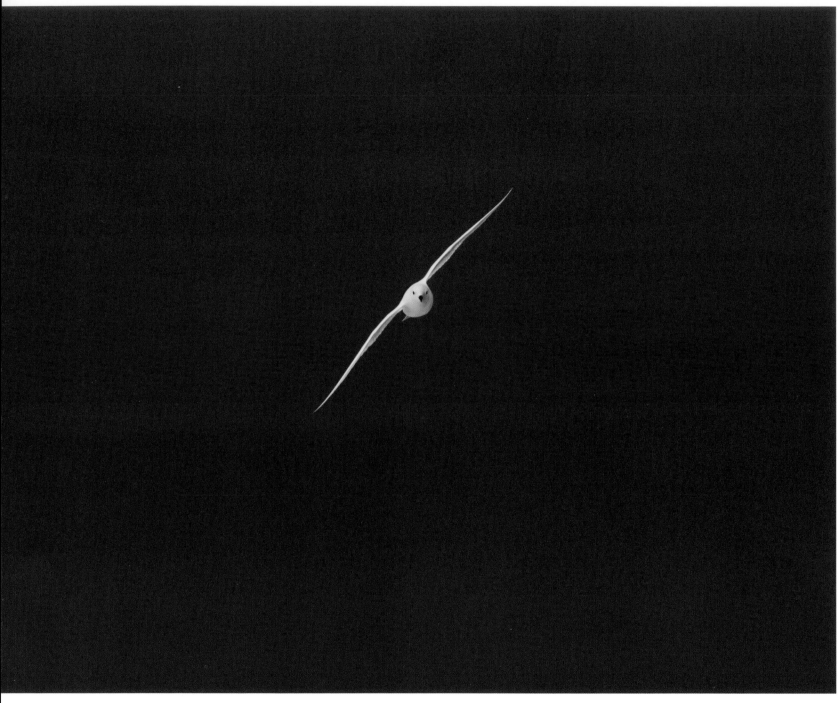

Above: **Snow petrel** | Opposite: **Snow petrels and iceberg**

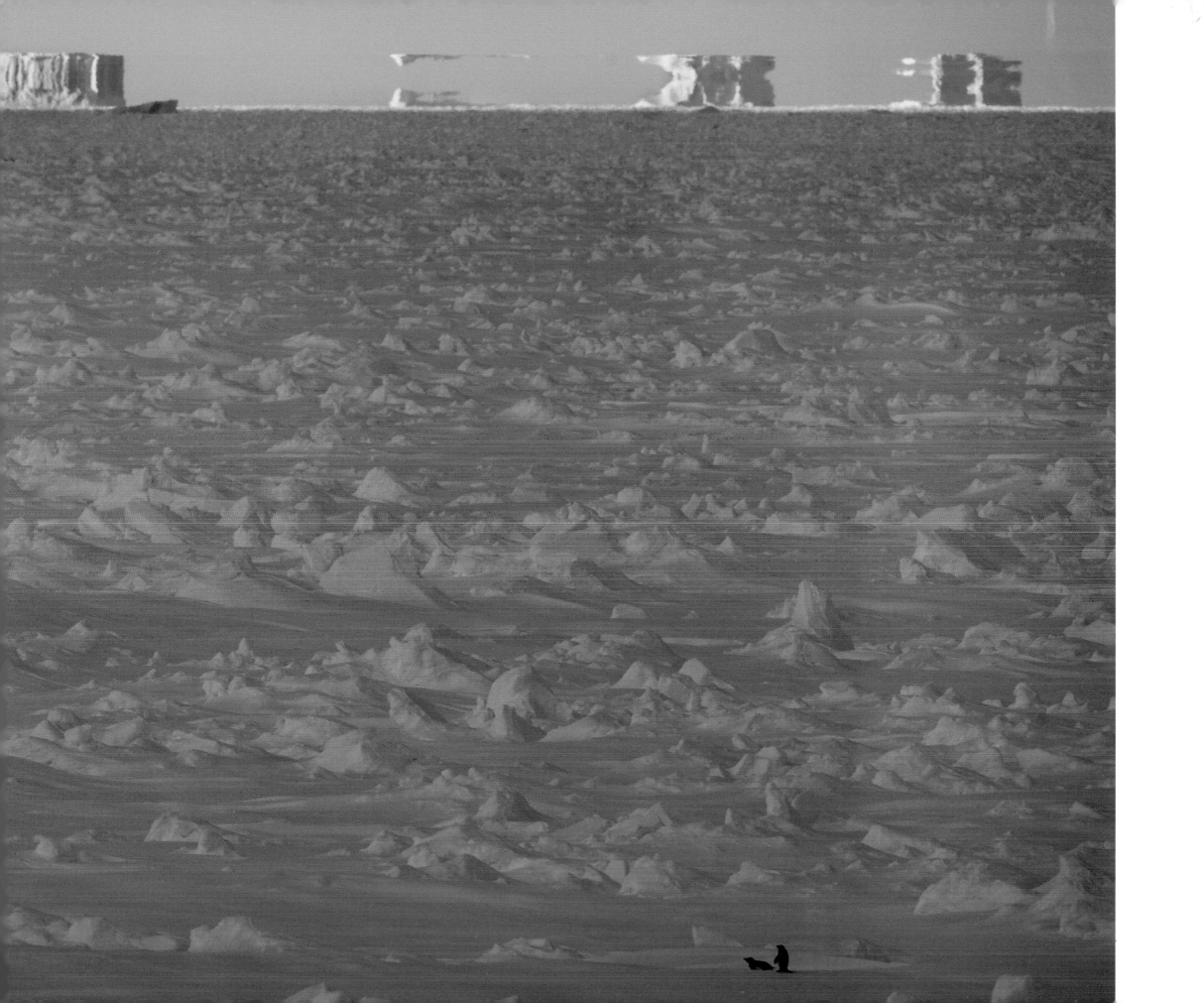

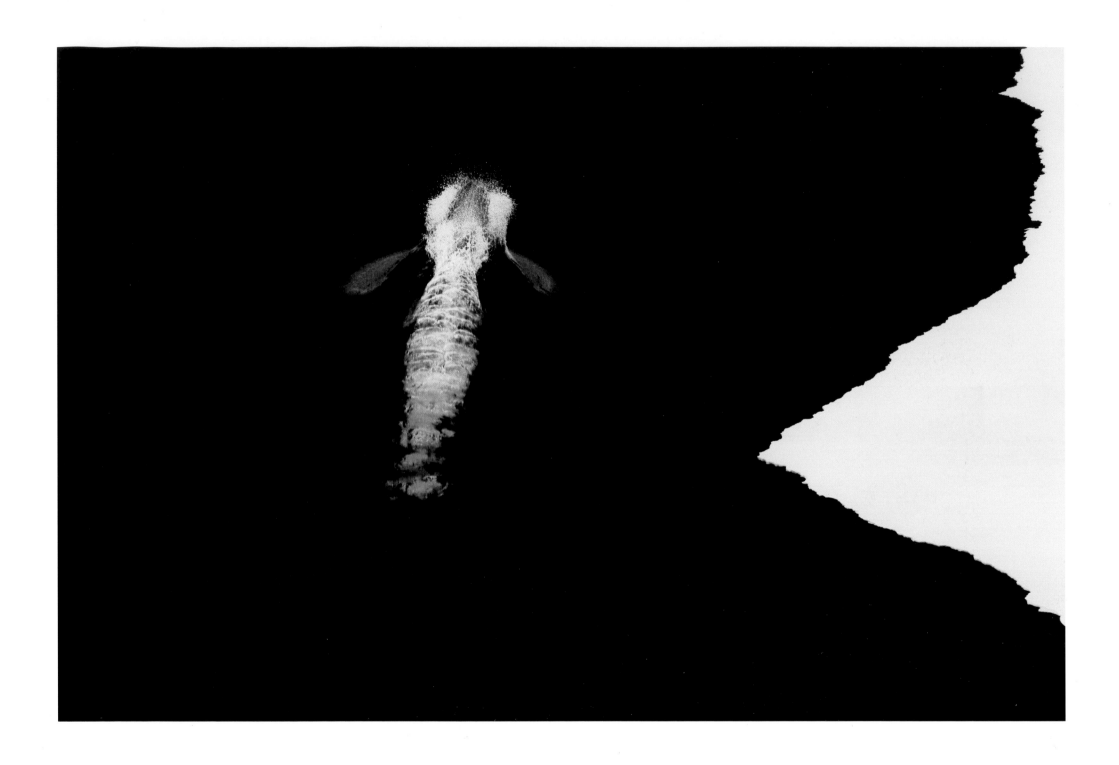

Above: **Minke whale in the pack ice** | Opposite: **Minke whale surfacing**

"Some men see things as they are and say 'why.' I dream things that never were and say 'why not.'" —ROBERT F. KENNEDY

First published in the United States of America in 2013 | by Rizzoli International Publications, Inc. | 300 Park Avenue South, New York, NY 10010 | www.rizzoliusa.com

© 2013 John Weller | Foreword © 2013 Carl Safina

Text and Photography: John Weller | Project Editor: Candice Fehrman | Book Design: Susi Oberhelman

The images in this book were taken during several trips to the Ross Sea as a guest of Quark Expeditions and one extended stay as a guest of the National Science Foundation. I used Canon cameras and a variety of lenses from 16 to 600mm. The images have all been interpreted using Photoshop, with the intent of embodying Ansel Adams's statement that, "The negative is comparable to the composer's score and the print to its performance." That is to say that I have used all my skill as a printer to accentuate the underlying drama in the photographs, and bring forward with clarity the resounding and profound beauty of the Ross Sea. That said, these images accurately reflect my experiences. Adams also said, "A great photograph is a full expression of what one feels about what is being photographed in the deepest sense and is thereby a true expression of what one feels about life in its entirety." In presenting this work, I hope that, at least in a few cases, I have approached this high plateau.

p. 67: Image courtesy of NASA/MODIS

2013 2014 2015 2016 / 10 9 8 7 6 5 4 3 2 1 | Printed in China | ISBN-13: 978-0-8478-4123-3 | Library of Congress Catalog Control Number: 2013934954

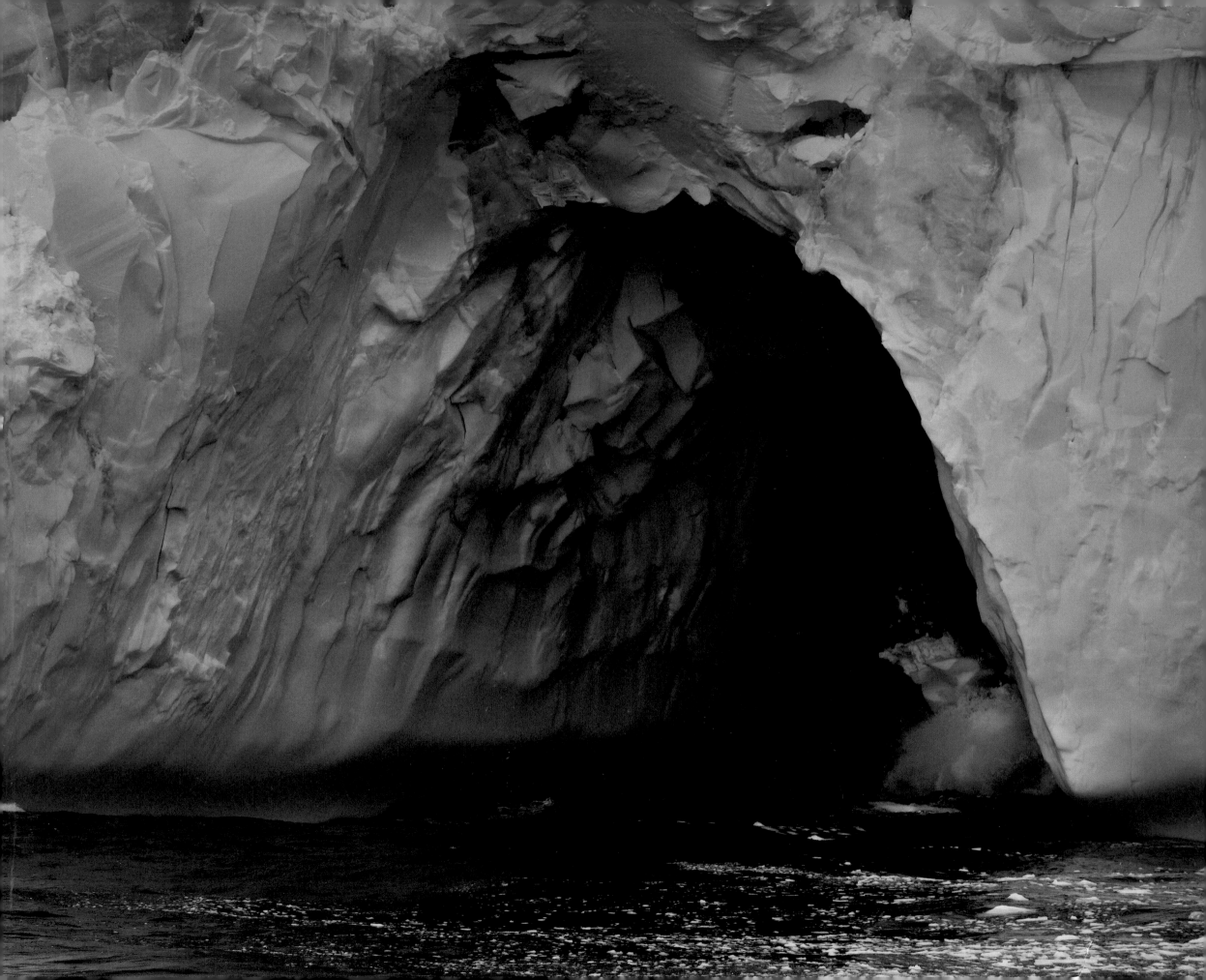

ACKNOWLEDGMENTS

I WOULD HAVE TO WRITE ANOTHER BOOK to describe the people who supported this decade-long project and their individual contributions of time, money, and guidance. Without these people, this project would never have happened. But I have to say more. These people are the most compassionate, farsighted, and generous people I've ever met. These are the people who inspire me to believe that we can act in defense of the ocean, and save ourselves. My work is a tribute to them. And though the people I mention below have been supporters, advisors, and collaborators, they are more than that—they are my friends.

SUPPORTERS: Doug Allen, Joseph and Jean Barban, Mollie Bassett, Jan Berg, Tamara Bianchi, Arin Billings, Erik Burns, James Butler, Steve Campbell, Prisca Campbell, Rit and Linda Carbone, Irina Chernenko, Amy Christopher, Catharina Clausen, Gary Cole, Francesco Contini, Perry Conway, Jordan Cooper, Lee Crockett, Judith Crowell, Richard Curley, Andrew Currie, Glenn and Ruth Carol Cushman, Patricia DeCory, Lynn and Ed Dolnick, Tony Dorr, Deb Durand, Brad Feld, Joanne Feldman, Stephen Frink, Cassie Gallagher, Julie Gilmore, Terry Gold, Vicki Goldstein, Carolyn Grant and Robert Kernz, Jeremiah Habets, Norman Hall, Susan Hall and Brian Muldoon, Marianne Hargreaves, Adam Harris, John Hart, Margaret Hauser, Woody Haywood and the rest of the McMurdo Wood Shop, George Heinrichs, Danielle Heinrichs, Wolcott Henry, Ron Hipschman, Hollis Hope and David Chapman, Nick and Joanne Jambor, John Johnson, Richard and Marlene Jones, Steve Jones and Nancy Dawson, Dave Jordan, George Kattawar, Lewis Kemper, Pat and Rosemarie Keough, Robyn Kravit, Cathy Lane, Michael Littlejohn, Charlie Lord, Neil Lucas, Nora Manella, Joan Manheimer, Thomas and Diann Mann, Dawn Martin, John Martin and Gina Martin-Smith, David Mastbaum, Kathy McCaughin, Daniel McGovern, Jessica Meir, Yves and Janelle Mercier, Steve Miller, Hugh Miller, Mary Miller, Bronwyn Minton, Naseem Munshi and Michael Tupper, William and Sadhna Neill, Jesse Osborn, Tony Pacheco, Blair Palese, Sarah Payne, David Perez, Jeff Pevar, Howard Pollack, David A. Price, Doug Quin, Shannon Ragland, Terrance Reimer, Michael Reinstra, Andy Rice, Rob Robbins, Tony and Jan Robinson, Robert and Julian Rosenbloom, Wayne and Nancy Starling Ross, Steve Rupp, Roger and Vicki Sant, Theodore and Kari Santos, Chip and Susan Scarlett, Rich and Susan Seiling, Linda Sikkema, Matthew Smith, Rich Smith, Steve Steadman and Laurie McKager, Lisa Strong, James Stuelke, Cindy Giordano Taylor, Jeff Taylor, Bruce Thompson, Stefan Töpfer, Tim Turner, Daniel Uhlmann, Valerie Usher, Roelof van der Merwe, Elizabeth van der Merwe, Al Vinjamur, Paula and Robert Wales, Pat Wales, Roxie Walker, John Walsh III, Steve Weaver, Dareni Wellman, Gene Wells, John Whitehurst, Lars and Erica Wikander, and Karen Wilbrecht.

ADVISORS: Steve Ackley, Kevin Arrigo, Grant Ballard, Tosca Ballerini, James Barnes, Jim Barry, Sandra Birnhak, Mariachiara Chinatore, Claire Christian, Steve Clabuesch, Rich Clarkson, Meg Collins, Vonda Cummings, Bill Curtsinger, Kendra Daly, Randall Davis, Loyd Davis, Paul Dayton, Kama Dean, Art DeVries, Rob Dunbar, Sylvia Earle, Joseph Eastman, Robert Garrott, Heidi Geisz, Catherine Halversen, Ellen Hines, Kim Johnson, Jill Johnson, Miguel Jorge, Stacy Kim, Joanna Knight, Gerald Kooyman, Nicola Legat, Susan Lieberman, John Macdonald, Sarah Mager, Roberta Marinelli, Elliott Norse, Silvia Olmastroni, Daniel Pauly, Andi Pearl, Polly Penhale, Andrew Penniket, Jean Pennycook, Robert Pitman, Paul Ponganis, Jay Rotella, Joellen Russell, Karen Sack, Don Siniff, Walker Smith, Mark Spalding, Lucy Spelman, Craig Strang, Simon Thrush, Mark Udall, Marino Vacchi, Charlotte Vick, and The Pew Marine Fellows.

SUPPORTING ORGANIZATIONS AND BUSINESSES: The Antarctic and Southern Ocean Coalition, The Antarctic Ocean Alliance, Canon U.S.A., The Charl van der Merwe Trust, The Exploratorium, Epson, Fidelity Charitable Gift Fund, The Foundry Group, Gold Systems, Greenpeace, The International Marine Conservation Congress, Intrado, La Petite Pearle, The National Museum of Wildlife Art, The National Science Foundation, The Ocean Foundation, The Pew Environment Group, Quark Expeditions, SeaWeb, Silverleaf Framing, Star Lzi Resources, West Coast Imaging, and The World Wildlife Fund.

COLLABORATORS: I must express my gratitude to: James Balog, who paved the way for this book; James Muschett, Candice Fehrman, and Susi Oberhelman, the crack editorial team at Rizzoli; Ron and Susan Crowell, James Manning, and Bill and Bethany Koenig, who funded the production and for whom friendships are precious treasures; and Carl Safina and the Blue Ocean Institute for everything they do.

Finally, I must express my deepest gratitude to: David Ainley, who saw clearly from his perch on the edge of the world, led the fight for the Ross Sea, and edited this book; Peter Young and Tracy Roe, the New Zealand arm of the Last Ocean Project, who took the ideas through and mounted a full campaign in New Zealand, and now the world, with their film *The Last Ocean*; Shawn Heinrichs and Michael Ramsey, my brothers-in-arms; Polita Glynn and the Pew Fellows Program in Marine Conservation, the backbone of my work and my continuing council; Daniel Cohen, who has been with me from the beginning as supporter, advisor, and friend; my sister and brother-in-law, Molly Weller Thompson and William Thompson, who saw me through tough times in the project, and helped build and plant our garden; my parents, Steven and Emily Weller, whose love and support are at the center of all of this, and who plan the year around our family vacation; and my wife, Cassandra Brooks, who discussed, researched, edited, and helped me write this book, and who inspires me every single day.

Moline M et al. 2004. Alteration of the food web along the Antarctic Peninsula in response to a regional warming trend. *Global Change Biology* 10: 1973–1980.

Stammerjohn S et al. 2008. Trends in Antarctic annual sea ice retreat and advance and their relation to El Nino–Southern Oscillation and Southern Annular Mode variability. *Journal of Geophysical Research* 113: C03S90.

Stammerjohn S et al. 2012. Regions of rapid sea ice change: An inter-hemispheric seasonal comparison. *Geophysical Research Letters* 39: L06501.

Turner J et al. 2009. Non-annular atmospheric circulation change induced by stratospheric ozone depletion and its role in the recent increase of Antarctic sea ice extent. *Geophysical Research Letters* 36: L085502.

Southern Ocean Oceanography

Orsi A, T Whitworth & W Nowlin. 1995. On the meridional extent and fronts of the Antarctic Circumpolar Current. *Deep-Sea Research* II 42: 641–673.

Smith W et al. 2012. The Ross Sea in a sea of change. *Oceanography* 25(3): 90–103.

Toggweiler J. 1994. The Ocean's Overturning Circulation. *Physics Today* 47(11): 45–50.

Ross Sea Ecology

Ainley D. 2002. *The Adélie Penguin: Bellwether of Climate Change.* New York: Columbia University Press.

Ainley D. 2004. Acquiring a "Base Datum of Normality" for a Marine Ecosystem: The Ross Sea, Antarctica. *CCAMLR WG-EMM 04/20.*

Ainley D et al. 2007. Paradigm lost, or is top-down forcing no longer significant in the Antarctic marine ecosystem? *Antarctic Science* 19(3): 283–290.

Ainley D, G Ballard & J Weller. 2010. Validation of the 2007 CCAMLR Bioregionalization Workshop Results Towards Including the Ross Sea in a Representative Network of Marine Protected Areas in the Southern Ocean. *CCAMLR WG-EMM 10/11.*

Arrigo K et al. 1998. Primary production in Southern Ocean waters. *Journal of Geophysical Research Oceans* 103: 15587–15600.

Clarke A & N Johnston. 2003. Antarctic marine benthic diversity. *Oceanography and Marine Biology: An Annual Review* 41: 47–114.

Cziko P et al. 2006. Freezing resistance of antifreeze-deficient larval Antarctic fish. *The Journal of Experimental Biology* 209: 407–420.

Eastman J. 1993. *Antarctic Fish Biology.* Academic Press, San Diego.

Kooyman G & P Ponganis. 1997. The challenges of diving to depth. *Scientific American* 85(6): 530–539.

Kooyman G. 2009. *Weddell Seal: Consummate Diver.* Cambridge University Press.

Pitman R & P Ensor. 2003. Three forms of killer whales in Antarctic waters. *Journal of Cetacean Research and Management* 5: 1–9.

Ponganis P et al. 2007. Returning on empty: extreme blood O_2 depletion underlies dive capacity of emperor penguins. *The Journal of Experimental Biology* 210: 4279–4285.

Smith W, D Ainley & R Cattaneo-Vietti. 2007. Trophic interactions within the Ross Sea continental shelf ecosystem. *Philosophical Transactions of the Royal Society B* 362: 95–111.

Thursh S et al. 2006. Broad-scale factors influencing the biodiversity of coastal benthic communities of the Ross Sea. *Deep-Sea Research* II 53: 959–971.

Waterhouse E. 2001. *Ross Sea Region 2001: A State of the Environment Report for the Ross Sea Region of Antarctica.* New Zealand Antarctic Institute, Christchurch.

Ross Sea Conservation

Ainley D, C Brooks, J Eastman & M Massaro. 2012. Unnatural selection of the Antarctic tooth×sh in the Ross Sea, Antarctica. *Protection of the Three Poles.* Huettmann F (ed). Springer.

Ainley D et al. 2012. Decadal trends in abundance, size and condition of Antarctic toothfish in McMurdo Sound, Antarctica, 1972–2011. *Fish and Fisheries.*

Ainley D & C Brooks. 2013. Exploiting the Southern Ocean: rational use or reversion to tragedy of the commons? *Exploring Antarctic values.* Liggett D & AD Hemmings (eds). Christchurch: University of Canterbury, Gateway Antarctica Special Publication Series.

ASOC. 2010. Scientists' Consensus Statement on Protection of the Ross Sea. *ASOC Secretariat.*

ASOC. 2011. The Case for a Ross Sea Marine Reserve. *CCAMLR-XXX/BG/23.*

White M. 2010. Fish out of water: hypocrisy on the high seas. *North & South* July: 57–65

On the Web

The Last Ocean: www.lastocean.org

CCAMLR: www.ccamlr.org

The Antarctic Treaty System: www.ats.aq

Antarctic and Southern Ocean Coalition: www.asoc.org

Antarctic Ocean Alliance: www.antarcticocean.org

RESOURCES

I read hundreds of articles and dozens of books to write my narrative. The following is a list of resources that I feel were the most influential and informative for me, and where I believe the reader could start if they want to learn more:

The State of the World's Oceans

Barnes D et al. 2009. Accumulation and fragmentation of plastic debris in global environments. *Philosophical Transactions of the Royal Society B* 364: 1985–1998.

Caddy J & K Cochrane. 2001. A review of fisheries management past and present and some future perspectives for the third millennium. *Ocean & Coastal Management* 44: 653–682.

Cullis-Suzuki S & D Pauly. 2010. Failing the high seas: A global evaluation of regional fisheries management organizations. *Marine Policy* 34(5): 1036–1042.

Davies R et al. 2009. Defining and estimating global marine fisheries bycatch. *Marine Policy* 33(4): 661–672.

FAO. 2012. The state of the world fisheries and aquaculture. Food and Agriculture Organization of the United Nations, Rome.

Halpern B et al. 2008. A global map of human impact on marine ecosystems. *Science* 319: 948–951.

Morato T et al. 2006. Fishing down the deep. *Fish and Fisheries* 7: 24–34.

Myers R & B Worm. 2003. Rapid worldwide depletion of predatory fish communities. *Nature* 423: 280–283.

Norse E et al. 2011. Sustainability of deep-sea fisheries. *Marine Policy* 36: 307–320.

Pauly D et al. 1998. Fishing down marine food webs. *Science* 279: 860–863.

Pauly D et al. 2002. Towards sustainability in world fisheries. *Nature* 418: 689–694.

Pauly D, R Watson & J Alder. 2005. Global trends in world fisheries: impacts on marine ecosystems and food security. *Philosophical Transactions of the Royal Society B* 360: 5–12.

Pauly D. 2009. Aquacalypse Now: The End of Fish. *The New Republic* October 7: 24–27.

Thompson R et al. 2009. Plastics, the environment and human health: current consensus and future trends. *Philosophical Transactions of the Royal Society B* 364: 2153–2166.

Williams T et al. 2004. Killer Appetites: Assessing the Role of Predators in Ecological Communities. *Ecology* 85(12): 3373–84.

World Bank. 2008. Sunken Billions: The Economic Justification for Fisheries Reform. Agriculture and Rural Development Department. The World Bank. Washington, D.C.

Worm et al. 2006. Impacts of Biodiversity Loss on Ocean Ecosystem Services. *Science* 314: 787–790.

Worm et al. 2009. Rebuilding Global Fisheries. *Science* 325: 578–585.

Marine Protected Areas

Gaines S et al. 2010. Designing marine reserve networks for both conservation and fisheries management. *Proceedings of the National Academy of Science* 107(43): 18286–18293.

Halpern B, S Lester & J Kellner. 2010. Spillover from marine reserves and the replenishment of fished stocks. *Environmental Conservation* 36(4): 268–276.

Lester S et al. 2009. Biological effects within no-take marine reserves: a global synthesis. *Marine Ecology Progress Series* 384: 33–46.

Human Ecology

Berkes F. 2008. *Sacred Ecology*. 2nd ed. New York: Taylor & Francis.

Johannes RE. 1981. *Words of the Lagoon: Fishing and Marine Lore in the Palau District of Micronesia*. Berkeley: University of California Press.

Climate Change and Ocean Acidification in the Southern Ocean

Ainley D et al. 2010. Antarctic penguin response to habitat change as Earth's troposphere reaches 2 C above pre-industrial levels. *Ecological Monographs* 80(1): 49–66.

Aronson R et al. 2007. Climate Change and Invasibility of the Antarctic Benthos. *Annual Review of Ecology, Evolution, and Systematics* 38: 129–154.

Atkinson A et al. 2004. Long-term decline in krill stock and increase in salps within the Southern Ocean. *Nature* 432: 100–103.

Bednaršek et al. 2012. Extensive dissolution of live pteropods in the Southern Ocean. *Nature Geoscience* 5: 881–885.

Forcada J et al. 2012. Responses of Antarctic pack-ice seals to environmental change and increasing krill fishing. *Biological Conservation* 149(1): 40–50.

Jenouvrier S et al. 2012. Effects of climate change on an emperor penguin population: analysis of coupled demographic and climate models. *Global Change Biology* 18(9): 2756–2770.

Massom R & S Stammerjohn. 2010. Antarctic sea ice change and variability—Physical and ecological implications. *Polar Science* 4: 149–186.

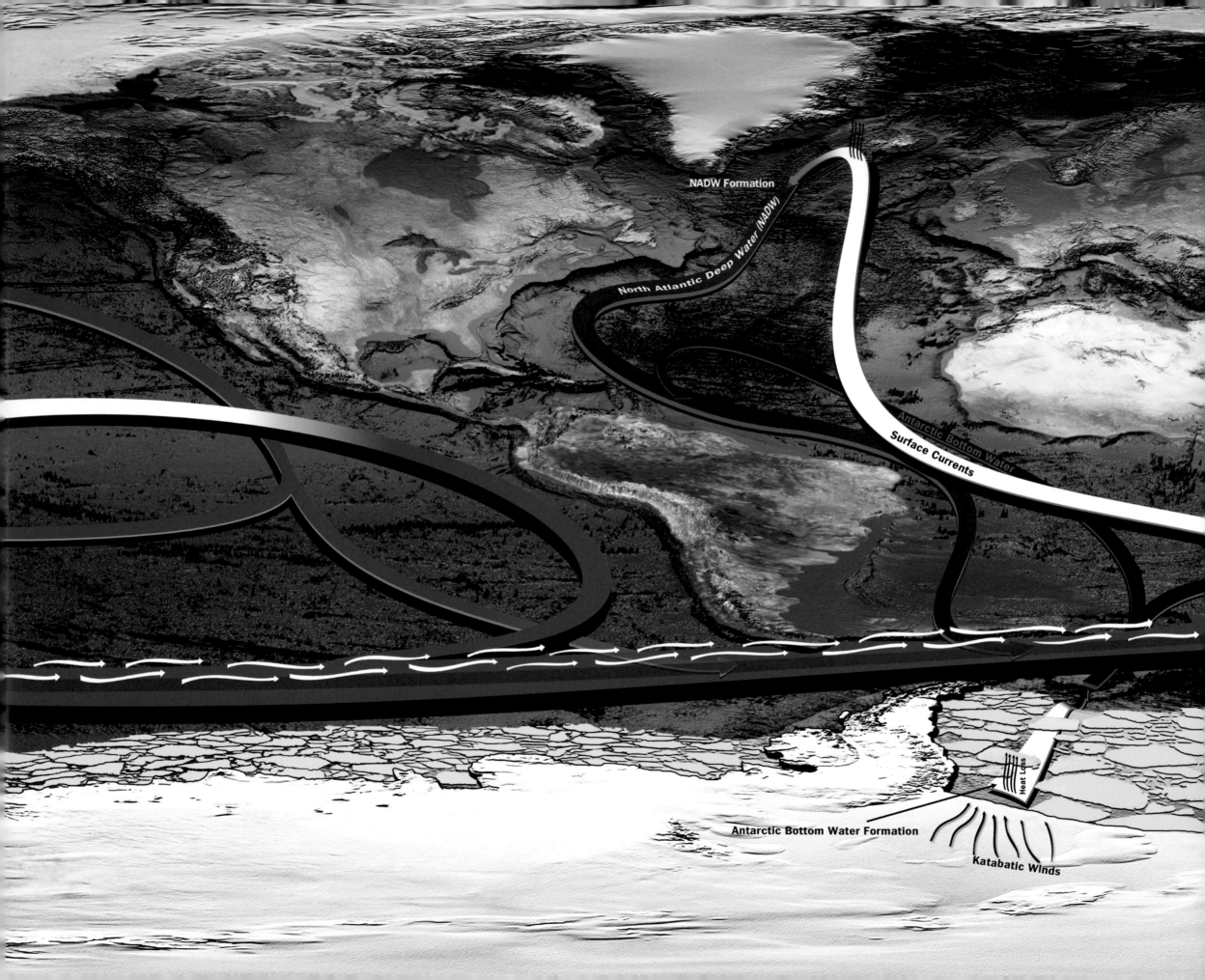

NADW Formation

North Atlantic Deep Water (NADW)

Heat Loss

Antarctic Bottom Water

Surface Currents

Heat Loss

Antarctic Bottom Water Formation

Katabatic Winds

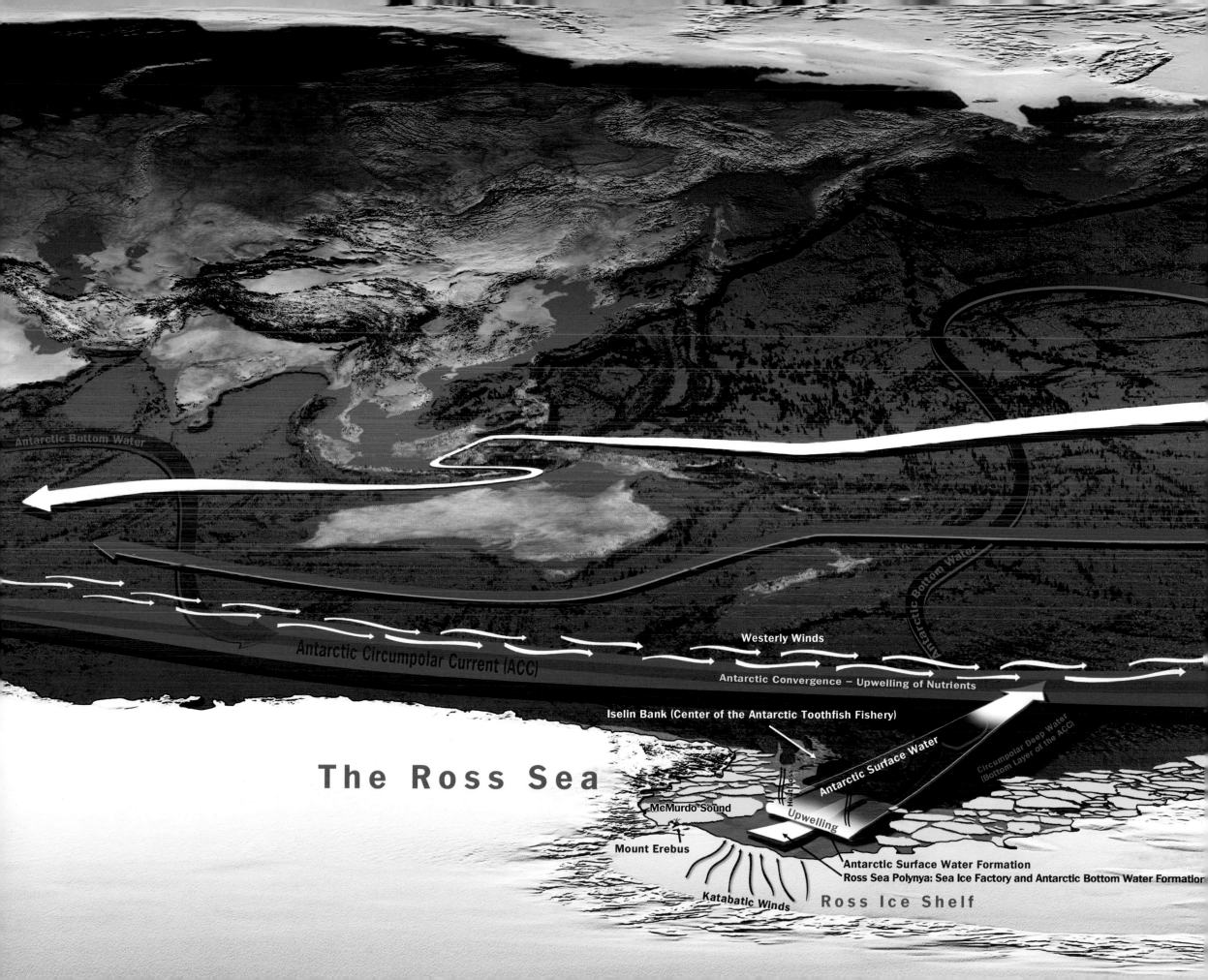

Antarctic Bottom Water

Antarctic Bottom Water

Westerly Winds

Antarctic Circumpolar Current (ACC)

Antarctic Convergence – Upwelling of Nutrients

Iselin Bank (Center of the Antarctic Toothfish Fishery)

Antarctic Surface Water

Circumpolar Deep Water (Bottom Layer of the ACC)

The Ross Sea

McMurdo Sound

Heat Loss

Upwelling

Mount Erebus

Antarctic Surface Water Formation
Ross Sea Polynya: Sea Ice Factory and Antarctic Bottom Water Formation

Katabatic Winds

Ross Ice Shelf

lunch and gave us her reaction. She said sagely, "This, if it's achievable at all, will take a decade." After nine full years, during which I devoted my career to supporting the push for Ross Sea protections, seeing the idea of a Ross Sea marine protected area actually discussed at this level—and being so close to fruition— brings me great joy and hope. A Ross Sea MPA would be an astounding international achievement.

However, any MPA that comes out of the 2013 meetings will still leave much work to be done. The current proposal is a serious compromise from the boundaries and practices that scientists say would best encompass and protect the entire ecosystem. It excludes areas of high toothfish abundance on the Ross Sea Continental Slope, including the Iselin bank, the main fishing grounds for the toothfish fishery. The size of the fishery would be left unaffected. And I have to ask myself why we—humanity, that is—would let a compromise be our legacy when it comes to the last remaining intact large marine ecosystem on earth.

When I tell my grandchildren about the fight to protect the Ross Sea, I want to be able to describe the moment when the fishing nations gracefully withdrew their boats, and the Ross Sea MPA was expanded to fully protect the ecosystem. I want to be able to describe the proclamation of a network of MPAs around Antarctica, designed to protect the Antarctic core. I want to be able to describe the ensuing worldwide rejection of our culture of overuse, the creation of a worldwide network of MPAs, and the slow and steady recovery of the oceans. I want for us all to be able to tell our grandchildren how we took responsibility for our actions, turned the page, and changed the course of history. And despite the desperate state of the oceans, the brilliant, compassionate people I've met along this journey—those who work to protect our natural world—have strengthened my faith that we can. Imagine what we could do if we join together, and take the next steps . . .

The Ross Sea MPA was finally on the table. Unfortunately, that is where it stayed. Talks quickly stalled on the Ross Sea MPA, and on two other MPA proposals. The WSSD 2012 target passed, and CCAMLR nations had failed to follow through.

The Ross Sea toothfish fishery is playing with fire in this last intact large marine ecosystem. The seals that eat their way through the ice, the birds that hold eggs on their feet through months of darkness, the fish that make their own antifreeze, and all the organisms that have conquered the cold already face an uncertain future, and building evidence indicates that the fishery is already compounding these challenges. CCAMLR is charged with managing Antarctic ecosystems under the directive of "rational use," and there doesn't seem to be anything more rational than protecting these vulnerable creatures as they fight for their lives in a fast-changing world.

But the argument for Ross Sea protection goes far beyond the question of whether this fishery is sustainable. While we squabble over a few thousand tons of fish—1/300th of one percent of the global catch—ocean health continues to decline precipitously. We need to take a stand. We need to open the door to a new age of enlightenment, a new global ocean culture. I believe the Ross Sea holds the key.

In July and October 2013, CCAMLR will again discuss MPAs in Antarctica. The joint U.S./New Zealand Ross Sea MPA proposal and Australia's Eastern Antarctic MPA proposal, both stuck in discussion at the 2012 CCAMLR meeting, are at the top of the docket, and the unprecedented July intercessional meeting was called specifically to discuss these proposals.

In 2005, I was in a meeting at the National Science Foundation where David Ainley presented his evidence for the necessity of a Ross Sea MPA to an audience of two. Afterward, one of them took us out to

recognized the need for more. Over the last 10 years, the Republic of Kiribati in the South Pacific, South Africa, Great Britain, Australia, the United States, and New Zealand all declared expansive no-take marine protected areas in their national waters. But despite these farsighted and courageous decrees, marine protected areas still cover only two percent of the ocean. To return a healthy balance to our oceans, we need to think bigger.

Since 2002, scientists and policy institutions all over the world have added their support to a bold proposal voiced at the World Summit on Sustainable Development (WSSD) in South Africa—a worldwide network of no-take marine protected areas, strategically placed to protect the biological core of the ocean as a whole. Researchers believe that if we could protect up to 30 percent of our oceans, and complement those protections with appropriate fisheries management elsewhere, we might be able to correct our mistakes.

This grand vision is likely the only way to give the ocean a fighting chance to recover from our industry and adapt to our changing climate. Protection on this scale would likely take generations to achieve. We have to start now, and this brings us back to the Ross Sea. Doesn't the most pristine place left in the entire ocean deserve our highest level of protection?

At the height of the Cold War in 1959, nations were already starting to claim regions of Antarctica. However, instead of dividing up the continent and its resources, these nations conceived the Antarctic Treaty, setting aside the entire continent in the name of peace and science. The Antarctic Treaty System is one of the finest examples of humankind's ability to collaborate in the face of global crisis. But in line with trends at the time, even this great treaty failed to protect the seas *around* Antarctica.

Organized management of Antarctic fisheries started in 1982 with the creation of the Commission for the Conservation of Antarctic Marine Living Resources. CCAMLR was designed with significant improvements over other fisheries management bodies. The Southern Ocean as a whole had already sustained widespread damage from the massive extractions of whales, seals, finfish, and krill. Thus, the commission was directed to take a long-term, ecosystem-wide view in assessing current and potential industry in the Southern Ocean. In theory, CCAMLR provides protections akin to a multiuse, National Forest–style MPA for the entire Southern Ocean. It is the most progressive international fisheries management organization that we have ever built.

CCAMLR immediately shut down overexploited finfish fisheries and took control of a dangerously large krill fishery, establishing catch limits and instituting ecosystem monitoring. The commission also assumed the power to designate closed areas, and in October 2002, shortly after the World Summit on Sustainable Development, CCAMLR officially recognized the call for a global network of MPAs, created a separate agenda item in future annual meetings to discuss protected areas, and encouraged countries to take the lead on MPA proposals in their areas of influence within the Antarctic.

Scientists from many nations took on the challenge, assembling existing research and engaging in ambitious analyses of the entire Southern Ocean to find the right areas to propose for protection. The process took years. Finally, in 2009, the United Kingdom brought forward a formal proposal for the South Orkney Islands, 600 kilometers north of the Antarctic Peninsula. CCAMLR ratified the proposal, establishing the southern shelf of the South Orkney Islands as the very first international no-take MPA.

Unfortunately, this achievement was not as profound as it might sound, and a closer look at the South Orkneys MPA reveals something unexpected. The most biologically significant areas of the South Orkneys, immediately surrounding the islands themselves, were left out of the MPA. In fact, the MPA starts far offshore, and there is a strange "bite" out of the otherwise rectangular area. As it turns out, the MPA was designed specifically to *not* interfere with any existing or potential fishing interests. The rich areas closer to the islands supported not just 400,000 pairs of nesting Chinstrap Penguins, but also a krill fishery. The "bite" out of the MPA was intended to allow room for a proposed crabbing industry, which, by the way, proved fruitless. The very first international no-take MPA was defined by fishing interests, not by the future of the islands it was meant to protect.

Despite this disappointment, the new MPA was a giant first step, and the international community lauded the achievement. The WSSD directive had called for a representative global network of MPAs by 2012, and it seemed CCAMLR was going to lead the way. All eyes turned to the 2012 CCAMLR meeting.

The Ross Sea is the crown jewel of the Antarctic, and from the very start of the discussion in 2002, scientists from the United States and New Zealand began assembling evidence. But ideas about the details of the MPA differed between the countries, and by the time of the 2012 meeting, there were two Ross Sea proposals. Neither encompassed the whole Ross Sea ecosystem. In fact, both proposals were carefully designed to exclude most major toothfish hotspots, again submitting to the power of industry. And with two competing proposals, there was no chance for a Ross Sea MPA, even one that avoided conflict with fishing. Spirits sagged. However, through a series of intensive negotiations during the two-week-long CCAMLR meeting, the United States and New Zealand came to a compromise, and submitted a single Ross Sea MPA proposal to the rest of the CCAMLR nations.

THE FUTURE
OF THE LAST OCEAN

No panacea exists for this web of overlapping problems, but the ocean itself provides a key piece of the solution. Perhaps the most remarkable thing about the ocean is this: despite our overuse and abuse, if we just simply leave it alone, the ocean will start to recover. And this remarkable resiliency, in combination with more cautionary and effective fisheries management and a general awakening to the seriousness of the problem, may provide the recovery we so desperately need.

Aside from local ownership of resources and the resulting stewardship, the most frequently reported traditional conservation measure for island nations was the creation of what we currently think of as marine protected areas (MPAs). The term *marine protected area* often causes confusion, and rightly so: it can mean a lot of different things. The most recent definition is from the International Union for Conservation of Nature (IUCN). It reads, "A clearly defined geographic space, recognized, dedicated and managed, through legal or other effective means, to achieve the long-term conservation of nature with associated ecosystem services and cultural values." This definition is intentionally broad in order to encompass multiple levels of marine protection.

The management of all levels of MPAs intends to protect the overall marine system rather than stocks of a single species, as attempted by modern fisheries management, but this does not mean that all MPAs prohibit fishing. In terrestrial terms familiar to citizens of the United States, different types of MPAs are roughly equivalent to everything from a National Forest—where management includes sustainable logging, mining, and grazing—to a dedicated National Wilderness Area, where all commercial activity is prohibited.

As might be expected, different levels of protection result in different levels of recovery in damaged systems. An MPA with management akin to a National Forest will, hopefully, support a slow recovery of marine health. But an MPA with the highest level of protection, a no-take MPA, can expect a dramatic and rapid rebound. Several recent studies hammer this point home. Assessing independent data from 124 no-take MPAs, one set of researchers recorded average increases of 446 percent in biomass, 166 percent in the density of organisms, 28 percent in the size of individual organisms, and 21 percent in species diversity. Even more exciting, researchers have shown that with such high productivity, no-take MPAs act as "fish factories," exporting life and helping the surrounding areas recover as well. In short, MPAs work, but no-take MPAs work exceptionally well. With the current state of our natural resources, we need the exceptional.

In 1960, marine protected areas covered only 1/100th of one percent of the global ocean. By 1980, the figure had risen to 1/10th of one percent. In 2000, the global total stood at just under one percent. This trend was encouraging, but depletion still far outpaced protection. Nations worldwide

type of conservation—areas completely closed to fishing. Furthermore, these cultures based their local management decisions on specific and accurate knowledge. Fisheries ecologist Robert Johannes, a leading researcher of traditional fishing practices, reported, "While interviewing and working with Palauan fishermen in the mid 1970s, I was told of the months and lunar periods as well as the precise locations of spawning aggregations of some fifty-five species of food fish in this tiny archipelago. This amounted to more than twice as many species of fish exhibiting lunar spawning periodicity as had been described in the scientific literature for the entire world." But perhaps most striking is that conservation was not just a set of rules imposed by a leader; it was a way of life. Robert further reported that older fishermen still practiced unlegislated conservation, routinely releasing some of their catch unharmed to maintain local stocks.

Historical conservation practices were not confined to the Pacific Islands. France, Spain, Japan, the Philippines, Mexico, and communities on the Pacific coast of North America developed sustainable practices, traditions, and laws. When people controlled their local resources and had few options for exploring far from home, they protected what they had, and their resources held.

Local control, unfortunately, was soon trumped by expanding economies. In the 16th century, territorial disputes in Europe led to a politically and economically motivated concept: the "freedom of the seas." Queen Elizabeth I of England officially condoned the idea, declaring, "The use of the sea and air is common to all; neither can any title to the ocean belong to any people or private man." On that premise, European nations colonized the world, building empires and forcing their ideas on the societies they vanquished. Many sustainable local practices and laws, developed over a millennium of island stewardship, were extinguished.

In the early 20th century, we finally began to rediscover these lost practices and started to revise the concept of the "freedom of the seas." Countries claimed their 200-nautical-mile exclusive economic zones and created a maze of legislation within their EEZs, attempting to curb overuse. Fisheries management bodies at national, regional, and local levels were created to determine catch limits, seasonal closures, licensing, and other infrastructure. International treaties also emerged to address fisheries on the high seas and fish stocks that straddled two or more EEZs. There are now more than 20 of these international fisheries management organizations, and every country has the equivalent of a Department of Fisheries at the very least. As Daniel Pauly points out, almost all fishing is now subject to some sort of regulation. After 400 years, the "freedom of the seas" no longer truly exists.

Why then have we failed to create sustainability? Few of these organizations have been successful in maintaining stocks at a local, let alone national or international, level. Most have miserable track records, and the numbers speak for themselves. To pick just one example, the International Commission for the Conservation of Atlantic Tunas (ICCAT) has presided over the sharp decline of almost all of the tuna stocks under its charge. Overall, fishing industry regulations have done little to even *slow* the decline of the ocean's health, let alone reverse downward trends.

Part of the problem is that we have set our sights too low. Fisheries organizations attempt to manage fish stocks in a way that maximizes sustainable yield, and while this terminology sounds good on paper, it has a high probability of failure in practice. Maximum sustainable yield (MSY) is defined as the point at which yearly extraction is exactly equal to yearly population growth. Thus, in theory, the overall population can remain stable, though of course at a lower level than before fishing started. But this is a dangerous target. If a fishery overshoots the catch limit by even a little bit, or the science that determined the catch limit is slightly wrong, the yearly catch will exceed the yearly population growth, leading to slow, and then accelerating, declines. Using MSY as a target for fisheries management is like trying to keep a ball perpetually balanced at the top of a slide.

Another part of the problem is the culture of entitlement, derived from the "freedom of the seas," which we have fostered since the expansion of the European empires. In ancient island cultures, the need for conservation was understood from the bottom to the top of the community, and penalties were serious. Poaching was often punishable by death. In modern times, however, conservation measures are usually imposed on fishermen from the top, and punishments are rare. Thus, quite simply, people don't follow the rules.

Illegal, unregulated, and unreported (IUU) fishing catches between 11 and 26 million tons of fish per year, meaning that IUU fishing may be as high as 30 percent of the total legal catch. IUU fishing actually dwarfs some fisheries. In the past, Southern Ocean Patagonian toothfish fisheries have reported IUU estimates of more than five times the legal catch. Even assuming, generously, that policies correctly identify truly sustainable limits, such a massive illegal catch would certainly push industries past the point of sustainability. By fishing so far from home, we have separated ourselves, at least in the short run, from the devastating effects of our culture of overuse. All we've done is move the problems to someone else's waters.

WE MUST UNDERSTAND and appreciate that, in reality, we all live on islands.

THE WISDOM
OF PEOPLE WHO LIVE
ON ISLANDS

By all accounts, the problems we face in the oceans are some of the most serious environmental issues in history. But this is not the first time that people have depleted their resources, been forced to take action, and succeeded in protecting their livelihoods. To find a sustainable path forward, we must start by looking back, and learn from people who live on islands.

THE MAN SAT CROSS-LEGGED across from us on a floor mat from Mecca, a clove cigarette dangling from one well-weathered hand. Soft gray light and the sound of pouring rain filled the room through the glassless window frame. Pak Imam is the religious leader as well as the *Kepala Adat,* or the traditional leader, in his remote village of Fafanlap, in Raja Ampat, Indonesia. He told his story with increasing speed and animation, emphasizing again and again that the future health of his small community depends directly on the conservation of the marine ecosystem. His eyes went dark as he identified the problems: outside fishing interests bringing a tide of dynamite fishing, longlining, and shark finning. He gestured outside to the street, where children from the village were collecting rainwater streaming off the roof of the mosque, dancing in celebration of the simple gift of rain. The future of these children, he said, demands that we conserve, that we stop the destruction of the very source of life. As he finished, he took a drag from his cigarette, and curls of smoke floated toward the open window and out into the rain.

THE IMAM'S IDEAS on conservation did not come from books. His is an ancient wisdom, borne of necessity, the legacy of a people who were completely dependent on the sea. And this legacy is not unique. More than a thousand years ago, the great navigators of Micronesia and Polynesia migrated in dugout canoes from Asia across great expanses of open ocean and established small communities all across the southern Pacific, each its own island paradise. But paradise comes with a price, and these peoples soon faced local depletions of critical marine resources. They had no choice but to learn how to conserve. The "Tragedy of the Commons" arises from a lack of ownership, and these societies solved this problem by giving each small community on an island exclusive rights to specific areas. Without the continuous threat of competition from surrounding clans, and with the knowledge that if resources did not last people would be in immediate peril, conservation rules and ethics developed all across the region.

In fact, these ancient societies developed versions of almost every conservation tactic employed in modern society, including bans on taking juvenile fish; catch and collection limits on fish, turtles, seabirds, and eggs; annual closures to protect spawning aggregations; and even the most comprehensive

populations exploded, and urchins eat kelp. The rapidly rising numbers of urchins ate through the bases of the giant kelp, detaching the 45-meter-tall stalks from the ocean floor. Entire kelp forests were clear-cut by the army of spiny loggers, and the kelp ecosystems—including all the fish and invertebrates that live in kelp canopies—floated out to sea.

The Alaskan trophic cascade was dramatic, but even less obvious cascades weaken an ecosystem's defenses against invasive species and make it more susceptible to the forces of climate change. The effects of this weakened "immune system" have been shown again and again in systems where top predators have been removed. These are the most important costs of the fishing industry. In pursuing unsustainable industries, we have fundamentally changed and weakened almost all marine ecosystems. It is one thing to bite the hand that feeds you. It is another to take the whole arm.

As the situation progressively worsened, fishing boats were forced to fish even deeper and farther from shore. Soon, all temperate waters were overrun. To meet the needs of a growing world population hungry for fish, the ships pressed south. In 1996, a single longline boat, carrying a 15-kilometer-long line of hooks, finally cut its way through the ice and into the most isolated body of water on Earth. In addition to the challenges presented by a changing climate, the Ross Sea ecosystem must now contend with a commercial fishery that targets its largest fish. The fishery is international and takes 3,000 tons of Antarctic toothfish from the Ross Sea every year. The deep-dwelling Antarctic toothfish—the shark of the Southern Ocean, and the largest member of the notothenioid flock—now supports the most remote fishery on Earth.

Of all fishes, those that dwell in deep waters are most vulnerable to overfishing. They live a long time and can take up to 30 years to start breeding. Many species tend to congregate in massive spawning aggregations, increasing their vulnerability to targeted fishing. Before the advent of the Antarctic toothfish fishery, deepwater fisheries depleted nearly all known populations of orange roughy and Patagonian toothfish. The majority of these fisheries, and the fishes they targeted, are gone.

To create a sustainable fishery, managers must have excellent knowledge of the fish's biology and apply that knowledge correctly. But even if we intend to create a sustainable fishery, we can only gain this critical knowledge as we fish. And with deepwater fishes, population problems are usually punctuated with a crash instead of a slow decline. By the time we know with certainty that overfishing is occurring, it's often too late to reverse the trend. Many scientists argue that it is impossible to target deepwater fish sustainably, and to date, there is no undisputed evidence to the contrary. The Antarctic toothfish, living in the coldest water, is perhaps the most vulnerable of them all.

Toothfish can grow in excess of two meters and 150 kilograms. They grow slowly, maturing in their teens, and live for almost 50 years. They are by far the largest fish in Antarctic waters, and they play a key role in the Ross Sea ecosystem. They prey on silverfish, squid, and other fish, and are thought to constitute a significant proportion of the diets of Weddell seals and Ross Sea killer whales. Scientists are already reporting fewer sightings of these whales in the Ross Sea, the first indication that the ecosystem is experiencing the rippling effects of depletion.

Further evidence suggests that the fishery may be in position to do great harm. Toothfish are believed to make a remarkable spawning migration. From the depths of the continental slope, where they feed, the fish catch the clockwise current of the Ross Gyre, which carries them to deep ocean ridges 500 kilometers north of the Ross Sea. Here they likely spawn, release their eggs, and catch the same gyre to return to the Ross Sea. If this scenario is correct, the fishery is targeting the toothfish on both its feeding grounds and its breeding aggregation—the most vulnerable time in its lifecycle.

The most dangerous thing about the Ross Sea toothfish fishery, however, is how little we actually know about toothfish. Despite the building evidence, their life history remains hypothetical. No one has ever found a larval fish or an egg. No one knows when or how often the fish spawn, but it's likely not every year. No one knows how big the population actually is. And without this critical knowledge, managers—though they are intent on creating a sustainable fishery—are shooting in the dark. No one alive today ever had the chance to see Huxley's "cod mountains." If we don't stop now, the last intact marine ecosystem on Earth, the final stronghold, will join the downward spiral of shifting baselines. The natural balance of marine systems will be lost completely, even to memory.

capture the full severity of the situation. Fisheries have continually sought new species to fill in the gaps in production. In the last 10 years alone, we established fisheries for 160 new species, 14 percent of the total number of species caught. Daniel Pauly describes the situation as a Ponzi scheme: the industry will maintain returns only when there is a continuous stream of new capital to pump into the system. But most of the new species we've found are invertebrates and small fish, poor replacements for tunas and jacks. Thus, even with all these new fisheries, the industry has not been able to curb the slow decline in the overall global catch. The problem is only going to accelerate. We are running perilously low on fish.

If the state of marine resources wasn't damning enough, economists at the World Bank have yet another scathing assessment of the global fishing industry. The rash of government subsidies led to an immense buildup of global capacity, and thus the overall efficiency of the industry has plummeted. Ships often sit unused and rusting in harbors. Reduced catches render them too expensive to run. The catch per vessel has dropped by 50 percent since 1970. Not surprisingly, experts estimate that we could achieve the same level of production with half the boats. It is often said that there are too many vessels chasing too few fish.

The economic inefficiency of this excess capacity is staggering. Businesses lose an average of $30 billion each year because their investments sit unused in harbors, making no money. These businesses are unable to liquidate their boats and invest the money elsewhere, because no one is buying old fishing boats. Thus, the boats sit and rot. And the *investment opportunity costs* of these bad investments present only part of the problem. Fish have become more expensive to catch than their market worth. The value of the entire global catch is estimated at $85 billion, while the actual production costs of catching all these fish approaches $105 billion. Thus, the industry is running yearly operating deficits of $20 billion. With opportunity costs and operating deficits, the global industry is losing $50 billion per year, and has been a $2.2 trillion net drain on the global economy since 1970. Many fisheries would have folded long ago if not for the continuing subsidies of nearly $30 billion a year that offset the operating deficits and kept boats on the water. The fishing industry is, quite literally, the worst-run business in the world.

Terrible economic performance, however, does not capture the real costs of the industry. The situation is even more disturbing if you consider the mix of species in the overall catch. In another study, Dr. Pauly's team measured the average trophic level of the fishes being caught. A trophic level is a designation that indicates where a species falls in the food chain. Phytoplankton has a trophic level of one. Zooplankton and small fish, which eat the tiny plants, have a trophic level of two; small predatory fish, three; large predatory fish, four. Only humans have a trophic level of five. Pauly's team found that the average trophic level of the global catch was also declining. As populations of top predators—tunas, groupers, and the like—have been fished out, we have moved on to smaller and smaller organisms. In the Atlantic, cod, redfish, and silver hake were replaced with shrimp, scallops, and lobster. Pauly termed this migration to smaller species "fishing down the food web," and this process has particularly detrimental impacts on ecosystems.

An ecosystem is a collection of tightly interconnected organisms that live in dynamic balance, and each member depends on the other members to create that balance. Some species have familiar connections, like that between direct competitors or between predators and prey. Others have indirect but no less important connections, like that between a species and the *predator* of its predator, or that between a species and the *predator* of its competitor. It is a grand play of checks and balances. In essence, the ecosystem acts as a single organism. Any damage to one part of this organism trickles through the maze of interconnections, affecting every other part of the system in some way, or even multiple ways. The balance changes entirely.

Effects from these *trophic cascades* are complex and often unexpected. As previously mentioned, some killer whales off the coast of Alaska switched their feeding preferences from seals to sea otters in the 1990s, substantially reducing otter populations. (The seals, by the way, had moved farther down the Aleutian island chain, presumably forced to find better stocks of prey, which had been heavily fished in Alaska.) But the disruption to the ecosystem didn't stop with otters. The otters eat vast numbers of sea urchins, which they pick up on the seafloor and bring to the surface. As the otters declined, urchin

commonly reported catches of 20 tons over two-day trips. Yet the stage was already set for broader-scale depletions. By the 1880s, stocks on Georges Bank had begun a slow decline, which accelerated in the early part of the 20th century. By the 1940s, the catch was only one-quarter of what it had been the century before. And the depletion of halibut around New England constitutes only a footnote in relation to what lay just around the corner.

The 1950s brought fast-moving changes to the global fishing industry. Ships got more powerful. Nets got bigger and more sophisticated, and new synthetic fibers made them stronger and long lasting. The first sonar devices took the guesswork out of finding underwater terrain, and even schools of fish. Advances in flash-freezing technology allowed ships to become their own processing plants; thus, fishermen no longer had to worry about a rotting catch.

The floating factories could go farther and stay out longer, and so they did. There was an ocean full of free fish for the taking, and the buffet was first come, first served. By the early 1970s, the global catch had nearly tripled, but major fisheries, concentrated in coastal waters around the world, were achieving what would prove to be peak production and already starting to decline. Pacific herring fisheries reached their peak production in 1964, Atlantic herring in 1966. Atlantic cod peaked in 1968, haddock in 1969, and the Peruvian anchovy in 1970. On and on it went, as one stock after another reached maximum yield and began a slow decline.

As stocks close to home started to dwindle, governments all over the world threw money at their national fisheries, providing incentives to start or expand fishing operations. Fueled by these subsidies, and incorporating ever better technology, the total capacity of the global fleet ballooned, increasing sixfold in 30 years. In the shadow of the Cold War, there was another arms race—on the high seas.

The "Tragedy of the Commons," a term first coined in 1968 by ecologist Garrett Hardin, is driven by human motivations. If a single business owns a limited resource, it will likely use that resource conservatively, hoping to stretch profits into the future. Leaders of that business may even consider the livelihoods of their children and grandchildren when making decisions. But if no one owns the resource, competition will drive overconsumption because every business within the market has incentive to take as much of that resource as it can, as quickly as possible. There is no planning for tomorrow, because by tomorrow competitors will have taken what could have been taken today.

Thus, as the race to fish intensified, nations started asserting ownership of coastal resources to exclude access to distant-water fishing fleets, claiming exclusive economic zones (EEZs) in the waters within 200 nautical miles of their shores. Within those exclusive zones, countries were able to more effectively manage fisheries, but even this management was usually inadequate. Coastal fish stocks continued to fall. But beyond the newly defined national waters, the ocean remained largely unregulated. Driven by local depletions and the promise of vast unclaimed fish stocks in international waters, ships fished deeper and pushed farther and farther from shore.

In 1497, Captain John Cabot returned to England with wild tales of abundance from the new world, reporting that, "the sea there is full of fish that can be taken not only with nets but with fishing-baskets." He was referring to cod. New England's signature species supported a fishery for more than 500 years and has been widely accepted as one of the driving forces in the colonization of North America. Severe overfishing finally exhausted cod stocks by the 1990s, but this was only a fraction of the overall problem.

In the 1990s, Dr. Daniel Pauly and his team measured the change in efficiency for fisheries all over the world. Using data from the fisheries themselves, the researchers found that the catch per unit of effort—the number of fish caught in an hour with a single hook—was, and is, on the decline for almost all fisheries worldwide. This indicates both that we are expending more effort to catch each fish, and that the ecosystems themselves are in decline all over the globe. The fish can't sustain their populations. Overall global fish landings peaked in the 1980s and have been in a slow decline ever since, despite 30 years of new technology.

In 1974, the Food and Agriculture Organization of the United Nations determined that 10 percent of global fisheries were overfished, 50 percent were at full capacity with little room to expand, and 40 percent were developing, with the prospect of larger future catches. In 2009, 30 percent were overfished, 57 percent were at full capacity, and only 13 percent were developing. And these numbers don't even

THE MOST REMOTE FISHERY ON EARTH

Thomas Henry Huxley, one of the great biologists of the 19th century, gave the keynote presentation at the first Fishery Congress in 1883. As part of his address, he was asked to comment on the rising question of whether overfishing ocean stocks was possible. His assessment was this:

> At the great cod-fishery of the Lofoden Islands, the fish approach the shore in the form of what the natives call "cod mountains"—vast shoals of densely-packed fish, 120 to 180 feet in vertical thickness. The cod are so close together that Professor Sars tells us "the fishermen, who use lines, can notice how the weight, before it reaches the bottom, is constantly knocking against the fish." And these shoals keep coming in one after another for two months, all along the coast . . .
>
> . . . I believe, then, that the cod fishery, the herring fishery, the pilchard fishery, the mackerel fishery, and probably all the great sea fisheries, are inexhaustible; that is to say, that nothing we do seriously affects the number of the fish. And any attempt to regulate these fisheries seems consequently, from the nature of the case, to be useless.

Huxley's belief, in some modified form at least, still seems to pervade our collective consciousness. From a purely visceral and emotional perspective, I can understand this grave misconception: standing alone on the shore, the ocean seems so vast, so deep, and so powerful that it is hard to imagine any human activities causing serious harm. But the nature of the case is deceptive. Huxley also said, "The great tragedy of science [is] the slaying of a beautiful hypothesis by an ugly fact," and the facts in this case are truly ugly.

Fisheries were already exhausting populations of oceanic fish when Huxley made his address. By the 1840s, the great halibut fishery of the northeastern United States had already emptied nearby waters—Massachusetts Bay, the Nantucket Shoals, Cape Cod, Barnstable Bay, and Cashes Ledge—and moved on north to Georges Bank. The migration of the fishery hid the fact that stock depletion was already occurring, and on paper, overall catch totals stayed high, even increased. Georges Bank, an underwater plateau bigger than the state of Massachusetts, supported thriving populations of fish. Ships

THE RATIONAL CHOICE

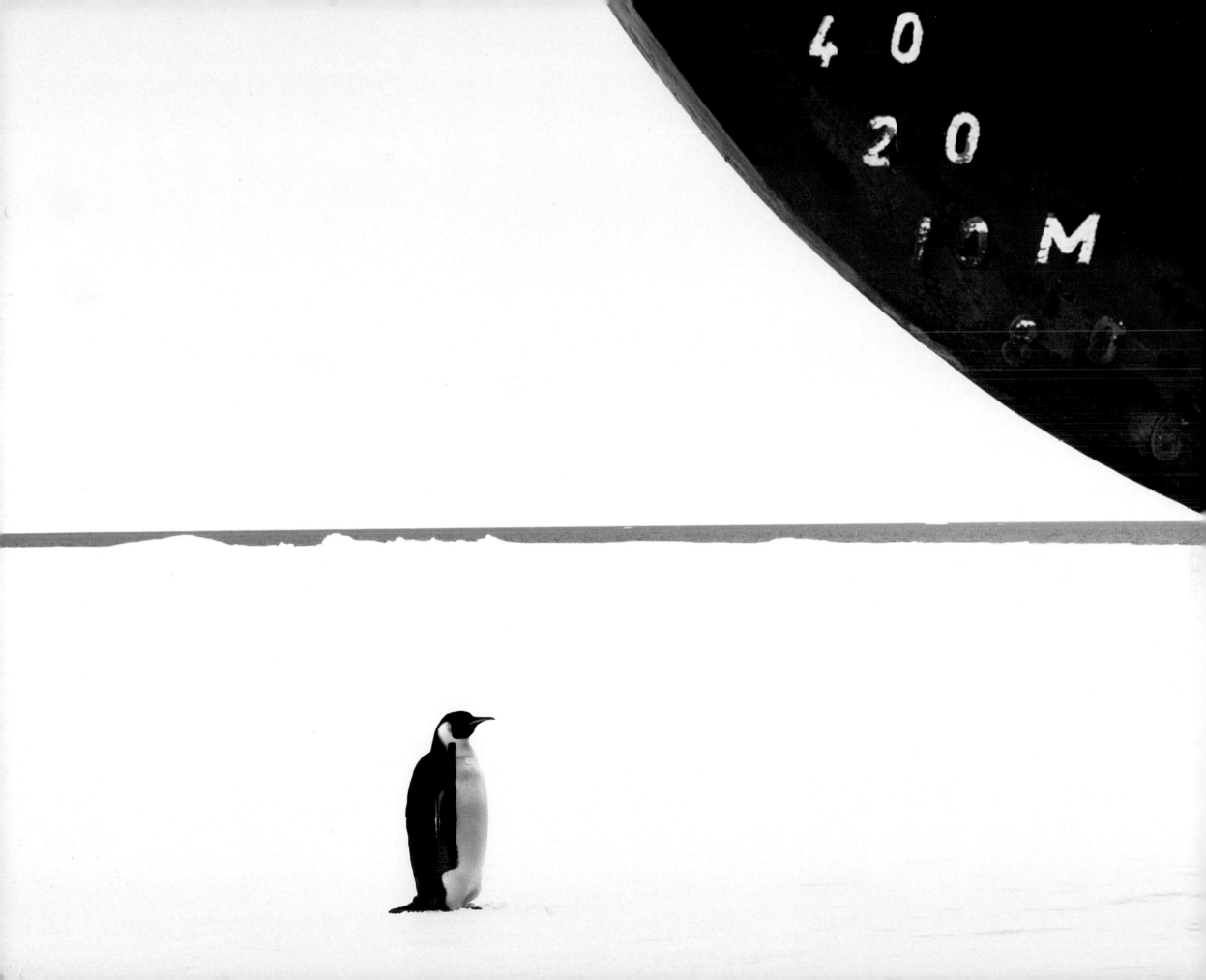

David Ainley in Adélie colony

Opposite: **David Ainley's Cape Royds camp** | Above: **David Ainley**

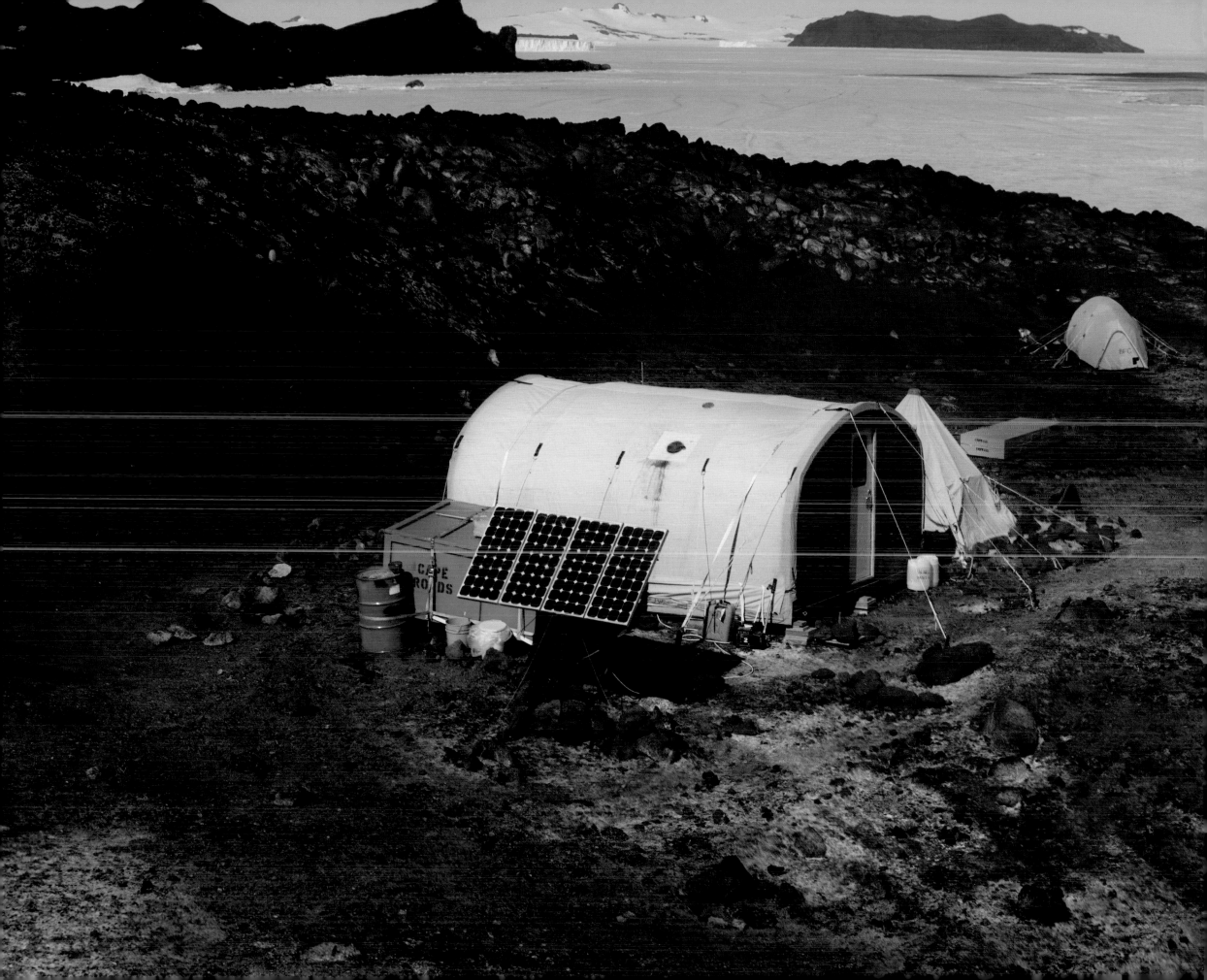

ecosystems. Scientists started studies in a gold rush for knowledge, trying to decipher some of the complex fallout as Southern Ocean ecosystems responded. The removal of whales would, logically, leave a huge surplus of krill in the Southern Ocean, and this wealth of food would drive ecosystem change in countless ways. Antarctic Treaty member nations were, in fact, so concerned with the management of this surplus krill that in 1982 they formed another new international body: the Commission for the Conservation of Antarctic Marine Living Resources (CCAMLR).

Implicit in the formation of CCAMLR was the assumption that species interactions were likely major driving factors in Southern Ocean ecosystem dynamics. But the gold rush didn't quite pan out. While there were distinct indications that the surplus was having profound effects, some of the evidence didn't fit logical assumptions for how a boon of krill would resonate through different levels of the ecosystem. There are many examples, but one in particular was evidence collected from Emperor Penguin colonies in Adélie Land, just west of the Ross Sea. Emperors eat krill, so a surplus should result in an increase in penguins, but the Adélie Land Emperors experienced the opposite result: a dramatic decline in adult survival rates.

In light of the conflicting evidence, scientists started looking at climate-change-related phenomena to explain some of the observations. Emerging technologies—remote sensing, high-resolution satellite imaging, and powerful computers—were opening new doors for research. For the first time, scientists were able to accurately measure physical factors like ice cover and ice thickness, and these variables seemed to explain much of the conflicting evidence, like in the case of the Adélie Land Emperor Penguins: decreases in cover and thickness correlate with the birds' decline. The direction of Antarctic science shifted quickly. With the allure of new technologies, access to substantially more funding, and the relative ease of conducting remote research, the majority of Southern Ocean scientists stopped studying interspecies interactions, and focused their research largely on climate change. The scientific paradigm had shifted.

Climate change is, quite obviously, transforming Antarctic ecosystems, but with the quick and nearly universal movement to climate science, the fallout of the whaling industry remained relatively unexplored. David identifies this as a major mistake in the history of Antarctic science. He asserts that the original paradigm of species interactions was not wrong; scientists just failed to explore its effects from enough angles.

Looking more closely at the data for the Adélie Land Emperors, another story starts to emerge. The population of nesting pairs crashed in only two years, from more than 6,000 pairs in 1975 to only 3,500 pairs in 1977. Again, a model in which a krill surplus was helping penguin populations would predict the opposite. But the original analysis did not account for the effects of killer whales. Type A orcas eat minke whales, and when the whaling industry took 10,000 minkes out of the region during the 1970s, it left the killer whales with a short supply of food. The whales would either have to move or find something else to eat. What if the killer whales started eating Emperor Penguins?

Subsequent studies have clearly shown that killer whales switched from eating seals to eating sea otters in specific areas along the coast of Alaska. These studies also showed that as few as five killer whales could have a devastating effect on local otter populations: orcas can each eat more than 1,000 otters per year. Furthermore, killer whales are known to eat King Penguins in the Southern Ocean. A small number of "rogue" killer whales, failing to find minkes, could have easily eaten the missing 2,500 pairs of Emperors over two years, and the next twist in the story suggests that this is just what happened. In 1978, directly following the crash in the Emperor population, Russia started hunting killer whales off of Adélie Land, quickly depleting the population in a three-year campaign. The crashing Emperor population leveled off as adult mortality rates returned to normal.

The colony has still failed to recover, and this, most likely, is the result of climate-related habitat loss. Deteriorating ice conditions make it harder for Emperors to successfully raise chicks. Climate-change drivers are very real. But that initial crash, and the subsequent stabilization of adult mortality rates, is better explained through species dynamics in response to the massive extractive industry. The problems compounded into disaster for the penguins.

With attention focused almost entirely on the melting ice, science failed to ask the right questions, especially in relation to new industries proposed in the Antarctic. And as Antarctic ecosystems struggled to deal with their melting world, nations were readying their ships, preparing to expand industrial fishing even farther into Antarctic waters. David could see the danger, and in 2004, he wrote the paper that inspired my journey.

We had been talking for several hours, and David made a final haunting point: CCAMLR was created specifically to ensure that human beings don't replace whales as the top consumer of krill in the Southern Ocean. But we are now positioned to become the top consumer of yet another crucial species in Antarctic waters, the Antarctic toothfish. We failed to learn from the past, and we are putting the future at risk. David's voice cracked and his eyes filled. He could say no more, and so he dressed and left the tent to go study the birds, looking for new patterns, standing his post in the long and noble line of Antarctic exploration. There are some things you can only discover by gazing intently out to sea. exploration. There are some things you can only discover by gazing intently out to sea.

is anchored with five-centimeter-wide webbing ratcheted to thick metal stakes. Even stretched tight and held down with the webbing, the canvas top flaps loudly against the aluminum frame in the wind.

The scene inside the tent was strikingly similar to the historic hut. Makeshift shelves lined the walls, filled with an assortment of canned foods and loosely stacked gear. David's bedding—a thin pad and sleeping bag—was rolled and stowed in the corner during the day. His desk, actually a narrow shelf itself, barely accommodated a laptop computer, a pile of papers, and a few books.

David has studied Adélie Penguins for more than 40 years and began his 12th season at Cape Royds in 2008. His primary research focused on explaining the dramatic and surprising increases in Ross Sea Adélie populations in the 1970s and 1980s. His working hypothesis was that a combination of climate-change-related environmental issues—changes in ice thickness, extent, and season—were responsible for the population boom; he just had to decipher how it was happening.

His team affixed satellite tags on selected penguins in four colonies to see where they were hunting and how deep they were diving. They isolated a small number of nests in each colony with a fence, forcing the birds to walk over specially designed bridges. As they did, the birds were weighed and their identities logged by a small computer chip that each carried. With this data, David could glean how long their trips were taking and how much food they were able to catch on each trip.

But this type of measurement is only a part of David's science. He spends the bulk of his time studying the birds in person. A consummate observational scientist, he watches intently, recognizing subtle patterns, thoroughly researching every relevant angle, and slowly assembling the puzzle pieces to see more clearly into the world around him. David's research, indeed, has identified climate-related phenomena that will define the future of these penguins. But his study quickly started to reveal other possible contributing factors to the 1970s and 1980s penguin boom, and it all began with the polynya.

David works almost continuously, but when he needs a break, he skis. In 2003, he set out for a ski, hiking an hour up the slope of Erebus to begin his run. That year, the famous iceberg B-15A, which was the size of New York's Long Island, had cracked off of the Ross Ice Shelf, spun around, and capped McMurdo Sound, nearly cutting it off from the rest of the Ross Sea. Thus, just like the year of my visit, the sea ice was stuck in the sound, and the Cape Royds penguins had a long walk. But when David turned around and sat down to put on his boots, he saw open water. The polynya had formed in just an hour. And again just like what I had witnessed, minke whales showed up in the polynya only two days after it opened.

During the natural experiment that followed, David first fully recognized the profound link between minkes and Adélies. In the first seven years of the project, David had consistently seen a distinct switch in the penguins' diet in the beginning of December as they went from eating mainly krill to eating mainly silverfish. It just so happens that minkes usually arrive at the ice edge at the same time, but until the 2003 polynya formed, he had assumed the switch was also related to ice conditions. When the whales showed up in the polynya and the experiment played out, he witnessed the switch in diet in a virtual test tube. Minkes are natural competitors with penguins, and the presence of only a few whales quickly and radically changes the birds' feeding behaviors, and potentially their success in raising chicks. To understand the significance of this critical observation, we must look beyond the Ross Sea and back in time to a different age of industry in the Southern Ocean.

FOUNDED IN 1904, the whaling station of Grytviken on South Georgia Island stands like an open grave for the great whales of the Southern Ocean. A whaling boat is beached near the rotting docks, its harpoon gun pointing toward the sky. Banks of massive boilers, huge winches, cutters, and cookeries for blubber, meat, and bone have all rusted into the color of blood. Heavy metal chains, once used to heave whales onto the flensing pad for blubber removal, lie in jumbled piles. One of these chains is stretched straight. It measures 30 meters long, matching the largest whale ever caught and processed at the station. This blue whale likely weighed more than 200 tons. It was one of the largest individual animals to have ever existed on Earth.

The great whales fell to lubricate the industrial revolution—literally. Whale oil was in high demand to make fuel for whale-oil lamps, lubricant for high-altitude instruments, cosmetics, detergent, transmission fluid, protective paint for steel, and margarine, to name a few products. Whalers couldn't keep pace with demand. By 1946, the industry had spurred the creation of a new international body—the International Whaling Commission (IWC).

By the early 1970s, populations of the great whales—fins, blues, and humpbacks—had plummeted by 90 percent worldwide. Still trying to maintain a dying industry, whalers turned their attention to minkes. In 1986, after more than a decade of prodding from the international community, the IWC declared a global moratorium on whaling. By that time, whalers had already taken more than 116,000 minke whales from the Southern Ocean, and 20,000 minkes from the Ross Sea region alone. David thought: Couldn't a large part of the 1970s and 1980s Adélie Penguin boom in the Ross Sea be directly related to this mass removal of whales? Without this major competitor, wouldn't the penguins be more successful?

This was not an entirely new question. In the late 1970s and early 1980s, scientists worldwide were buzzing with ideas about how this massive extraction of whales would affect Southern Ocean

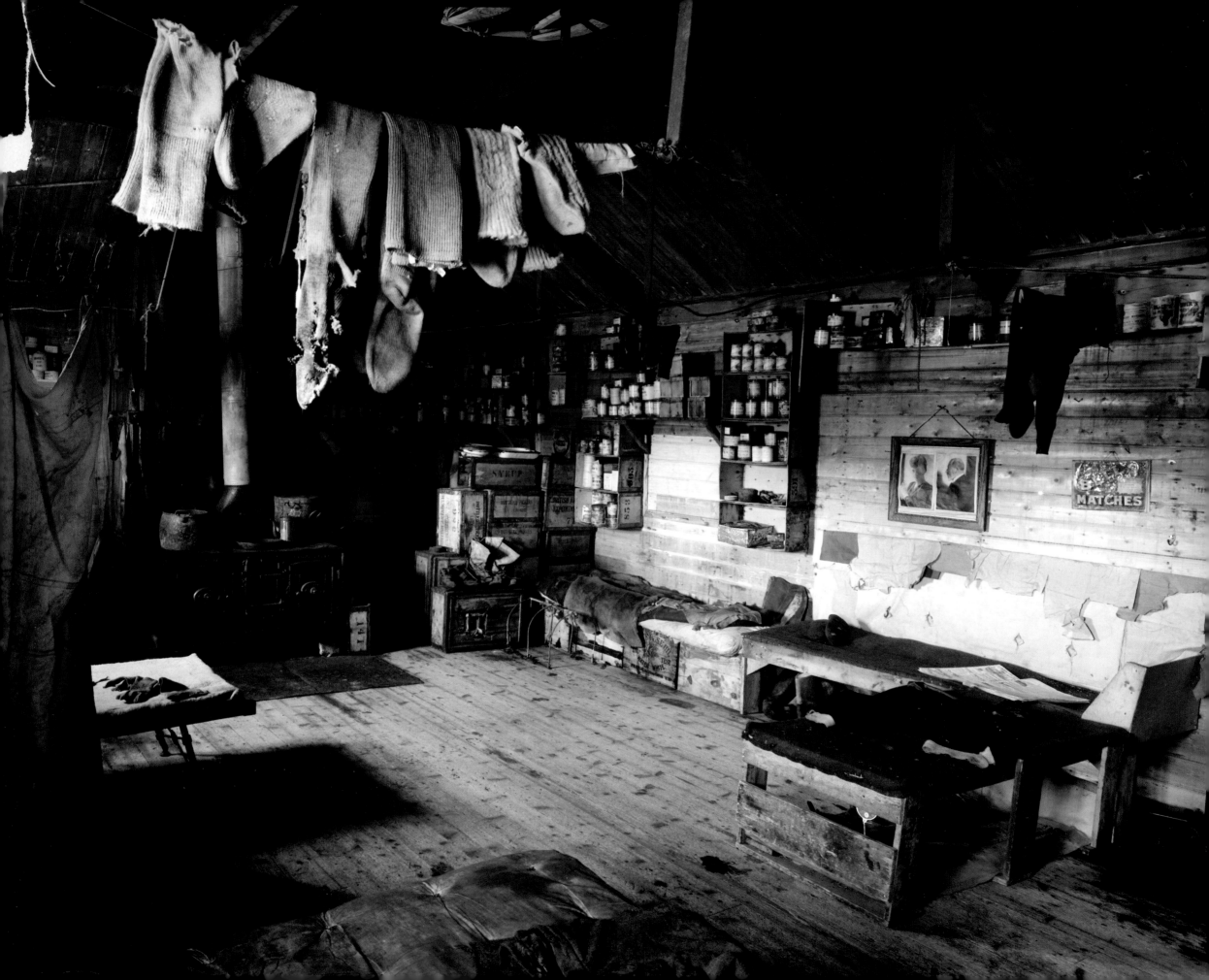

Above and Opposite: **Inside Shackleton's Hut**

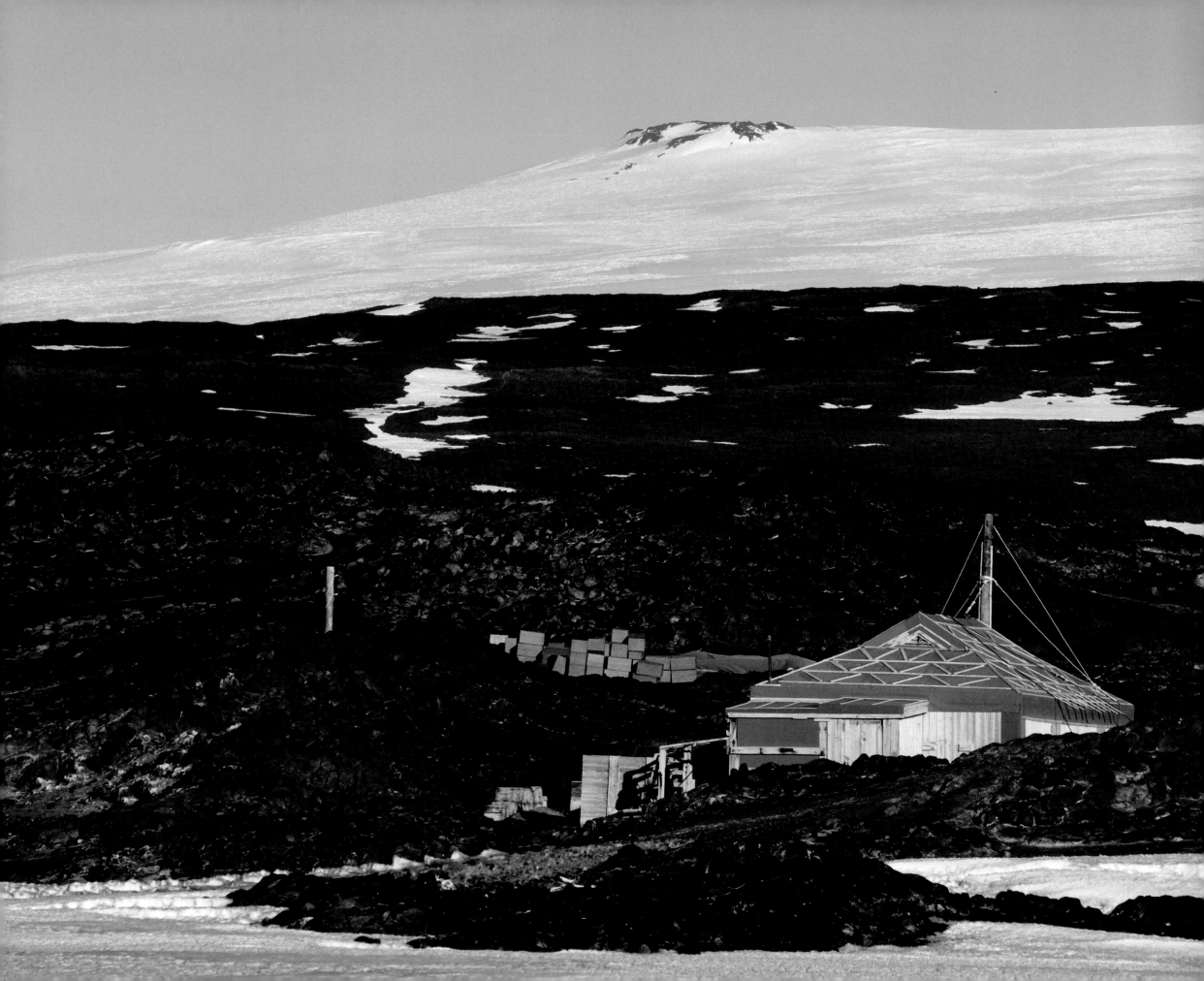

DAVID AINLEY

Shackleton's Hut is nestled into the black lava slope overlooking the sound. The tongue-and-groove pine siding is bleached nearly white. If it were not for the high stovepipe on the back of the structure, from a distance the eye could almost dismiss the whole building as a pile of snow caught in the lee of a lava ridge. It is somehow both humble and audacious, perhaps a direct reflection of Shackleton himself.

The 1908 *Nimrod* expedition, a centerpiece of the heroic age of Antarctic exploration, haunts any visit to Cape Royds. It's easy to imagine the men of the expedition: Shackleton standing on a precipice of rock, plotting routes up unnamed glaciers for his attempt to become the first man at the Geographic South Pole; Edgeworth David, the eldest member at 49 years of age, cresting the rim of Mount Erebus for the first time after a five-day hike through deep snow; and Douglas Mawson, watching his compass spin as he stood on the magnetic pole, dressed in wool and leather. From a high vantage point overlooking the hut and extreme world all around, it is easy to understand these men as heroes, but inside the hut, you can understand these heroes as men.

Diffused light floods in from the two windows on the north wall, filling the hut with a warm glow and soft shadows. A Smith and Wellstood cast-iron stove anchors the main room, and crate shelving lines the walls with a selection of relics. In the southeast corner, the pantry boasts stacks of unopened food—chicken and veal pate, oxtail soup, preserved cabbage, wholemeal biscuits, stewed rump steaks, and curried rabbit. Other shelves hold long candles, jars of salt, boxes of matches, and medicines of the day—boric acid, Virol, and cod-liver oil.

The hut is now a museum—a far cry from the sooty, sweaty, crowded place it must have been in 1908. Most of the truly personal items are gone, carried away to other museums, but you can still feel the presence of the men. Long wool socks dry on a grid of wires strung above the room from the open rafters. The 15 men slept nearly side by side on their thin mattresses, using the grid to hang curtains and divide the room into two-man cubicles at night. A tattered novel on the windowsill reveals snippets of a scene from high London society—Lady Shrewsbury, the Queen, and purebred horses.

On the wall near the entrance of the hut, provisions specialist Frank Wild signed his surname in black paint. He underlined it with a thick line, as if the inscription was not just his name, but a commentary on the whole experience. Four of the men in the hut would eventually be knighted. But crammed together with no escape during the Antarctic winter of 1908, buffeted by the famous Cape Royds winds, their very survival uncertain, I imagine they just tried to stay sane.

David Ainley's camp lies a kilometer uphill from Shackleton's hut. The main structure is a six-meter-long, hard-floored tent in the shape of a half cylinder. The hard front and back walls are painted sky blue. The roof is a thick yellow canvas stretched over an aluminum skeleton, and the entire structure

Shackleton's Hut

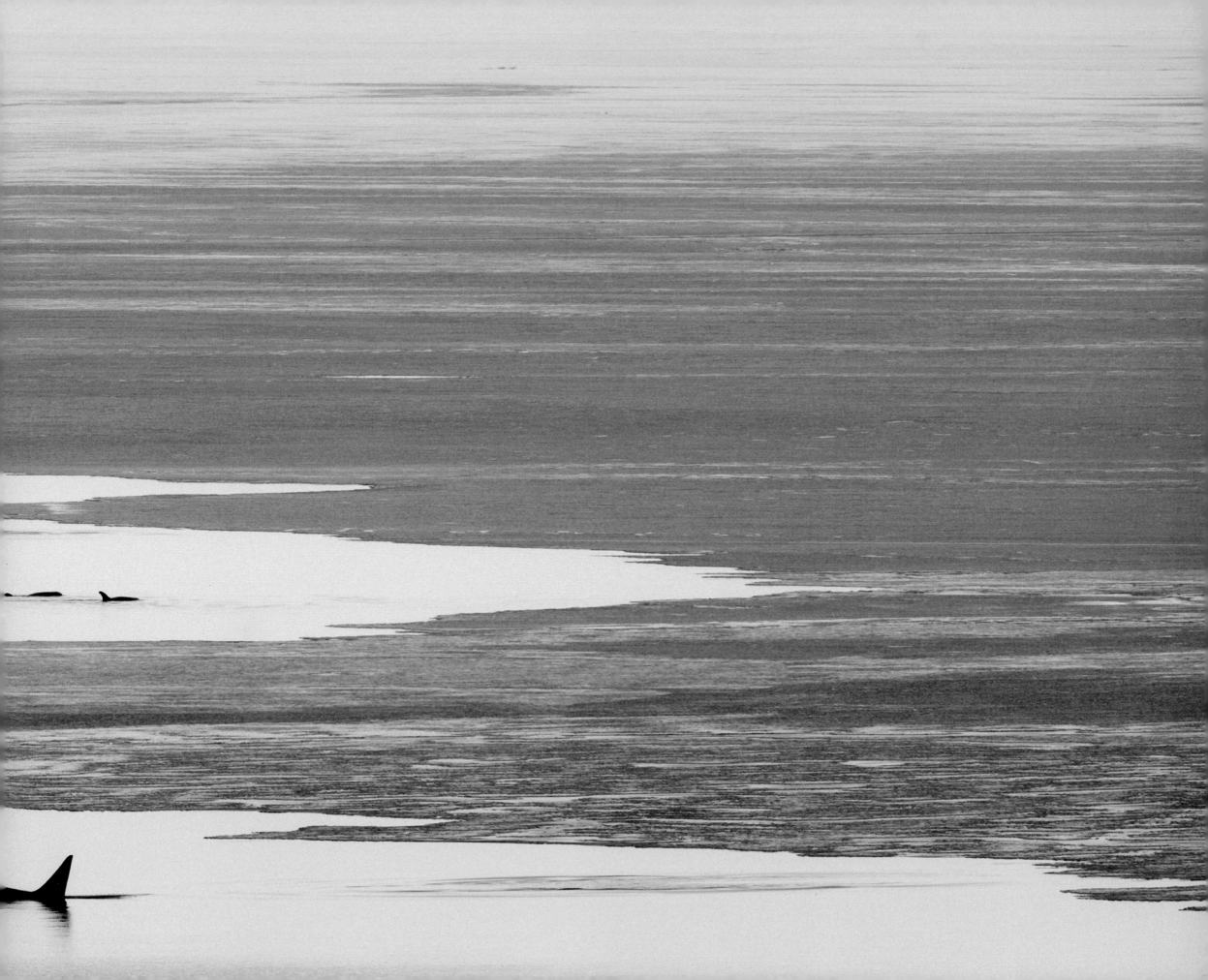

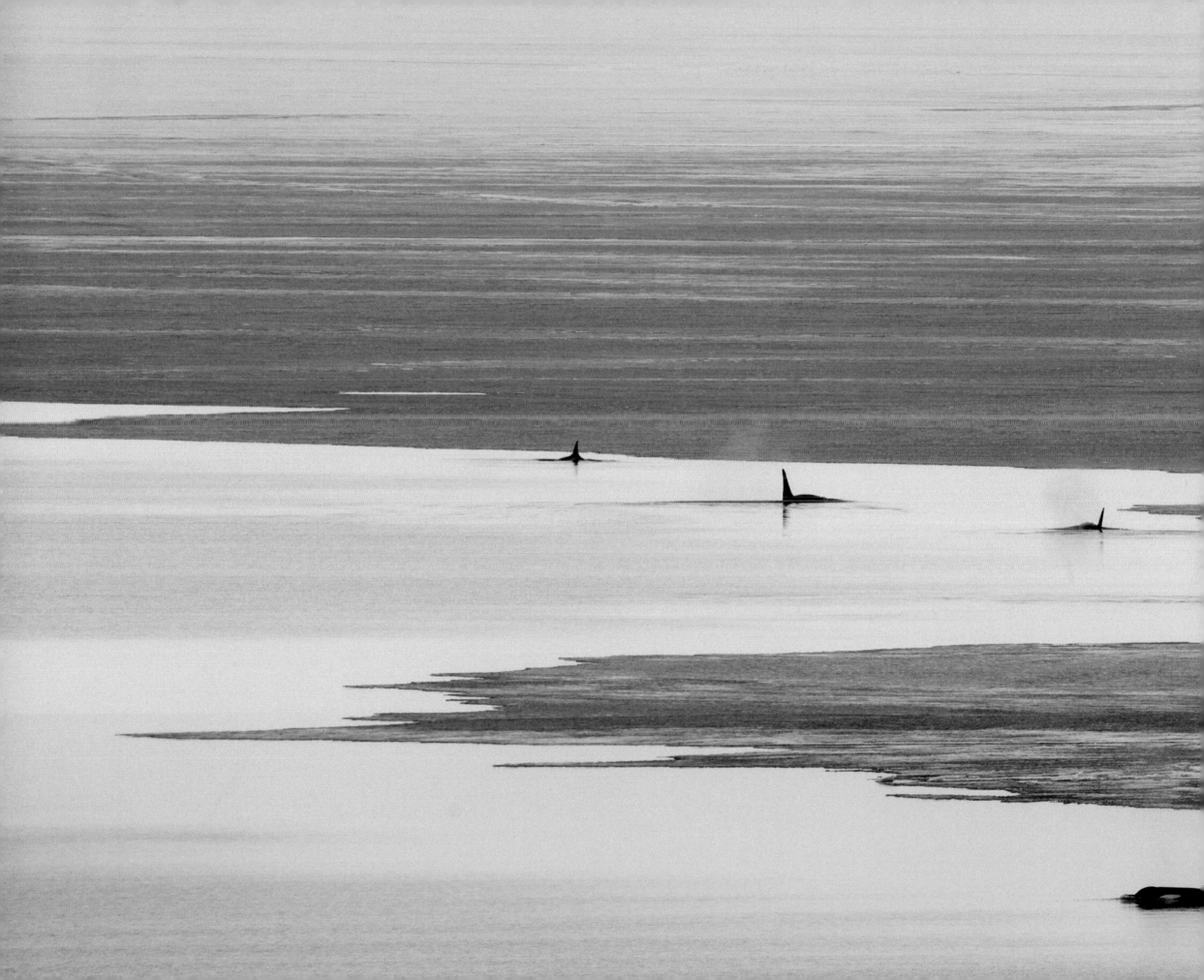

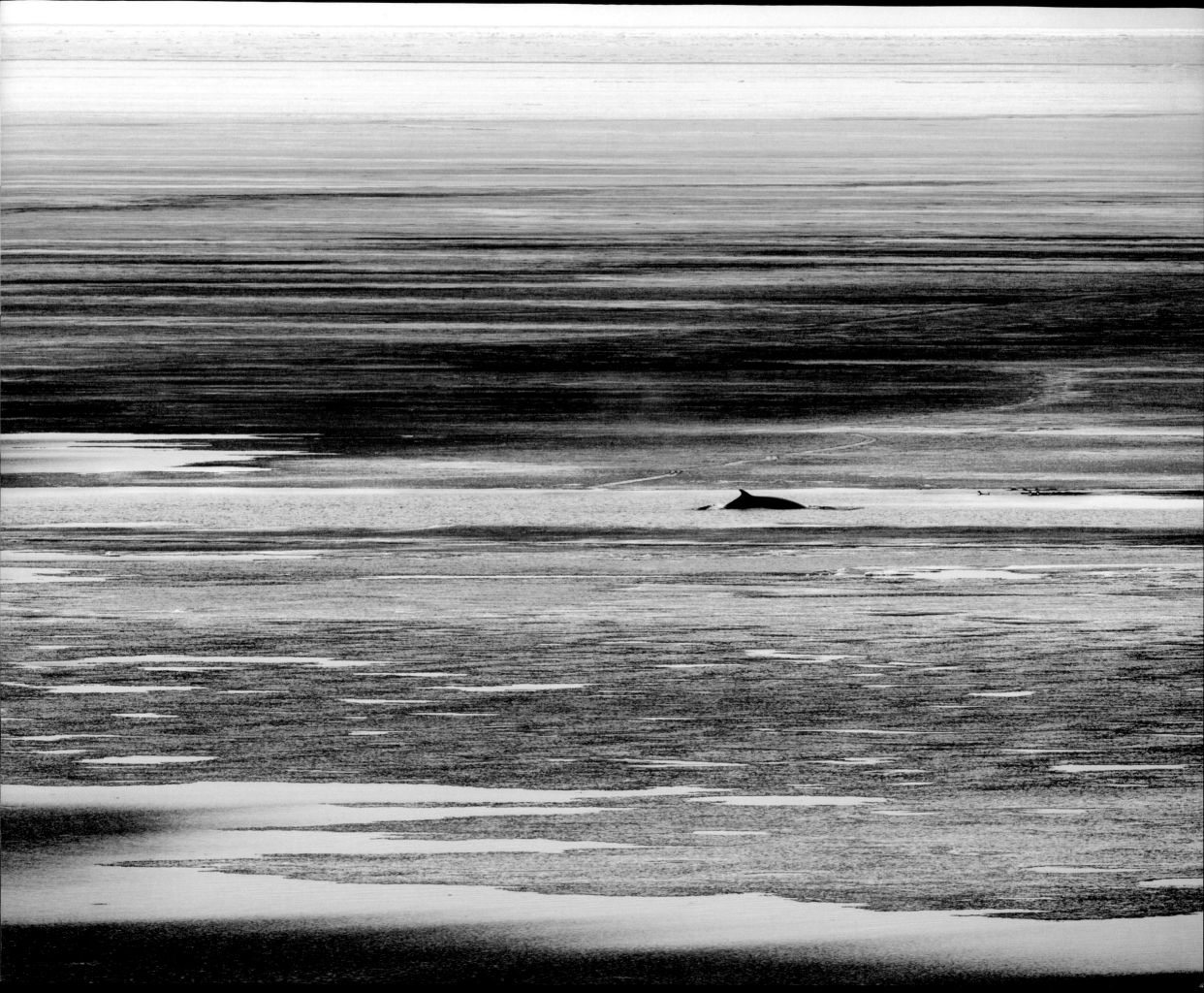

Opposite: **Minke whale in the Cape Royds Polynya** | Following Spread: **Pod of killer whales in the Cape Royds Polynya**

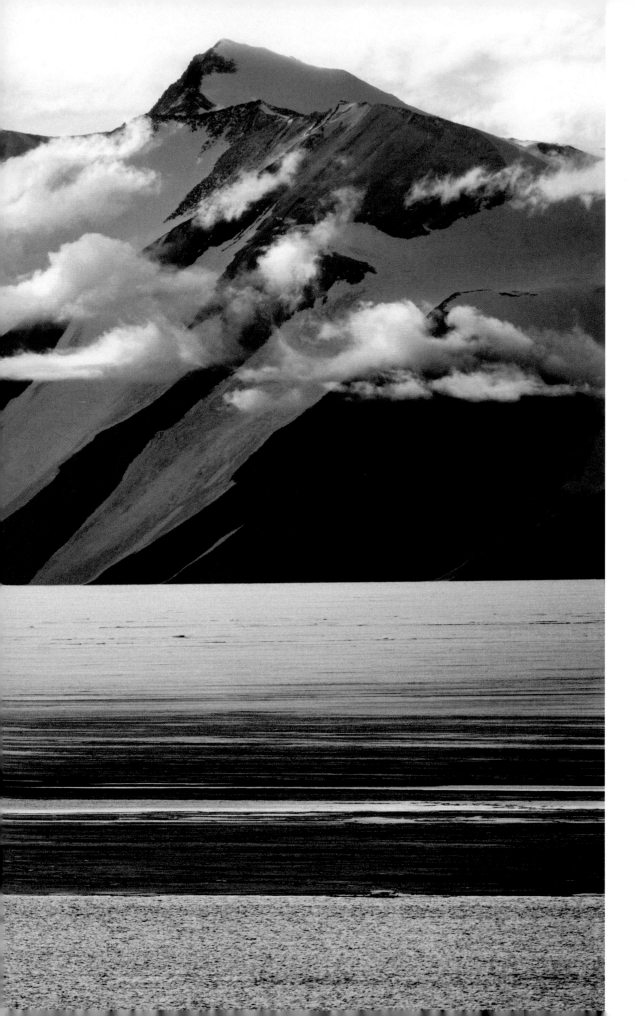

Killer whale and the Trans-Antarctic Mountains

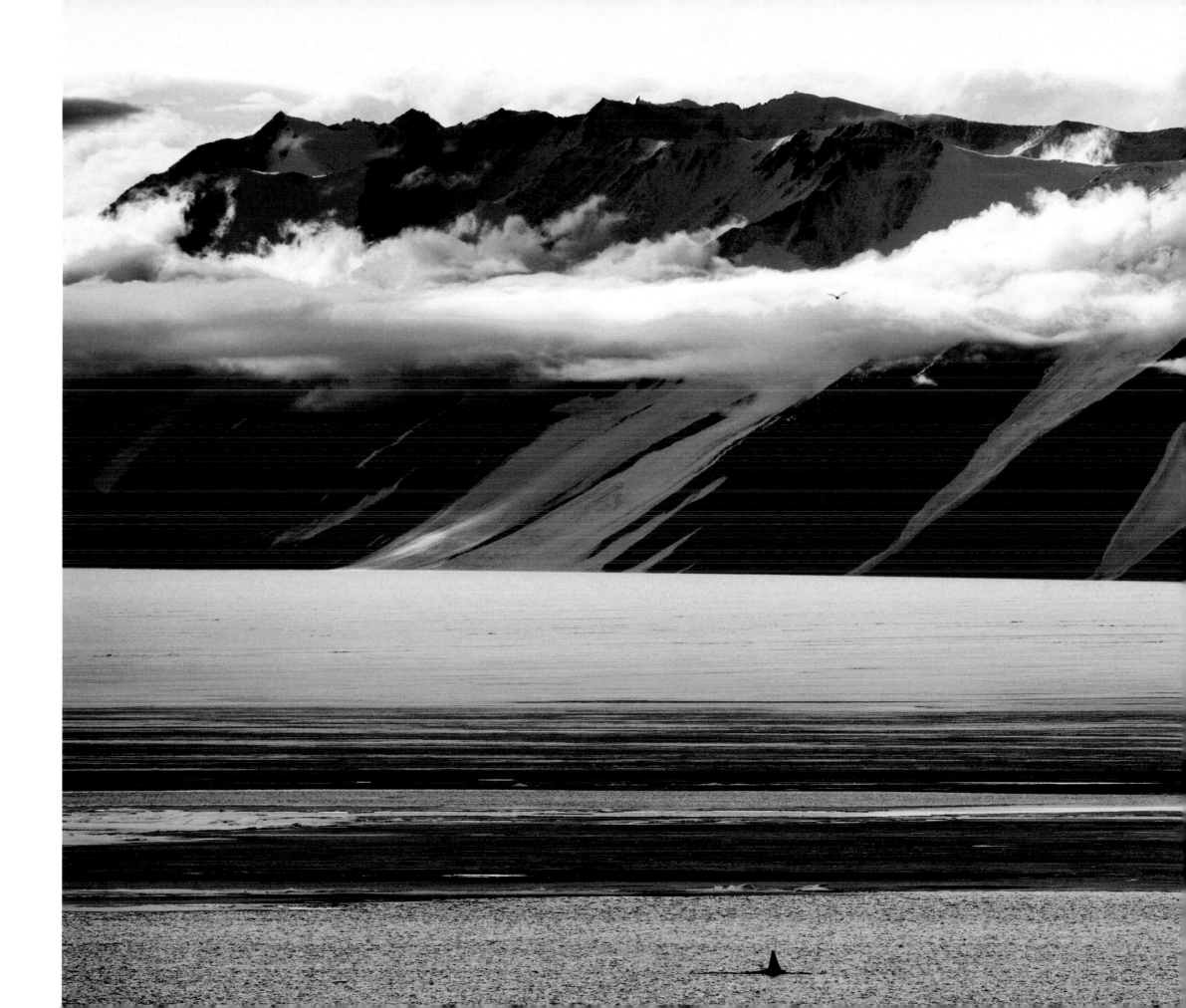

Ice in the Cape Royds Polynya

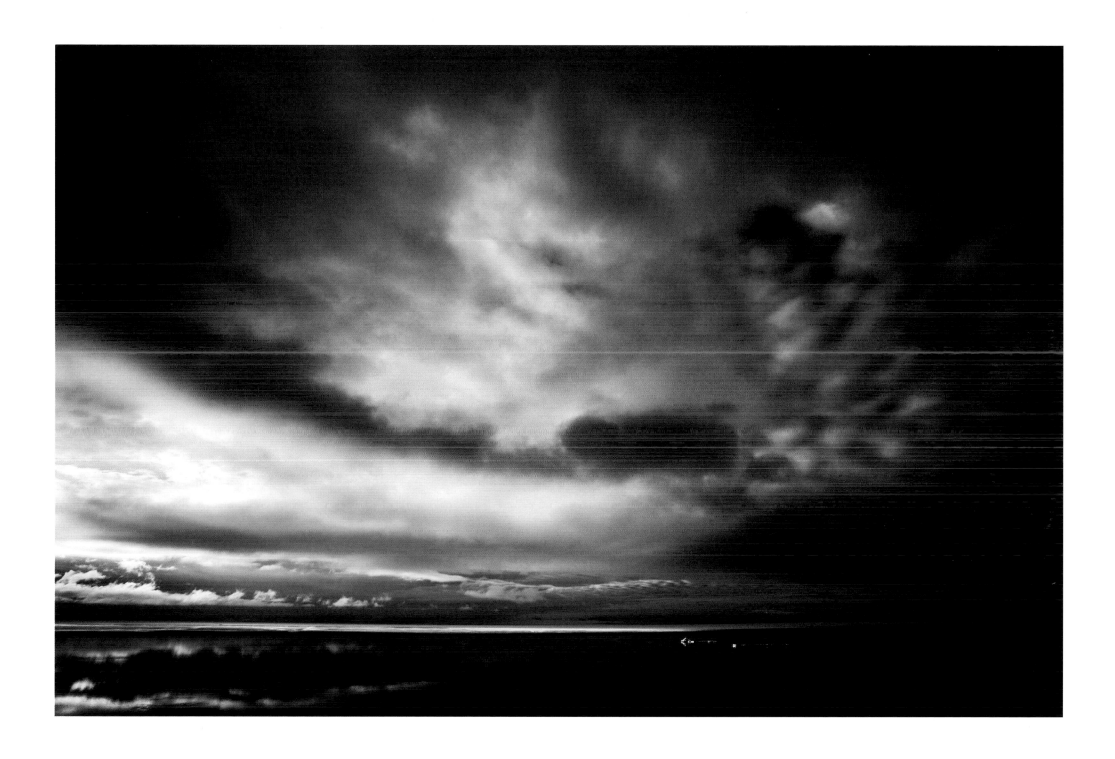

Midnight light over the Cape Royds Polynya

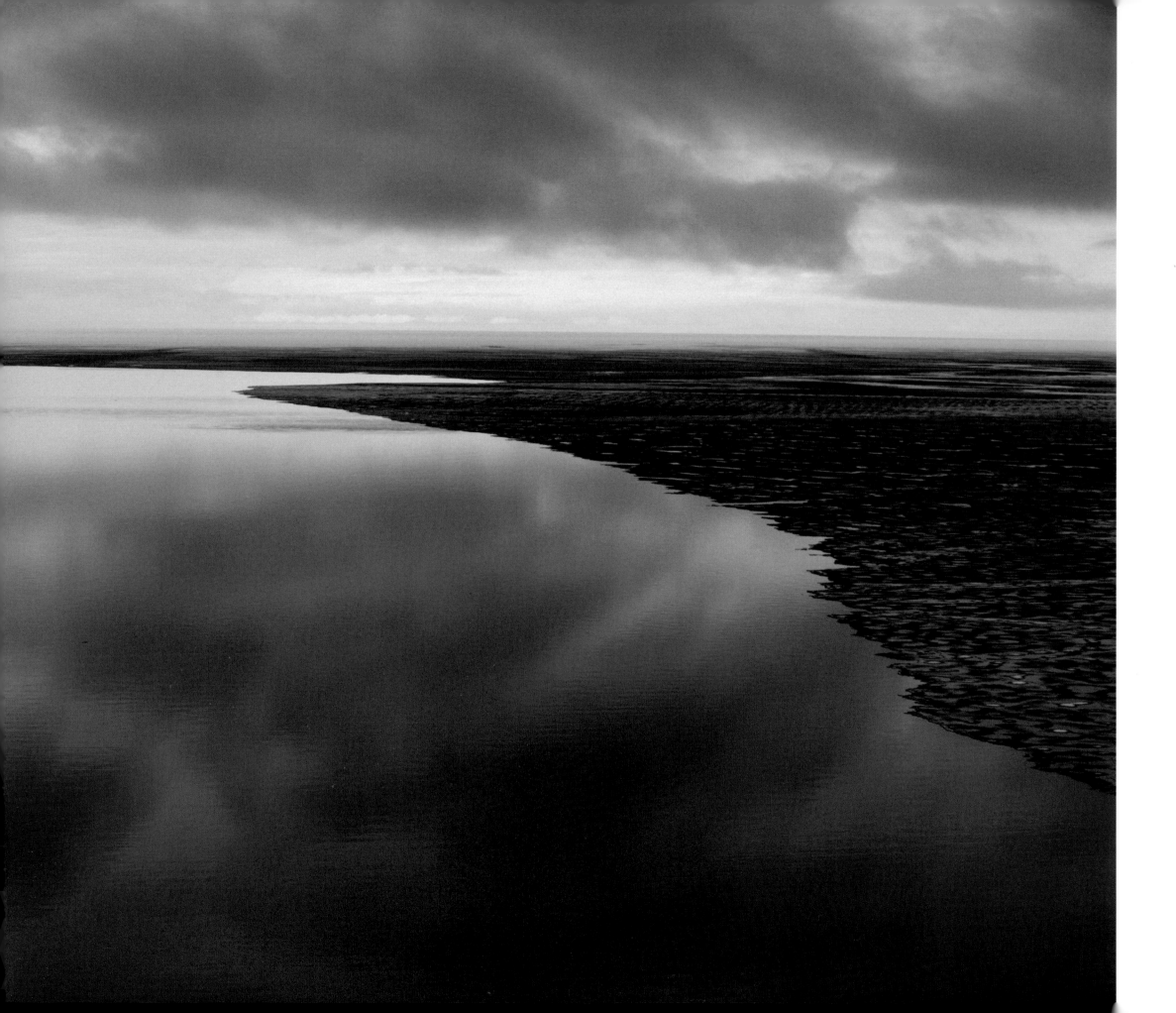

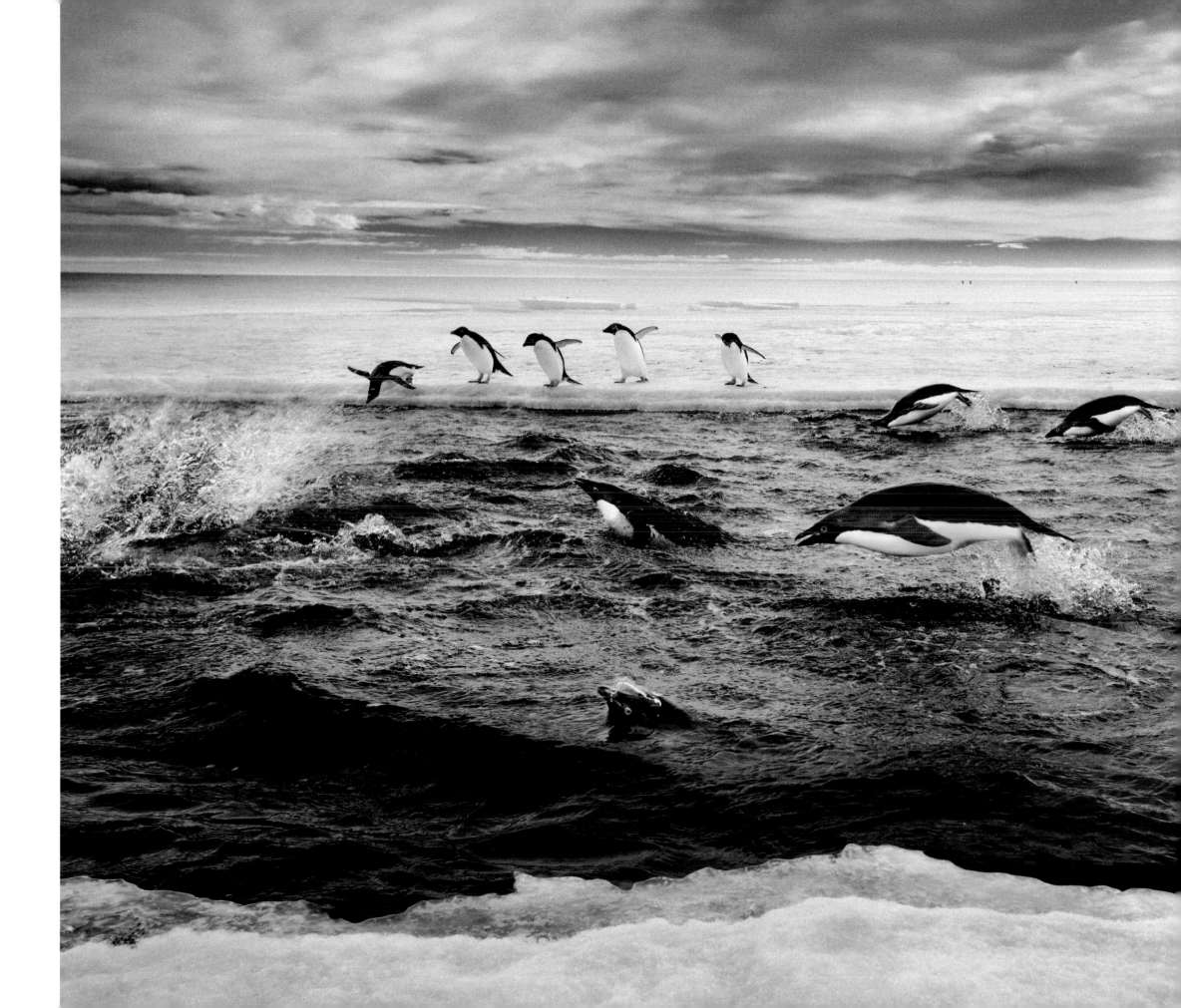

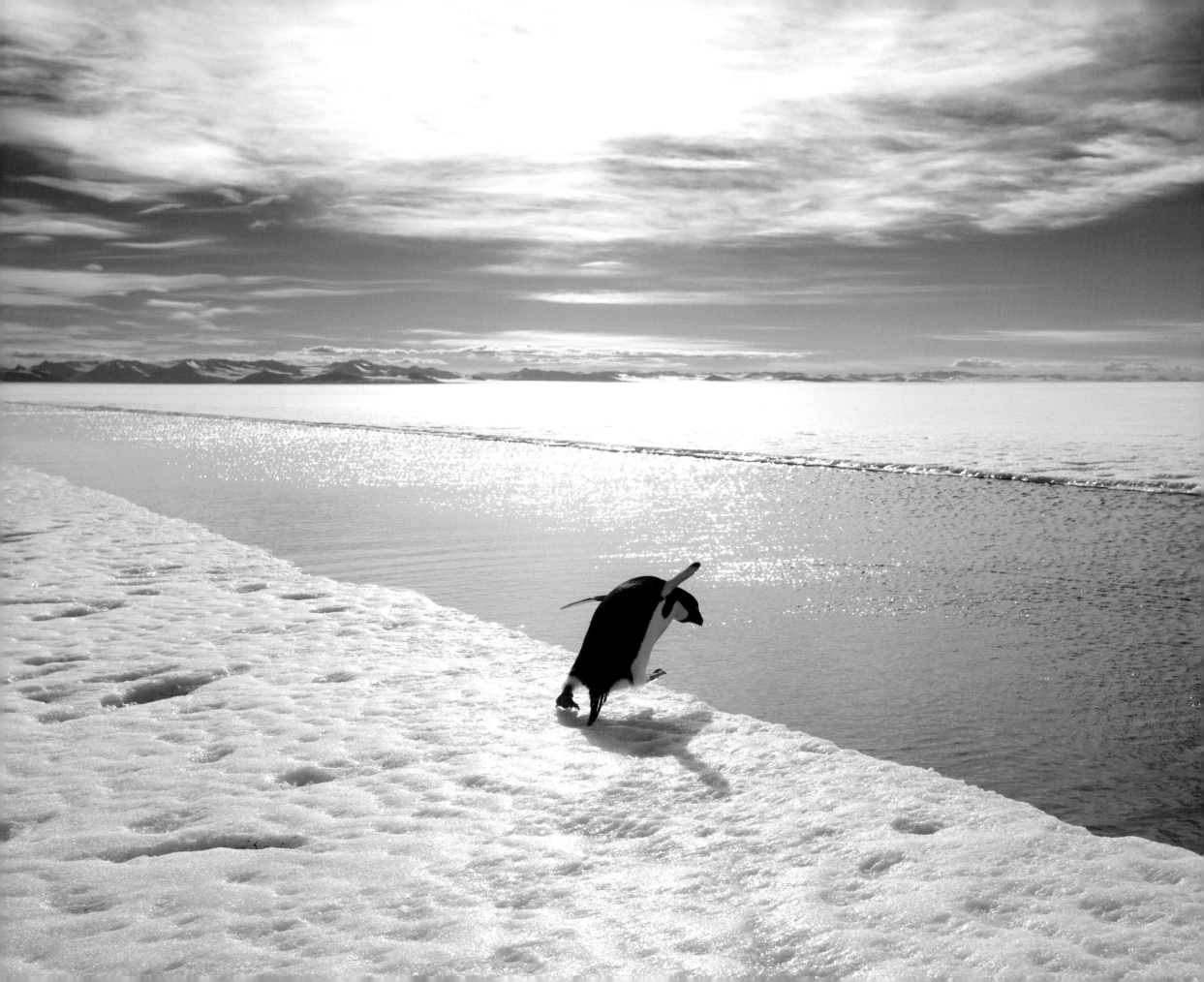

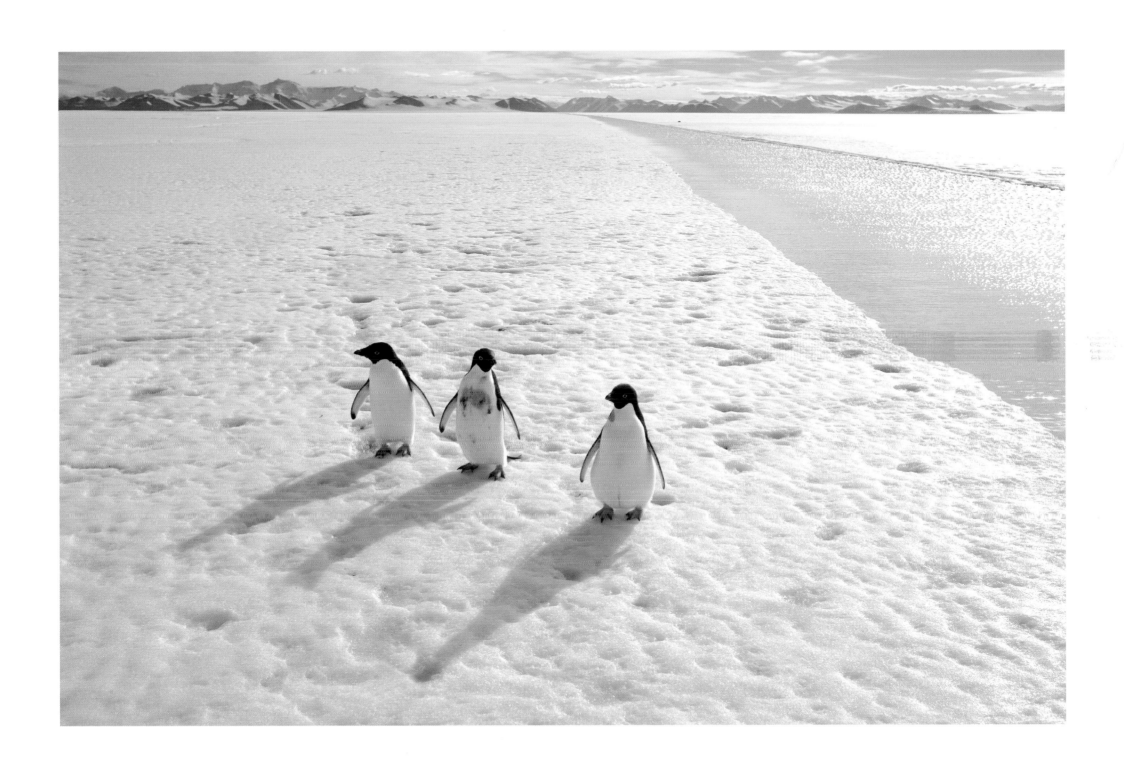

Above: **Adélie Penguins at the crack** | Opposite: **Adélie Penguin diving into the crack**

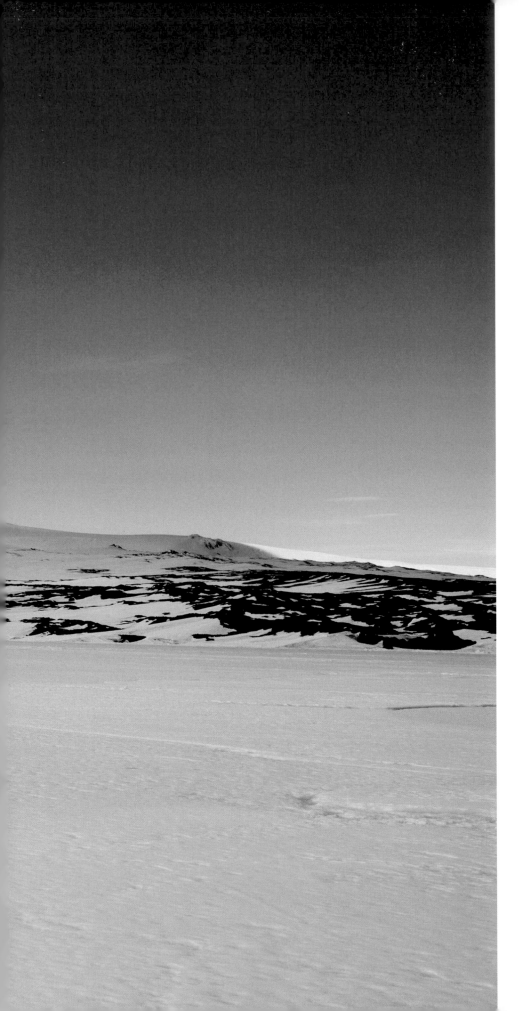

suddenly whipped across the ice. We made the walk back focused solely on speed, stepping off the ice and back onto the lava flow just as it started to snow. By the time we had made our way across the moor and back to camp, the gale was earnest.

Hot tea and dry socks were my first priority, but sleep came soon after, even though the Scott tent did little to muffle the wind. The events of the day filled my mind, and I tried to hold on to every nuance, every step on the path out to the crack. As exhaustion finally won its battle, I started to imagine what I had not seen—the mayhem underwater. I fell asleep thinking, "How did the hunt look to the krill?" The wind outside ripped down the slope, raking across the moor, and 3,800 meters above the camp, hidden in the caldera, a molten lava lake bubbled and spat, occasionally ejecting a lava bomb filled with smoky feldspar crystals.

Adélie Penguins on the way to the crack

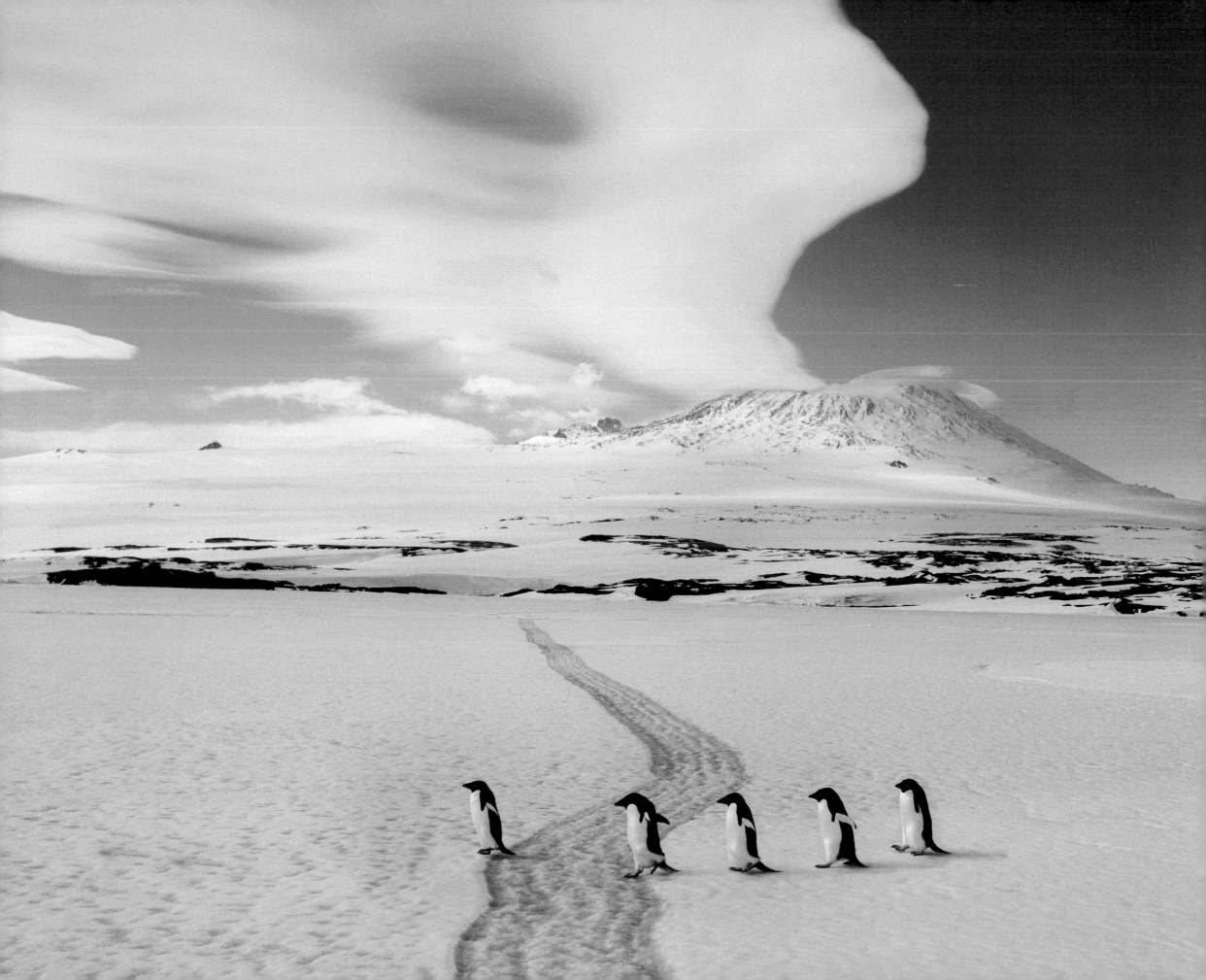

Opposite: **The moor of Cape Royds** | Above: **Skuas on the moor**

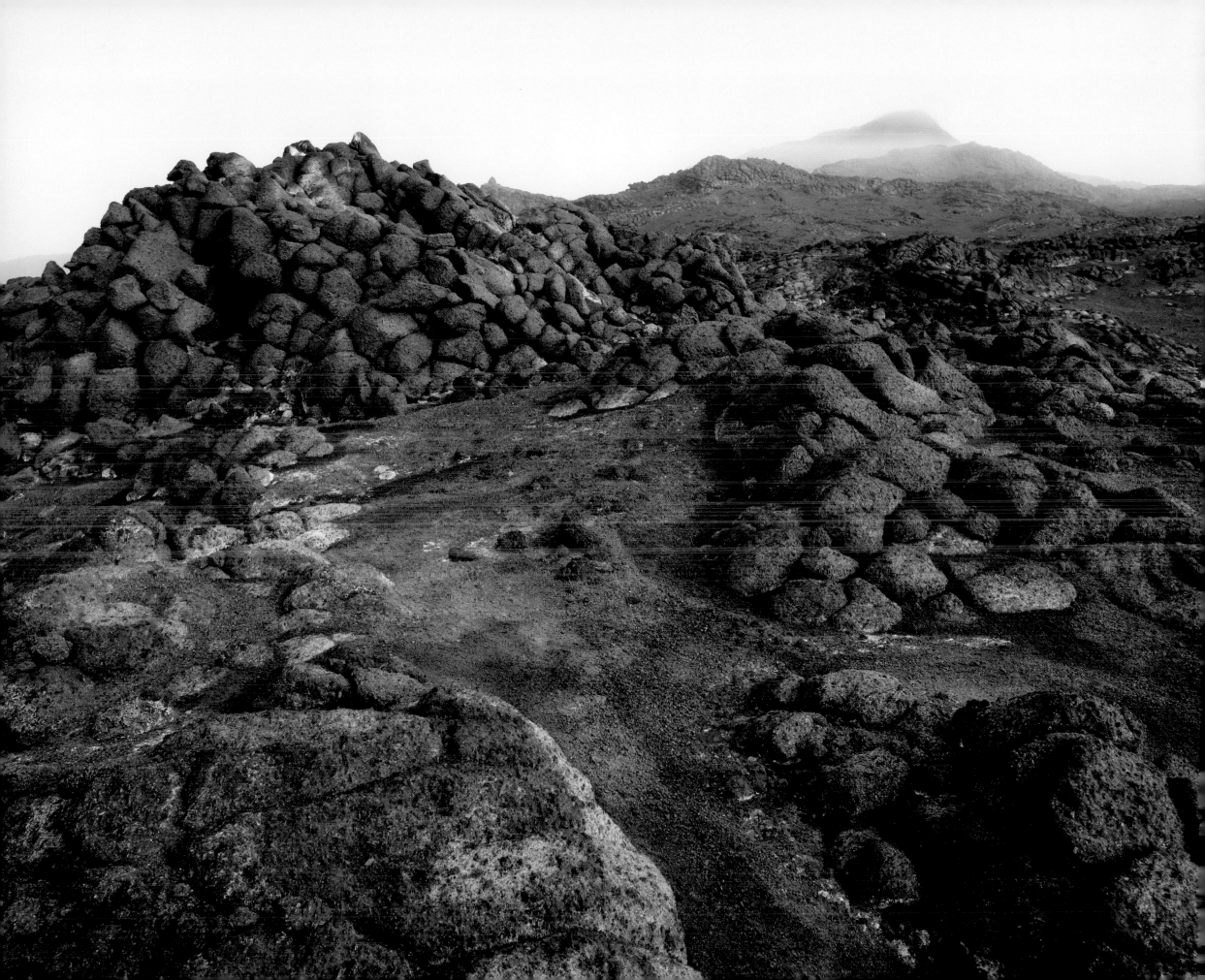

effectively divert the East Antarctic Ice Sheet, leaving the windswept glacial moraines nearly free of ice. When snow does fall, it quickly sublimates, reclaimed and carried away by the vicious katabatic winds that scour the valleys before any of the moisture can find the salty soil. Carbon and nitrogen, the basic building blocks of life, are almost absent as well.

Environments in the Dry Valleys are the closest terrestrial mimics of conditions on Mars, and, if there was ever a reason to admit the possibility of extraterrestrial life, it is this: life has found a foothold even here. Buried in the desert pavement of this most uninhabitable place is a rich diversity of highly adapted microbes. But when a confused seal somehow pulls itself into the valleys, it changes everything.

The mummified seals trap moisture, block damaging ultraviolet rays, and slowly release organic carbon and nitrogen into the soil beneath them. The microbial community responds almost immediately. Under the seals, the number of microbes doubles in only a few years. But this increase in biomass comes at the cost of biodiversity, as only two of the seven phyla common in these soils can take advantage of the new nutrients and shelter afforded by the mummified seal. This shift is long lasting. Some of the seal carcasses in the Taylor and Wright Valleys are almost 800 years old, and they continue to fundamentally change the microbial communities around them.

Staring down at the seal on the beach, I reflected on the inevitable question: If these organisms can be so highly adapted that a little more carbon and humidity can drastically alter the community makeup, what is in store for the rest of the Ross Sea creatures as climate change accelerates? The very physical foundation of the ecosystem is rapidly transforming. And their extreme adaptations make these animals highly vulnerable. Life in the Ross Sea rests at its own angle of repose.

We left the seal, picking our way through the uplifted ridges and out onto the solid sea ice itself. From this point on, we would be walking on water.

THE SURFACE OF THE SEA ICE was a palette of texture. Wind and pressure had had their way, sculpting fields of centimeter-high, interlocking ridges interspersed with long expanses of nearly glass-flat ice, as if the ripples from squirrelly breezes on an otherwise motionless lake had all frozen in motion. We walked north across the ice in the silence of still air. The trek through the lava flow was wiped from my mind. Now there was only the vast flatness, and the rising, childlike joy as we walked into the blinding white under the bottomless blue.

As it turned out, our careful compass readings proved unnecessary. Bellies full of fish, a small hunting party of Adélies tottered back toward the colony from the crack. We stood still and let them approach. They paused for curious looks, and then continued around and past us, diligently studying the uneven footing as they rocked and swayed toward home. Just as they disappeared behind us, another small group appeared as black-and-white specks on the northern horizon, wavering with the distortion of open spaces. The rest of the way to the crack, we just followed the trail of penguins.

We met the crack half a kilometer from where it touched the shores of Ross Island to the east. To the west, the silver ribbon of water narrowed and curved away out of sight into the middle of the sound. It was boiling with penguins. The small hunting parties had apparently merged into battalions of 100 or more, which were launching coordinated attacks on krill and small fish up and down the narrow waterway. The penguins torpedoed in and out of the water in overlapping synchronized waves, with up to 15 birds in the air at a time. I could only imagine what it must have looked like to the krill. The characteristic totter and curiosity were gone, replaced by speed, control, and predatory focus. They gorged.

As we approached, we could see five of the battalions, spaced 200 meters apart. Each group would maintain the undulating waves of attack for 250 meters or more and then stop en masse at the surface, resetting feathers, making adjustments, and inspecting the water below. The birds would then all dive at once, disappearing for several minutes before resurfacing, again en masse, in a different section of the crack. It was theater.

I took a front-row seat, sitting cross-legged on the ice at the edge of the crack. It didn't take long. Penguins boiled to the surface 40 meters east. They completed post-dive preening rituals and started swimming west as a group, slowly gaining speed, their heads above the water. The front-most penguins ducked under and disappeared, followed almost immediately by the rest of the group.

The purpose of this first short dive must have been to accelerate up to attack speed, because 10 seconds later the water directly in front of me erupted. Penguins launched out of the water at low angles five and six at a time, skimming the surface for more than a meter before reentry. Fifteen seconds later, the entire group had passed, rocketing west down the crack. The birds ended their offensive a minute later, preened again, and then dove out of sight, leaving the silver ribbon smooth and quiet. I was still holding my breath.

Penguins shuffled and squawked behind us, announcing the arrival of another hunting party from Cape Royds. They took up posts on the edge of the crack, preened, adjusted, and prepared for the hunt. Far to the north on the other side of the crack, more penguins appeared on the horizon, walking south from Cape Bird, 25 kilometers away. The word was out, and apparently the crack was a better option than the ice edge for even the birds in this more northern colony.

The next wave of hunting penguins came back from the west, and as they exploded past, the recent arrivals took running dives into the fray. And so it went. Every 10 minutes, another wave would pass. More groups arrived from Cape Royds, and then the first from Cape Bird. I tried to slow time and make deals with the weather, but three hours later the clouds were rolling in fast, and a cold wind

THE CRACK

Heat rose in visible waves from the towering hummocks of crumbling black rock and rubble, strewn down the slope from the rim of the caldera to the edge of the sea 3,800 meters below. A windswept cloud clung to the top of the volcano, an exaggerated plume of smoke in an otherwise bright blue sky.

Close to David Ainley's camp, the lava flow forms a pavement of closely packed, irregular, andesite blocks, grouted with thin veinlike intrusions; it is stable footing, even though the tiny, razor-sharp teeth of the andesite can quickly shred the thick rubber sole of a boot. Farther down the slope, the lava has eroded into a patchwork of gravels, sands, and piles of pitted rock precariously balanced at the angle of repose. If any rock moved, the whole side of a pile would tumble. Thus, we chose careful paths around the tors and up and over the steep loose ridges, testing each step before applying full weight. Still, small avalanches clattered and tinkled as they cascaded downhill, occasionally revealing the distinctive feldspar crystals that occur only here and on the slopes of Kenya's Kilimanjaro. Sparks of light flashed from every surface—rock, sand, snow, and ice.

Aside from the occasional drifts of snow and teardrop ponds that punctuate the erosion, it must be like walking on the moon. The tortured moor ends in crumbling cliffs high above the shores of McMurdo Sound. Eighty kilometers away across the frozen sea, the jagged peaks of the Olympus, Saint John's, Asgard, and Royal Society ranges were chiseled into the sky. From the high vantage point, Jean Pennycook and I took a last look at our intended destination through high-powered binoculars. Almost imperceptible black specks were strung along a hair-thin line of blue, cut into the flat white ice of the sound.

Two days prior, a helicopter pilot had reported this three-kilometer-long, five-meter-wide crack in the sea ice only five kilometers north. The penguins finally had open water close to the colony, and the crack would likely save the surviving chicks. It would also provide a unique opportunity to observe the penguins in action. We confirmed the location, took bearings, checked safety equipment, and then backtracked to a smooth gravel slope—an easy final descent that spilled out onto a narrow gravel beach directly below the cliffs.

Shoulder-high ridges of buckled sea ice were piled on the shore, a reminder that the entire mass of sea ice was moving in slow motion, driven by the prevailing clockwise currents in the sound. Elegantly outstretched on the black gravel, the bright yellow-brown mummified carcass of a Weddell seal faced out to sea, its final haul-out frozen in time. We paid respect with close inspection. The desiccated skin was its own tortured landscape in miniature—labyrinths of hoodoos, ravines, cliffs, and sharp crevasses—but the seal was elegant, flippers poised and within meters of the sea, as if readied for one more dive under the ice.

Twice a decade a disoriented seal travels dozens of kilometers in the wrong direction, hauling itself upslope into the McMurdo Dry Valleys on the far side of the sound, ensuring its own quick dry death. More than 98 percent of Antarctica is covered in ice, but the 15 Dry Valleys end in high rock cirques that

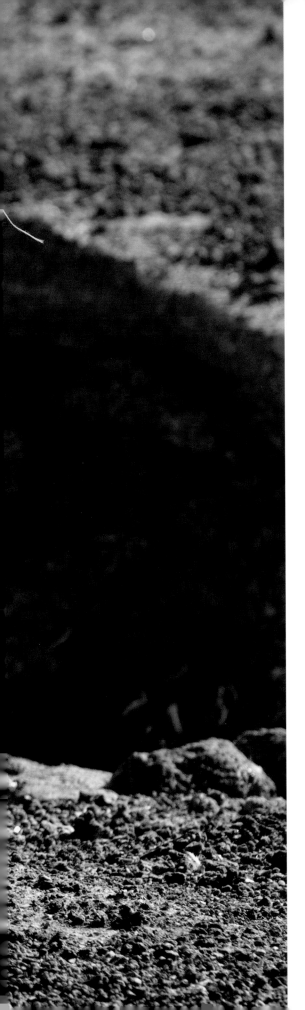

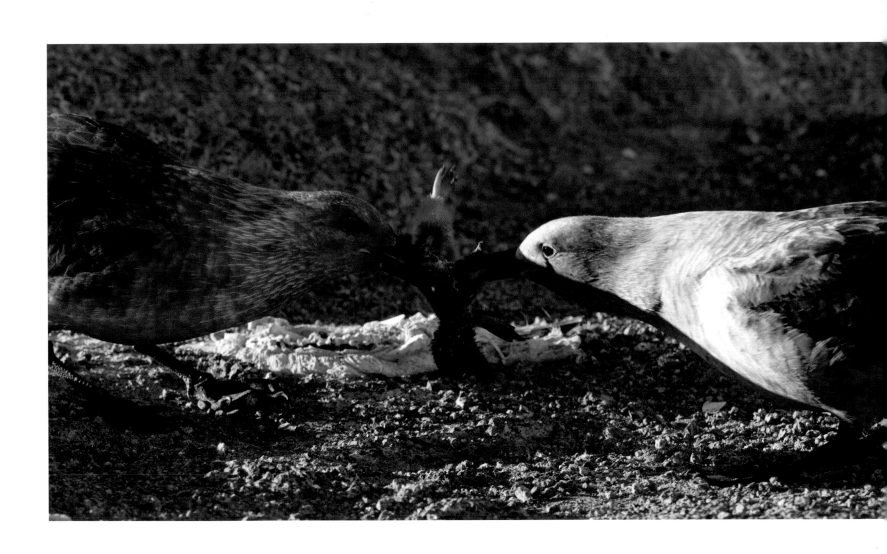

Opposite: **South Polar Skuas** | Above: **South Polar Skuas eating Adélie chick**

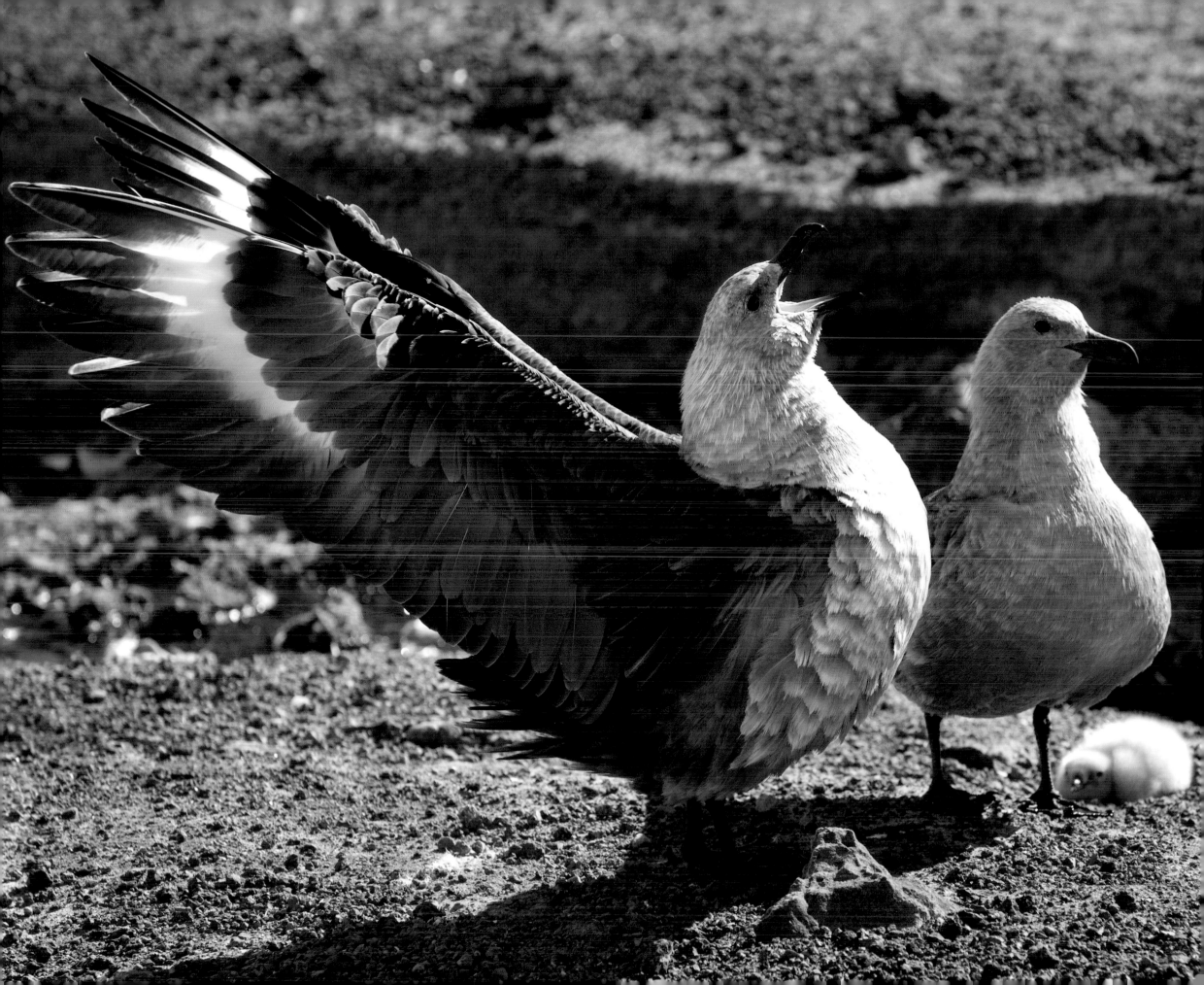

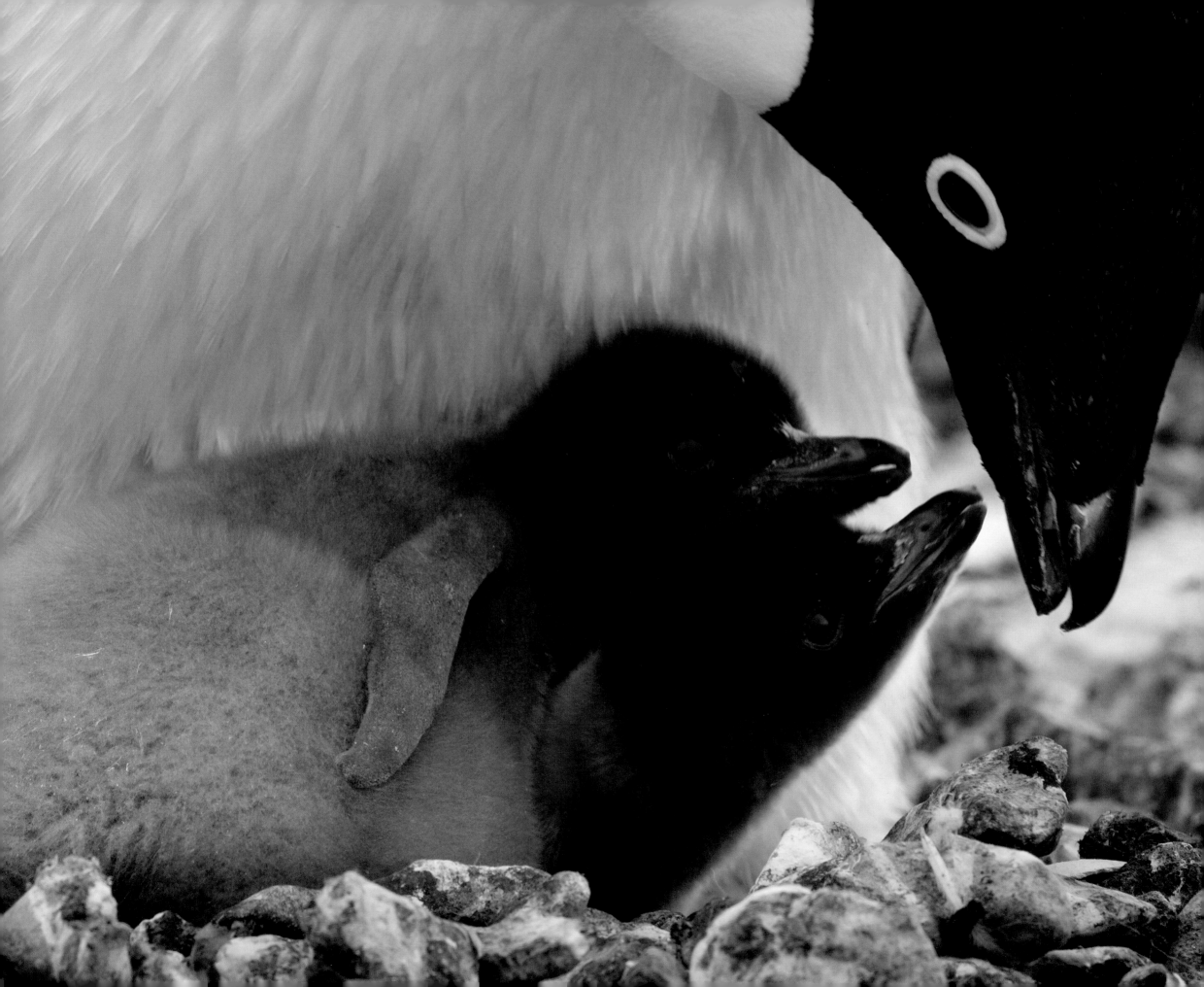

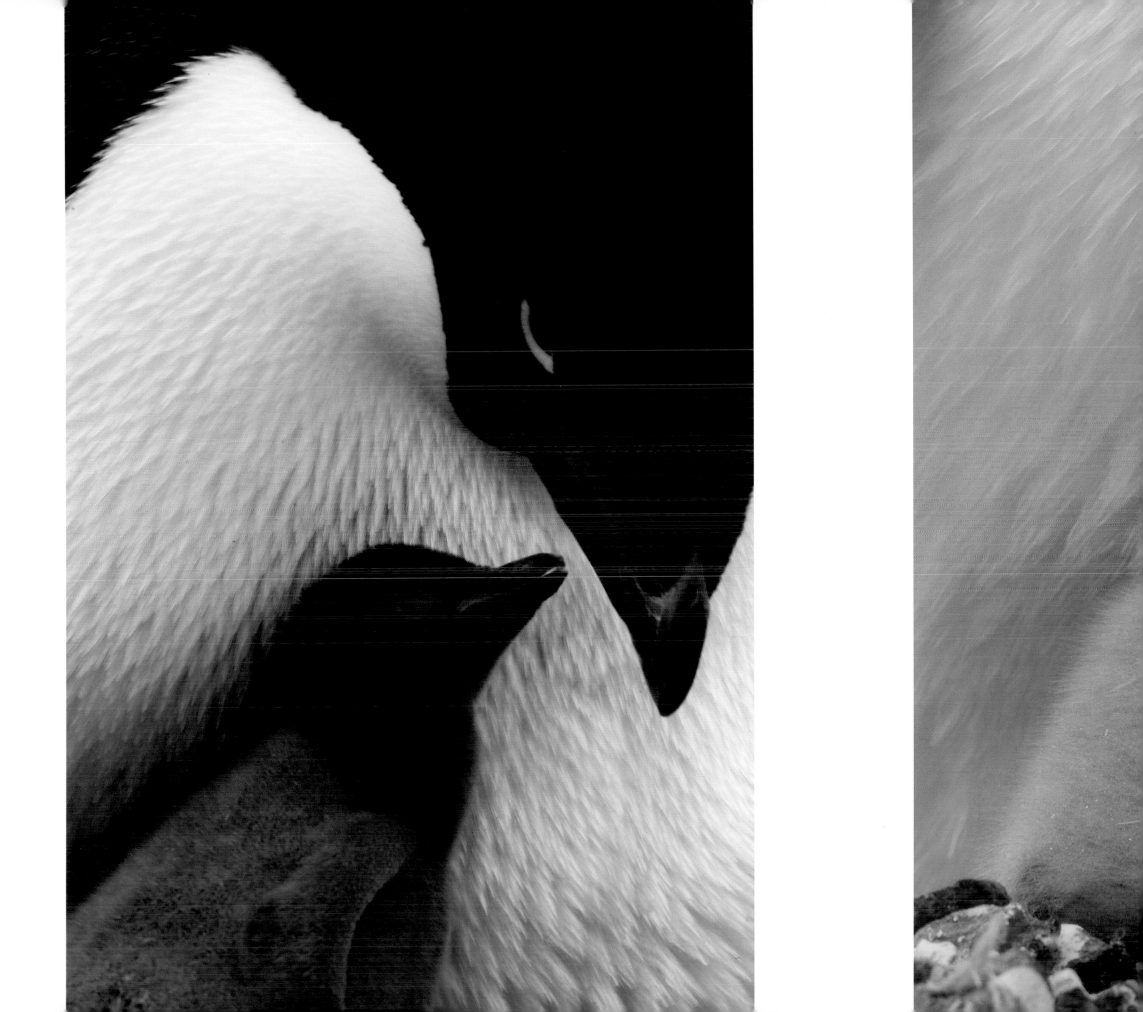

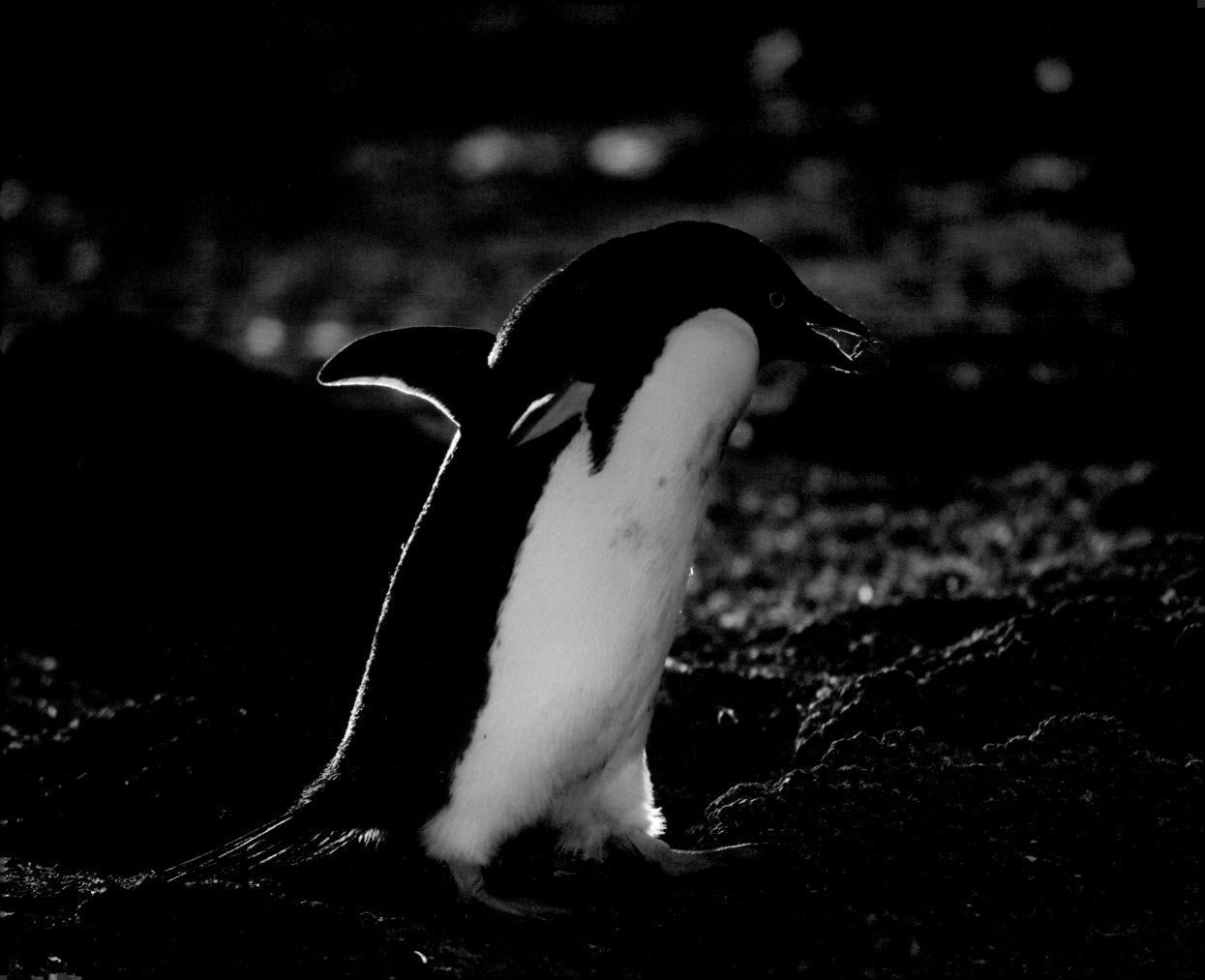

internal pressure and decreasing the pressure differential, thus pushing the great band of winds farther and farther north. In actuality, the pressure differential has steadily *increased*, and the band of winds has tightened and intensified around Antarctica. These winds push on the ice. Instead of moving the ice directly east, the spinning of the Earth deflects the eastward movement, and the ice moves northeast, pulling the whole complex of sea ice farther out to sea, increasing its extent.

This, however, doesn't fully explain what is happening in the Ross Sea. A perpetual low-pressure cell sits stationary over the Amundsen Sea, which borders the Ross Sea to the east. It creates its own localized winds, pulling cold air offshore in the Ross Sea, increasing the strength and persistence of the katabatic winds that fly off the Ross Ice Shelf and drive the ice factory in the Ross Sea Polynya. These offshore winds push new sea ice forming in the polynya out to sea more quickly. The ice is thinner, having had a shorter time to freeze before it started to move, but there is more of it. With more intense katabatic winds to produce sea ice, and more intense westerly winds to transport the ice farther north, the sea ice in the Ross Sea is actually growing more extensive and persistent, at least for the time being.

But why is the Polar Vortex tightening when global warming should produce the opposite effect? As it turns out, another highly significant atmospheric feature is obscuring the full force of warming—again, for the time being—the Antarctic Ozone Hole. Ozone is a naturally occurring molecule with three linked oxygen atoms instead of the regular two in the air we breathe. It is unstable and easily broken down by the man-made chlorofluorocarbons (CFCs), freons, and halons that are found in flame retardants, refrigerants, propellants, and solvents. Ozone absorbs harmful ultraviolet radiation, and in 1989, increasing rates of skin cancer, linked to the widespread loss of ozone, spurred an international treaty to ban the use of CFCs. *The New York Times*, however, reports that CFCs are still used worldwide, even in countries with severe restrictions. The black market for these substances apparently resembles that of the illegal drug trade. Thus, the Antarctic Ozone Hole has stayed open, even grown, though the global community has tried to address the problem.

The loss of ozone allows ultraviolet radiation to penetrate the atmosphere, but it also allows heat to escape. And in the Antarctic, the lack of ozone allows massive amounts of heat to radiate out into space. The upper layers of the atmosphere above Antarctica have cooled by an astounding 9°C since the mid-1980s. This decrease in air temperature leads to a decrease in pressure; thus, the Antarctic air mass contracts, bringing the winds closer to Antarctica.

Assuming that further international efforts will curtail the illegal use of CFCs, the effects of greenhouse gasses will eventually overpower the effect of the ozone hole, reversing the overall increasing trend in Antarctic sea ice. The changes in the Antarctic Peninsula region will then echo around the continent. Climate models predict that the average temperature of our planet will have increased by 2°C over preindustrial levels by the year 2050. Antarctic creatures will pay the price. Their homes will literally melt away. With two degrees of warming, scientists estimate that the loss of ice habitat will eliminate nearly half of the Emperor Penguin colonies and 75 percent of the Adélie Penguin colonies around Antarctica.

UNTIL THAT TIME, the katabatic winds will continue to pump out more ice, and the westerly winds will transport it north, filling the Ross Sea. And in 2009, that ice stranded the Cape Royds Adélie Penguin colony. Looking past the nesting birds to the north, all I could see was an unbroken white blanket to the edge of the horizon.

Adélies and Emperors have been able to colonize deep Antarctica, using habitat that other penguins cannot, due largely to a single adaptation: both of these species can fast. And while Adélies cannot challenge the Emperors' abilities, they are adapted to stay on the nest for up to two weeks as their mates walk to open water, hunt, and return to the colony. But in 2009, open water was more than 65 kilometers from Cape Royds, and the journey took much longer. Through binoculars, I could just make out the line of penguins, taking the long walk out to the sea. The walk was so long, in fact, that many of the waiting penguins, facing starvation, had to abandon their nests and go in search of food themselves. Unattended, the eggs and chicks made easy meals for South Polar Skuas, which continuously patrolled the edges of the colony, waiting for the adult birds to make a mistake. Eighty-five percent of the Cape Royds nests failed over the course of the season. I had to watch the tiny balls of fluff disappear one by one.

The next two weeks were hard to witness. More chicks fell prey to the skuas; more nests were abandoned. Still, the stream of penguins heading out to sea and coming back to the colony across the ice never ceased, driven on by the high peeping calls of hungry baby birds.

Opposite: **Adélie carrying pebble** | Following Spread: **Adélie and chicks**

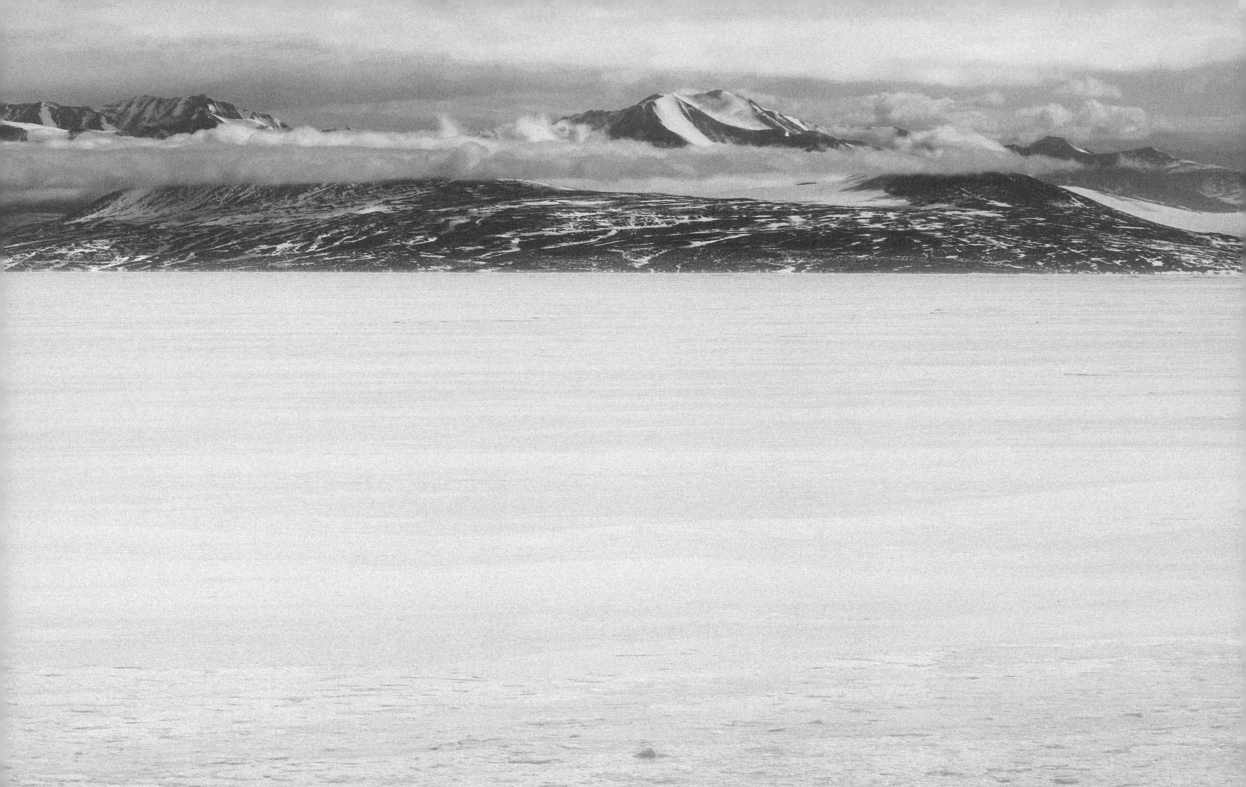

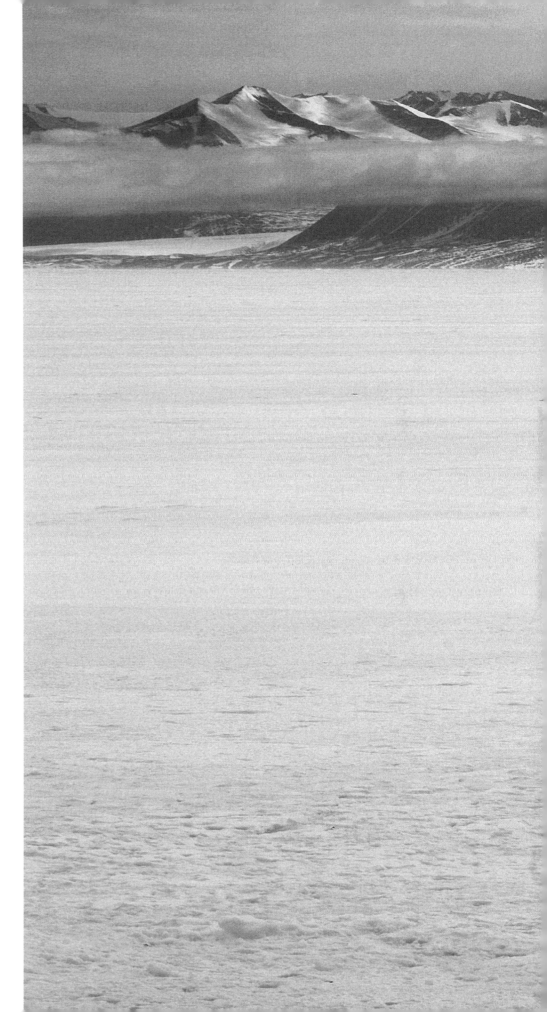

These changes have torn apart the complex web of interconnections. Adélie and Emperor Penguins have declined by 65 percent in the last 25 years. Chinstrap and Gentoo Penguins, subantarctic species that avoid sea ice, have replaced them. Weddell seals are also on the decline, as are silverfish, one of the most important prey species in the coastal Antarctic aside from krill.

Recent studies indicate that krill have declined dramatically around the Antarctic Peninsula, and gelatinous salps—zooplankton that fare better with less ice cover—thrive as krill disappear. Salps have very little nutritional value to predators; thus, this replacement does not support the higher levels of the ecosystem, and reports of large salp swarms are on the rise in the region. As krill struggle with the disappearing ice, the whole ecosystem struggles around them.

And the current situation in other regions of Antarctica is complicated by more than melting. In stark contrast to the Antarctic Peninsula—and to the high Arctic on the other end of the globe, where sea ice has been disappearing at an extreme rate in all locales, stranding polar bears on Arctic shores—the extent of sea ice around Antarctica as a whole has actually been increasing in the recent past. To understand this counterintuitive trend, we must look to the skies.

A huge mass of cold air covers all of Antarctica and extends north over the Southern Ocean. Because of its temperature, this mega-mass of air has a lower pressure than the warm air masses to the north, which encircle the massive cold front. Analogous to the Antarctic Circumpolar Current, which forms a barrier between northern and southern waters, the atmospheric pressure difference between the Antarctic air mass and the temperate air masses keeps the cold southern air contained. At the boundary, there is wind. With no landmass in the way, the famous Southern Ocean westerly winds form an unbroken path all the way around the continent, called the Polar Vortex, which follows the contours of that boundary between high-pressure northern air and low-pressure Antarctic air.

Every week or so, the pressure differential between these masses of air changes significantly over the course of only a day, and finds a new, temporarily stable state. When the pressure differential increases, the ring of high-pressure air to the north squeezes the polar air mass tighter around Antarctica, intensifying the band of westerly winds and bringing it closer to the continent. When the pressure differential decreases, the polar air mass expands, pushing its boundary, and thus the winds, farther north. The oscillations mean that storms in Antarctica come in fast, stay for a week, and then leave just as quickly.

Global atmospheric warming occurs disproportionately at the poles. In Antarctica, this indicates that the Antarctic air mass should warm more quickly than the temperate air masses, increasing its

Adélies walking to open water

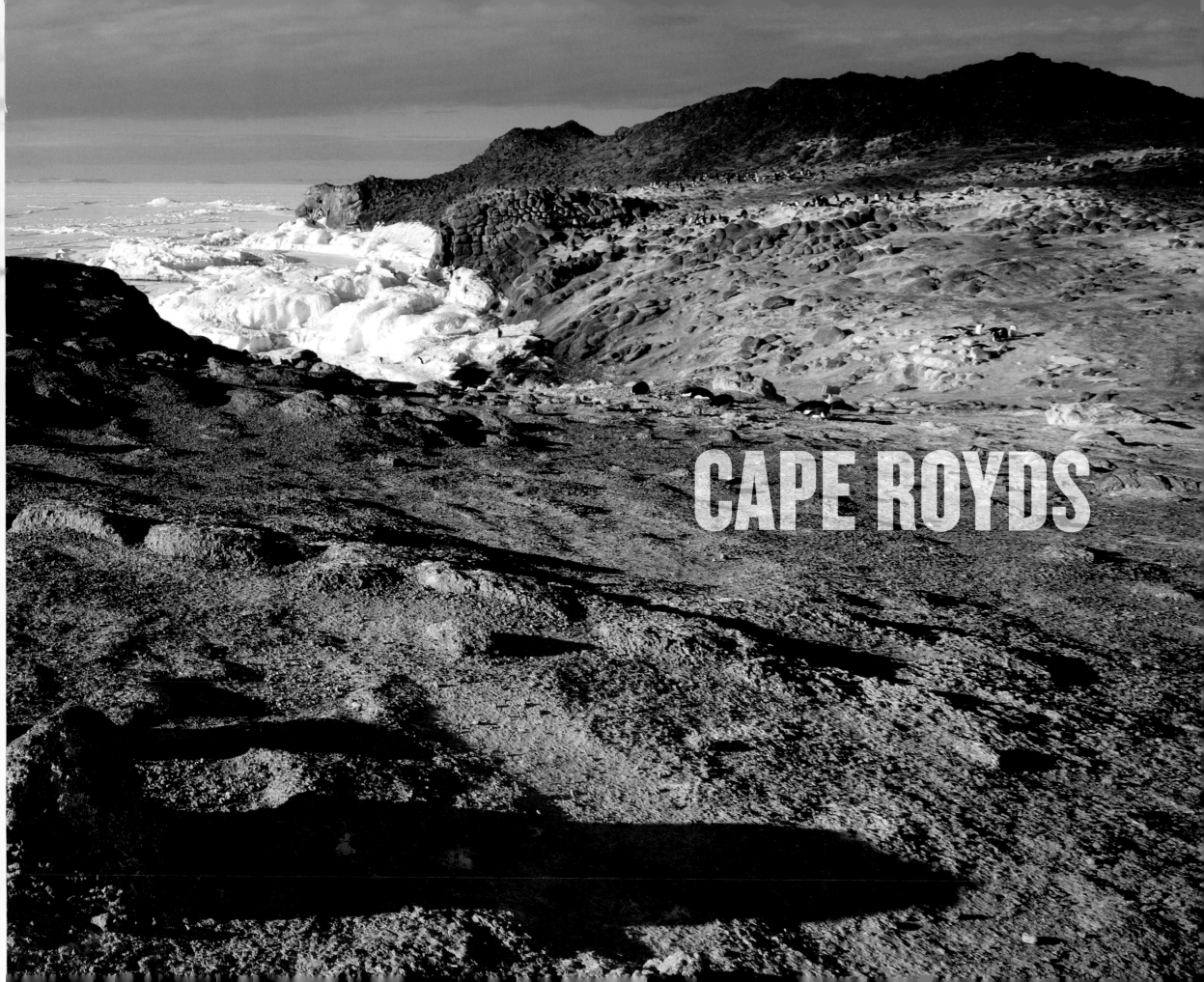

CAPE ROYDS

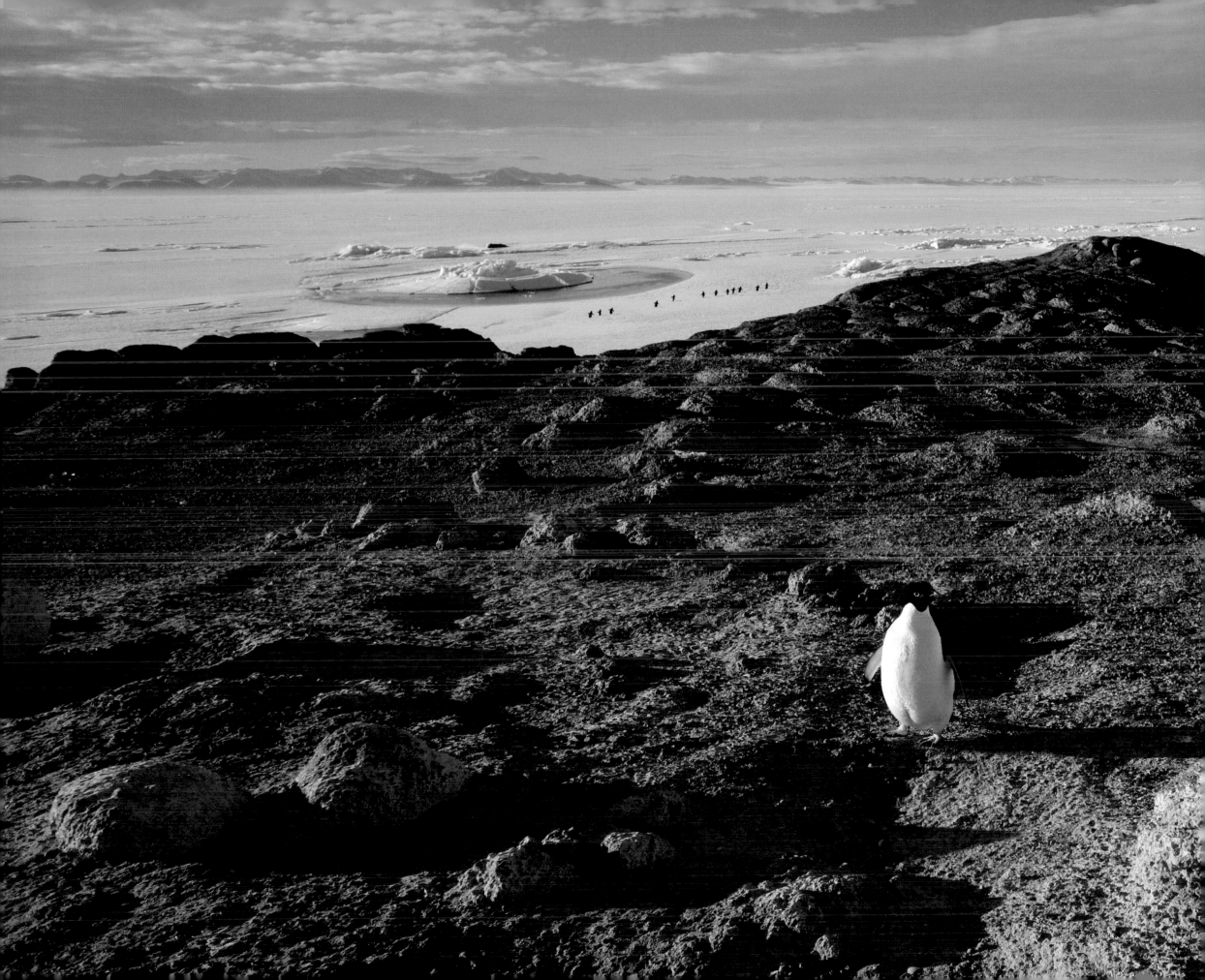

Above: Shafts of light under the ice | Opposite: Diver in a shaft of light

is no direct evidence, many observations can be most easily explained by assuming that the animals have such a capacity.

Sperm whales provide a provocative example. The whale's distinctive lobed forehead measures approximately one-third of the length of the animal and is filled with structures that create, amplify, and direct sound. Dolphins have the well-documented ability to "see" with their ears by emitting sharp bursts of sound that bounce back off of anything in the vicinity, revealing an accurate picture of the immediate surroundings. Sperm whales hunt at depths of up to 1,000 meters, where there is no light, and they also likely use echolocation to find prey.

But the ability to "see" at great depths does not explain other mysteries surrounding the diets of these animals. Sperm whales are the only known predators of colossal squid, which grow in excess of 15 meters long. Artistic depictions of these deadly deep-ocean encounters feature the whale, with its long lower jaw open, and the squid, hooked tentacles flared in a fruitless defense as the whale prepares to bite down with rows of sharp teeth. The evidence, however, presents a different picture of what might be happening a kilometer below the surface.

Dissecting sperm whale stomachs, researchers discovered that the whales had often eaten large squid, but that there were rarely any bite marks on the prey; the squid were, instead, swallowed whole. Researchers also reported that even whales that had complete deformations of the lower jaw, in which none of the whales' teeth could be used to grip prey, nonetheless had normal quantities of prey in their stomachs. Another point of intrigue is the relative speeds of the animals. Though colossal squid have never been observed in their domain, other large squids have been clocked at 55 kilometers per hour in short bursts. Sperm whales have been clocked at only 40 kilometers per hour, and are also much less maneuverable. What happens at depth between these two titans will likely always remain a mystery, but the whales' success in hunting these massive squid could be explained by sonic stunning capabilities, and scientists estimate that the whales have the potential to make sounds exceeding 265 decibels.

I have replayed my experience with the seal back and forth in my mind countless times. Antarctica is a humbling place, and this was my most humbling moment, but not for the most obvious reasons. Despite more than 30 years of intensive study, we have only scratched the surface in understanding Weddells, and the seals are only one part of the Ross Sea story. How many critical interconnections, behaviors, and environmental factors intersect to make the Ross Sea work as an ecosystem? The beauty and complexity are what humble me most, and in the depths beneath the ice, there is much more to be discovered than is already known.

Cave at Turtle Rock

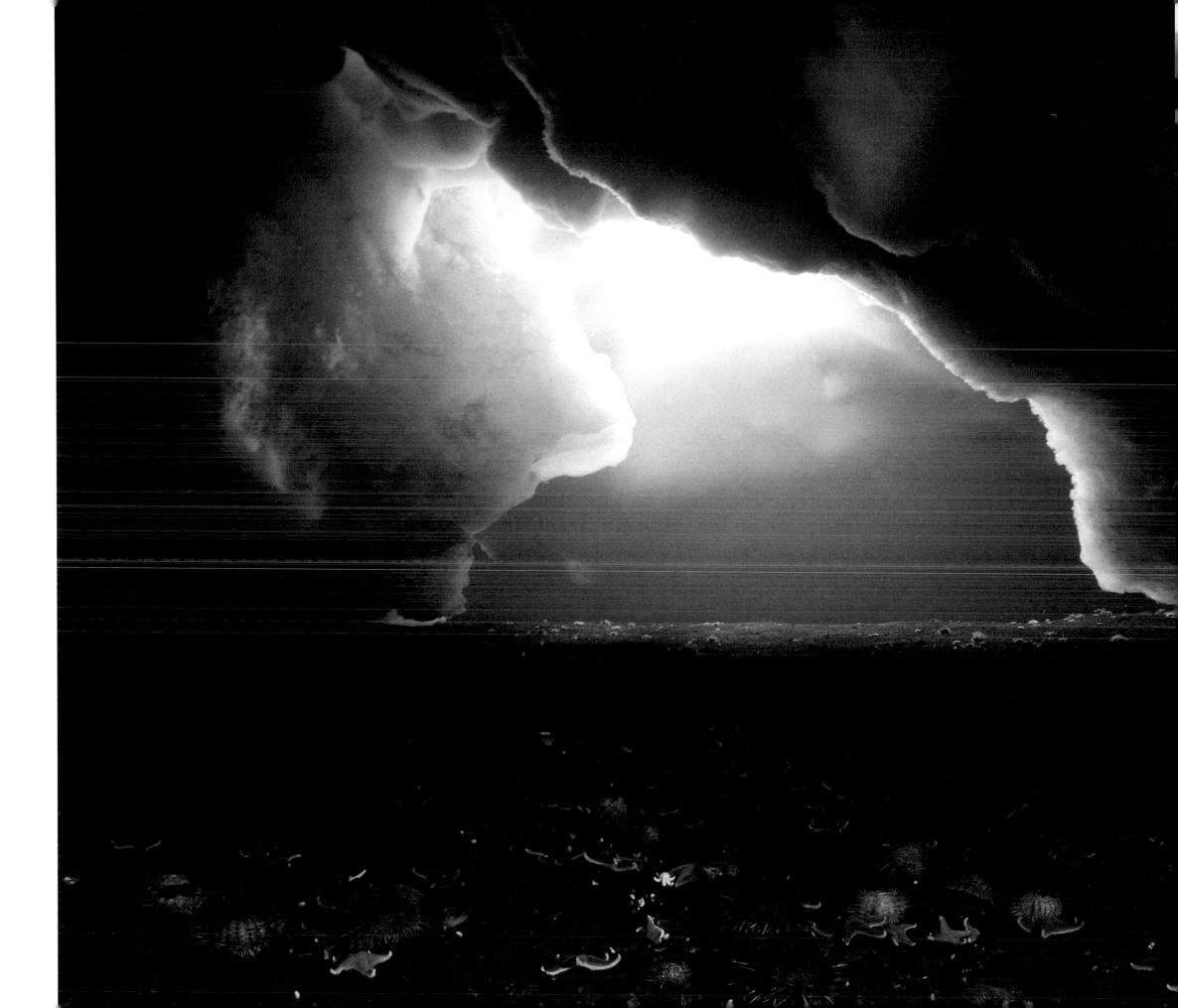

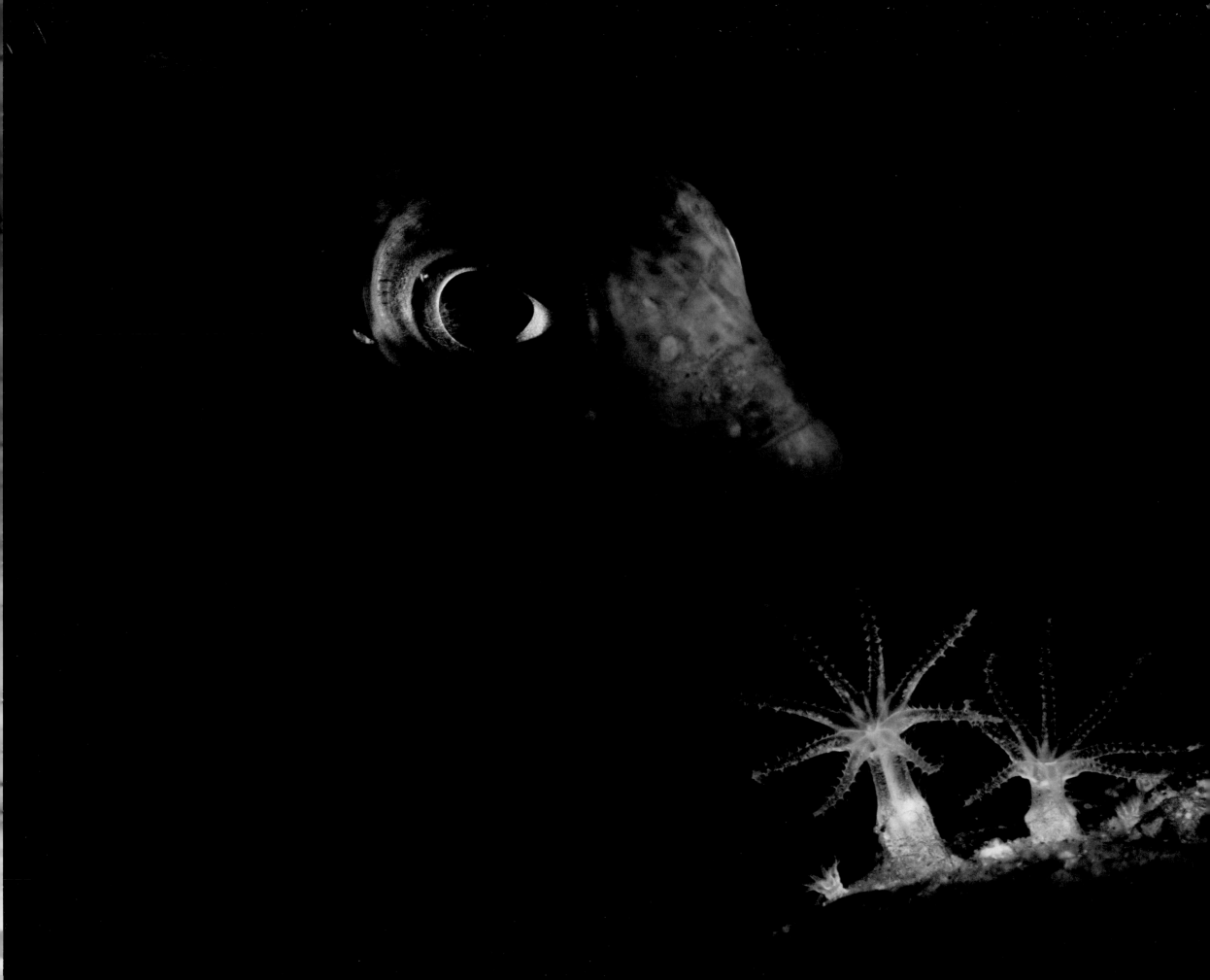

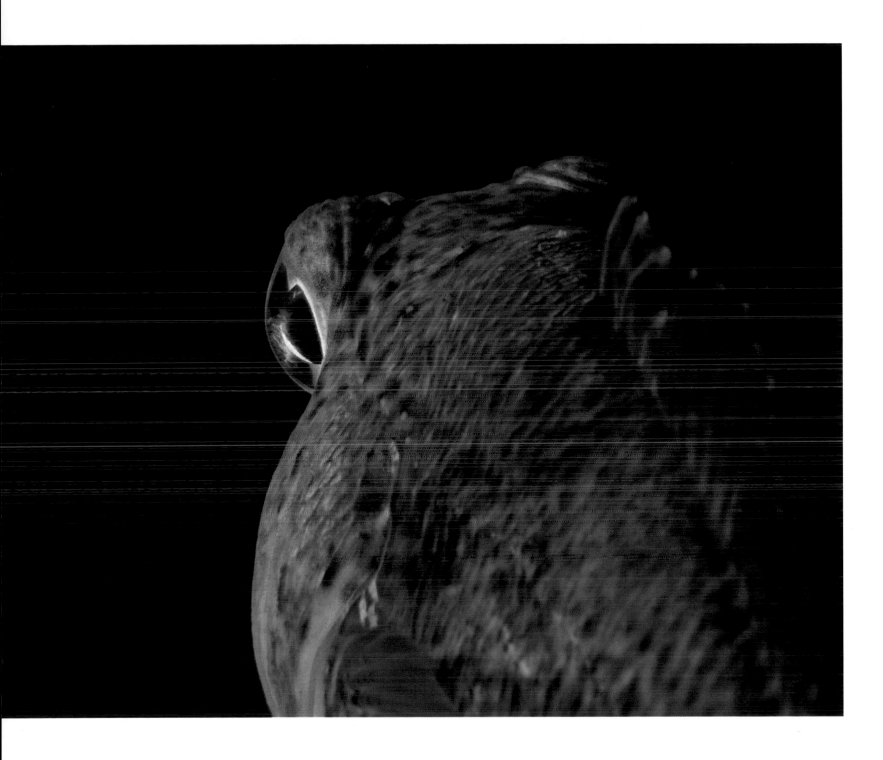

Above: *Trematomus bernacchii* | Opposite: *Trematomus bernacchii* and *Clavularia*

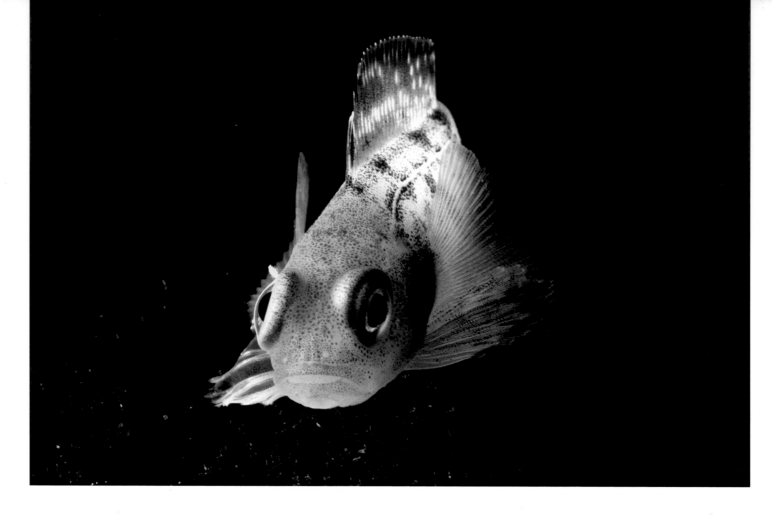

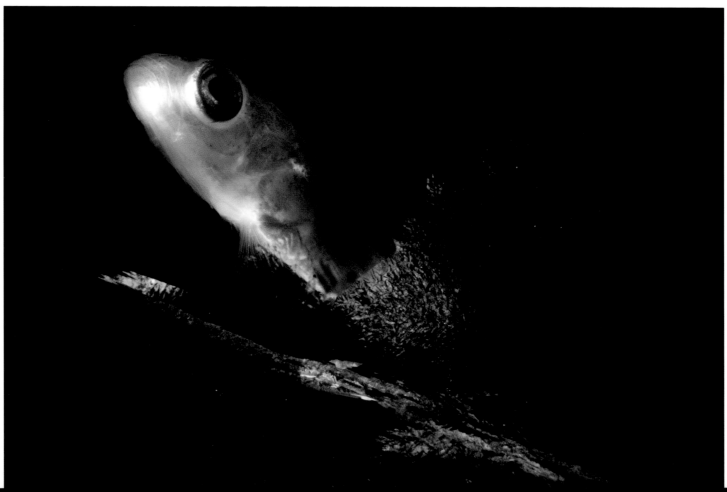

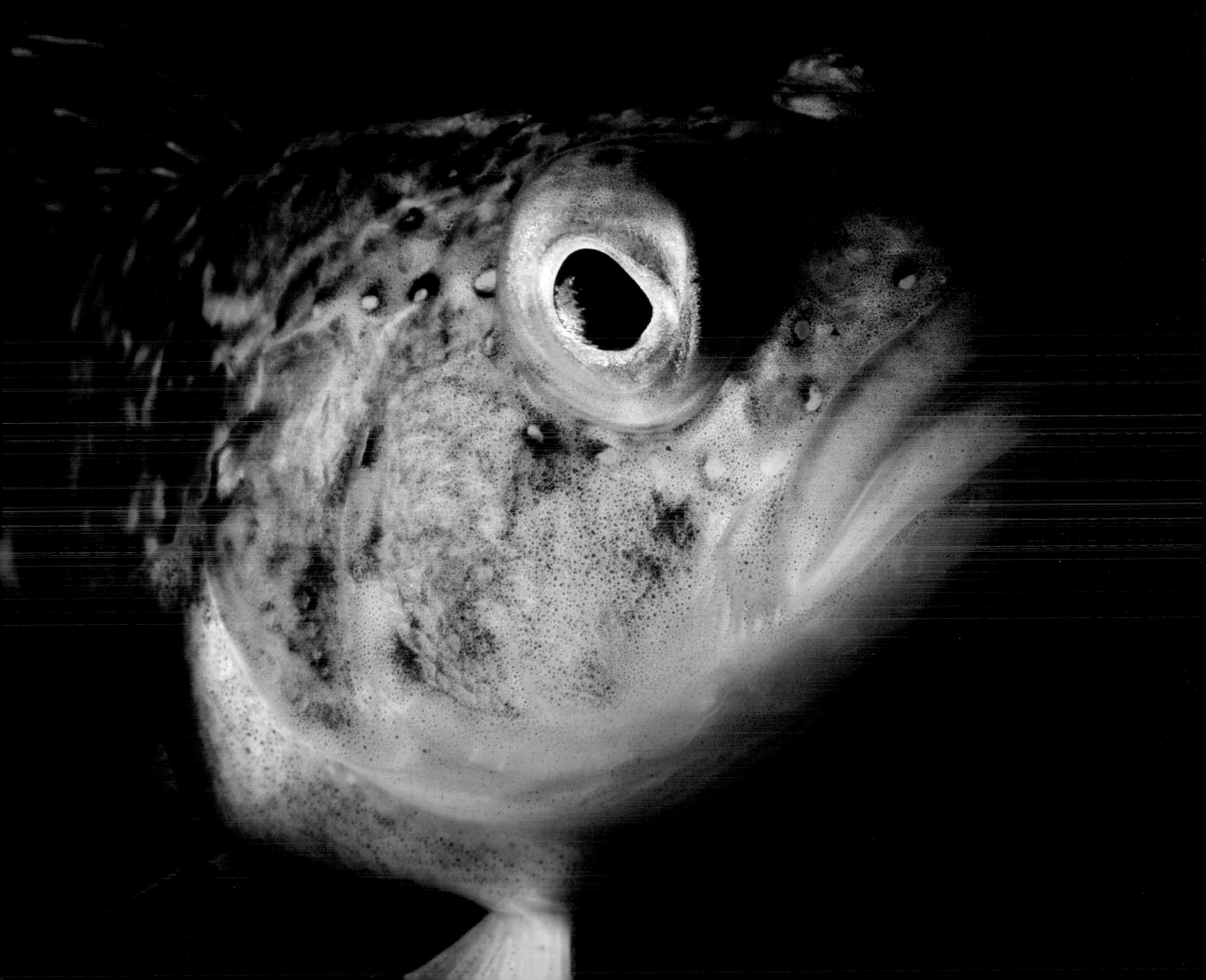

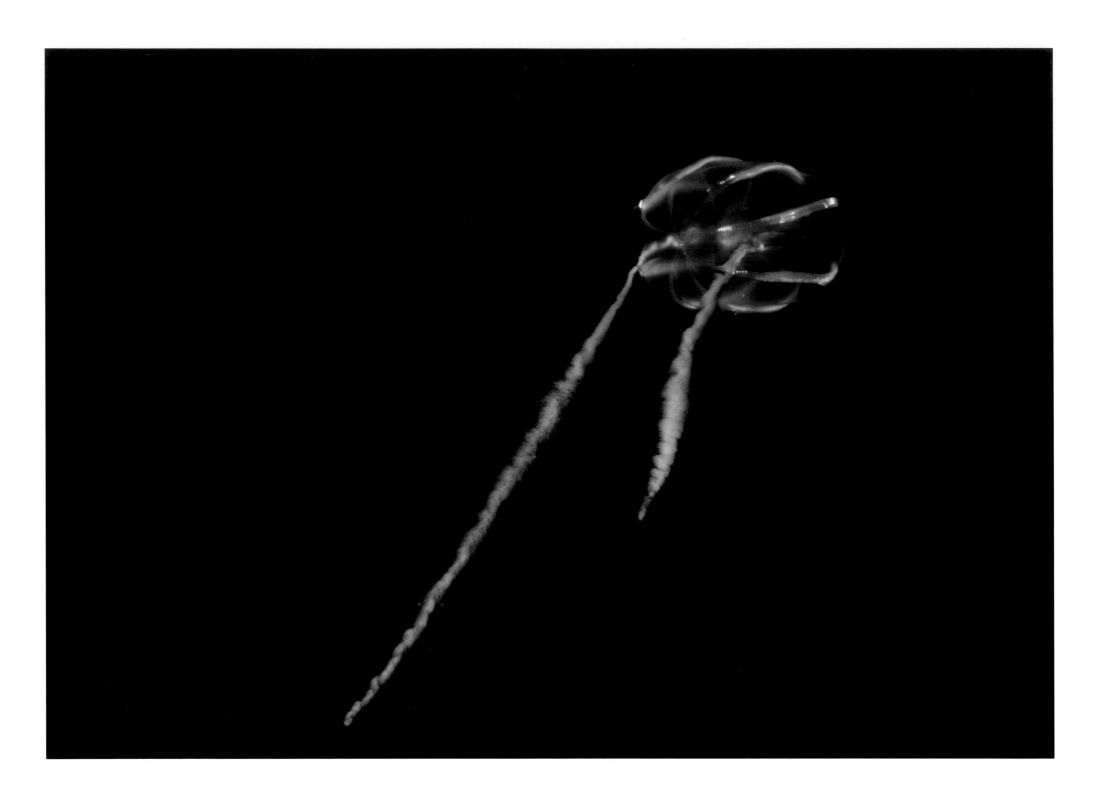

Opposite: **Mertensiid ctenophore with nets extended** | Above: **Mertensiid ctenophore recalling its nets** | Following Spread: *Trematomus pennellii* (left); *Pagothenia borchgrevinki* (right)

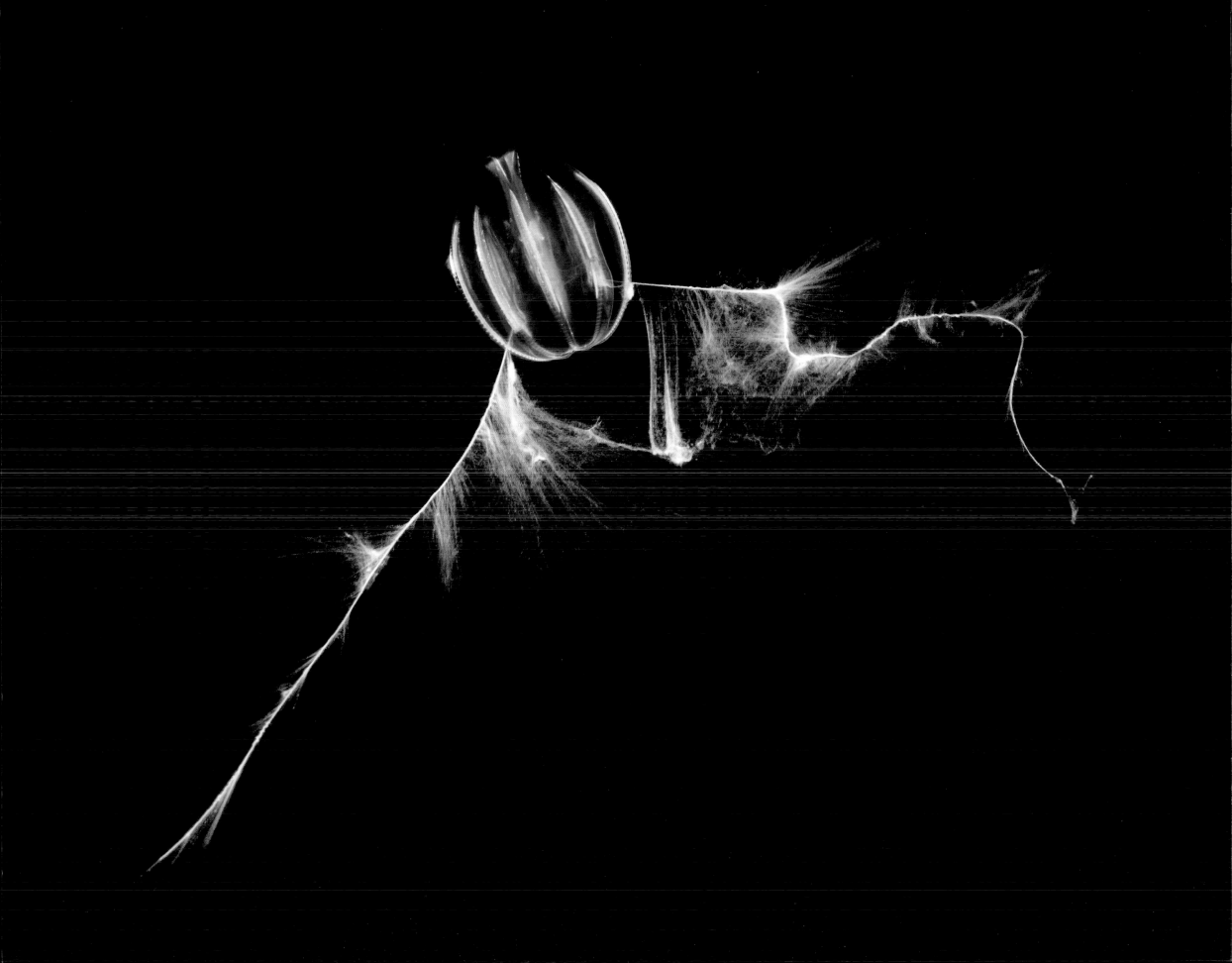

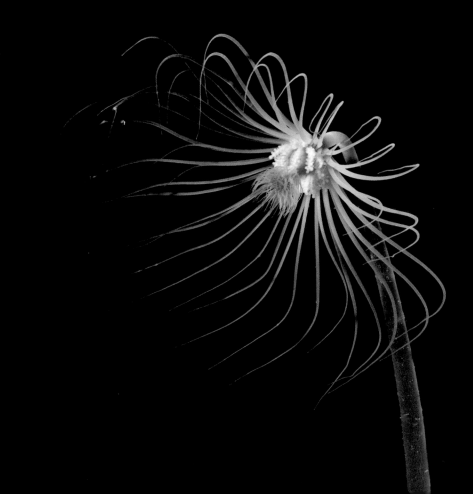

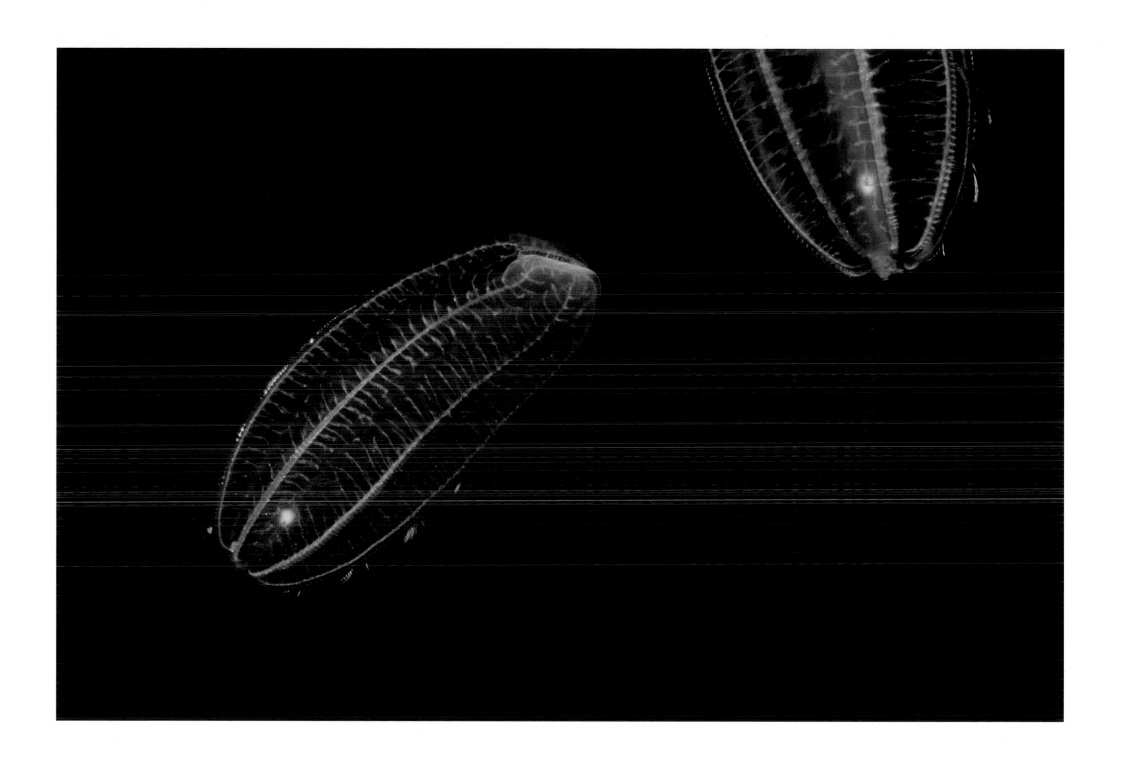

Above: *Beroe cucumis* (comb jelly) | Opposite: *Monocaulus parvula*

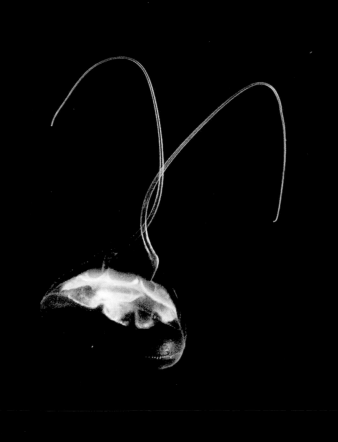
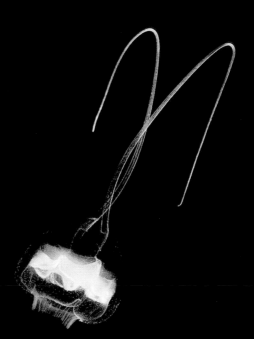

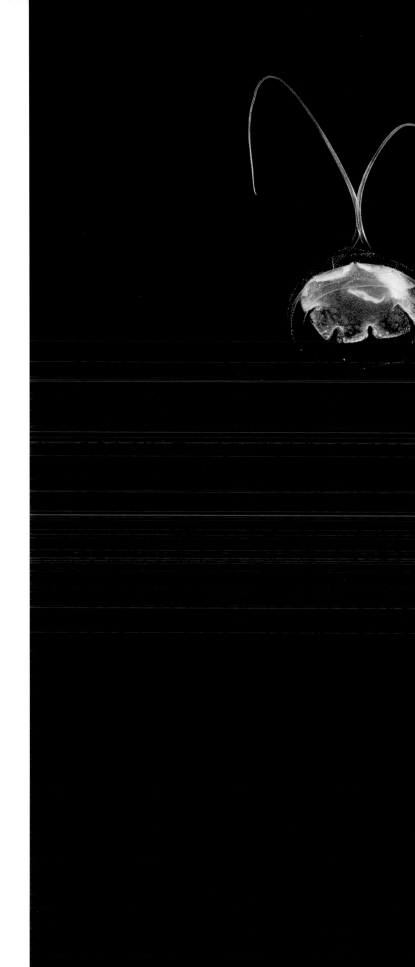

Though they have conquered the ice, the extreme adaptations have left notothenioids vulnerable in other ways, especially with the increasing human impacts on Antarctica. *Pleuragramma antarcticum,* the Antarctic silverfish, provides a provocative illustration of adaptations that result in vulnerabilities. Silverfish are neutrally buoyant small fish that use a wide range of depths in the water column, from the surface down to 900 meters. They are such popular prey that they are considered the single most ecologically important fish in the Ross Sea. Because they are, at times, in direct contact with platelet ice, especially near the surface, adults have high levels of glycoproteins to keep ice from forming in their bodies. But this is not true when the fish first hatches. Silverfish eggs are buoyant and thus rise to the bottom of the sea ice, embedding in the thick mass of loose platelets. A mother fish endows her eggs with a fresh supply of antifreeze, but with a half-life of only four weeks, the proteins break down while the eggs are developing. When the larval fish finally hatch, they don't have enough antifreeze left to protect them, and in the first parts of their lives, silverfish hide in the platelet ice, in nearly continuous contact with the crystals that could easily kill them. Producing glycoprotein is too costly for the larval fish, which must put all of their energy into growth. And so, to keep from freezing, these tiny fish rely on their completely unblemished skin to repel the ice. It takes more than five months for *Pleuragramma* to finally produce enough antifreeze to protect itself. And during those five months, the fish is exceptionally vulnerable. Any damage to the skin will lead to certain death. Imagine the effect that even small concentrations of pollutants would have on these important fish.

In a strange twist of fate, the very same adaptation that provides critical protection from the icy water is contributing to the decline of the most famous notothenioid—the Antarctic toothfish. The oily glycoprotein makes this fish's meat sweet and tender, and the market for the tasty fish has driven the establishment of the most remote fishery on Earth, a subject to which we will return later.

MY SURPRISE AT SEEING the small fish with the big yellow eyes was short-lived, and I quickly detached the camera, leaving the tripod in place as I hunted for the fish. I found it, and after a careful approach, was able to photograph it again. To the casual eye, the fish has a humble appearance. But I knew I was looking at a masterpiece of evolution—one of the few that had braved the long journey south on a slowly freezing continent and emerged from the shadows to meet the challenges of living in a sea of ice.

Narcomedusa *Solmundella bitentaculata*

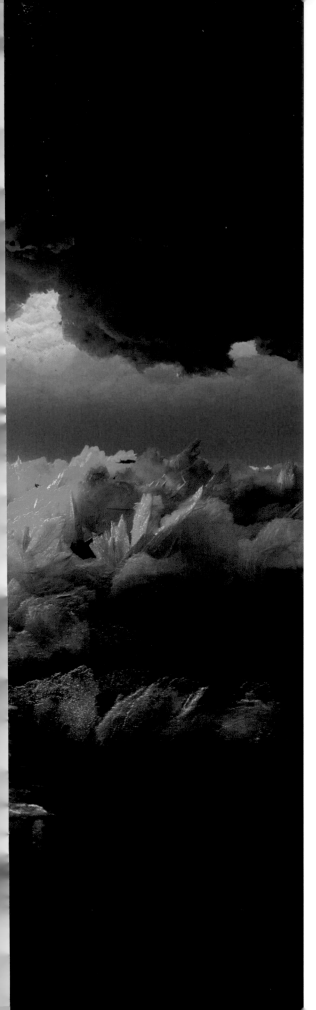

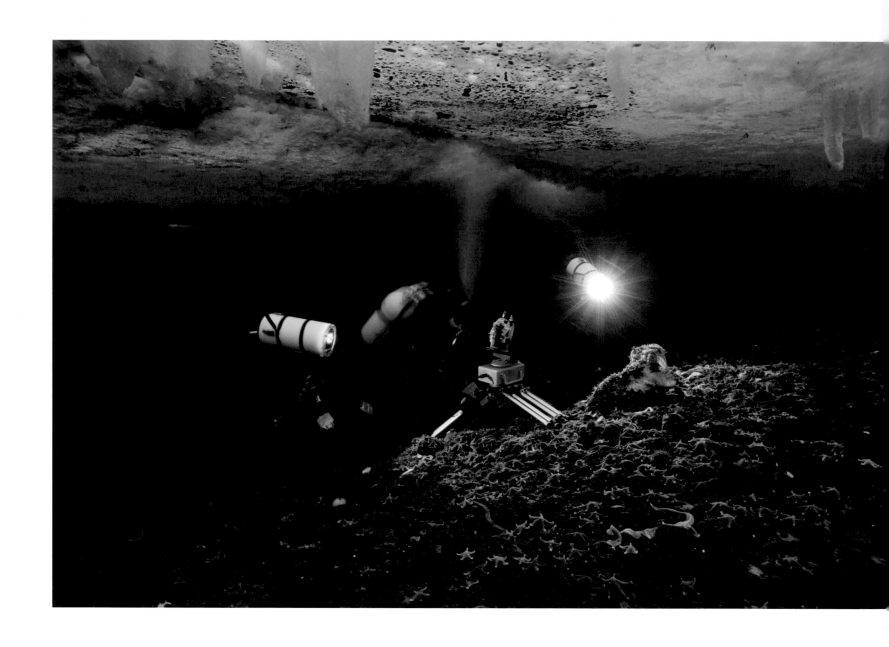

Opposite: **Seastars and anchor ice** | Above: **BBC crew filming an episode of** *Life*

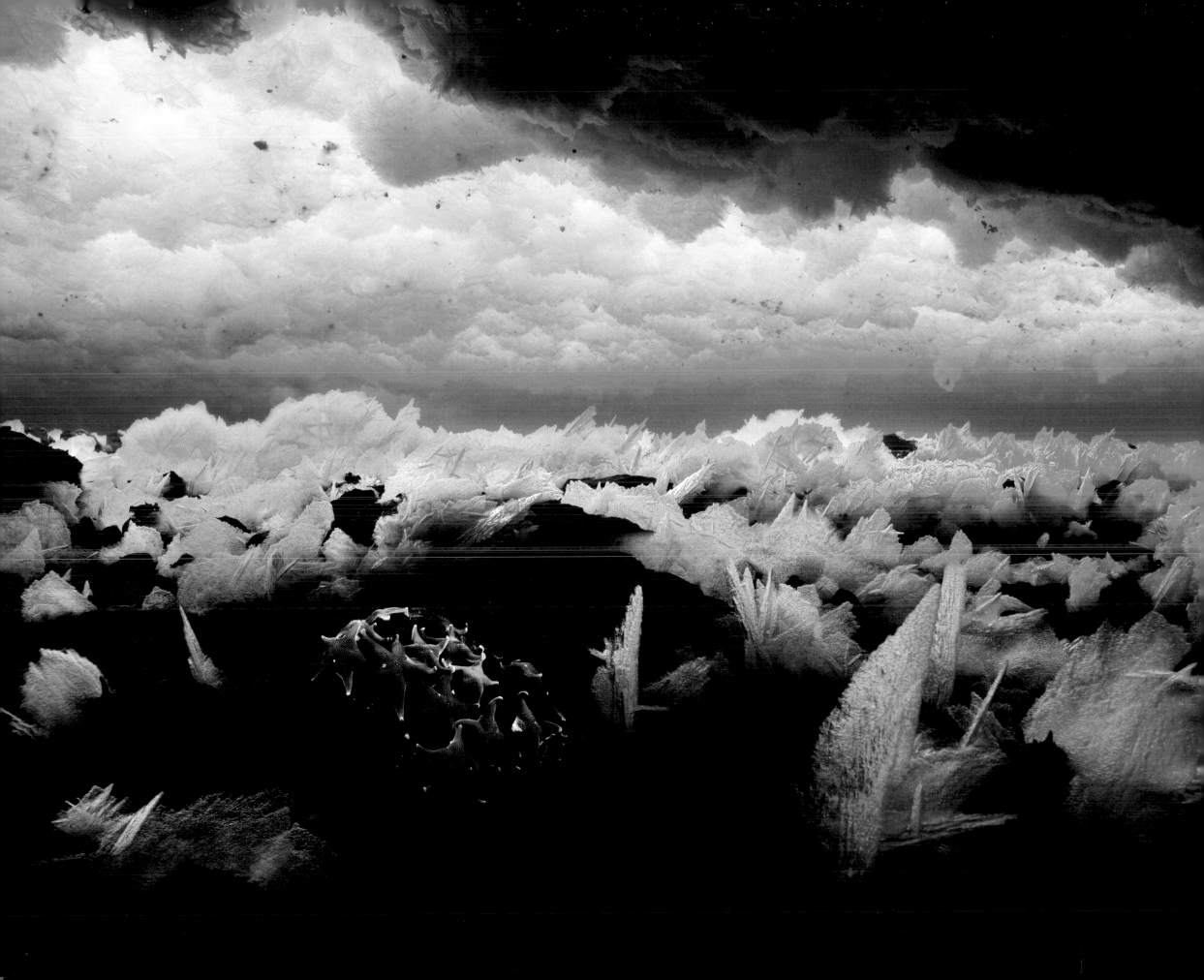

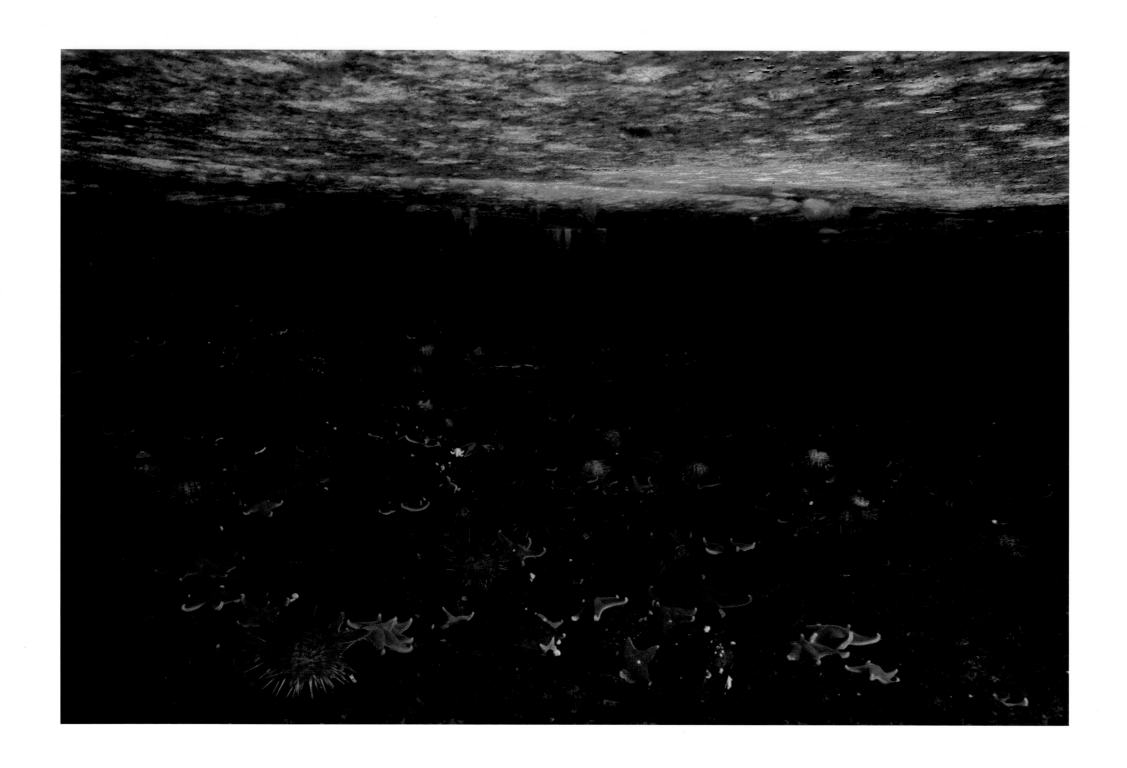

Opposite: **Anchor ice** | Above: **Benthic community and brine channels**

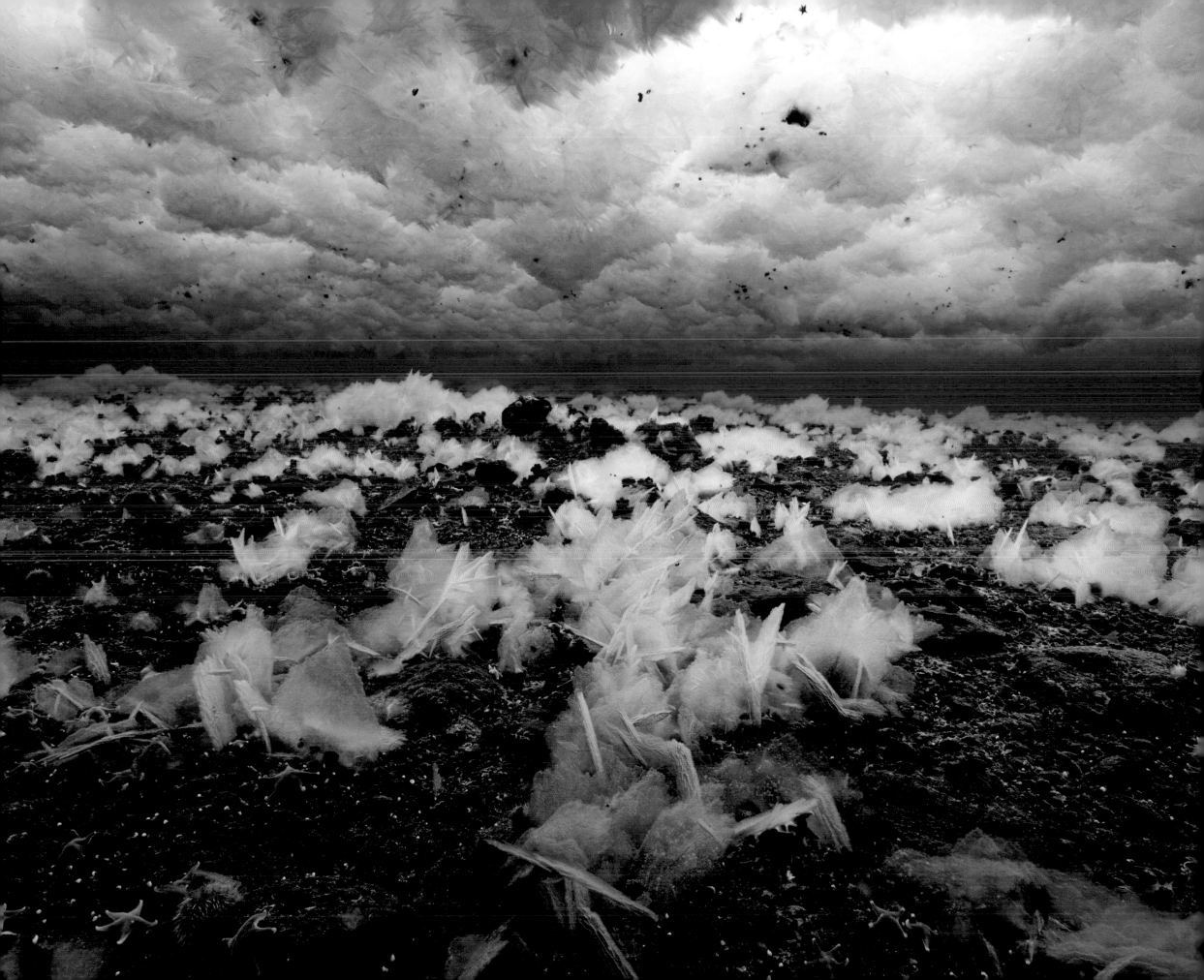

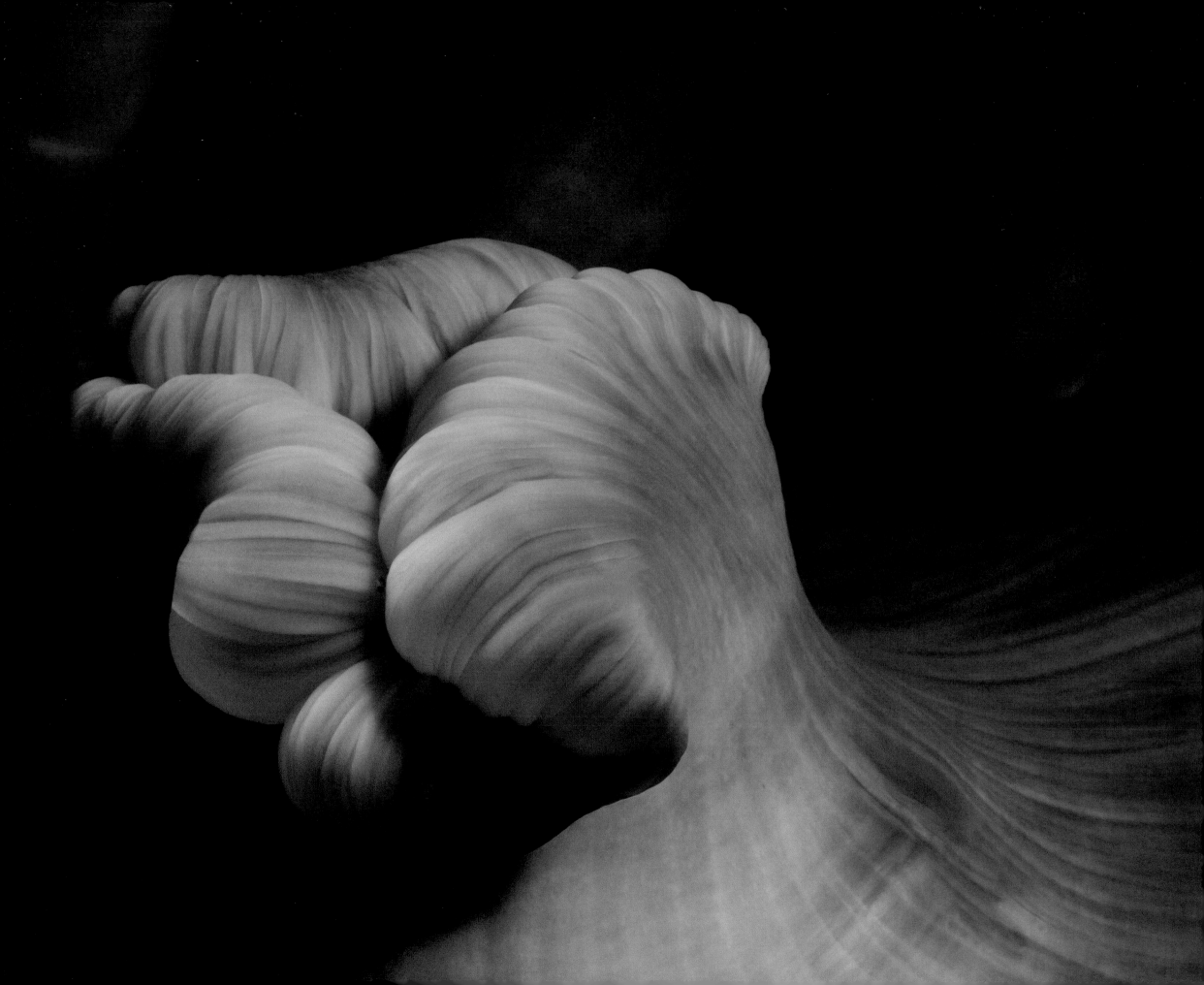

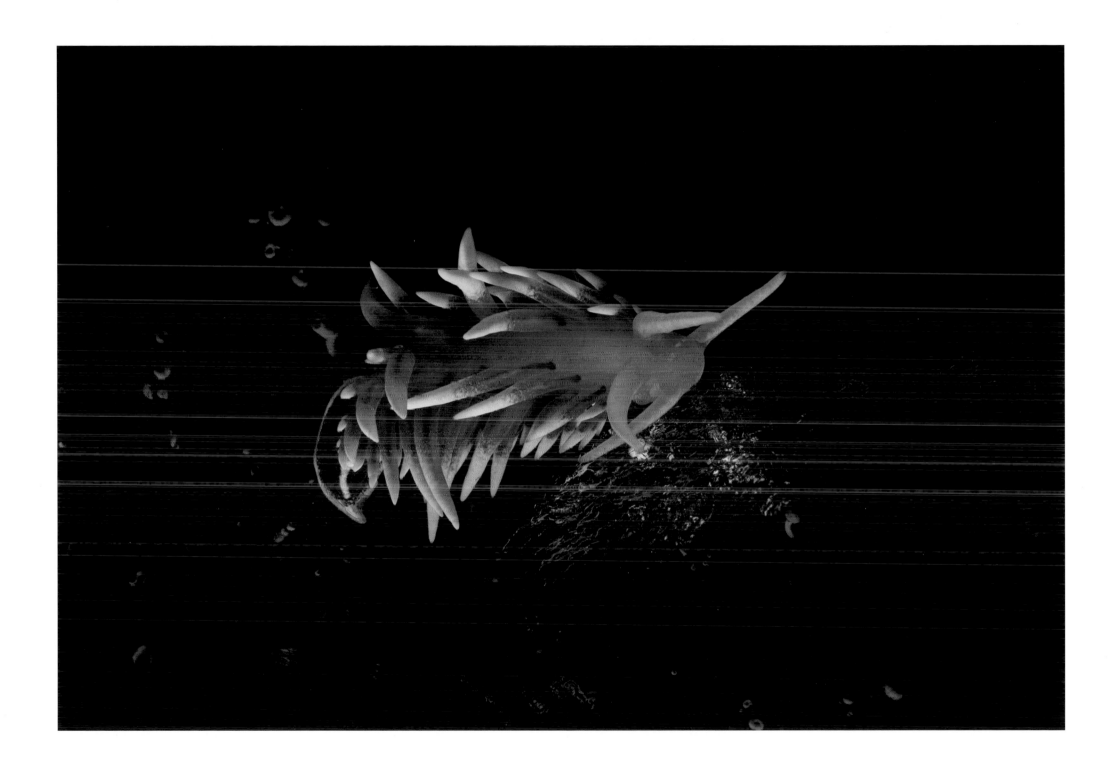

Above: Nudibranch *Notaeolidia gigas* | Opposite: *Epimeriid amphipode*

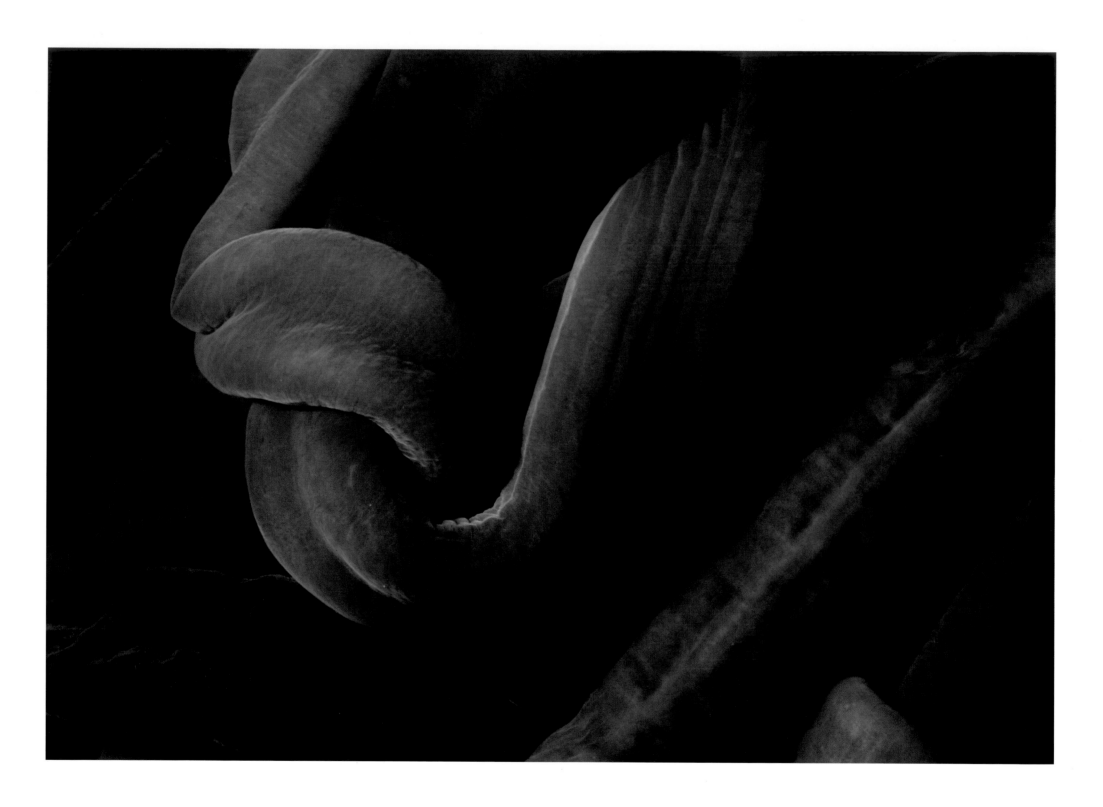

Opposite: Seastar *Odontaster validus* | Above: **Nemertean worms**

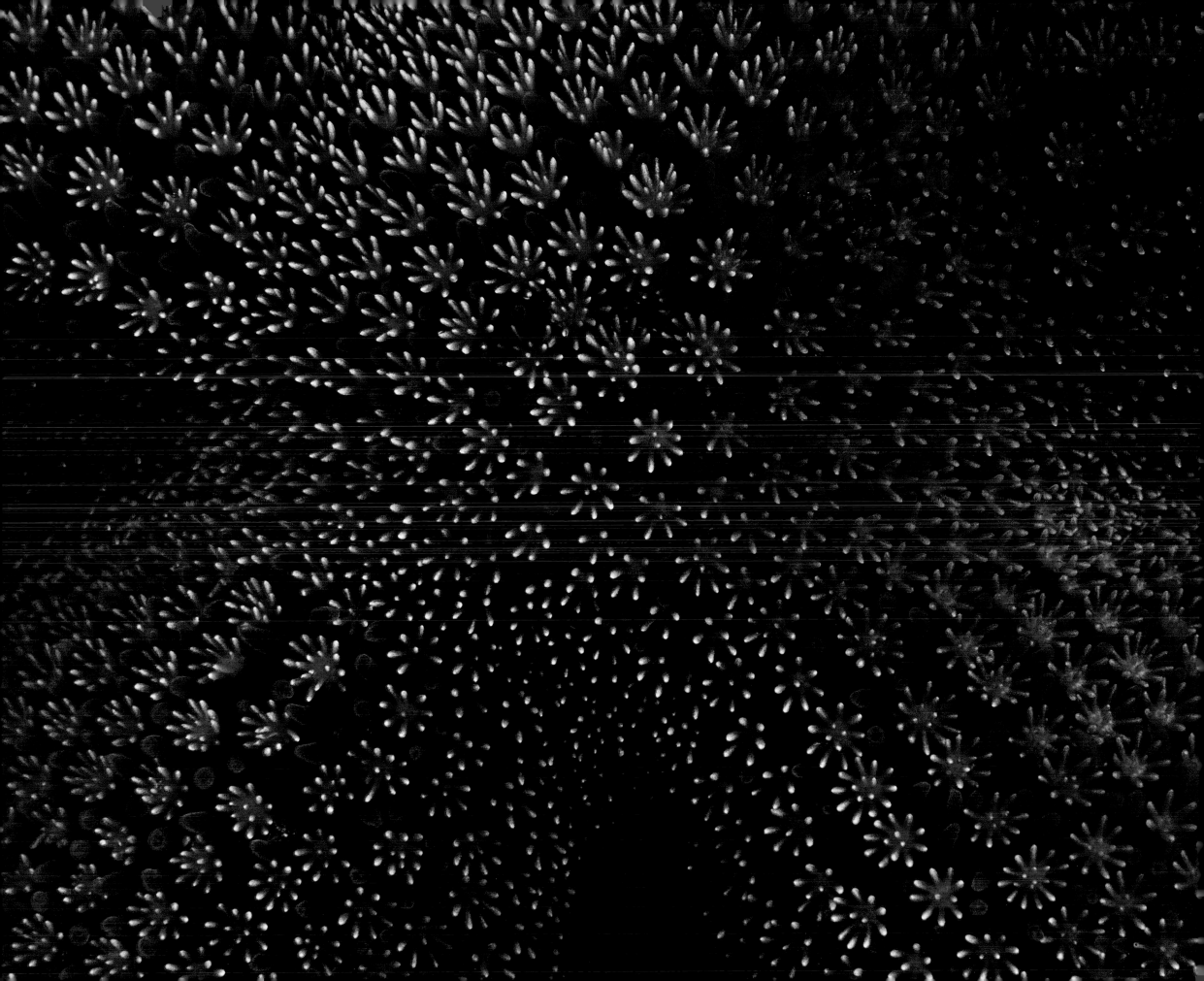

Weddell seal underwater at Little Razorback Island

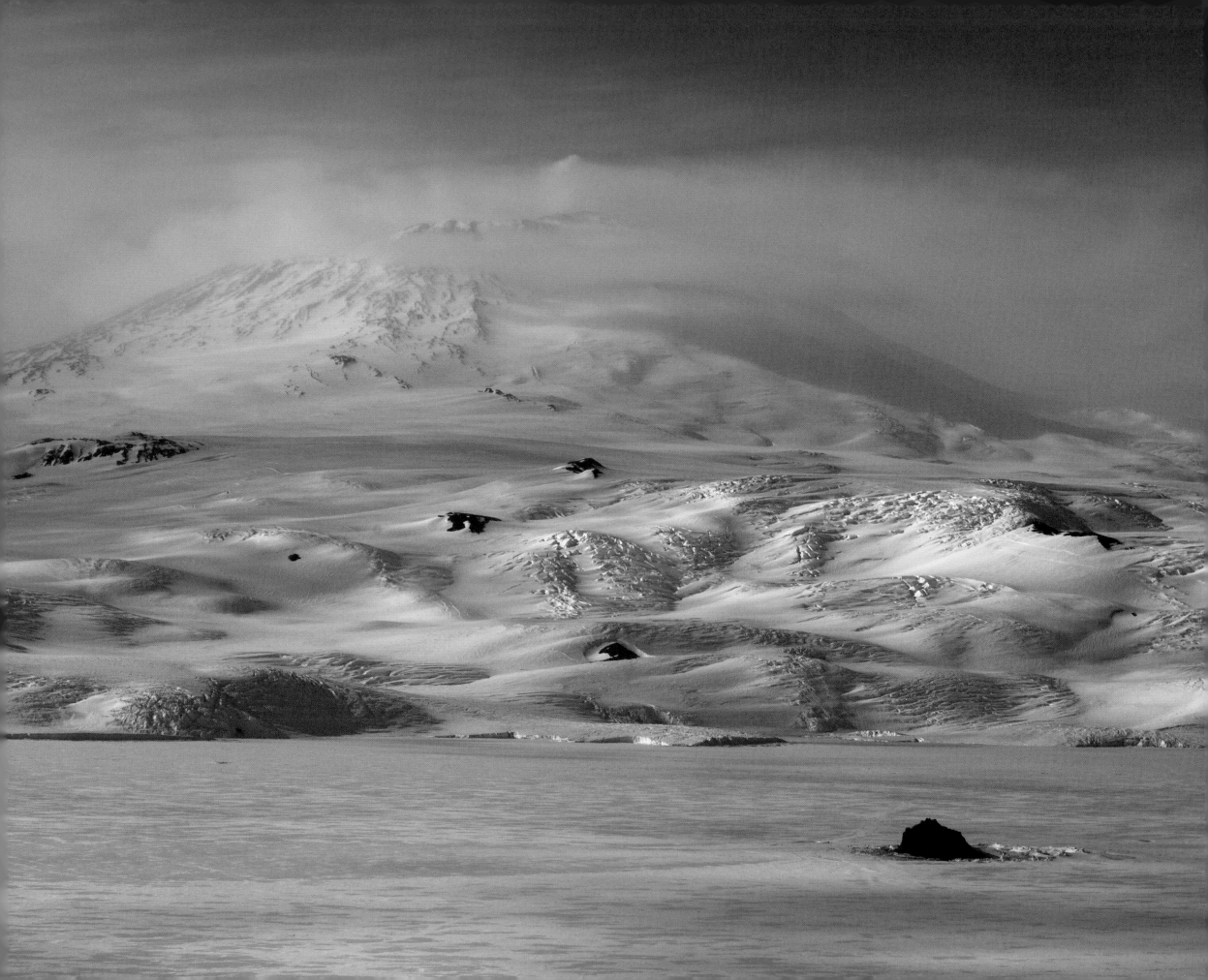

can have a profound effect across long stretches of coastline. Only local geology, like the tight turn around Cape Evans to get into Erebus Bay, can deter an iceberg from eventually grounding at any given locale. With all of these formative regional and local pressures, the benthos in the Ross Sea have developed into a patchwork of different habitats, and sometimes all the pieces line up with stunning results. In specific areas, undisturbed by anchor ice or icebergs, and protected by an army of hungry red sea stars, some sponges can live for more than a thousand years and grow bigger than 50 gallon drums.

AS I ROSE SLOWLY TOWARD THE HOLE, I looked down at the seal carcass from above. Up close the gore was like something from a bad horror movie, but from a distance it was hard not to appreciate the beauty of a system in which nothing is wasted and life is immediately recycled. Battle tested by cold, dark, ice, and starvation, life on the seafloor still thrived, hunting in slow motion in the icy depths of McMurdo Sound.

Little Razorback Island and Mount Erebus

the harder task of eating from the outside. They fed by clinging on and actually ejecting their stomachs and digestive juices out through their mouths to directly digest their prey. They had nearly covered the carcass, and were slowly eating their way through the fur and skin. Amphipods swarmed like flies around the nostrils. The feast was served, and it would likely take all season to eat.

The BBC sped up time and opened a new window into the lives of the benthic creatures that patrol the seafloor, but the forces that shape this community work on timescales of a season, a decade, and a thousand years. To understand them, we must expand the time lapse, and look deeper into the physics of the water itself.

THE WATER IN MCMURDO SOUND is so cold that changes of a few hundredths of a degree can make it freeze to the rocks as anchor ice. There are several ways in which this can happen, and the formation of the sea ice itself is the first pathway. As the surface freezes and the ice thickens, the crystallizing water releases most of its load of salt as brine into the water below, as it does in the Ross Sea Polynya. Salt lowers the freezing point of water; thus, the extra salty water can get colder, and since it is in direct contact with the ice, it does. The new load of salt also makes the water heavier, and thus it sinks, flowing toward the ocean floor in distinct streams. It creates its own funnels as it goes.

As a stream of supercooled salty water falls through the less salty, and slightly warmer, water mass below, the water directly around the brine freezes into a tube, encasing the stream of cold, salty water and delivering it deeper into the water column. The tubes can grow all the way down to the shallow ocean floor. In 2011, another BBC team filmed the formation of a brine tube with the same time-lapse techniques used on the seal pup. The online film trailer advertises "The Icicle of Death," and it does not disappoint. Over the course of several hours, the tube reached down from the sea ice, curling toward the bottom. When the tube finally touched the seafloor, the brine spilled out over the surface, freezing everything in its path and killing sea stars and urchins, which were too slow to escape the flood of brine and the growing ice.

These isolated events can be devastating, but supercooled water also comes to McMurdo Sound in greater quantities, shaping benthic communities across large expanses of the seafloor. The water deep underneath the gigantic Ross Ice Shelf and the smaller McMurdo Ice Shelf, though just above its freezing point, is still much warmer than the glacial ice itself, which starts to melt. The deep seawater gets even colder, but stays liquid because of the great pressure, which lowers its freezing point. The supercooled salt water mixes with meltwater from the ice shelf, and the combination is less salty and more buoyant. Thus, instead of sinking, as in the case of the cold brine, the supercooled shelf water rises from under the ice shelves in plumes, pooling under the sea ice and creating a supercooled layer that can measure up to 30 meters thick.

Where this mass of water touches the seafloor, fields of delicate stalagmites grow on the rocks. The complex clumps of interlocking ice plates provide hiding places for all manner of benthic creatures, and even fish. But the anchor ice is more buoyant than water, and it easily cracks off and floats up to the underside of the sea ice, sometimes carrying rocks or even a helpless urchin or anenome along with it, to be entombed in the thick ice above. Anchor ice shapes the entire community down to a depth of 30 meters, below which it rarely forms. Sedentary animals like anenomes, sponges, and hydras, which are rare in the anchor-ice zone, proliferate on the deeper reef.

The animals that escape a death by ice must face another major challenge: starvation. During the four months of night, phytoplankton is in very short supply. These tiny plants support the ecosystem from the bottom of the food chain on up, and the entire community must wait out the winter for fresh food. In midsummer, the prevailing currents carry the thick bloom of phytoplankton from the open water of the Ross Sea Polynya into McMurdo Sound. Most communities must fast all year until this feast, but some communities get new supplies even before the big feed.

Phytoplankton grows slowly under the ice in the summer sun, providing some relief before the bloom arrives, but certain localized areas in the sound also produce their own crops. The same troughs and holes that provide access for the seals support their own bloom of phytoplankton. The extra food bolsters the local ecosystem, resulting in, for one, a dramatic increase in the red and pink *Odontaster* sea stars. The dead seal pup was a rare treat, but the carpet of sea stars at Little Razorback Island owes its richness to the cracks in the ice.

The multitudes of *Odontaster*, in turn, completely restructure the local benthic community. The sea stars are generalists, eating anything they can find—including other species of sea stars, like the larger and slower *Acodontaster*. This species feeds preferentially on sponges. High densities of *Odontaster* limit *Acodontaster* populations, thus protecting the sponges that grow below the level of the anchor ice. In these areas, sponges grow in an almost unbroken mat below 30 meters, creating an entirely different niche.

And the complexities don't stop there. In some areas of the Ross Sea, benthic systems are subject to another defining force—icebergs. Grounded icebergs scrape deep into the seafloor, creating major, lasting disturbances before they eventually drift back out to sea and continue on their circuitous journeys north. In any given year, only a few icebergs may ground themselves along the Ross Sea coast, gouging the substrate beneath them. But over the course of centuries, the scraping action of grounded icebergs

THE OCEAN FLOOR

North of the Turtle Rock cutoff, the ice road wraps around the tip of the Erebus Ice Tongue and weaves between four steep volcanic islands jutting out of Erebus Bay. The smallest of the group, and closest to the slope of Mount Erebus, is Little Razorback, which looks like it sounds. The sea ice around the island has buckled into regularly spaced waves, a meter and a half from peak to valley. The bottom of each undulation of sea ice nearly touches a shallow underwater shelf on the north side of the island, creating a series of long, parallel underwater tunnels.

At the surface, the buckled zone ends in a trough of open water at the edge of the island, and the weak ice at the peaks of the waves sometimes cracks open as well. Seals have seized the opportunities to access open water from this predictable buckle zone, though the small Weddell colony at Little Razorback is only a fraction of the size of the main colony at Big Razorback Island, less than a kilometer and a half away. A seal will sometimes swim the full length of a tunnel before ducking under the tunnel wall, passing over the edge of the shallow underwater shelf, and disappearing out into the dark.

I joined a team of three filmmakers from the BBC in the Little Razorback dive hut and prepared for a dive. Beneath the seal colony, the ocean floor was a mosaic. Hundreds of lurid, pink and red sea stars explored the rocky substrate with their tube feet, continually testing the water for a taste of their next meal. Nemertean worms, more than two meters long, snaked through the carpet of stars, forming writhing piles as they consumed scraps of food dropped by a seal. Urchins tiptoed on their many spines.

Some benthic species adapt to the cold water by growing into giants, and sea spiders the size of dinner plates walked with their bizarre strides, sometimes taking freeloading passengers along for the ride on their lobster-red legs. Perched high on a small glass sponge, *Antarcturus* arched their backs and combed the water with their hairy legs in the hunt for passing zooplankton. Attached to the rocks, anemones waved their arms, mouths puckered until they caught something to eat.

Every creature was either eating or hunting, but it was all happening in slow motion. Over the course of a dive, the sea stars might move a few inches. The team from the BBC tracked the behavior on the seafloor over longer periods of time. They had deployed time-lapse cameras that would record hours of movement, one frame every few seconds. Played back at a normal frame rate, the images formed a high-speed movie, revealing the concerted industry of the seafloor. Sea stars stormed up the slope and over the lip of the shelf en masse, joining urchins and worms in an advancing army of singular purpose. The target of the attack was an unlucky Weddell seal pup that apparently had died under the ice and sunk to the bottom on the shallow underwater shelf. The animals climbed over each other in pandemonium, and the seal carcass was horrific. With their blunt pointed snouts and long bodies, the worms had burrowed deep into the seal through the eye sockets and under the skin. The sea stars had

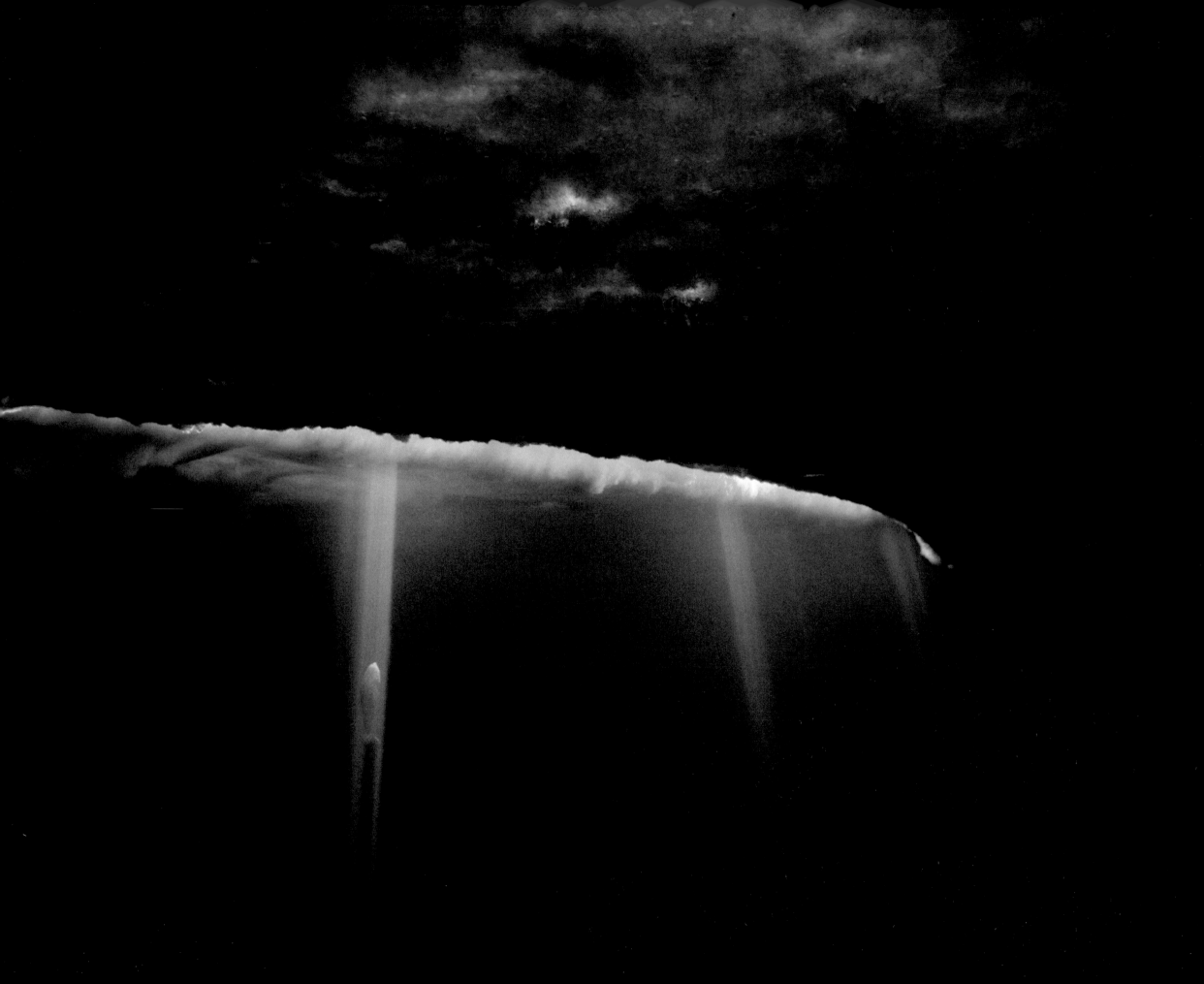

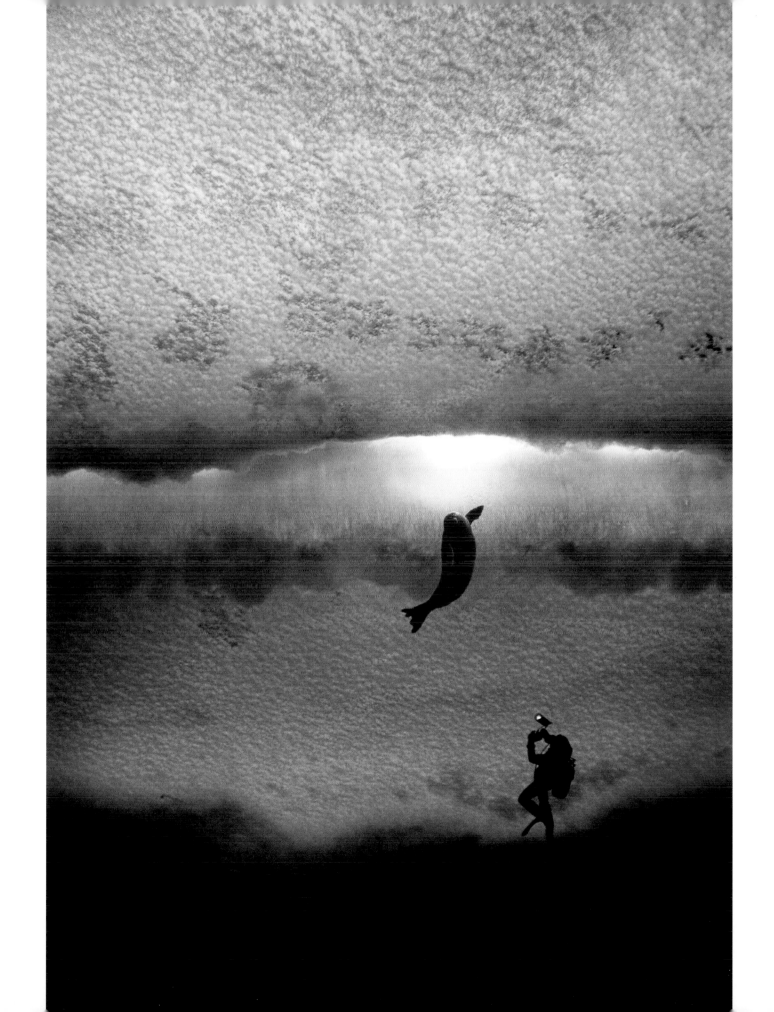

Opposite: **Weddell seal under the ice** | Following Spread: **Weddell seal and diver** (left); **Weddell seal rising to a hole** (right)

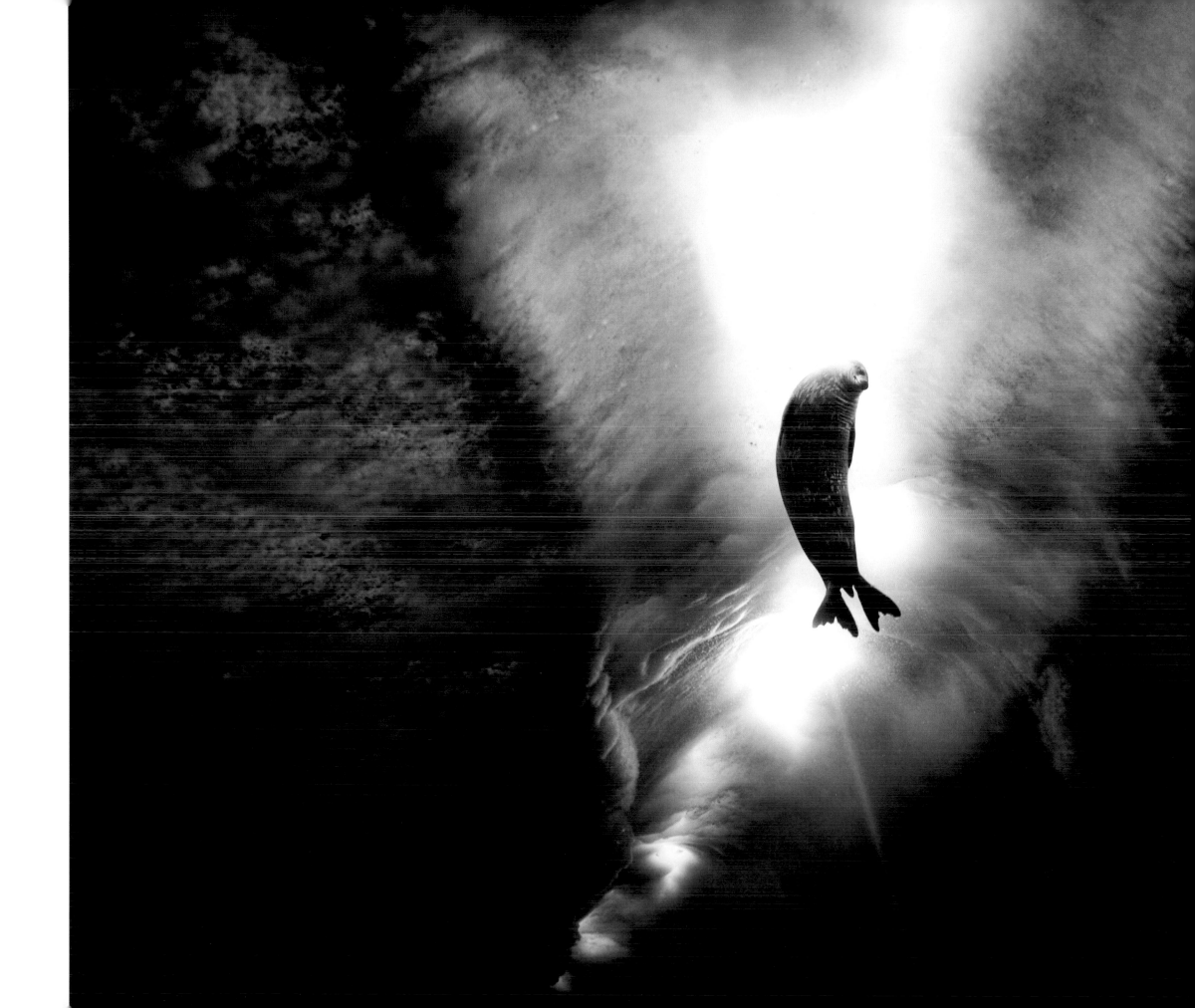

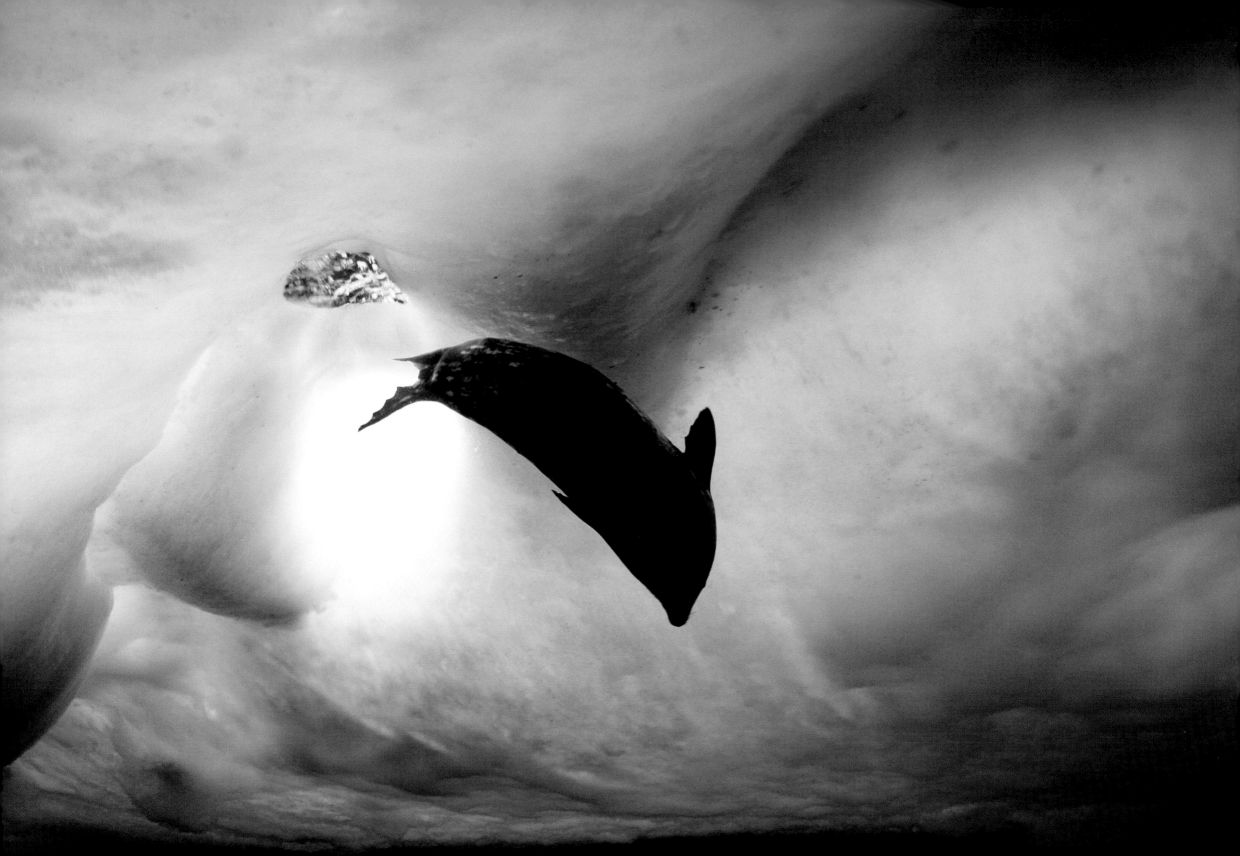

Weddell seal under the ice

Weddell seal and pup

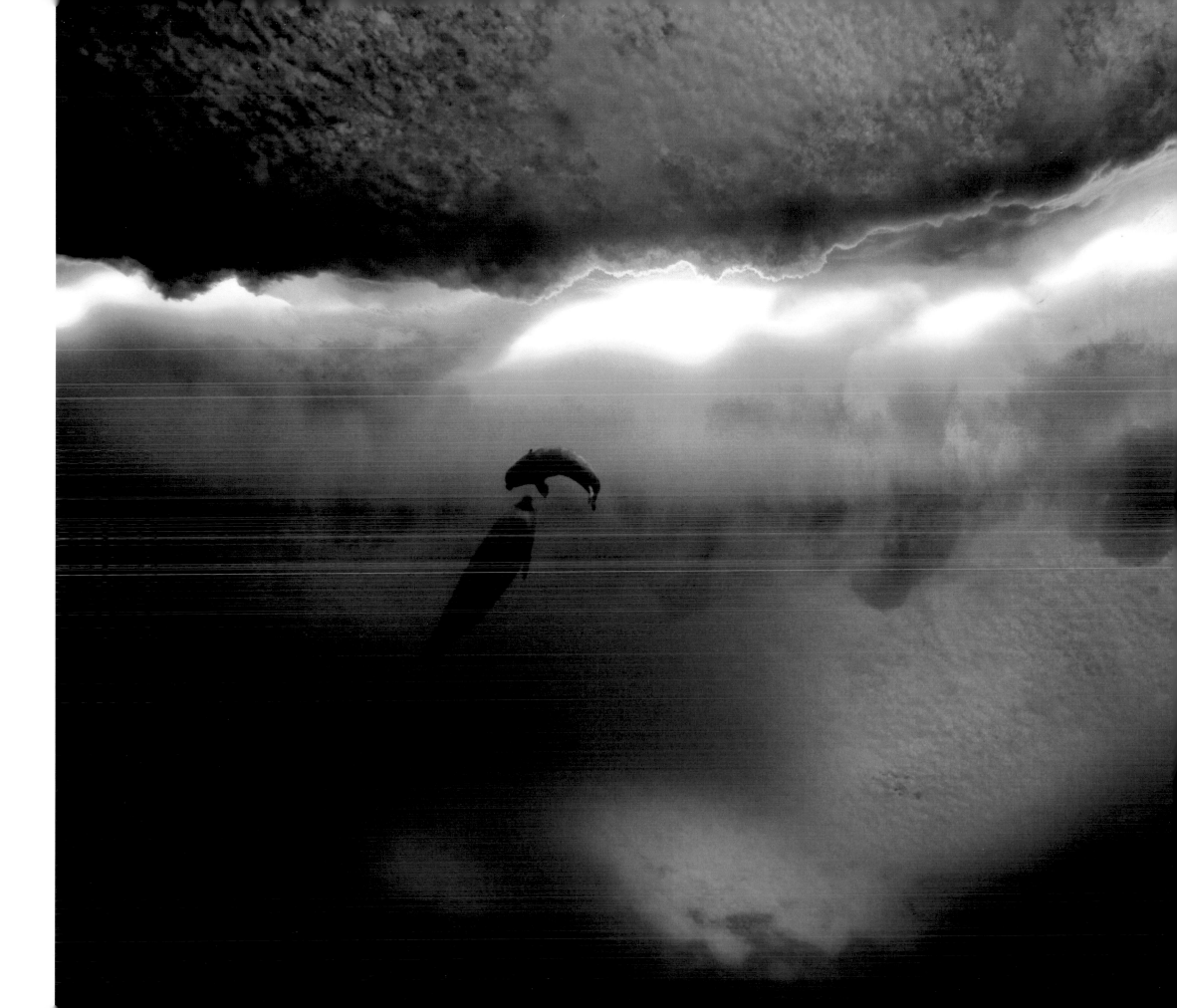

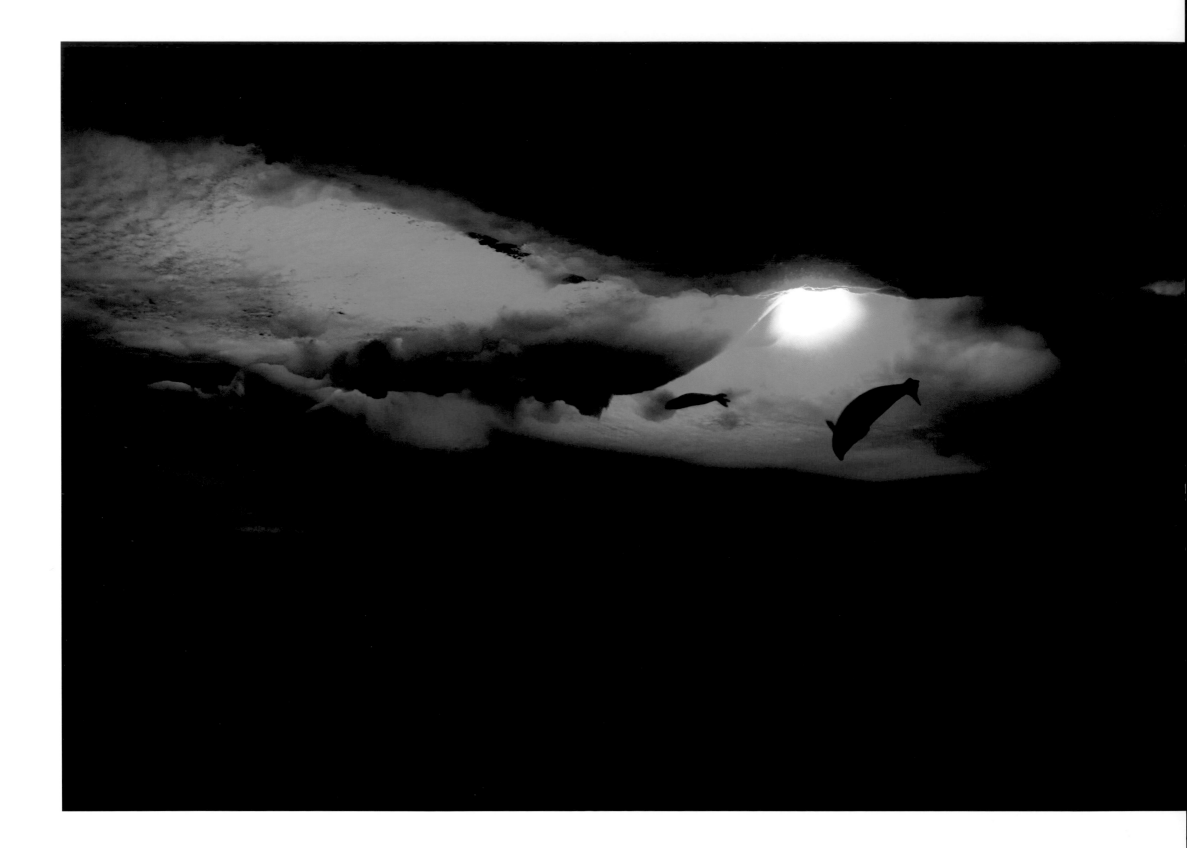

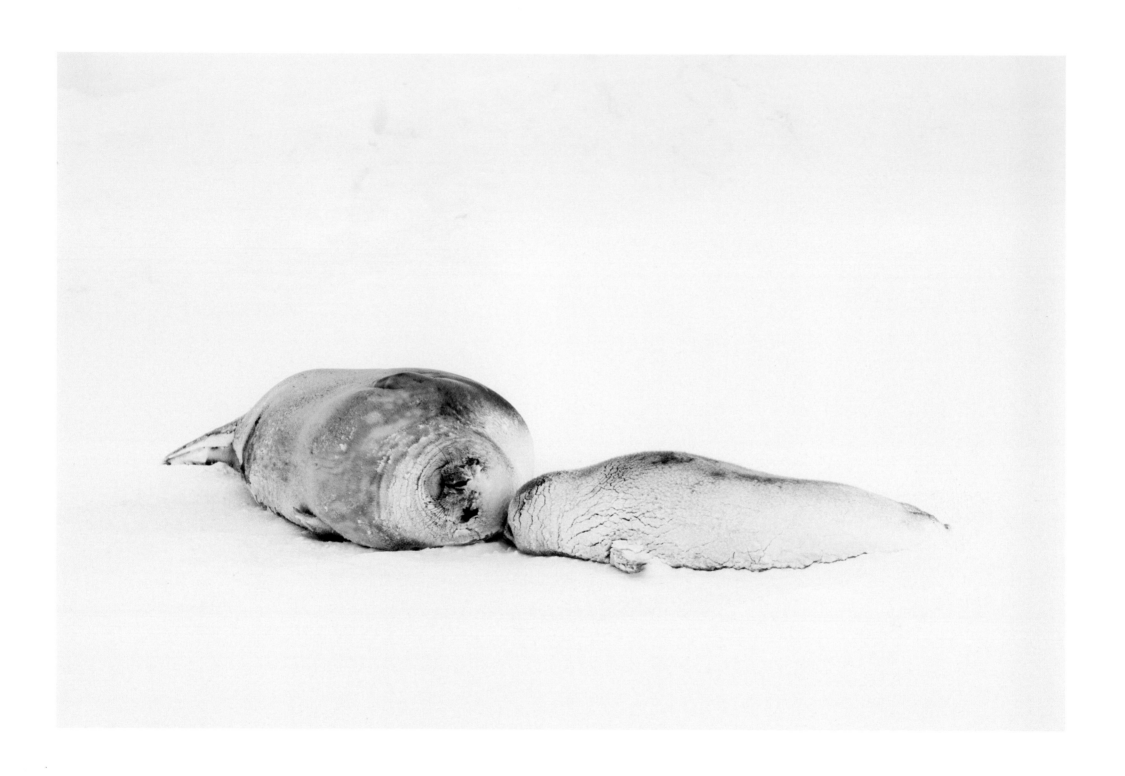

Opposite: **Weddell seal resting on the ice** | Above: **Weddell seal and pup in storm** | Following Spread (left and right): **Weddell seal and pup**

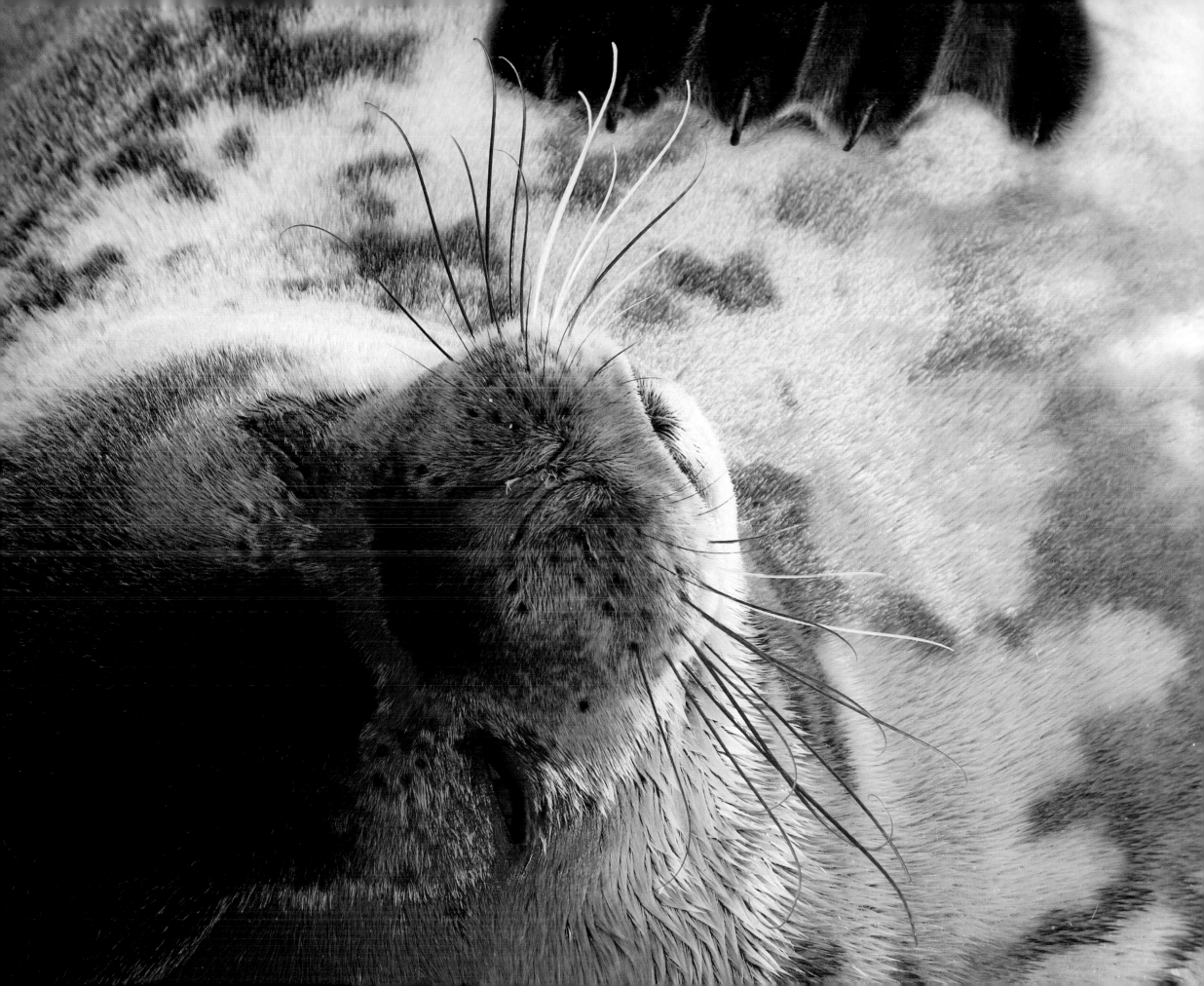

my suit, I walked outside into the still air. Rob and I lay down on the surface of the ice, looking up at the sky. The sun warmed our black suits, and we baked, blood flowing back into fingers and toes. Below us, through the ice, we could still hear the chorus, as the seals trilled, chirped, and glugged.

Over the course of the season I watched as this mother and pup, which I quickly learned to recognize, made longer and longer trips under the ice. Near the end of my stay, the pup was nearly independent. Big males started their rut, and I witnessed confrontations under the crack. Females came back into heat, and the whole cycle was beginning again. All in all, I had 10 precious dives at Turtle Rock, 10 chances to watch the graceful seals cruise the crack, 10 chances to drop through the iris of the giant eye and swim in the blue light through the cathedral of sound.

Weddell seal pup in crumpled ice

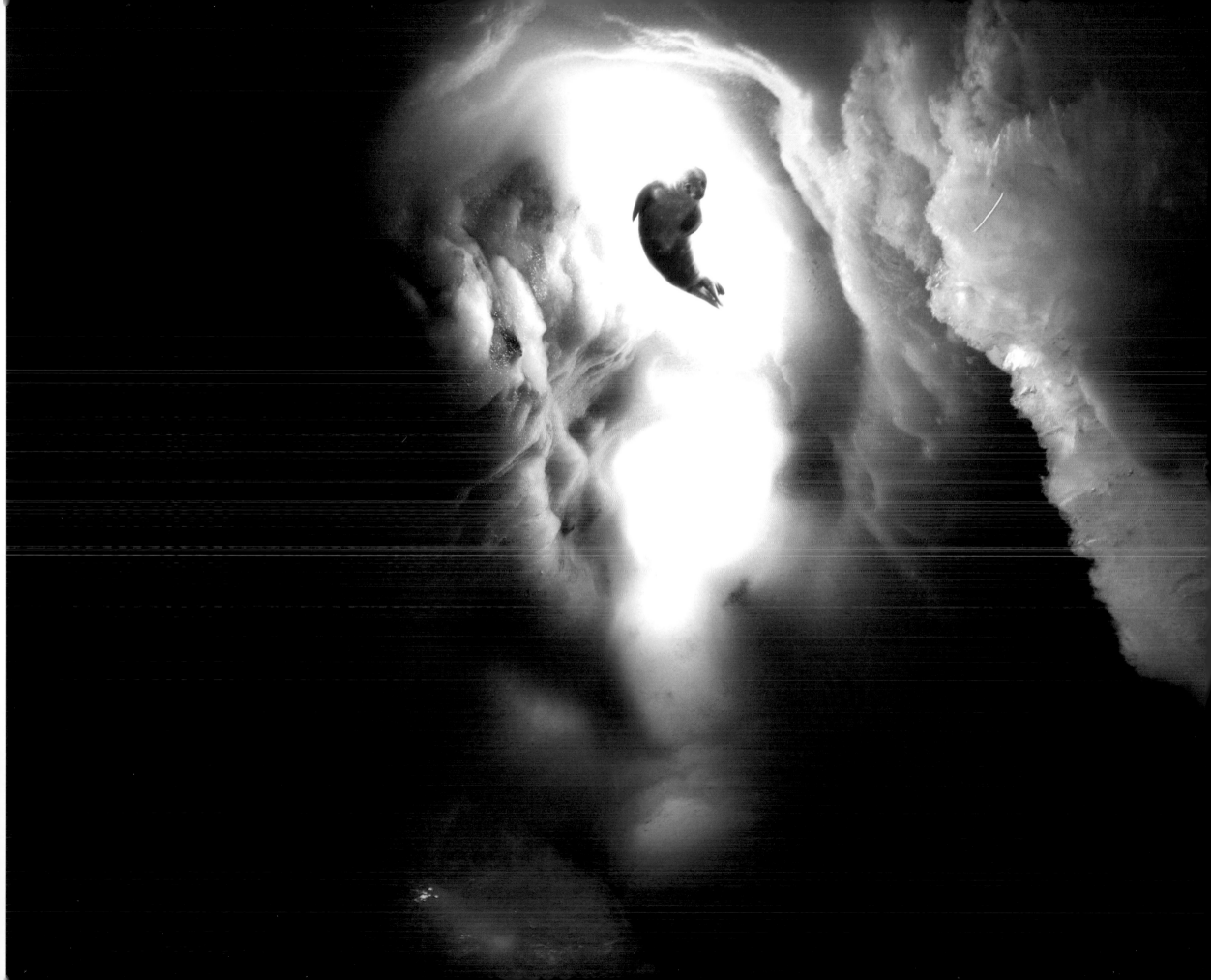

Dive hole from below

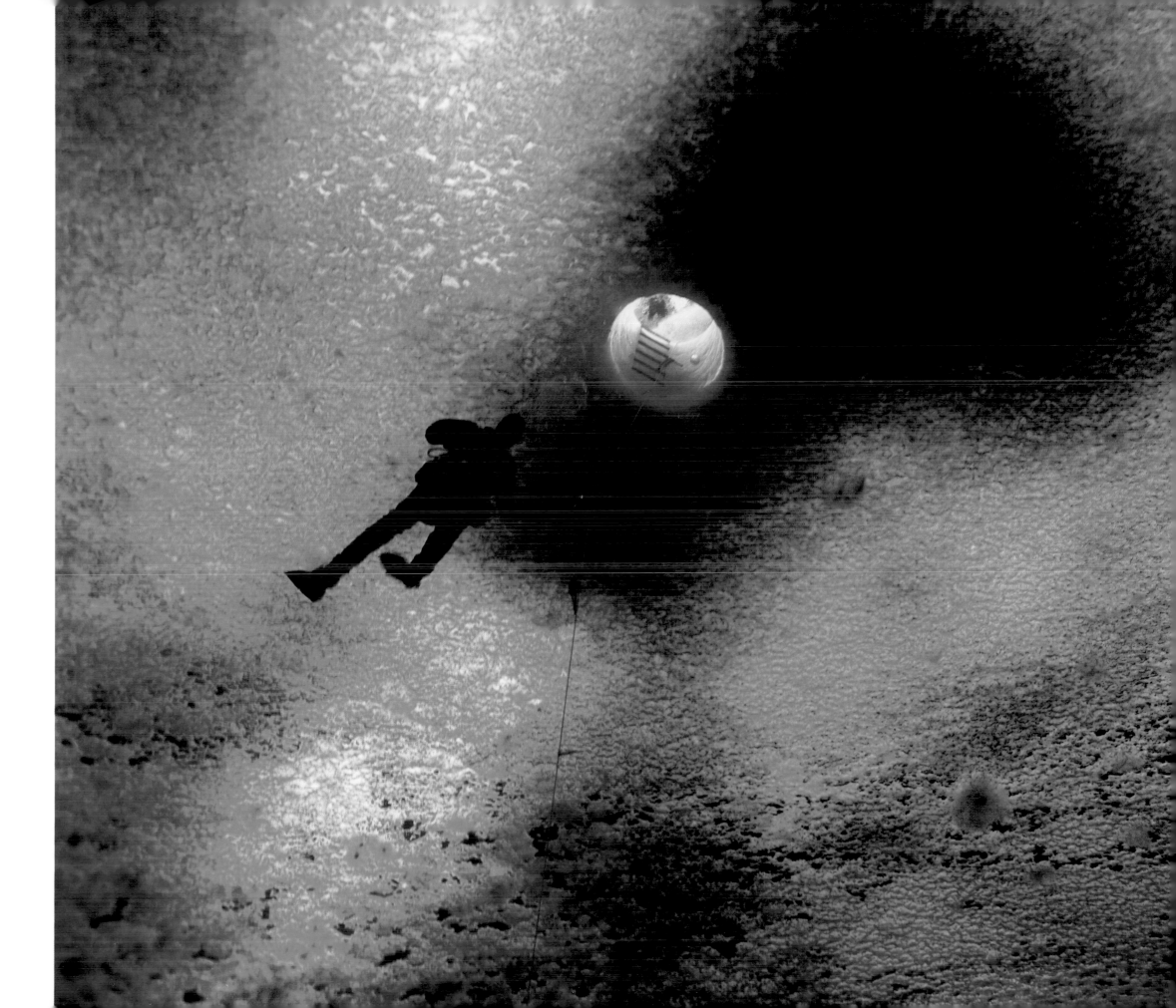

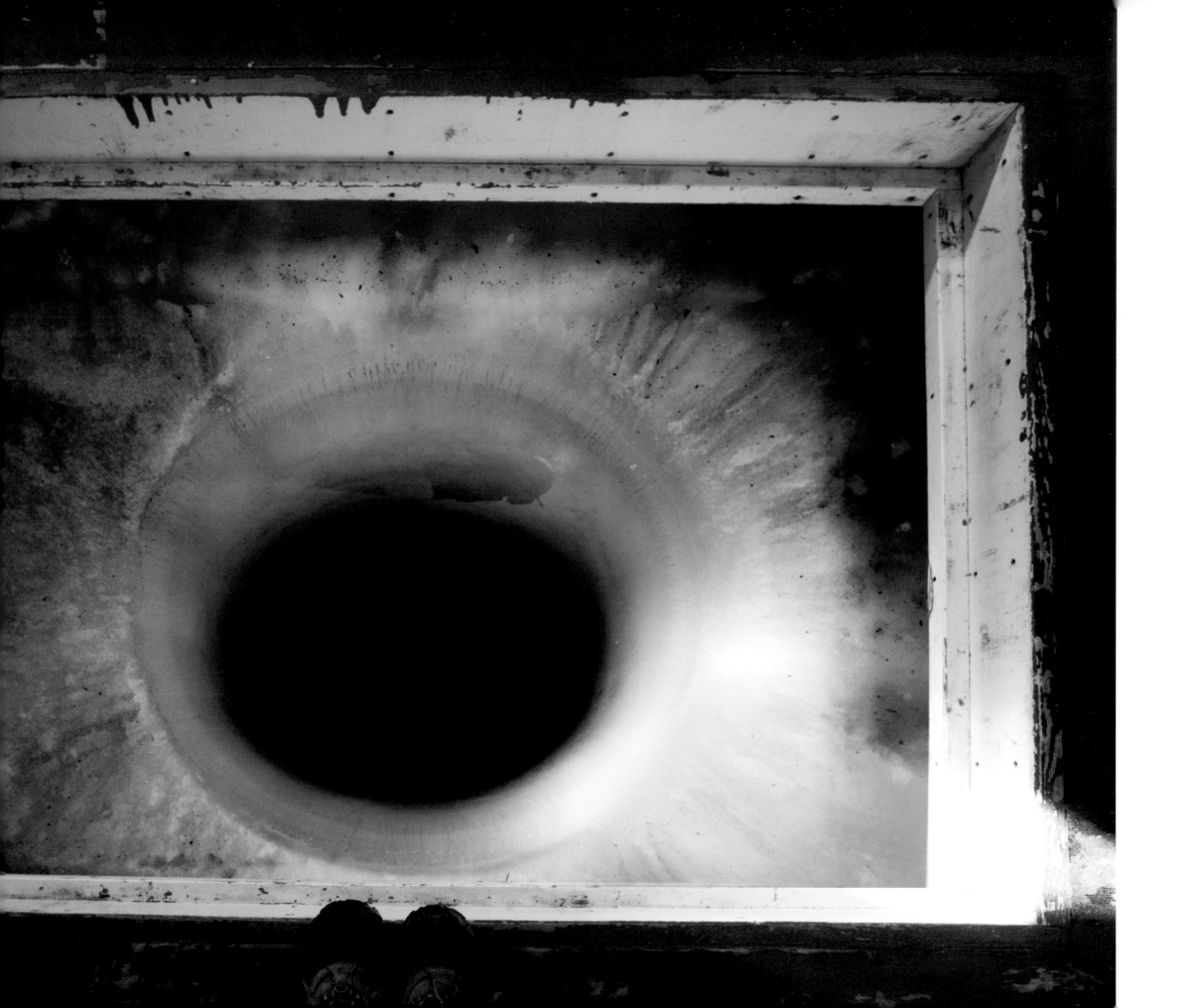

Dive hole

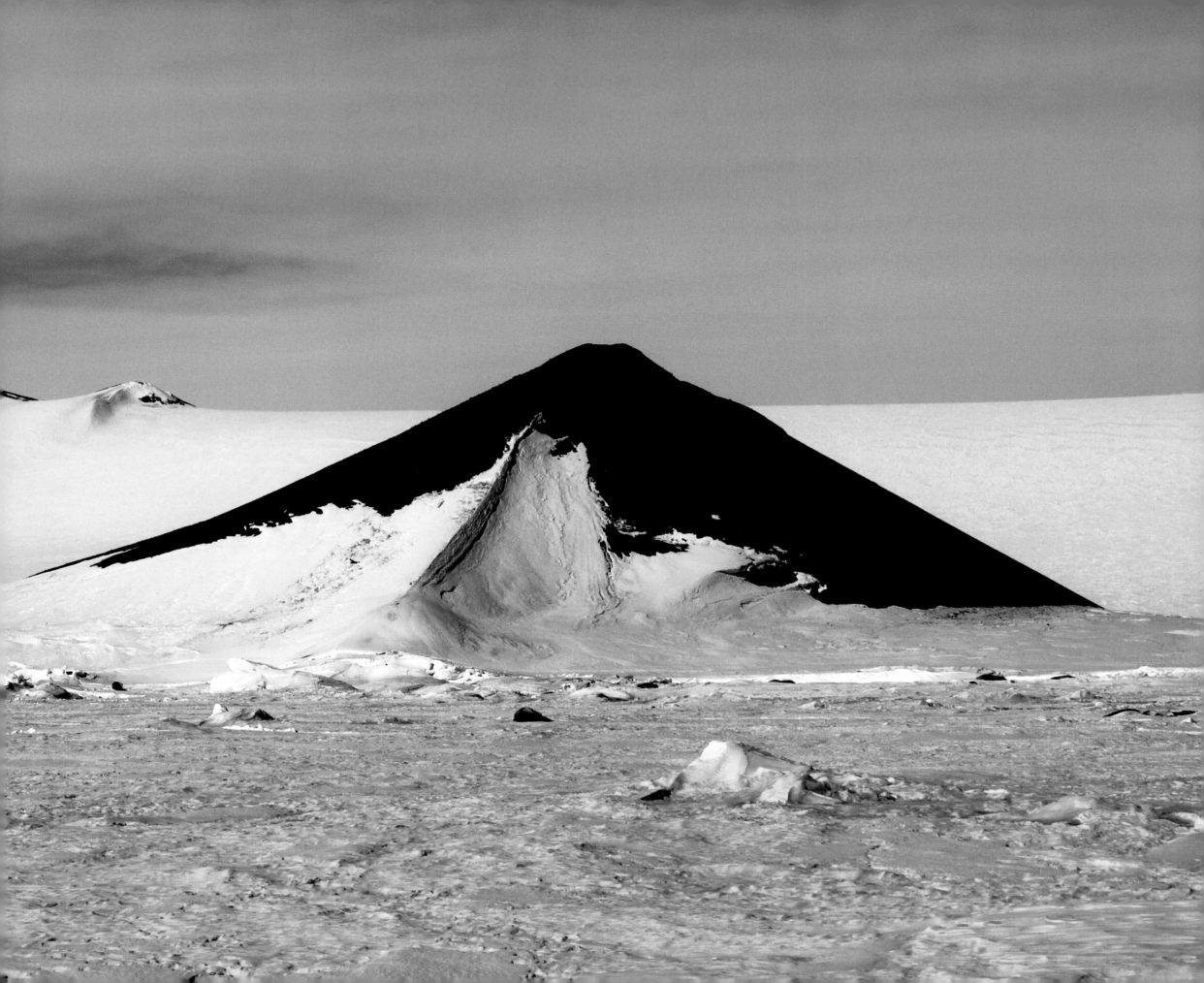

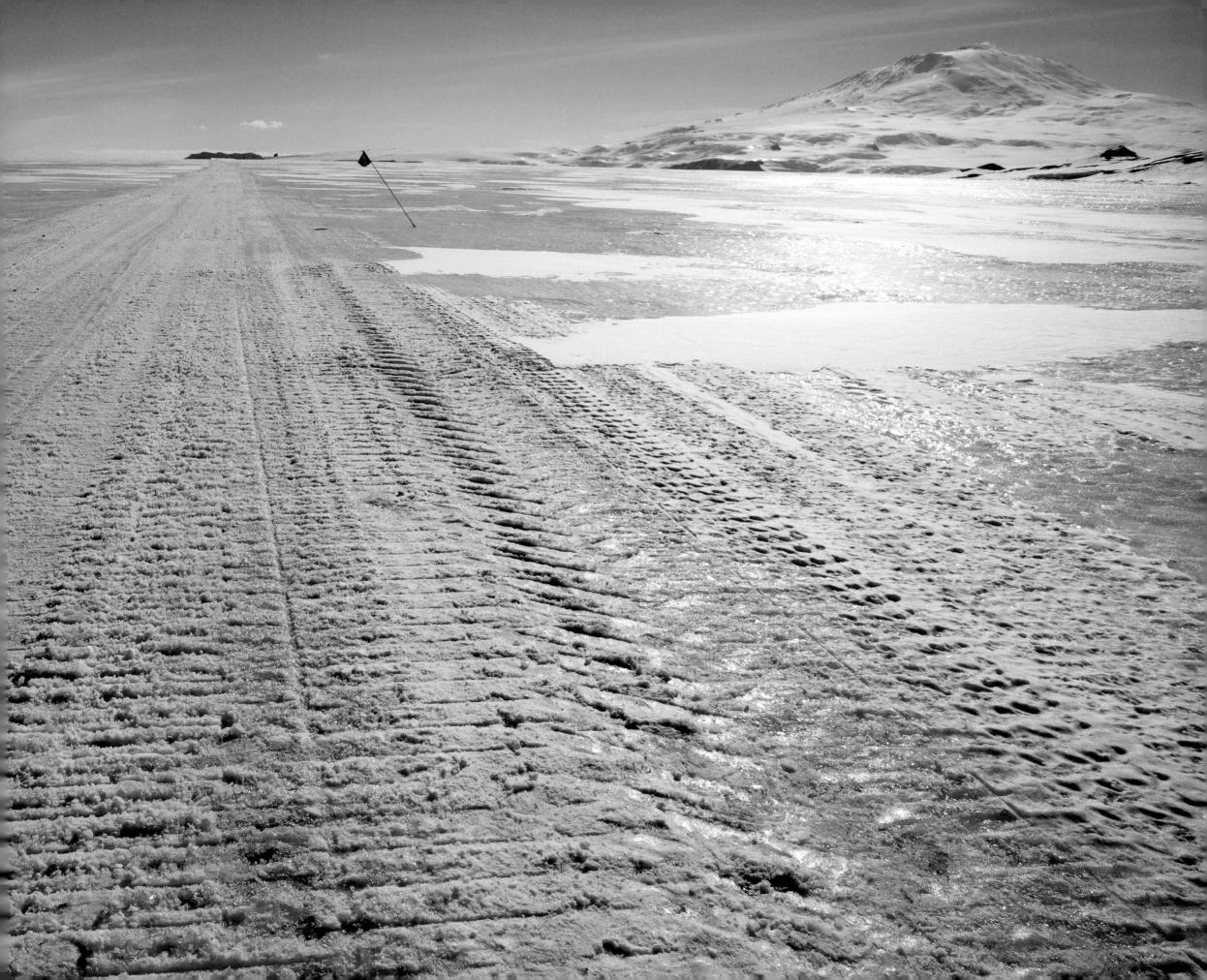

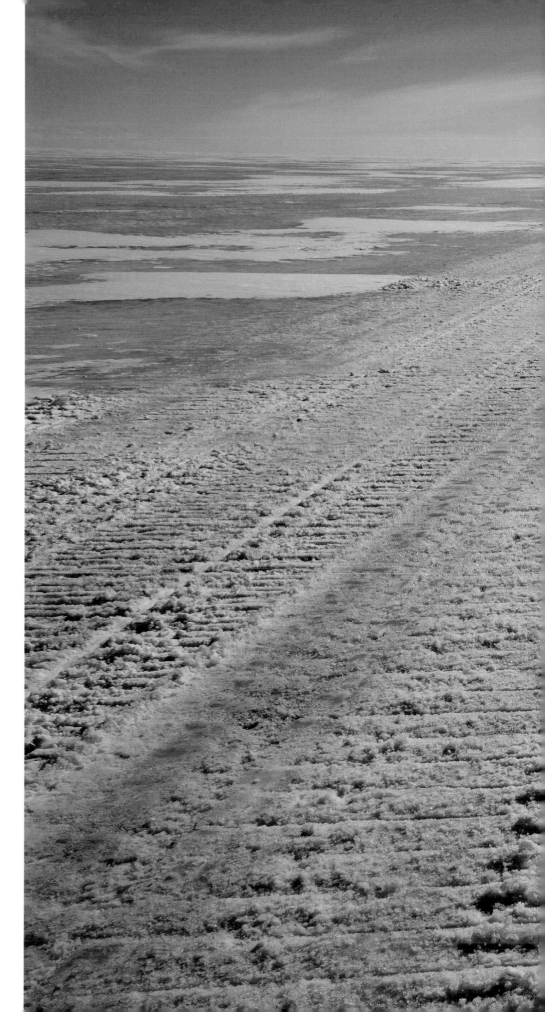

The clearest water anywhere else in the world allows visibility of 60 meters. Under the ice, the visibility is up to 300 meters. I might as well have been floating in air. I forgot to breathe.

Rob was floating over to my right in a vertical position, arms folded across his chest. Our eyes met and he gave me a wink through his mask. He signaled a descent, and I followed him down into the dark. We leveled out and floated at 20 meters, suspended a meter above the slope. Rob opened his arms, indicating that we should explore. I spied a creature in the blanket of ice a few meters up the slope, and swam over to inspect it. I knew immediately that something was wrong with my dry suit.

Depressing the button on the chest of the suit opens a valve and fills the suit with air. An exhaust valve on the left shoulder allows air to escape. At any given depth, neutral buoyancy requires either adding air to the suit or letting it escape through the shoulder valve. As you go deeper and the water pressure increases, you need to add more and more air to the suit to stay neutral. As you get shallower and the air in the suit expands, you need to do the opposite. As I swam upslope, I felt my suit get more buoyant. Normally, the shoulder valve automatically offsets unwanted buoyancy if the diver rolls to the right, raising the left shoulder to increase the air pressure directly under the valve and forcing it to open. I tried that maneuver several times to no avail. I tried to manually depress the valve with no result. The valve was stuck, and I started to slowly drift toward the surface as the air in my suit expanded with no escape. I flared out my arms and legs to slow my ascent, but by that time there was no way to stop it. I ended up stuck against the underside of the ice like a helium balloon nestled against the ceiling.

Rob slowly ascended, and I pointed to my valve. He nodded, and then relaxed, floating in the water next to me. We both looked over the scene. A minute later, he signaled that we should go back to the hole, a short distance away. I bounced my way over, and then up and out like a cork. My first dive under the ice had lasted only seven minutes.

After some good-humored ribbing, Rob and Steve let me in on a McMurdo diving secret. I had never previously found occasion to wear the full-body polar fleece suit with the other layers of long underwear. The extra loft of those layers had forced the thick fleece into the valve, clogging it. With all the fancy equipment, the solution to the problem was duct tape, and from that day on, I wore a wide patch of it on the left shoulder of my polar fleece suit.

Over the course of the season I had the opportunity to make 50 dives, divided among the four dive sites around McMurdo. Each dive was its own honor, a rare privilege. But that first time I popped out under the ice, all the years of training and preparation paid off in a single second as I floated over that indescribably beautiful alien world, seeing with new eyes.

Opposite: **The ice road** | Following Spread: **The Turtle Rock dive hut**

UNDERWATER

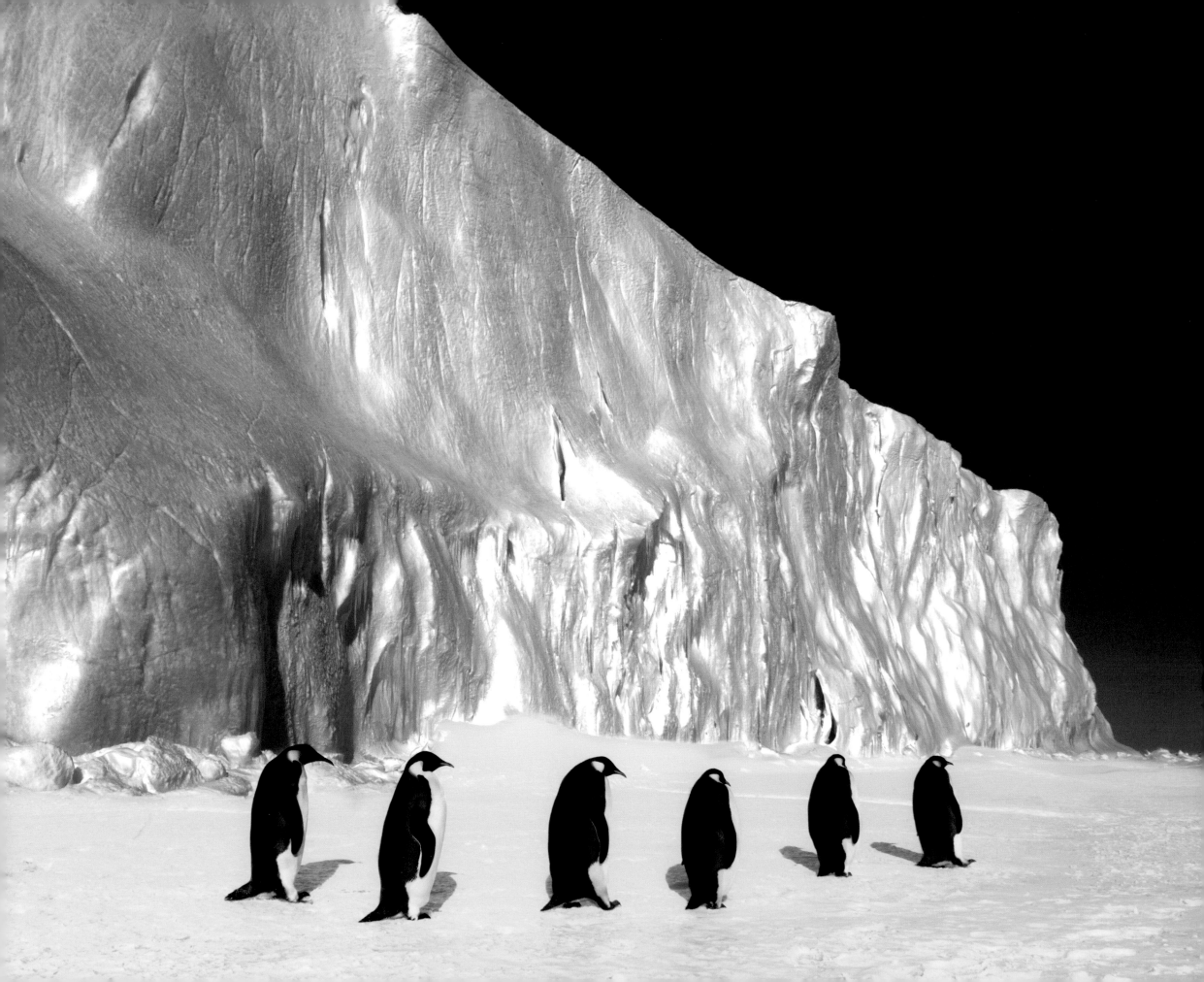

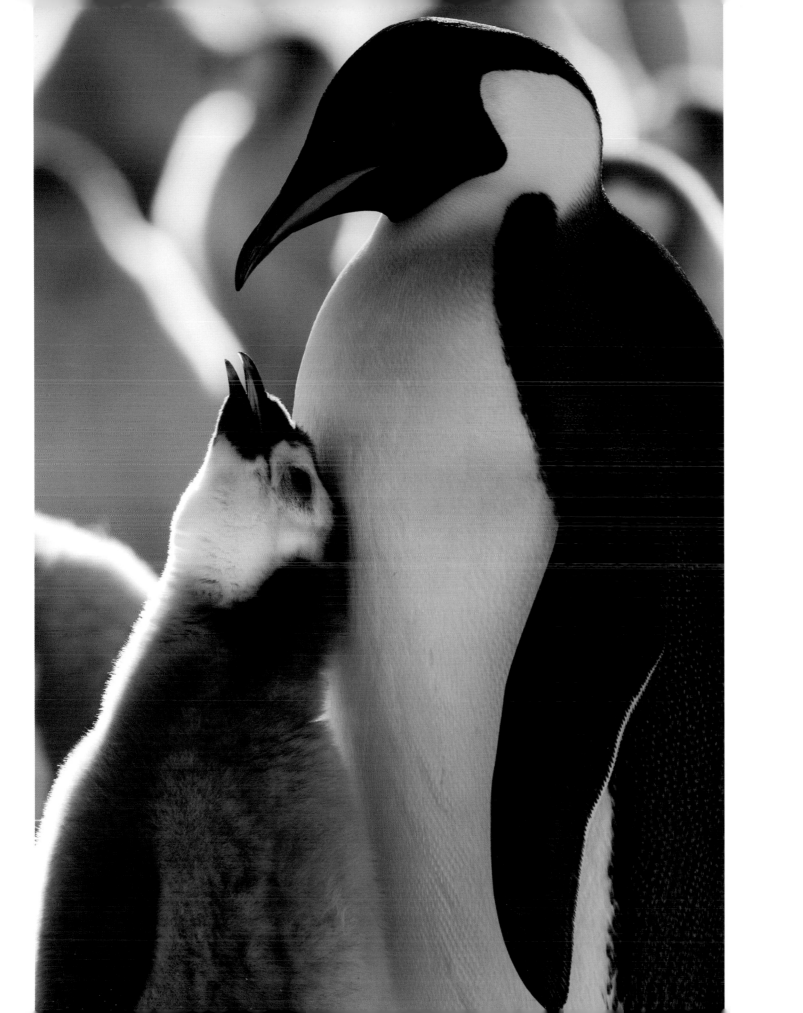

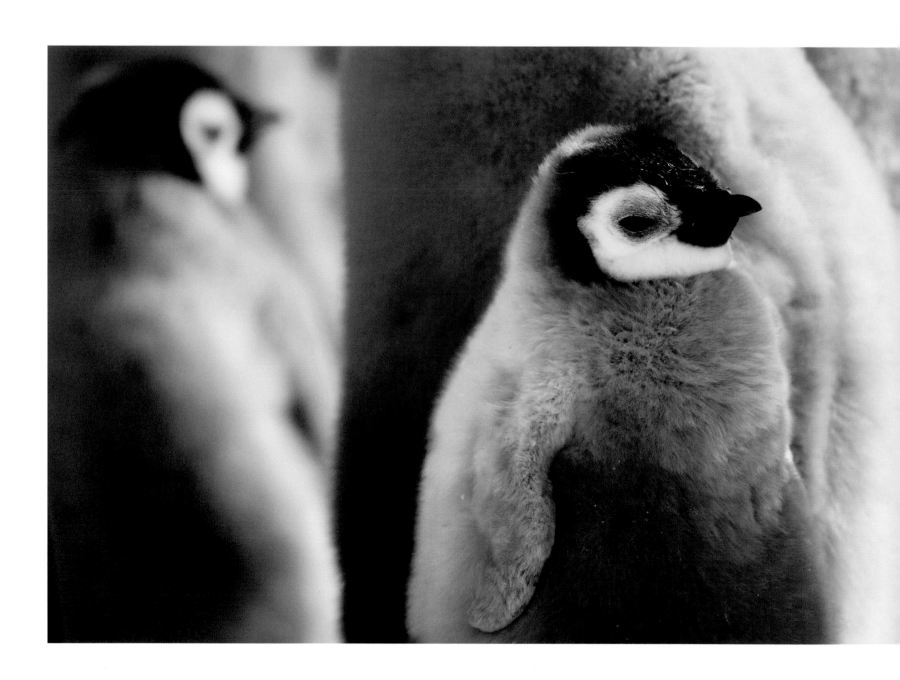

Opposite and Above: **Emperor Penguin chicks** | Following Spread: **Emperor Penguin and chick** (left); **Emperor Penguins and iceberg** (right)

93

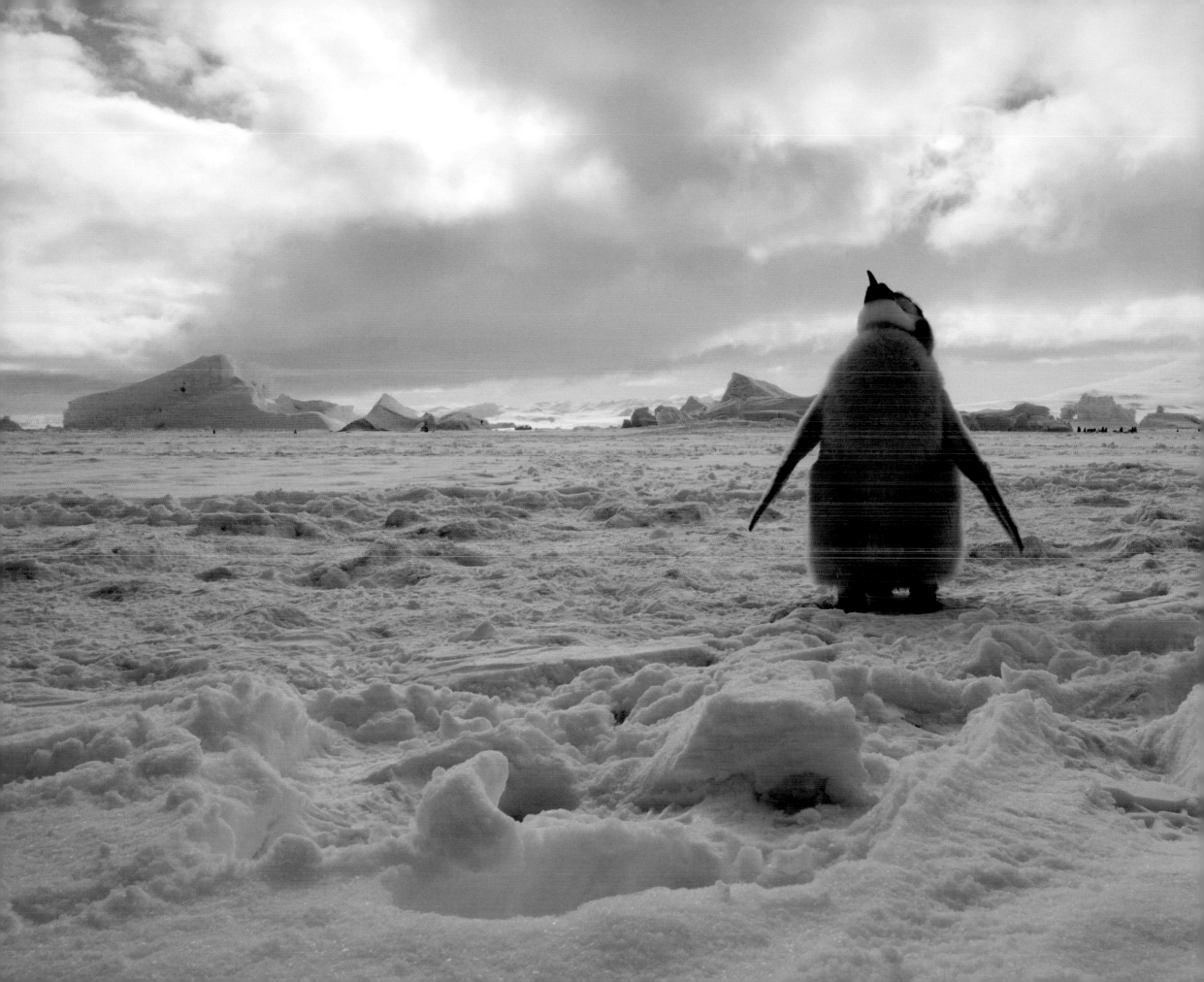

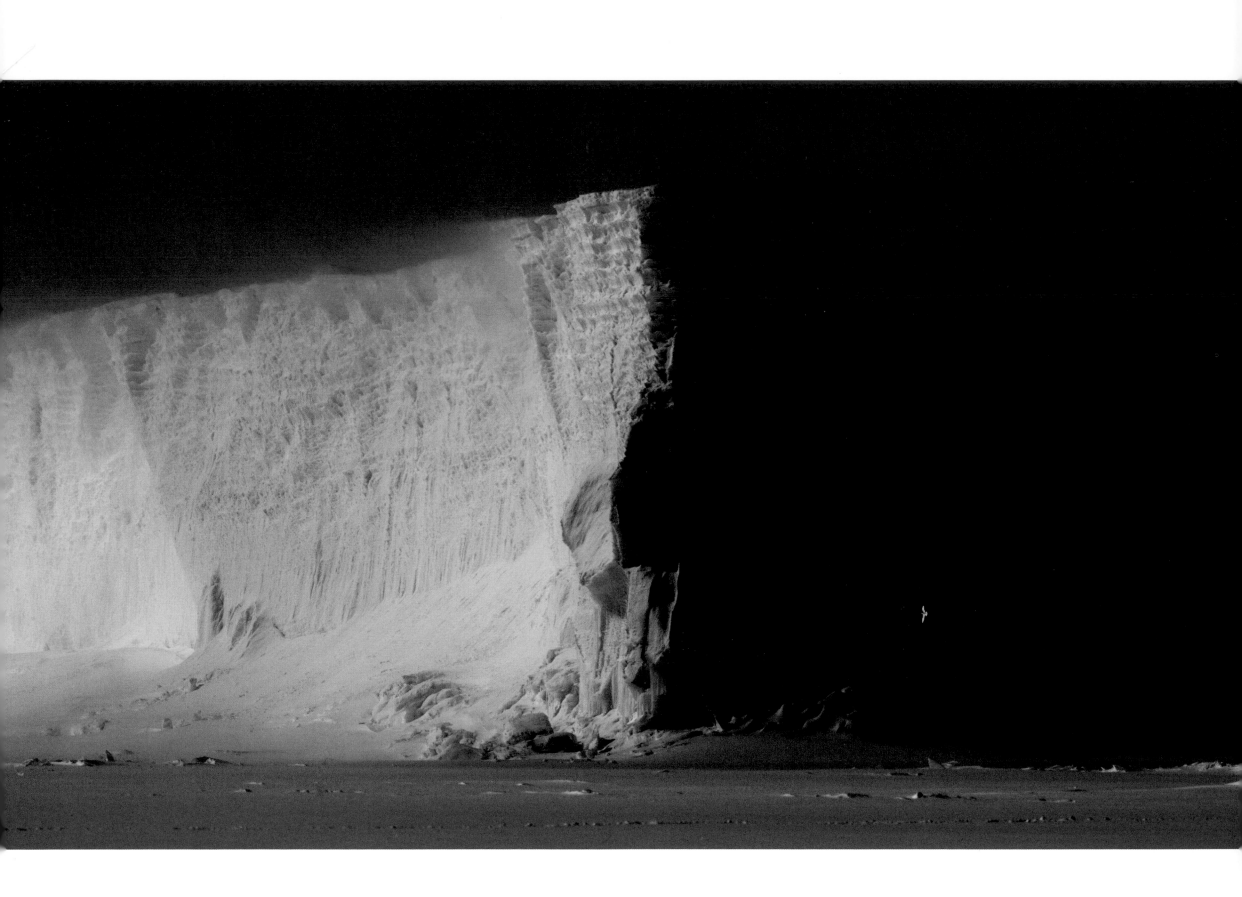

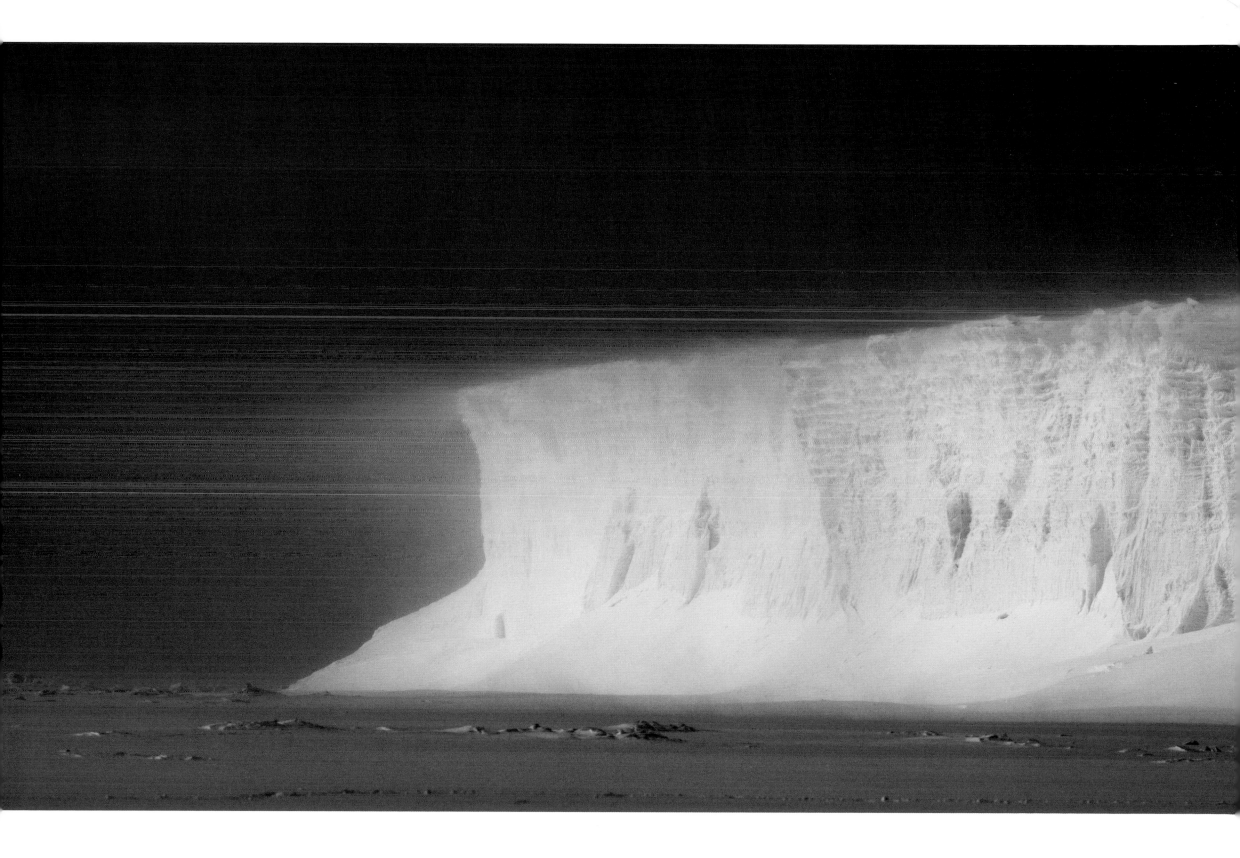

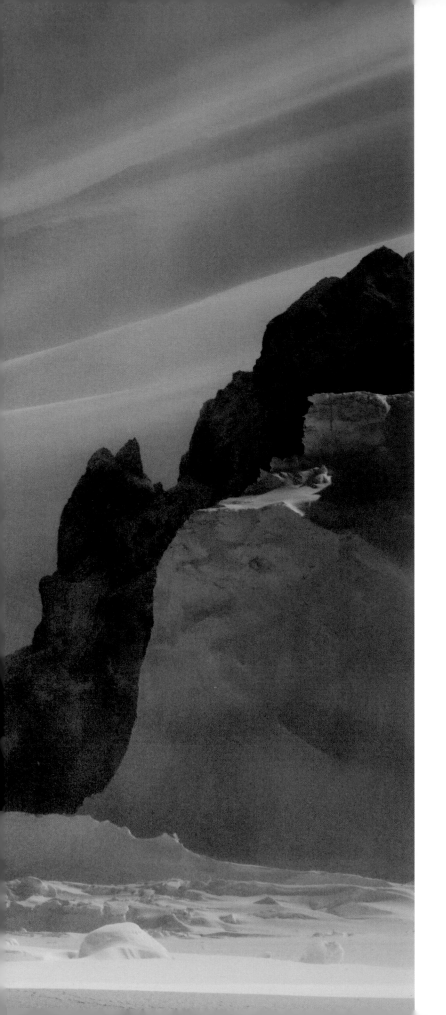

Opposite: **Snow petrel, iceberg, and volcanic cliffs** | Following Spread: **Snow petrels and tabular iceberg**

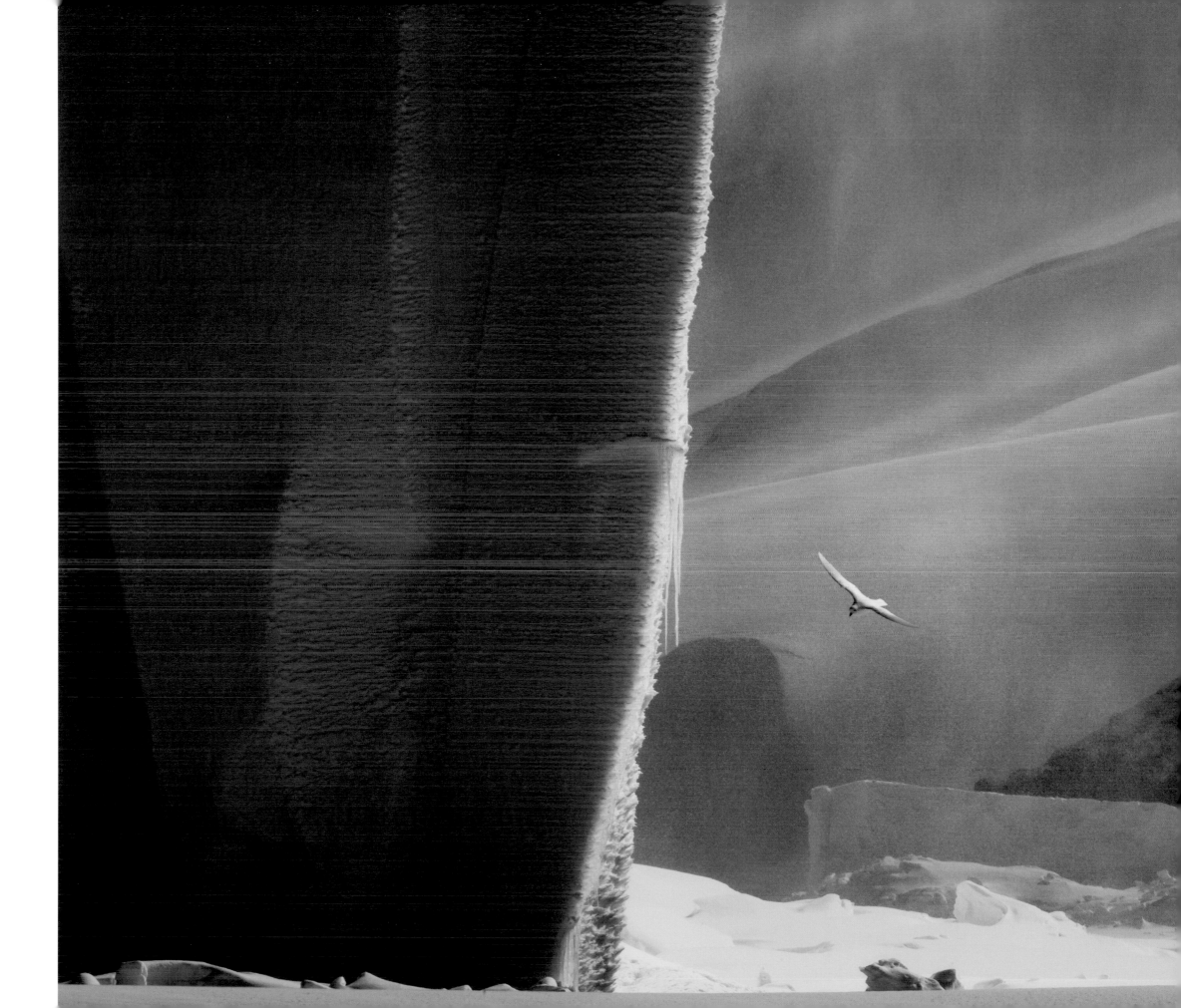

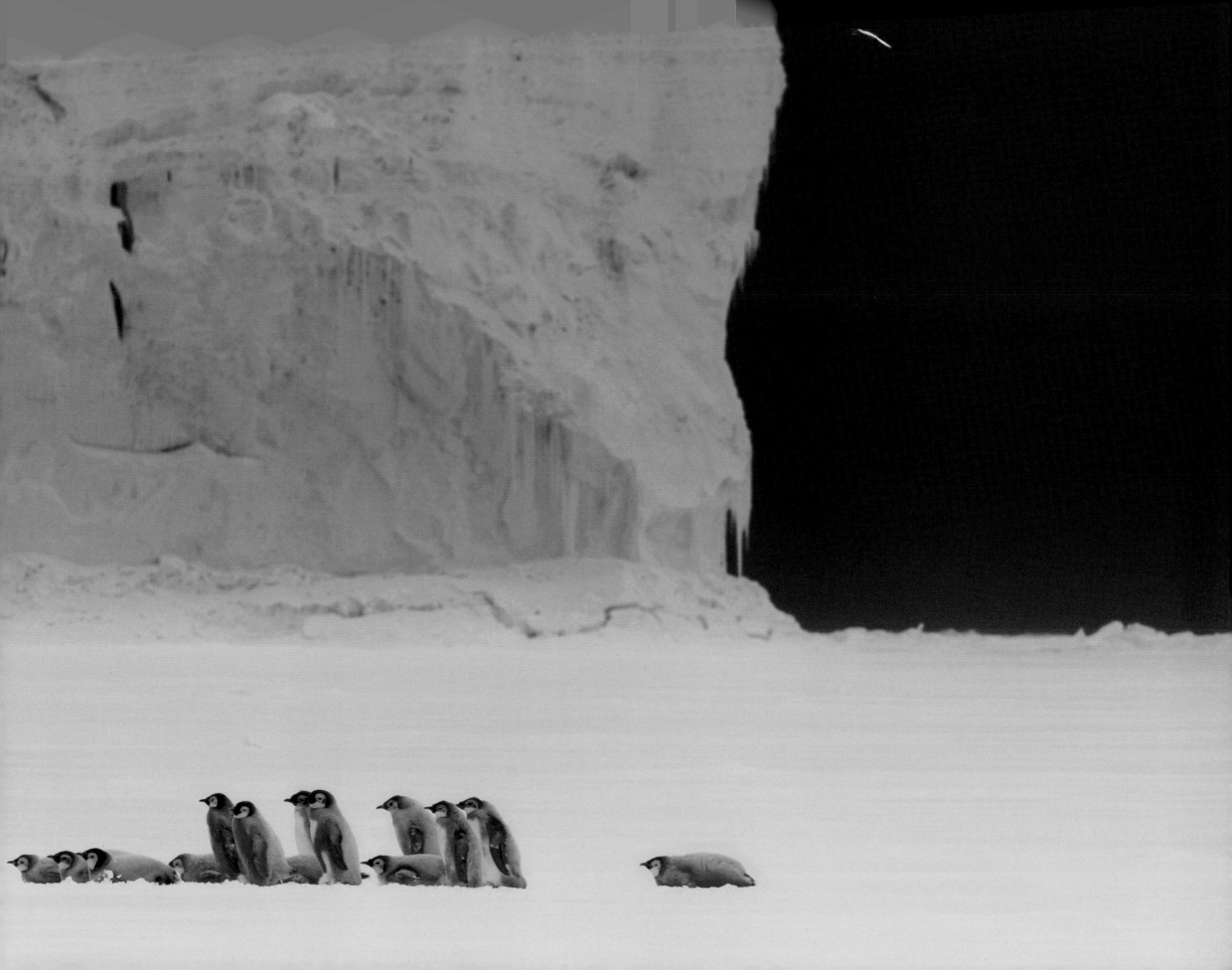

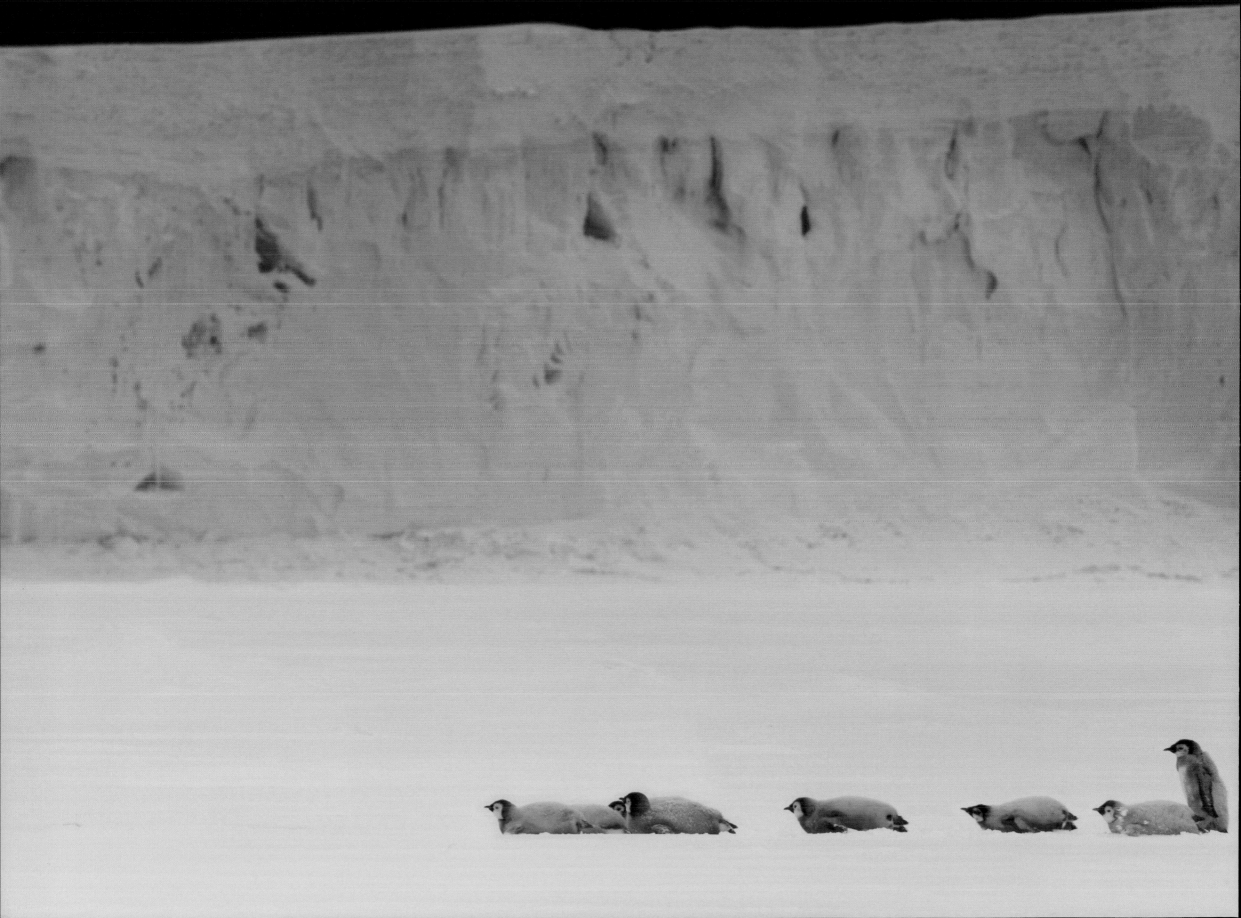

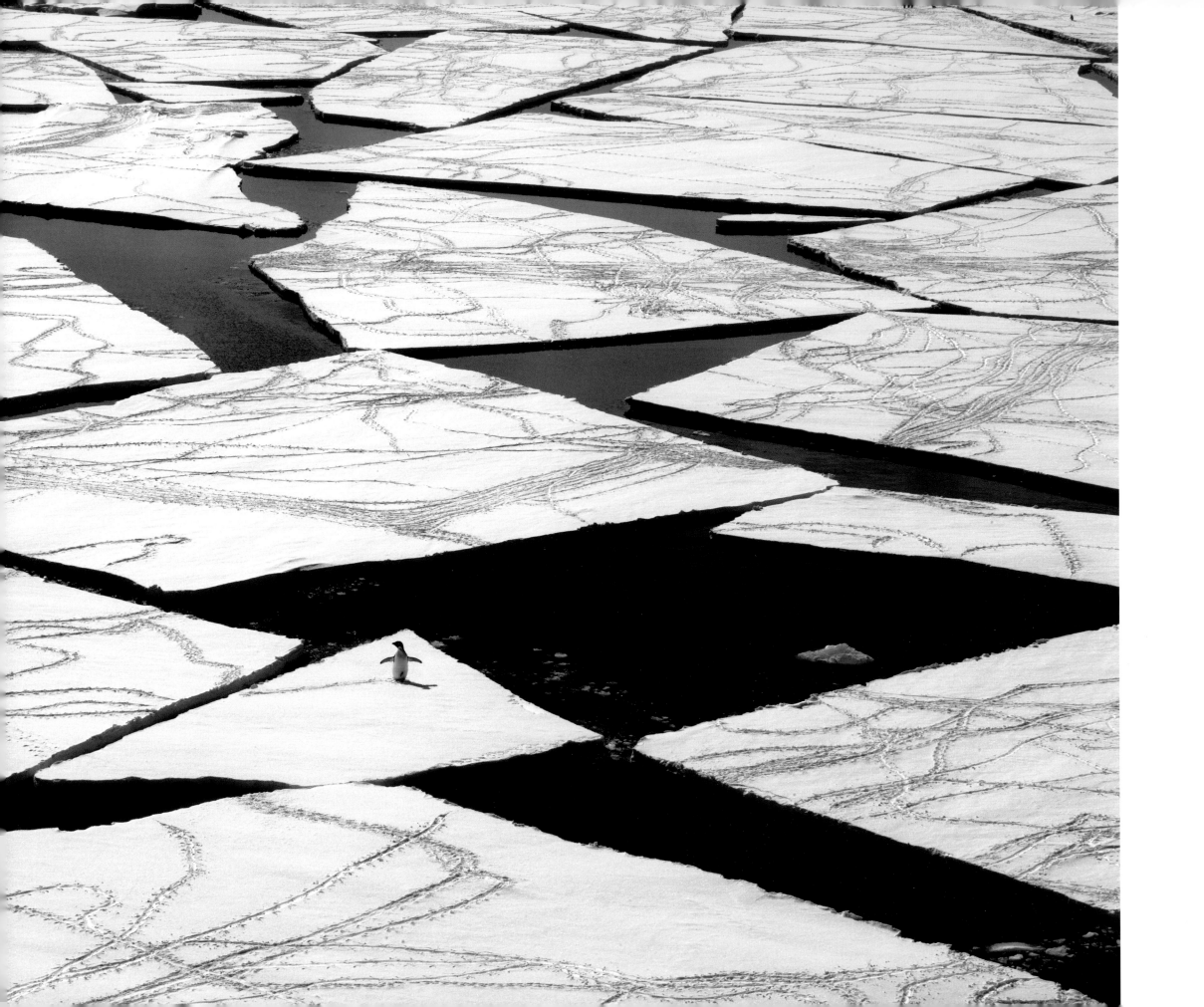

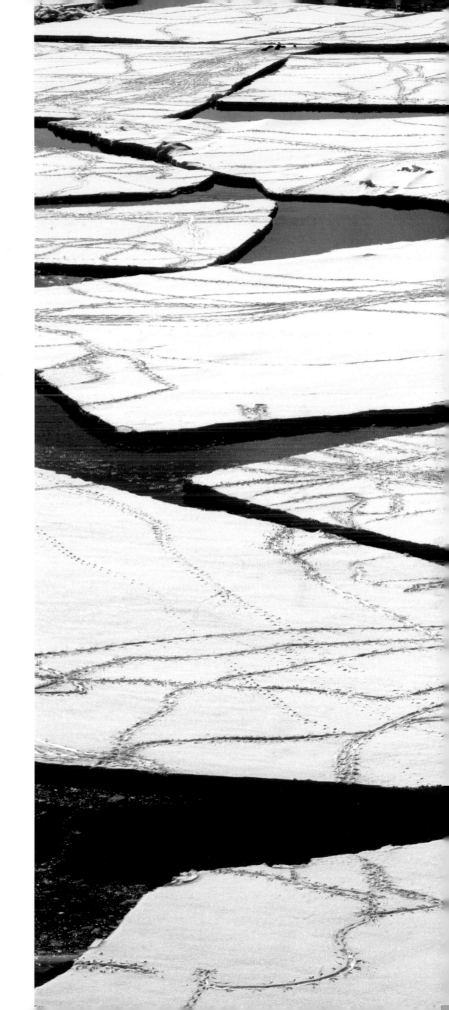

Opposite: **Adélie Penguin and tracks, Franklin Island** | Following Spread: **Emperor Penguin chicks and iceberg**

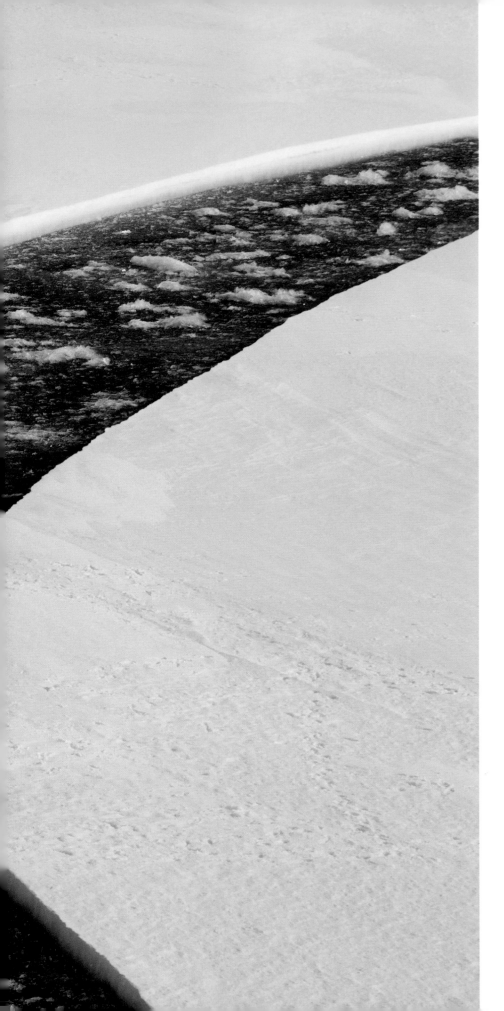

Emperor Penguins at the fast-ice edge

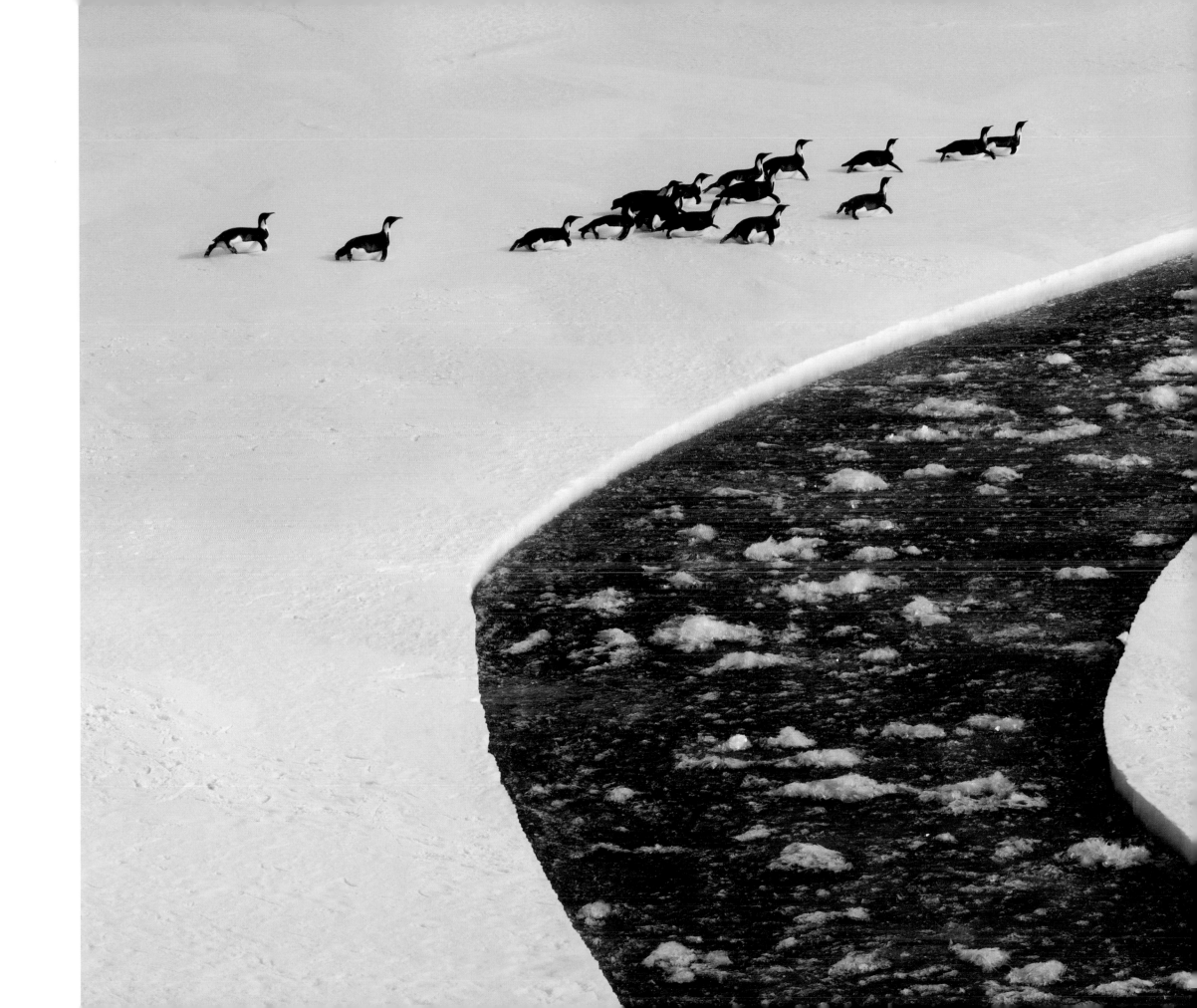

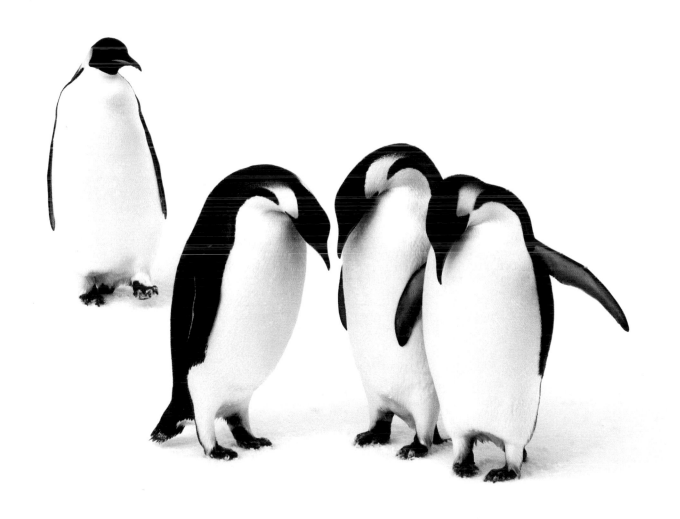

Opposite: **Minke whale along the fast-ice edge** | Following Spread: **Emperor Penguins** (left); **Emperor Penguin** surfacing after a dive (right)

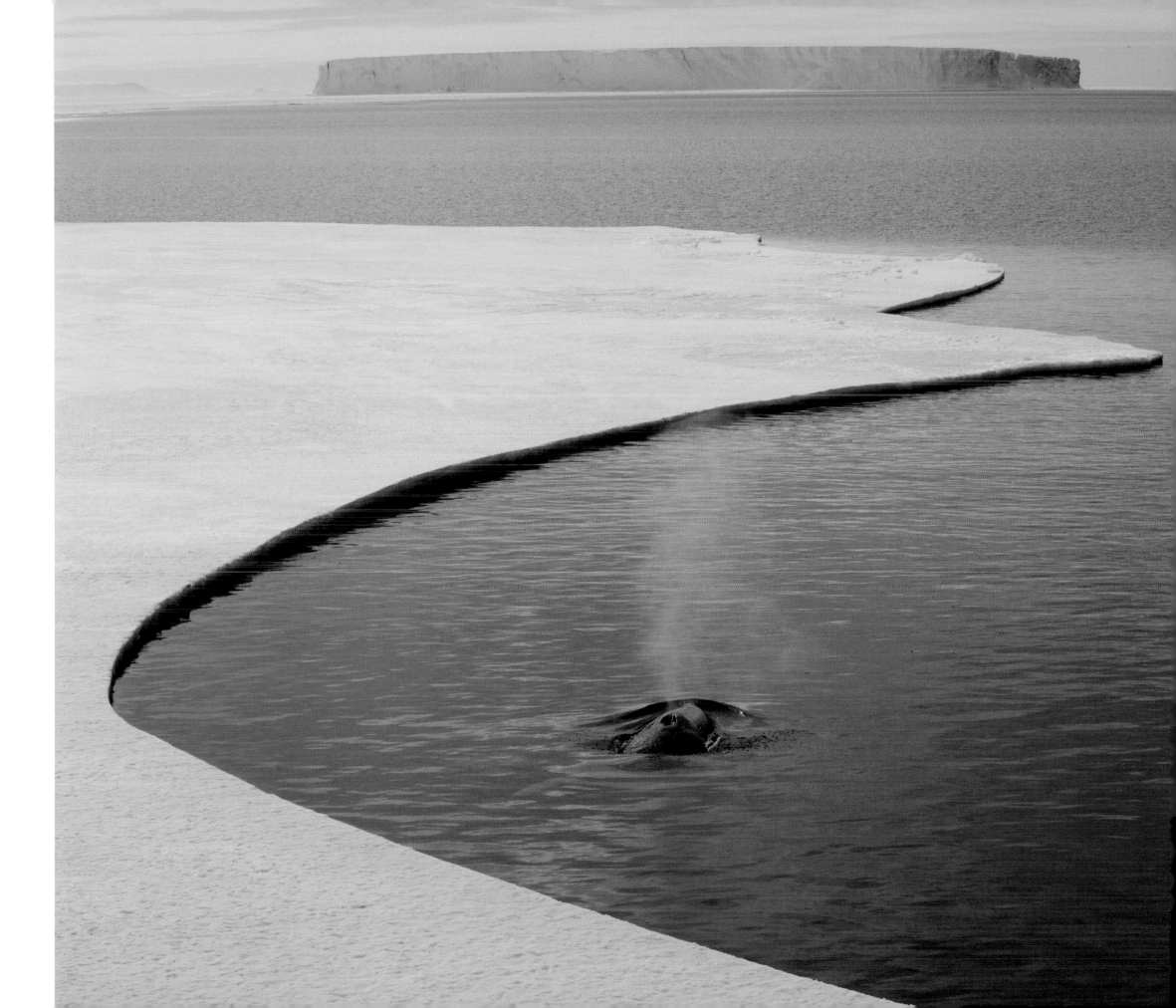

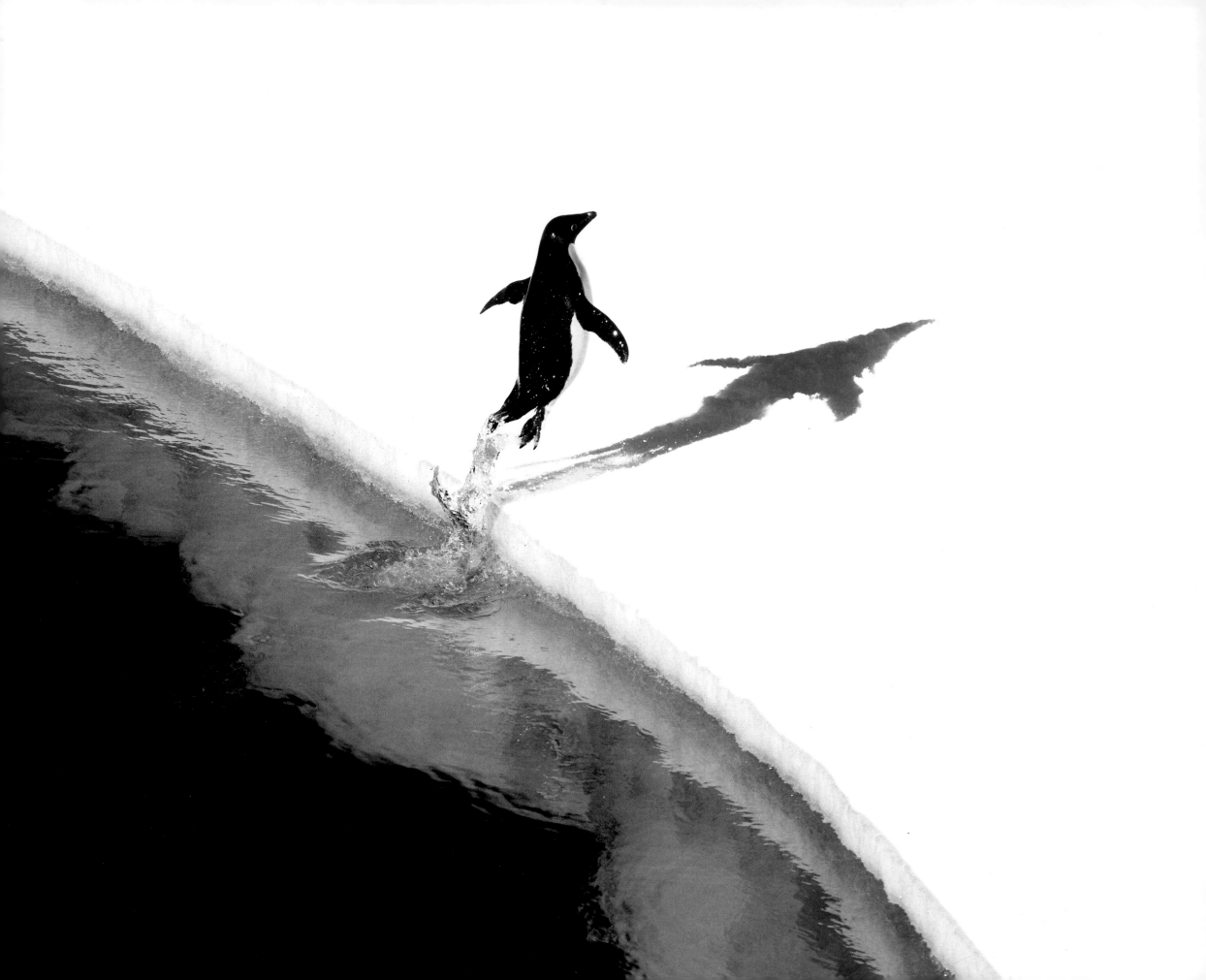

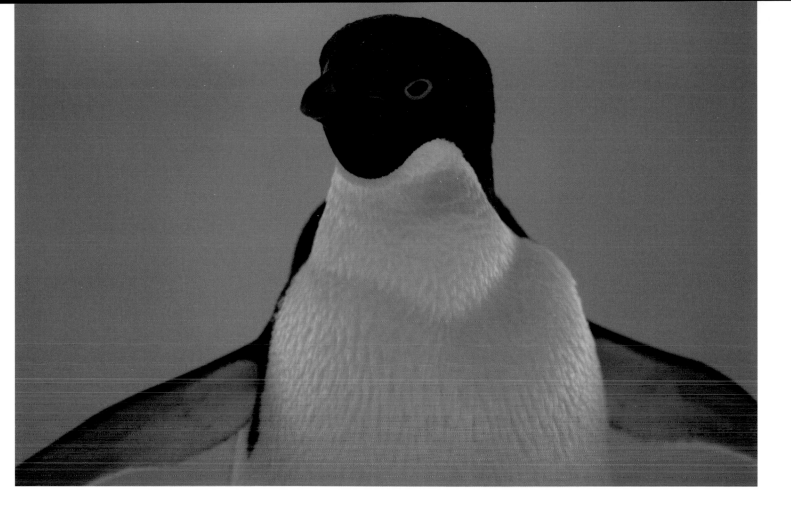
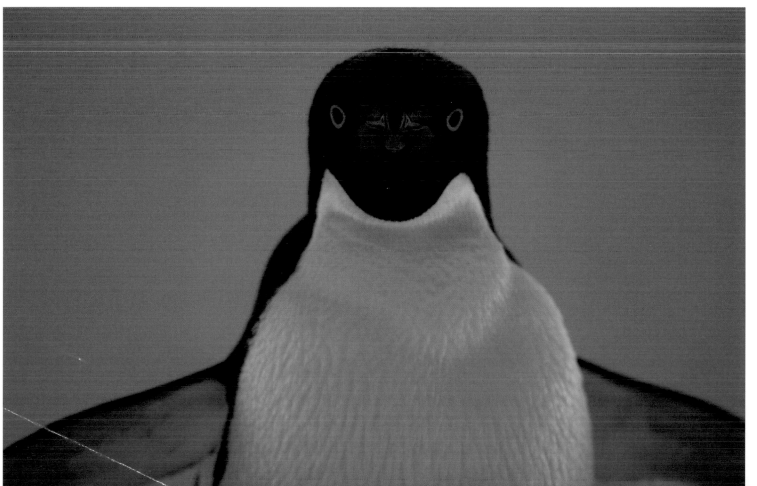
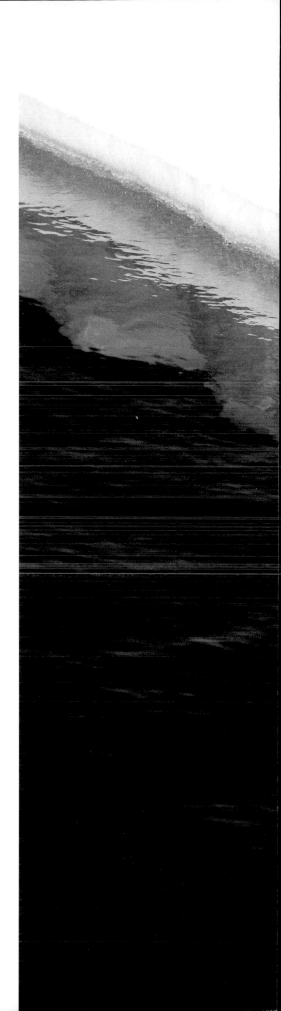

Opposite: **Adélie Penguins underwater** | Following Spread: **Adélie Penguin** (left); **Adélie Penguin launching onto the ice** (right)

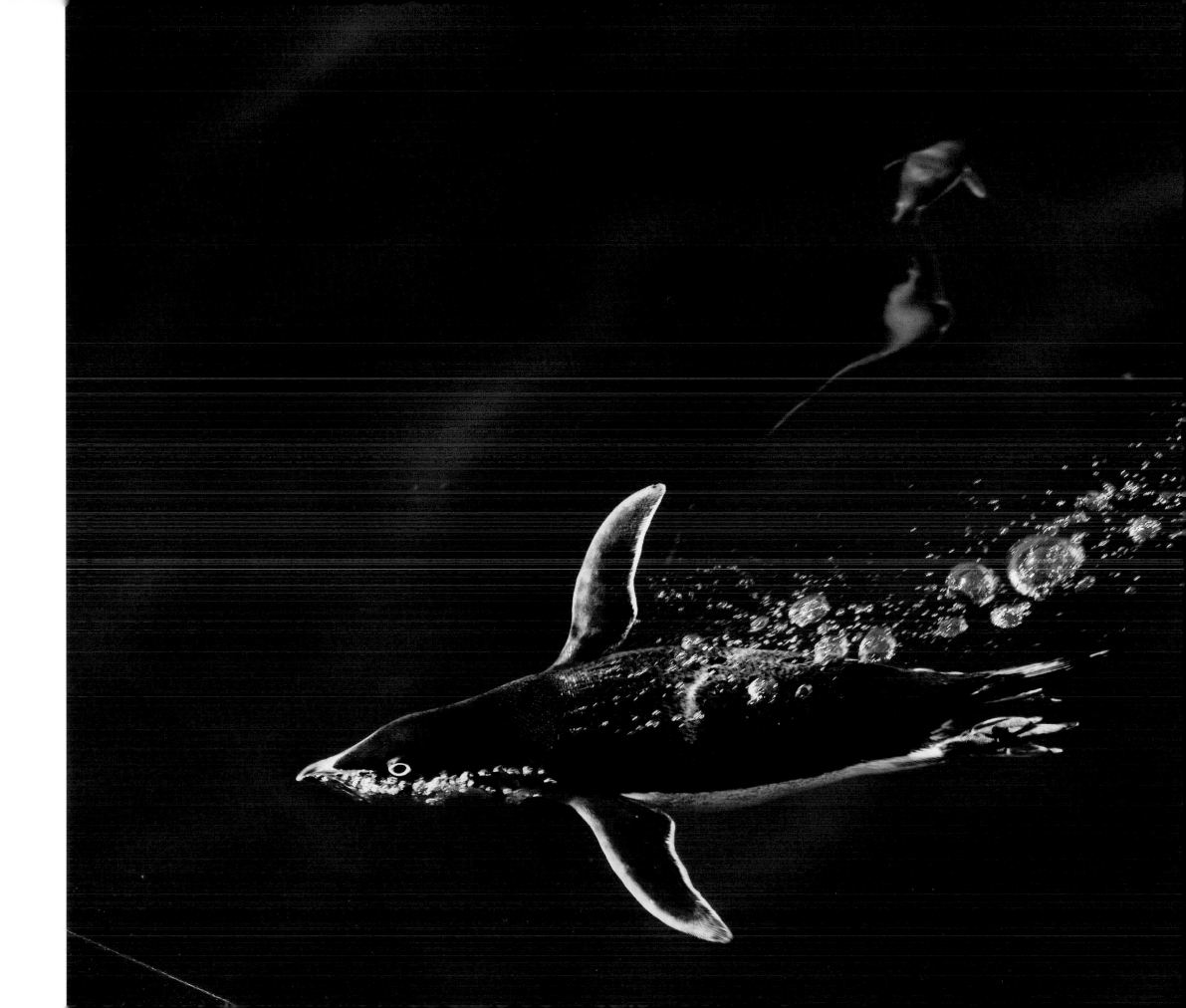

lost nearly half of their body weight. Incredibly, should the females' return be slightly mistimed, the males keep enough food in reserve to feed the chicks their first meal.

Alternating duties over the course of the next four months, the parents haul in more and more food to their chicks, and the young birds grow quickly. By December, the chicks have grown their adult feathers and head out to sea, staying in the northern reaches of the pack ice for five years before they return. In their absence the cycle continues, and in January, parental duties complete, adult birds gorge for a few weeks and then must fast again, waiting on the ice for a month as they molt and replace their all-important feathers. Protected by their new winter coats, the birds then have two months to put on weight before they walk back to the colony to start again.

But the birds' remarkable adaptations do not stop there. Emperors are the best avian divers in the world. They reach depths of 500 meters and dive times of up to 20 minutes. Just before a dive, a bird races its heart rate to 250 beats per minute, saturating its body with oxygen. As soon as it hits the water, the Emperor drops its heart rate back to 60 beats per minute, and continues to slow its heart over the course of the dive. On the longest of these dives, an Emperor can slow its heart rate to a mere six beats per minute, but as it explodes from the water, it again accelerates its heart, flooding oxygen back into its system. Physiologically, the bird endures the equivalent of a human heart attack on each dive with no ill effects.

THE SHIP BACKED OUT of its parking space late in the afternoon, and we left the circus behind, sailing northeast past the floating tabular bergs. Soon, a small black hump appeared far in front of us. Franklin Island seemed to grow out of the sea ice, finally revealing its true size as we drew close.

The ship sat nearly motionless in a slow tide of broken sea ice, creeping toward the shores of the black cliffs. The flow provided perfect dive platforms, and hunting parties from Franklin's western colony of 100,000 Adélie Penguins exploded from the water like so many corks, crash landing on the floating ice, leaving parts of their stories written in the snow.

As the flotilla of ice eased closer to the island, only one of the platforms remained disconnected from the entanglement of footprints, the proof of life. Engines rumbled and the ship fought inertia to back away from the island. At the same time, a lone Adélie popped out of the icy water onto a platform abutting the last untracked piece. The penguin tobogganed on its stomach to the closest edge, stood up, and jumped the small gap between the floating platforms. Tracks now connected every piece of the flotilla to the penguins' story. And as the bow of the ship slid backward past the scene, the penguin turned its attention, for the first time, to the tower of steel burping thick black smoke into the clear blue sky. Curiosity short-lived, the bird returned to its business, taking a few more steps before diving back into the sea.

Overnight, the ship broke its way through the pack, jagging northwest toward the towering mountains on the western edge of the sea. The East Antarctic Ice Sheet pushes against the backbone of mountains, overflowing and spilling down narrow valleys as glaciers, which in turn spill out to sea. The next morning we were drifting along another line of ice cliffs, the Drygalski Ice Tongue, terminus of the David Glacier, which rises 30 meters out of the water. The floating glacier tongue flows unevenly across its 20-kilometer width, and the resulting icescape, rolling ridges and bulges, can only be appreciated by helicopter.

The ship continued north along the western coast and parked in the fast ice only a few hours later off of Cape Washington. Again the ship was silent. Lines of adult Emperors slid on their bellies to and from their colony, 10 kilometers across the sea ice toward the black cliffs. Groups of juvenile birds, still dressed in their downy suits, also traversed the ice to the water's edge. Though they still had more than a month before they could safely make their first plunge, the young birds were already looking out to sea.

Wind blew plumes of snow off the tops of tabular bergs, locked in place by the fast ice, and Snow Petrels danced against backdrops of deep blue shadows as we walked across the ice from the ship to confront the giant blocks of ice. Light and shadow played across the ice, and the clouds raced.

Early the next morning, helicopters flew us inland toward the colony, depositing us at the base of a monolith of vertical black rock, with only a short walk to the birds. Emperors were spread out over the entire cape. Juvenile birds were testing their limits, climbing to the top of broken bits of bergs, also locked in by the ice, to look out over the scene. One large group had concentrated in the lee of a berg, and we approached slowly. Parents and chicks know each other's unique voices and reunite by calling back and forth when the adults return with food. As we skirted around the base of the berg, the concert of several thousand voices reflected off the wall of ice behind us, so we sat and listened in stereo. Moments before we had to leave, a single downy chick approached us curiously, stopping only a few meters away. It puffed out its chest, pointed its wings to the ground, and threw its head back, beak pointing straight for the sky.

MORE PROFOUND BEAUTY lay ahead of me, more moments of stillness, more audacious displays of grandeur and abundance: Adélies scrambling over great flows of broken ice; pods of killer whales cruising the edges of giant bergs; and long nights on deck, watching the ice and sky. But the image of that Emperor chick will never leave me, its head thrown back as if to announce its existence, demanding that we pay attention, recognize our own path of destruction, and tread lightly in this last pristine place.

The ship finally cut through the edge of the pack ice and into the open ocean, leaving the frozen world behind. But my journeys into the Ross Sea were just beginning. I would return once more by ship, but even during that second great voyage I ached to see the other side of the place, and would have done anything for just one peek under the ice.

presided over McMurdo Sound, the far southwest corner of the Ross Sea. At the center of the crater is an exposed lava lake, one of only a few in the world. At times, it erupts as frequently as twice a day. Mount Erebus is the southernmost active volcano in the world, anchoring a series of extinct volcanic domes that extend from the southwestern corner of the Ross Sea in a straight line, rising high above the icy water to form the black rock cliffs of Beaufort and Franklin Islands to the north.

But for the time being, our attention was focused to the south, and as we passed Cape Bird on the northern tip of Ross Island, McMurdo Sound stretched out in front of the ship. Unbroken sea ice covered the entire embayment—from the shores of Ross Island on its eastern side to the slopes of the Transantarctic Mountains, which run like an exposed backbone along its western edge—in a stark white blanket. The unbroken sea ice cut a clean line across the sound, and as we reached the edge, the ship carefully pushed forward, wedging itself into the immobile ice. After nearly three weeks of continuous noise and motion, the captain cut the engines, and everything was quiet and still.

We ate dinner, and the crew lowered a long metal staircase over one side of the boat. I filed down the stairs with the other passengers, stepped off onto the sea ice, and stood on the frozen sea over 200 fathoms of icy water. Tony Dorr, one of the expedition guides, had marked off a safe area of ice with flags. I picked the spot closest to the water's edge and sat down, resting easily in my thick goose-down pants. An hour later, only Tony and I were left on the ice, and we both sat alone in the late evening light.

A small group of Adélies popped out of the water onto the ice and made a beeline for me. The penguins had no fear as they approached. They waddled to within an arm's length, surrounding me, and settled down in a comic shuffling of positions as they yawned, preened, and stretched. Eventually they puffed out newly manicured feathers against the cold and slowly fell asleep, standing around me on the ice. Tony caught my eye just before midnight and signaled. The birds barely stirred as I inched away, slowly stood, and returned to the ship.

At 4:30 a.m. the next morning the sea ice glowed cyan, and the show had already started. The Ross Sea comprises only 3.2 percent of the Southern Ocean, but owing to its rich waters, it is home to a hugely disproportionate number of animals—38 percent of all Adélies, 26 percent of all Emperors, 30 percent of all Antarctic Petrels, 45 percent of Weddell seals in the Pacific Sector of the Antarctic, and the list goes on. In that day of stillness parked in the ice, everywhere I looked I saw more life, and the animals performed.

Throngs of Adélies rocketed past the edge of the ice just under the surface, trailing long bridal veils of white bubbles in the cerulean blue. They launched out of the water in waves, accelerating past any leopard seals that may have been lurking, waiting for a meal. More Adélies crowded together in groups at the ice edge, pushing and shoving until one of the penguins finally took the plunge, leading the way for its entire group.

A pod of killer whales surfaced in quick succession, sending the remaining groups of penguins scampering away from the ice edge. A lone minke whale surfaced at nearly the same time, just west of the orcas, sweeping up krill along the edge, and then slid smoothly back underwater.

Snow Petrels floated on their paper wings, and Antarctic Petrels whizzed by, just above the water. Lines of Emperor Penguins tobogganed in from the east on their bellies, planted their beaks in the ice, and pushed themselves into standing positions. Facing pairs of Emperors bowed to each other, then threw their heads back and let loose their ancient songs to the sky.

The day grew warm, and the Adélies and Emperors zoomed around in crisscrossing shallow dives directly behind the ship, resurfacing, preening, talking to each other, and then diving again. Orcas and minkes returned again and again over the course of the day, each salty breath sending waves of penguins erupting out of the water and onto the ice.

Tabular icebergs floated in the open water to the north. Still more were grounded along the western edge of the sound, dwarfed by the Transantarctic Mountains. To the east, the northern tip of Ross Island sloped into the sea, and Mount Erebus loomed through the clouds. In the few moments during the day when the water behind the ship was free of penguins and whales, it smoothed nearly to glass. A few ripples lapped softly at the edge of the ice, the only sound save my own breathing and the occasional chilling calls of crooning Emperors standing on the ice. The word idyllic does not cover it, this place was perfect.

As the ship had nosed in and parked the night before, it had cracked a section of the stable fast ice. The newly free-floating island of sea ice slowly drifted away, opening a short, curving channel filled with a slushy brown soup of phytoplankton and platelet ice. Hunting under the channel must have been good, because whole lines of Emperors slid headfirst into the slush, disappearing without a trace.

The life cycle of the Emperor Penguin is a well-known legend. As the Antarctic winter approaches, the birds walk hundreds of kilometers over the fast ice to breed in sheltered colonies on sea ice itself, picking locations where the ice remains locked in place almost all year by capes and grounded icebergs. Sheltered is a relative term. In the long months of night, temperatures regularly drop to -40°C, and winds can race at speeds of more than 200 kilometers per hour. Through it all, the Emperors stand on the fast ice huddled together, bracing against the cold. Females each lay a single egg in May and then transfer the precious package to their mates. After nearly two months of fasting, the female birds lose an average of 25 percent of their body weight, and they make the long trek back to the few open pockets of water—the coastal polynyas, kept free of ice by katabatic winds—to feed. The males, however, must stay to incubate the eggs, holding them on their feet, guarding them until they hatch in mid-July. The females bring stomachs full of krill and fish back to the colony, timing their return to coincide with the hatching chicks, and take over parenting. By this time, the male penguins have fasted for almost four months and

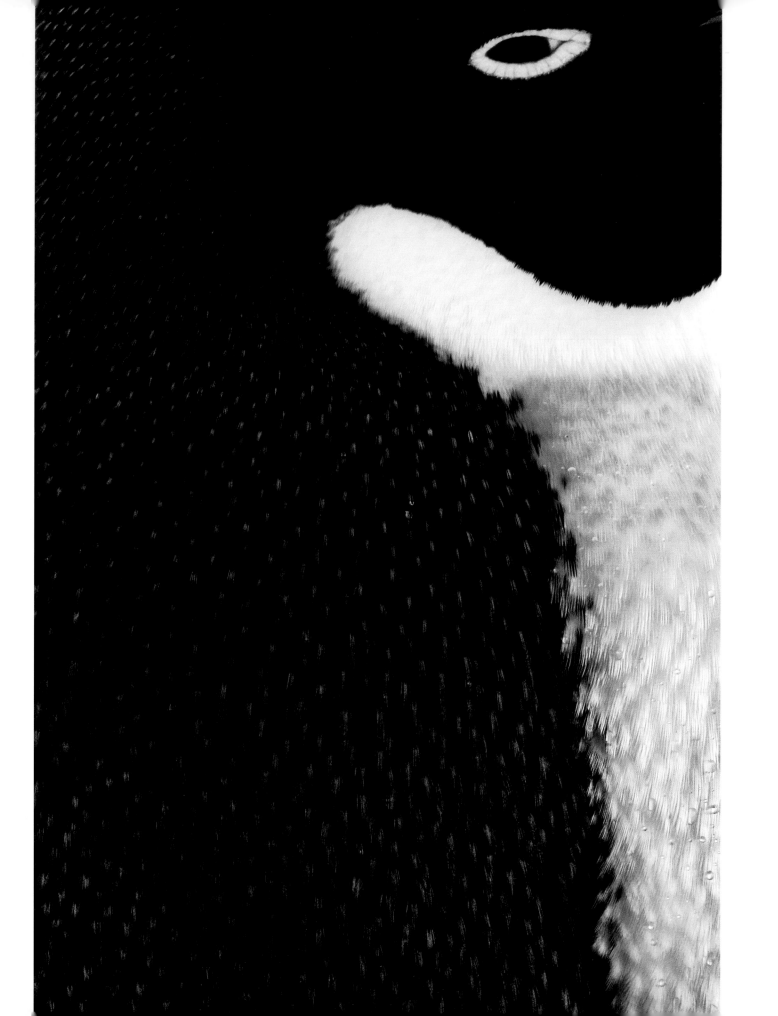

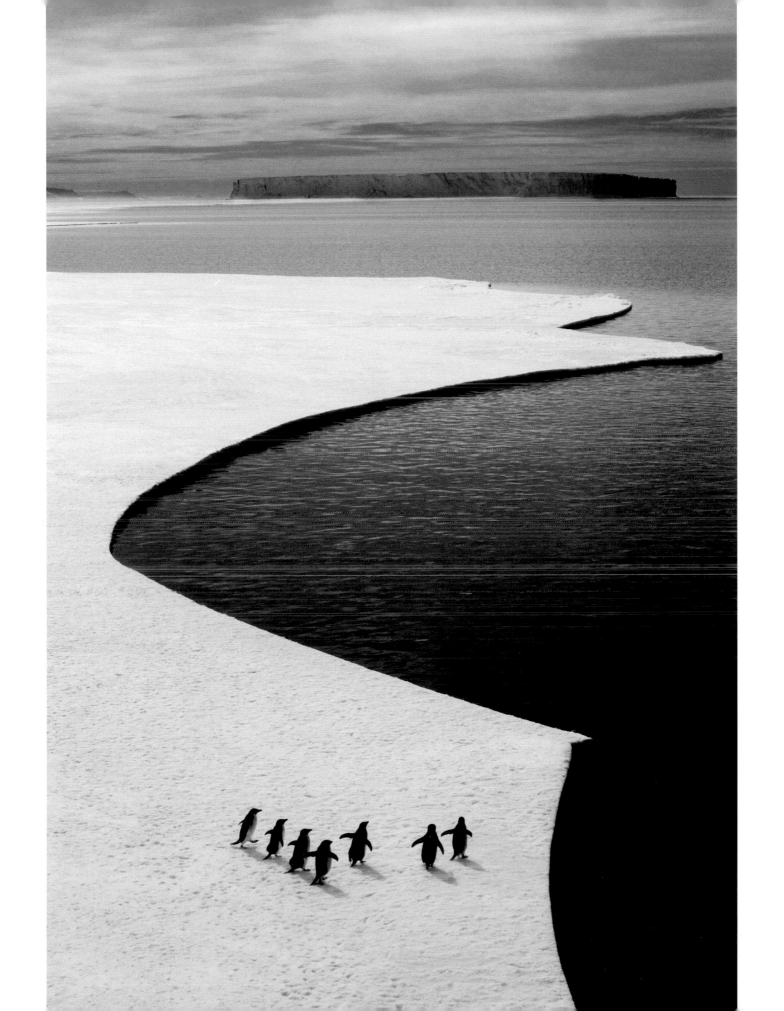

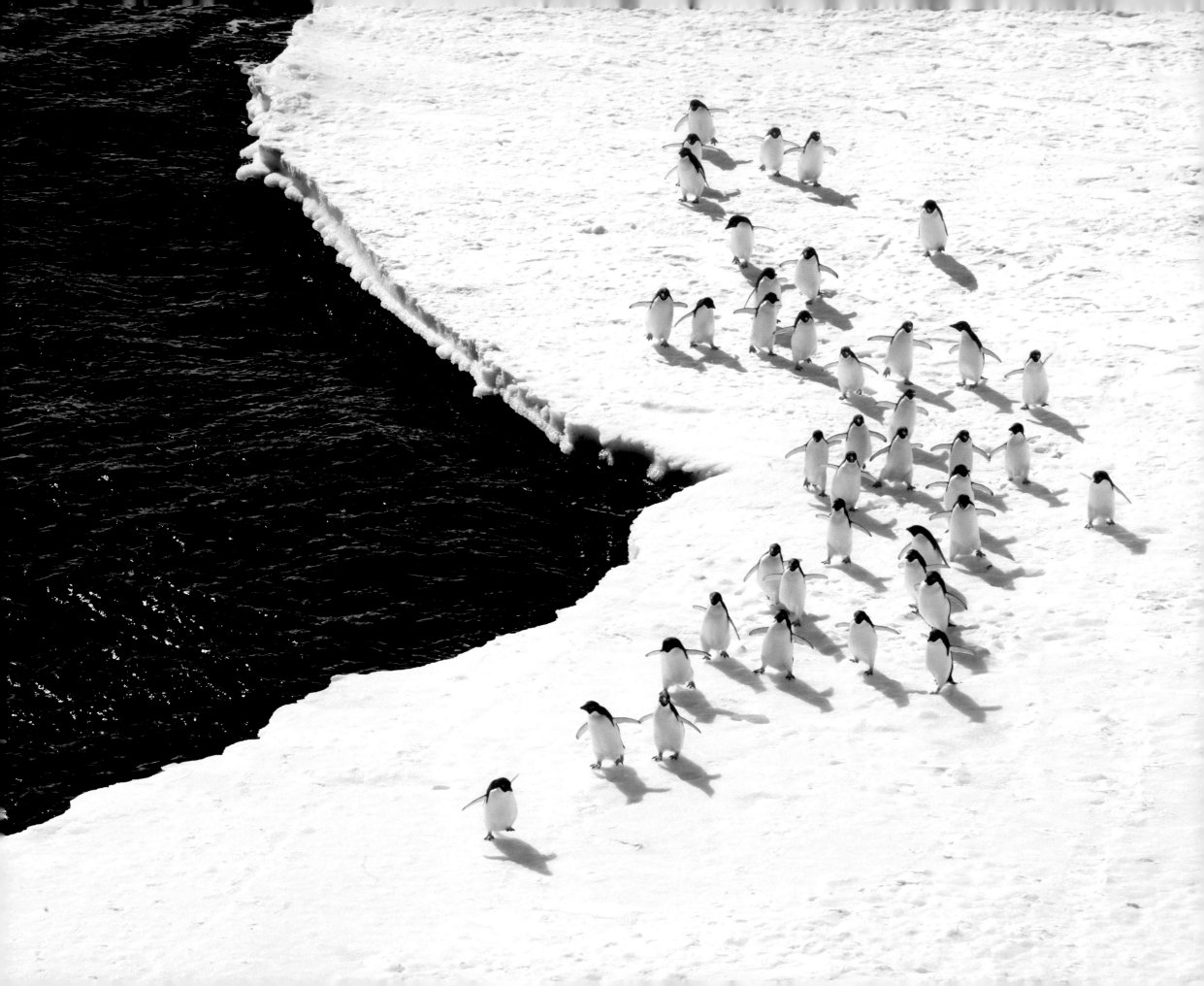

LIFE AT THE MARGINS

The ship paralleled the Ross Ice Shelf for two days. I moved inside as the weather changed and snow blew sideways across the deck. The katabatic winds had started again, pumping new sea ice out into the Ross Sea and heavy water to the bottom of the ocean. I sat in the bar, looking out on the blizzard, again lost in my thoughts, until a rough hand gripped my shoulder.

Alexei Andreyev was one of the ship's helicopter mechanics, and he kept odd hours. I spent most nights on deck, moving my tripod and cameras around from place to place on the ship, looking for photographs in the rich light. Often I was alone, but it was not unusual to see Alexei in the middle of the night, his hands clasped behind his back and his head bowed, talking to himself as he walked around and around the helicopter pad on the back of the ship. One night, I got an idea for a photograph from the level of the pad, which provided a unique elevation above the ice, and walked back with my gear to work on the image. Alexei was there, deep in his ritual. I didn't want to disturb him, but somehow I was transfixed for a moment, and I stood off to the side and watched him walk and mutter. I was about to leave when he looked up and saw me. He looked mildly embarrassed for only a second, and then he broke into a wide grin. "Poetry," he said. We became friends.

Alexei released my shoulder, asked me to come with him, and led me down a series of internal staircases into the bowels of the ship. I knew where we were going because of our conversation the day before. We were on our way to meet the engine doctor. We passed by the engine control room, with its monolithic bank of gauges and blinking lights straight out of a James Bond film, then into the engine room itself. The six giant gray and green diesels clicked, clanked, and thumped in nonrepeating overlapping patterns, and though the sound was deafening, it was also uplifting, like amplified African drums. We turned another corner and passed two-meter-tall spare pistons, spare propeller blades the size of conference tables, and masses of coiled cables and greasy equipment. Then I saw him—an unassuming man, perhaps in his late 50s, sitting at an immaculate workbench. Hanging from hooks on a large pegboard above his work area were 10 stethoscopes, but instead of ending in the familiar flat diaphragms, these earpieces were attached to long needles of varying sizes.

This man's job was to monitor the health of the engines and catch problems before they happened. He did it by ear. He knew the machines so well that by placing the appropriate gauged needle on the right spots, he could listen inside the engines, identifying misaligned rhythms before any modern diagnostics could detect an issue. Through Alexei, I thanked him for keeping us safe. I still wonder what he hears when he listens to the music of those engines.

THE WEATHER BROKE AGAIN, and we finally passed by the great cliffs of ice and around the northern tip of Ross Island. The landscape was a synthesis of fire and ice. Mount Erebus, 3,800 meters high,

Opposite: **Adélies on the fast-ice edge** | Following Spread: **Adélies on the fast-ice edge** (left); **Adélie Penguin detail** (right)

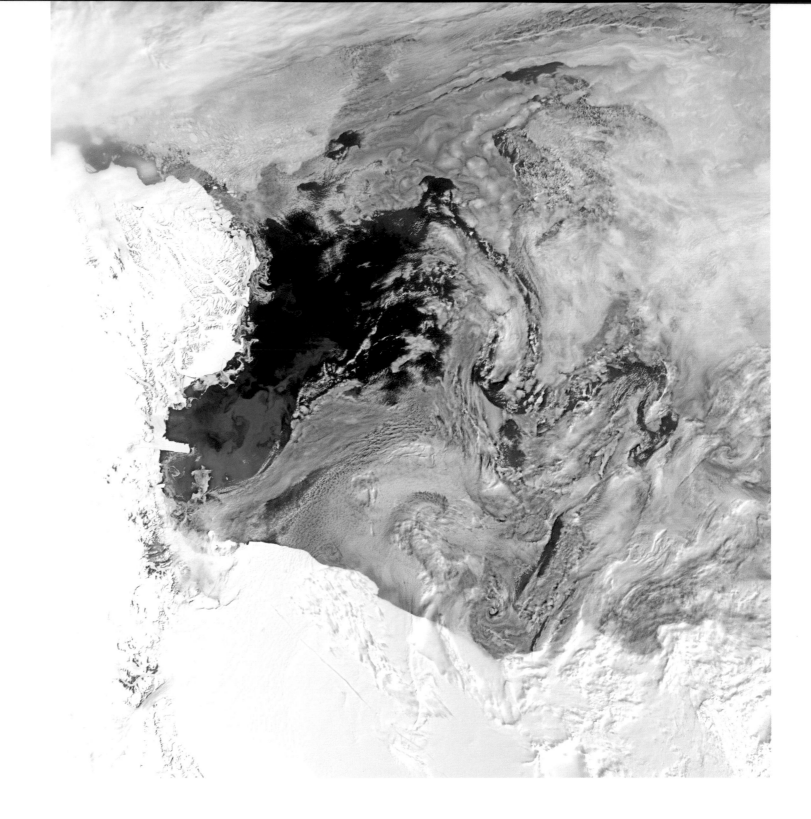

Opposite: *Phaeocystis antarctica* under a microscope | Above: The Ross Sea phytoplankton bloom from space

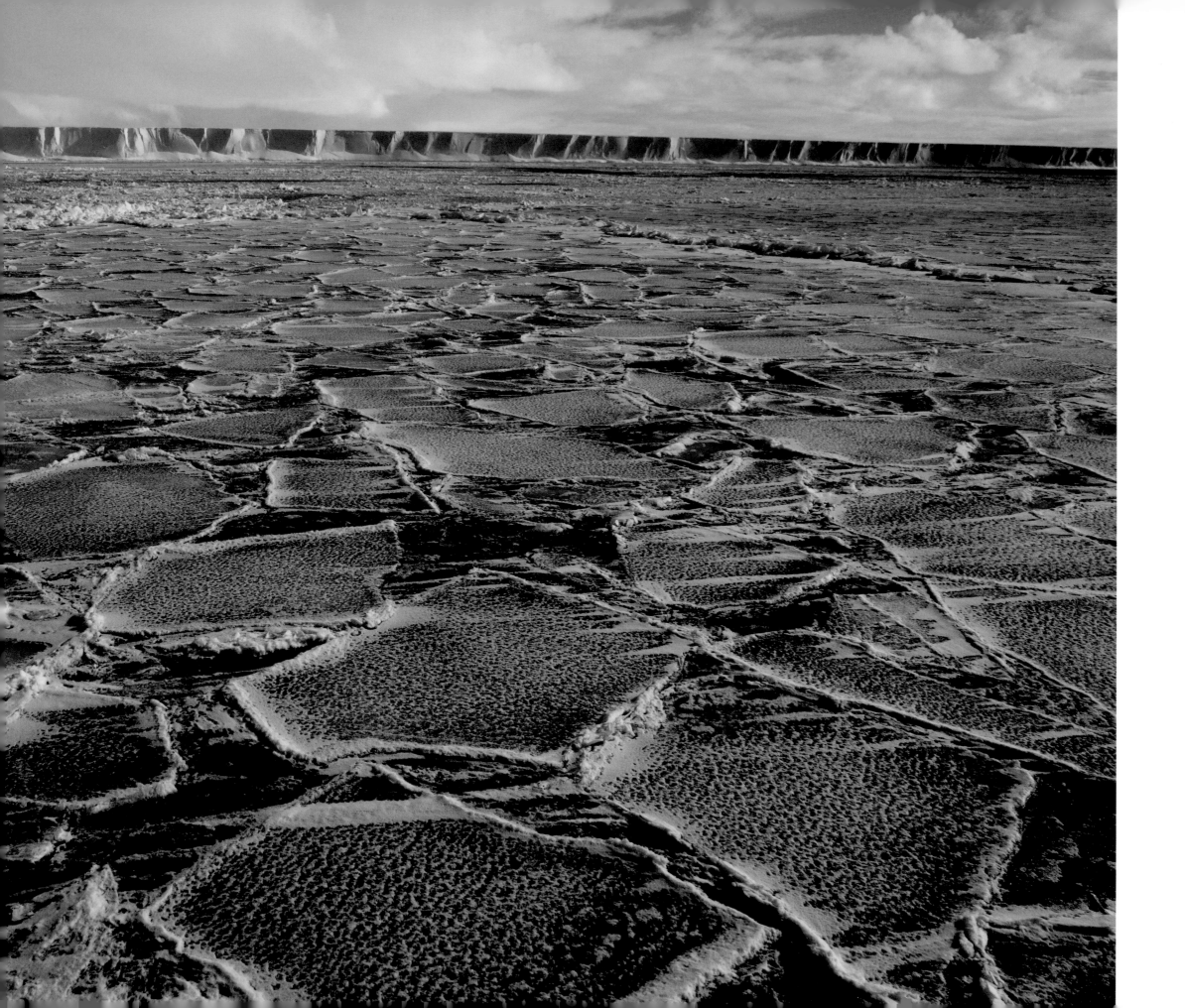

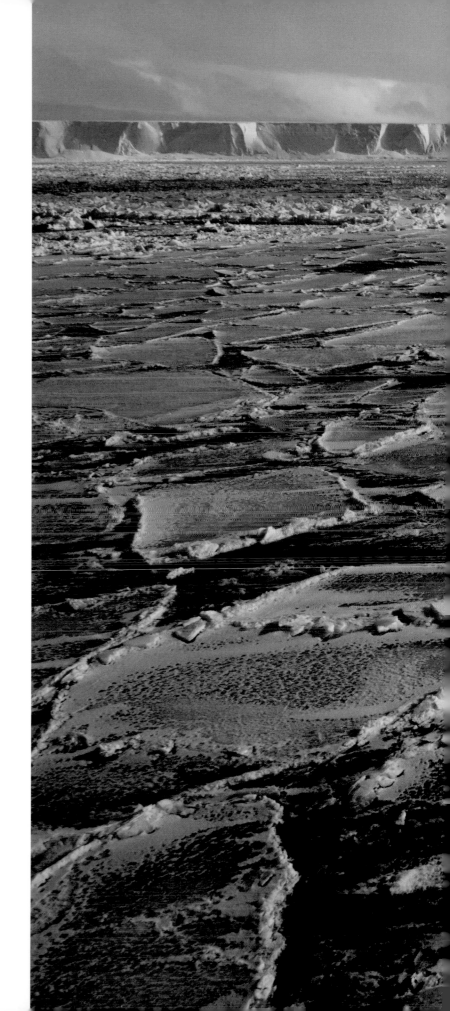

New sea ice forming in the Ross Sea Polynya

As seawater freezes into sea ice in the polynya, it drops most of its salt into the water column below. This extremely cold, salty water is the most dense seawater on Earth—even denser than the North Atlantic Deep Water that forms off the coast of Greenland, flows south down the coast of the Americas, and makes up the bottom layer of the Antarctic Circumpolar Current (ACC) that encircles Antarctica. Thus, the frigid, salty water in the polynya sinks down, flooding off the Antarctic continental shelf, and spreads across the very bottom of the ocean. The Ross Ice Shelf produces approximately one-quarter of all Antarctic Bottom Water, but ice shelves all around Antarctica contribute to this flood, which spreads north, filling in the deepest parts of the Southern, Indian, Pacific, and Atlantic Oceans. As the Antarctic Bottom Water flows under the ACC, it lifts the entire layered stack of water masses, and they angle toward the surface like the uplifted layers of a mountain ridge, setting the stage for one of the most important processes in the global ocean.

Directly around the continent, south of the ACC, another ocean current encircles Antarctica. This surface current flows west, and where it meets the southern edge of the eastward-flowing ACC, the surface waters diverge. Surface water south of the Antarctic Divergence moves south. Surface water north of the divergence moves north. Thus, the sea opens, allowing the North Atlantic Deep Water, already uplifted by the ultra-dense Antarctic Bottom Water spilling off the continental shelf, to rise from the depths and break the surface close to Antarctica.

At the surface, the North Atlantic Deep Water mixes with relatively fresh water from the continent and forms a new, lighter mass of water. This new water mass, Antarctic Surface Water, moves northward over the surface of the ocean, spreading out from Antarctica until it meets the even lighter Subantarctic Surface Water roughly 1,500 kilometers north of Antarctica, and sinks again, this time forming a mid-water layer. As the North Atlantic Deep Water rises from the depths, moves north along the surface, and folds back into the middle layers, the entire Southern Ocean is turned upside down.

As the ocean turns over, the deep water brings sunken nutrients, absorbed during its long journey south in the deep oceans, back to the surface. Then, during its relatively short stay on the surface as it spreads north from Antarctica, the water absorbs atmospheric gases, including oxygen and carbon dioxide. When it sinks again, undercutting the Subantarctic Surface Water, it takes the dissolved gases with it into the interior of the ocean. Dissolved oxygen is critical to marine life, and the dissolved carbon dioxide is sequestered far below the surface, buffering the effects of climate change. The overturning of the Southern Ocean is linked to all major global oceanic and atmospheric patterns, and it all starts in the polynyas.

And the Ross Sea Polynya has one final gift to give. In that pool of open water, with its upwelling of nutrients, a floating forest of phytoplankton blooms as the sun rises in the spring, dwarfing the bloom that occurs under the sea ice itself. Thus, the shelf and polynya feed every animal that lives in the Ross Sea, and fresh food, as it turns out, is delivered by the wind. The bloom in the Ross Sea Polynya is so large and dense that it can be seen from space.

As the captain pulled the ship away from the Ross Ice Shelf and started the long journey west along the cliffs of ice, I cleared my mind, put down my camera, and let myself just enjoy the view of the wall at the end of the world.

New sea ice forming in the Ross Sea Polynya

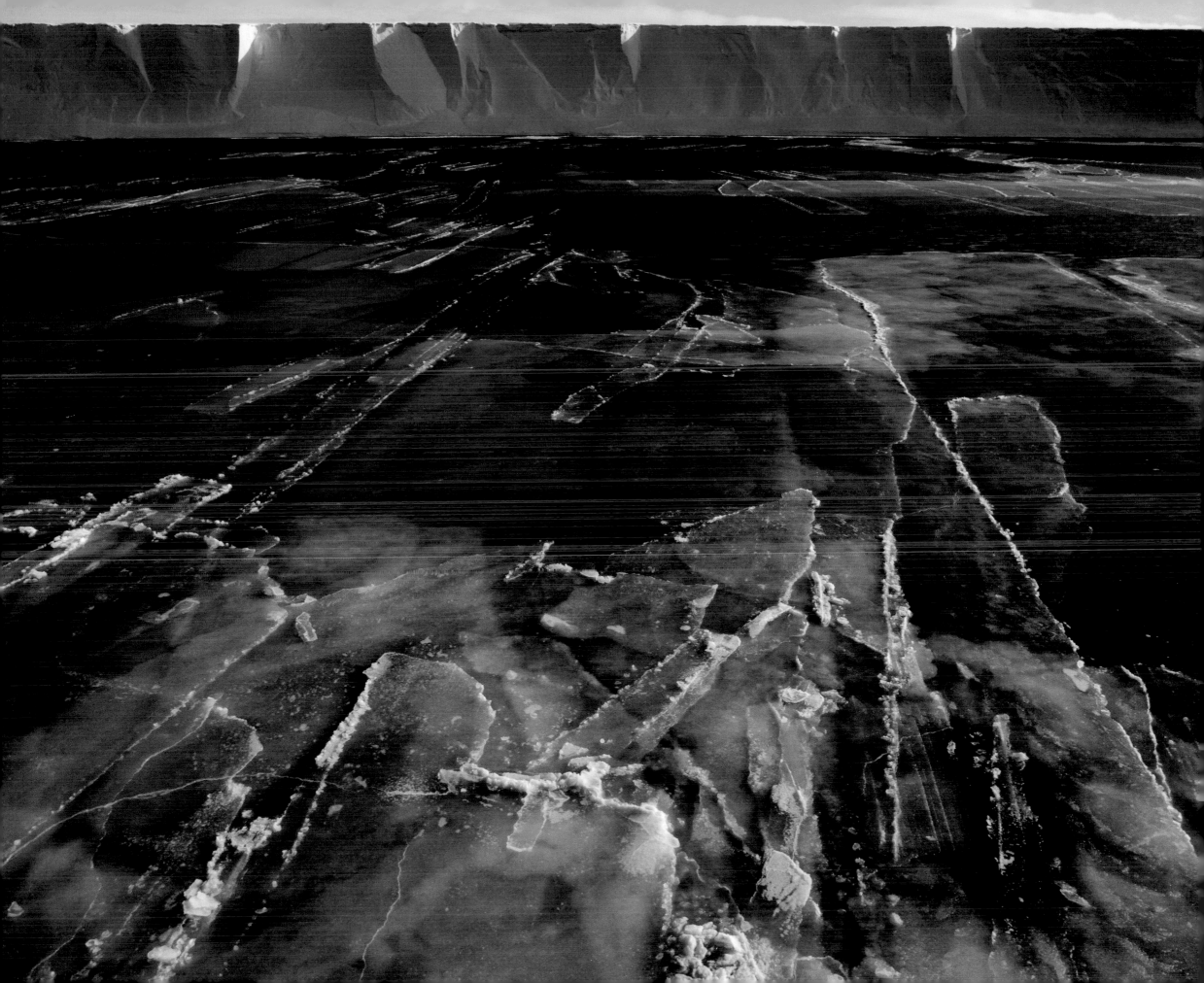

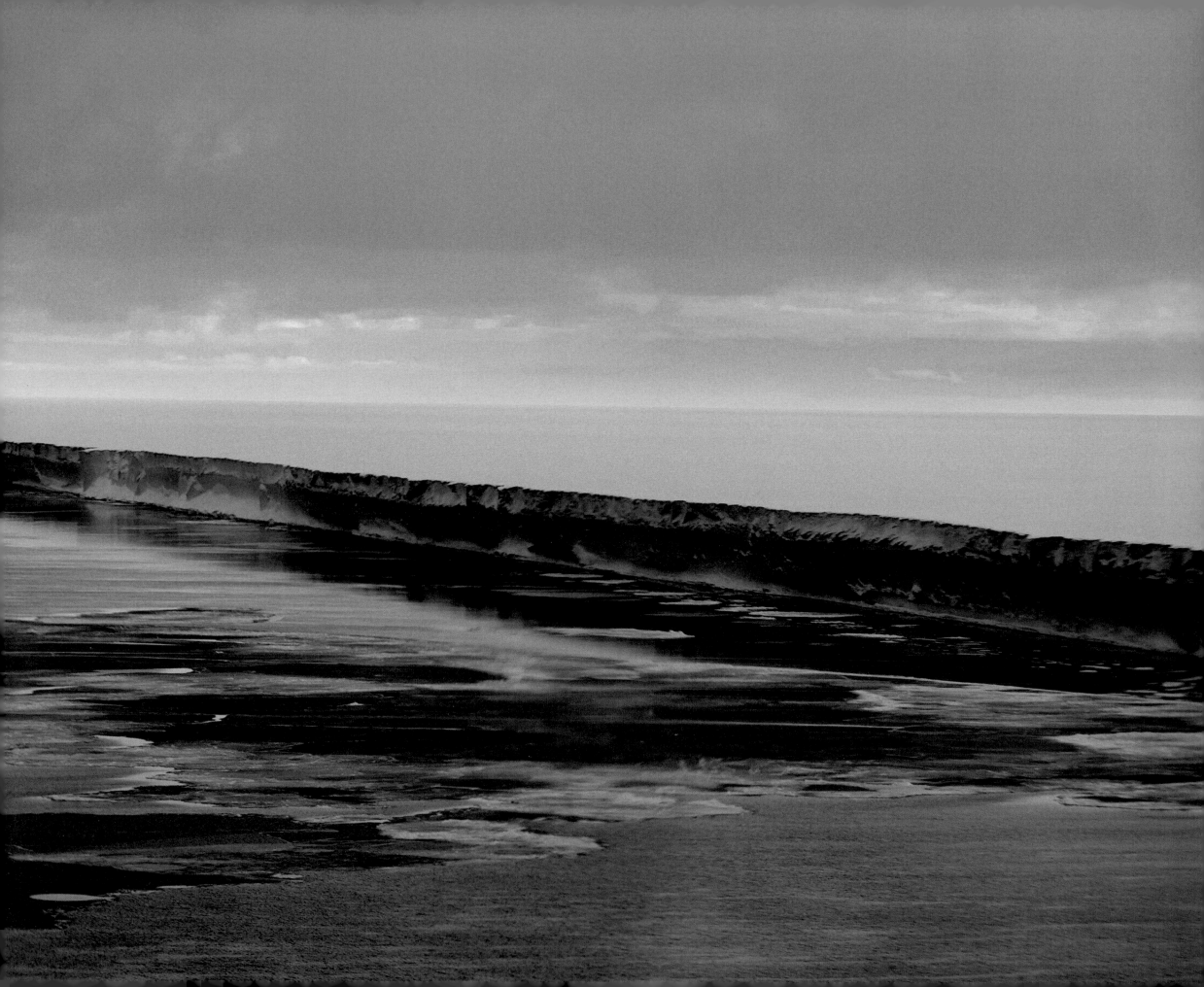

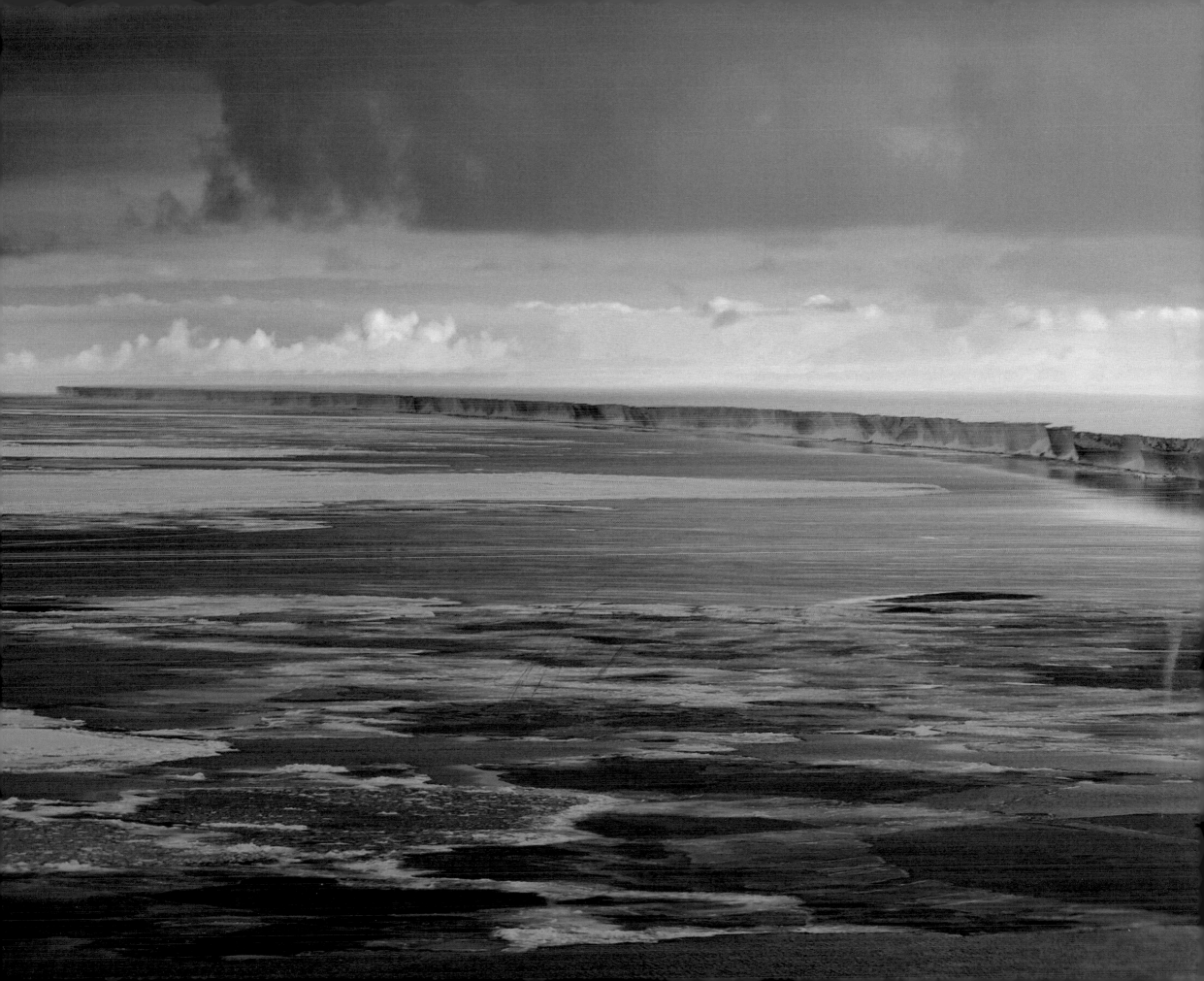

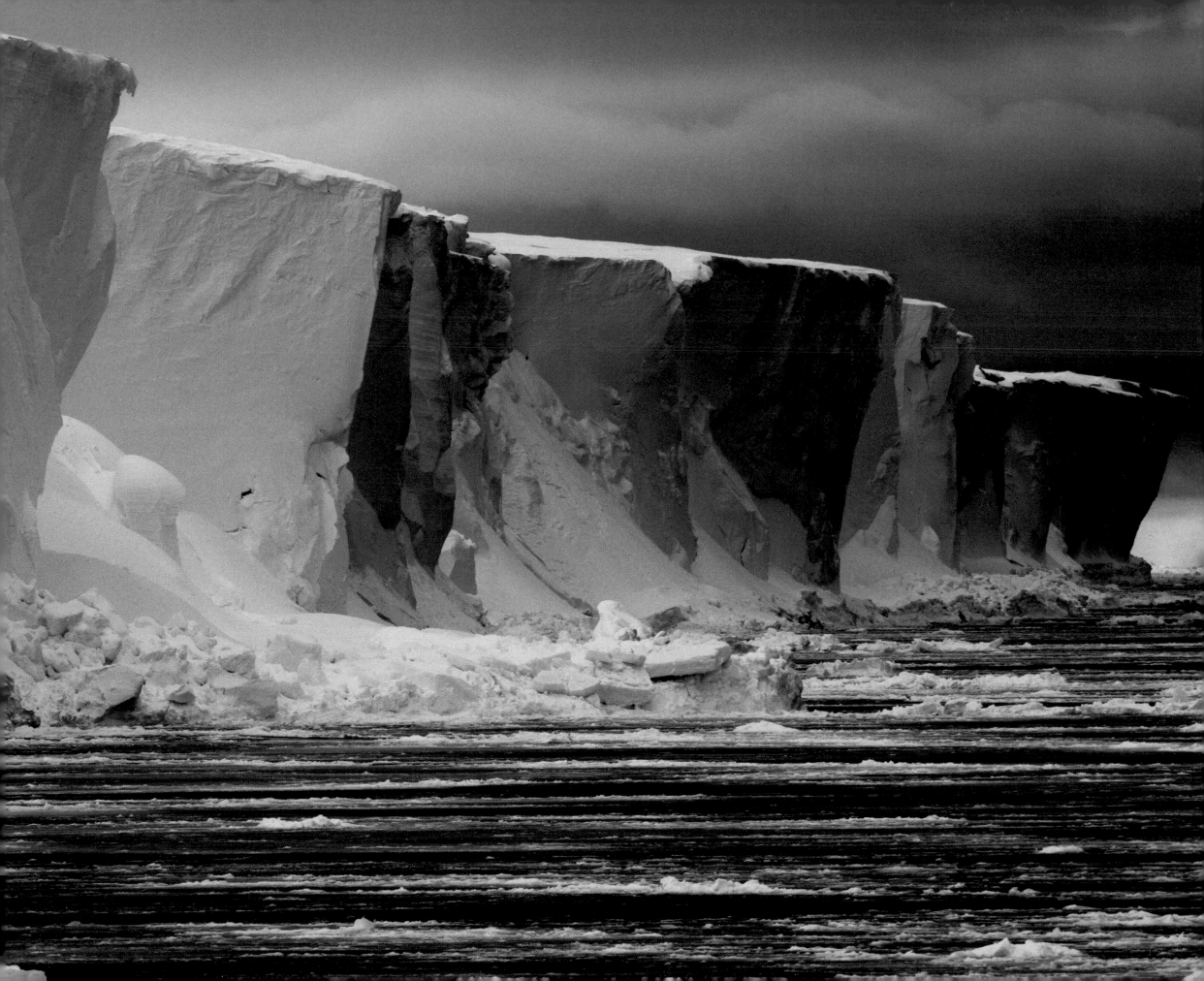

THE WALL AT THE END OF THE WORLD AND THE UPSIDE-DOWN OCEAN

Over the course of the next day, the thin white line grew more distinct, resolving into a wall of ice cliffs, towering 50 meters above the sea and plunging 450 meters below the water, dwarfing the ship as we finally approached. We had reached the Bay of Whales, the end of the Southern Ocean, the farthest south you can go on water.

The immensity of that wall of ice is beyond my ability to describe. The Ross Ice Shelf floats over the entire southern third of the Ross Sea. Dozens of glaciers—frozen rivers from the West Antarctic Ice Sheet—spill down the Transantarctic Mountains, converging into this massive flood of ice. The line of cliffs is 800 kilometers long. The shelf is up to a kilometer thick, and the size of France. But numbers cannot possibly do justice to the power it holds over the mind.

As the ship nosed slowly toward the cliffs of ice, I could not help but think back to the great explorers that had entered this most southern spot—James Clark Ross, who in 1841 discovered the Ross Sea, then sailed his wooden ships, *Erebus* and *Terror*, along the "Great Southern Barrier" and into the Bay of Whales with only the power of the wind; Ernest Shackleton, who visited in 1908 on his way home after his record-breaking overland trek to within 156 kilometers of the South Pole; and, Ronald Amundsen, who anchored his ship *Fram* at latitude 78°41' south in the Bay of Whales, a record that stood from 1911 to 2006. My thoughts spun, not because of the overwhelming size of the Ross Ice Shelf or the nobility who had seen the great wall, but because of the profound effects the shelf has on both the Ross Sea and the entire global ocean.

The nomadic icebergs in the Ross Sea are borne from the Ross Ice Shelf. Advancing three meters every day, the line of cliffs pushes forward until the shelf calves, releasing the enormous bergs. In March 2000, B-15, the largest iceberg ever recorded, broke off of the shelf and floated out to sea. It was bigger than the country of Luxembourg, and it drifted in the Ross Sea for years, changing weather and currents, disrupting biotic rhythms, and slamming into other ice titans. One collision broke off the tip of the Drygalski Ice Tongue. Maps had to be redrawn. The berg finally drifted north, breaking into smaller and smaller sections as it went. Pieces of the berg were spotted off the coast of New Zealand in 2006. As of November 2011, seven pieces of the berg were still floating in the Southern Ocean.

However, the Ross Ice Shelf produces more than just icebergs. Unobstructed by obstacles, winds race down from the high Antarctic plateaus, gaining speed over the vast, flat shelf until they shoot off the edge of the cliffs at 200 kilometers per hour and out across the Ross Sea. These katabatic winds push the blanket of seasonal sea ice away from the edge of the shelf, creating a large pool of open water—a polynya—even when the rest of the sea is covered in ice. But sea ice continues to form in the open water, and eventually more winds push this ice out to sea as well. Thus, the Ross Ice Shelf is actually a sea ice factory, pumping out an annual load of nearly 200,000 square kilometers of two-meter-thick sea ice into the Ross Sea. And this is still just the beginning of the story.

Opposite: **Cliffs of the Ross Ice Shelf** | Following Spread: **The Ross Ice Shelf**

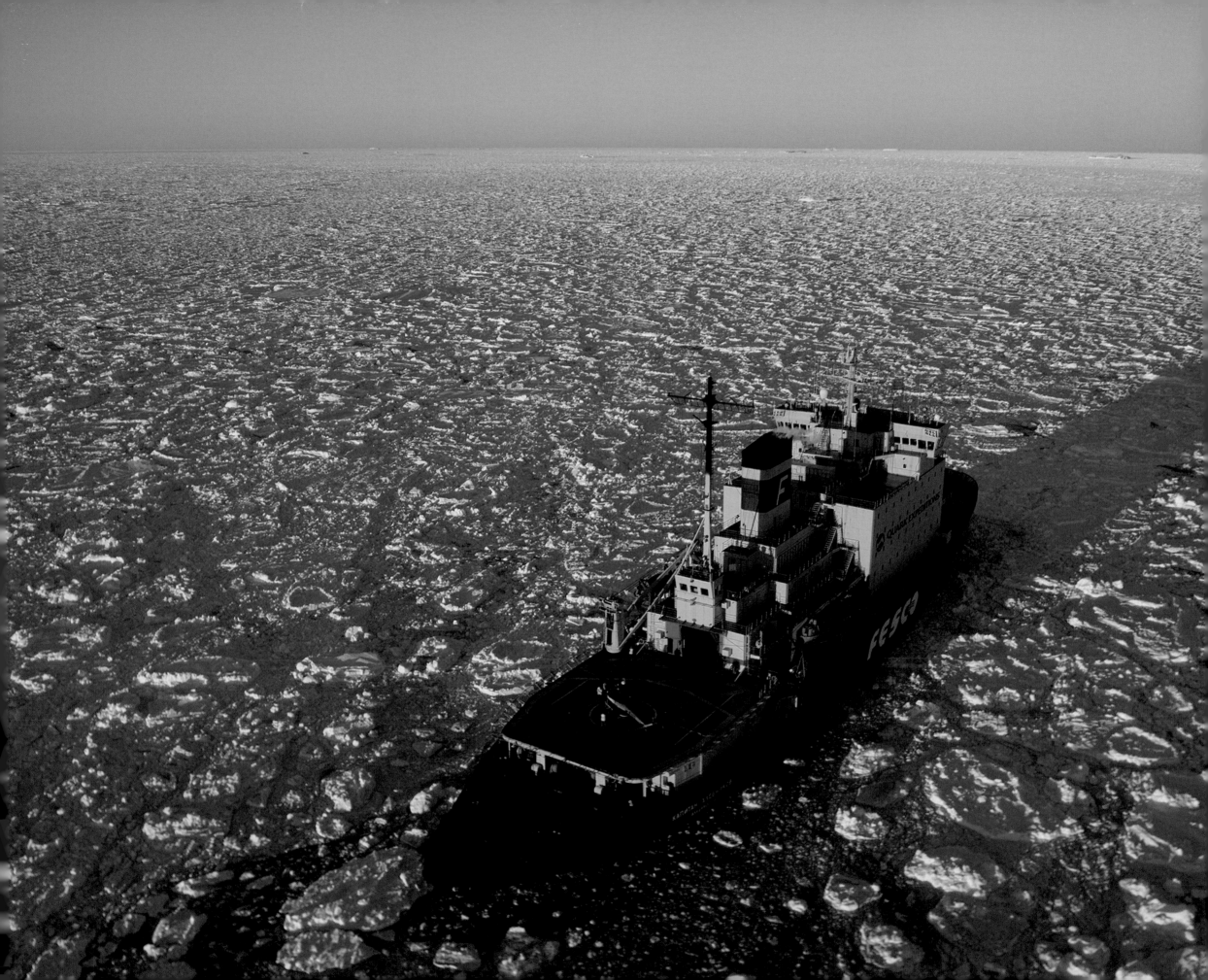

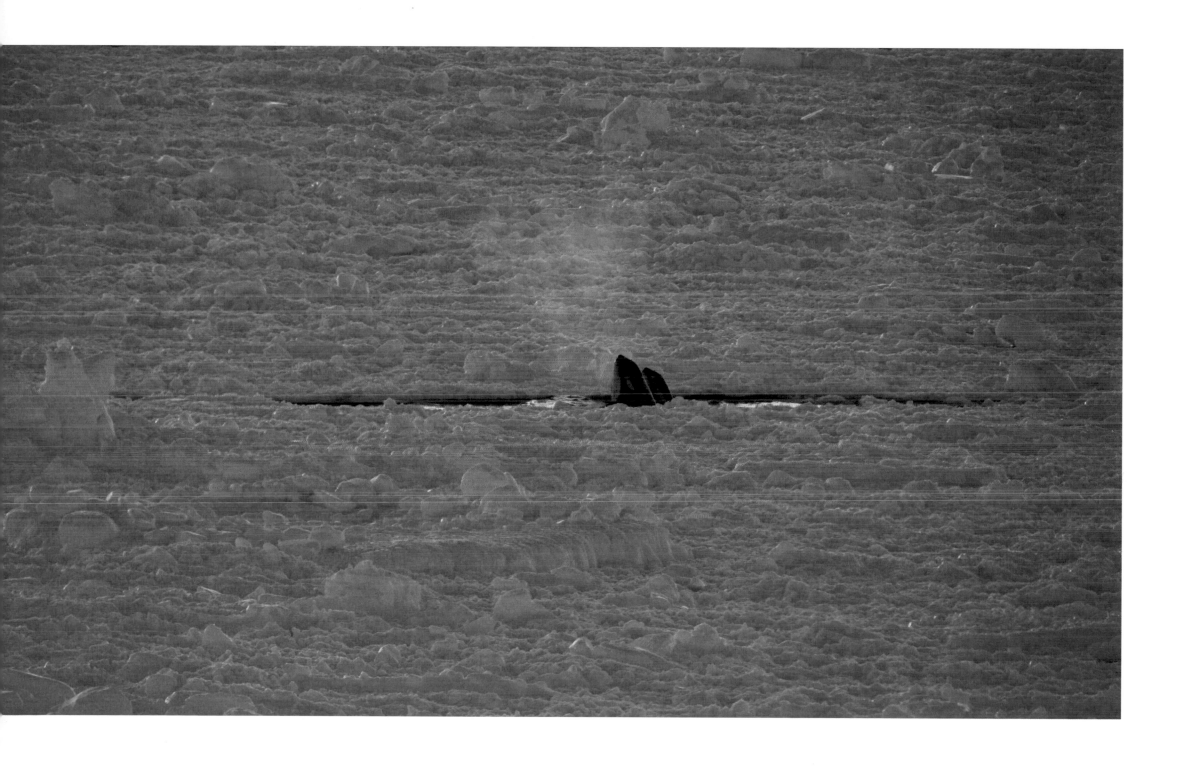

Above: **Killer whales spy-hopping in densely packed ice** | Opposite: *Kapitan Khlebnikov* in the ice

Killer whale in the pack ice

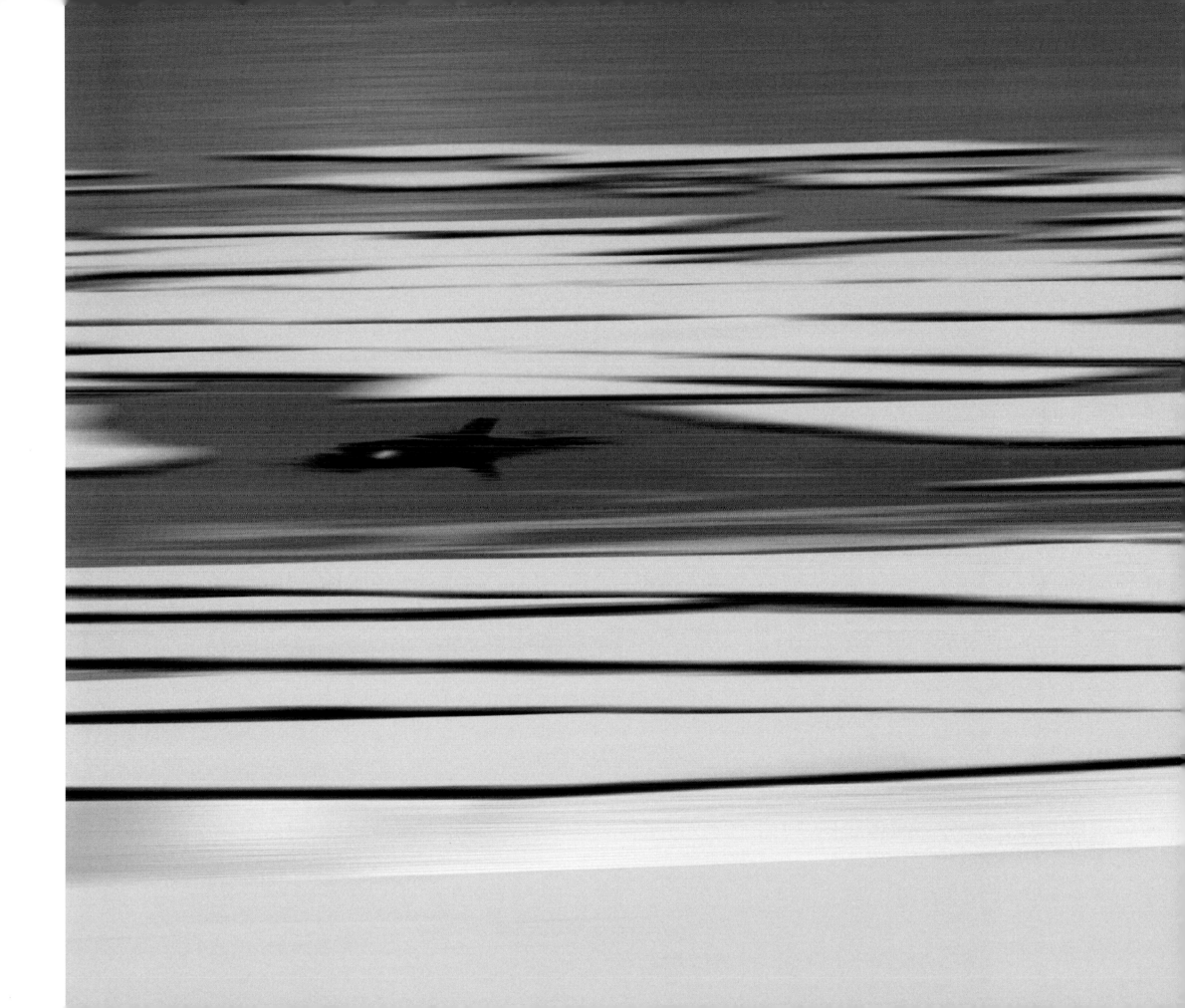

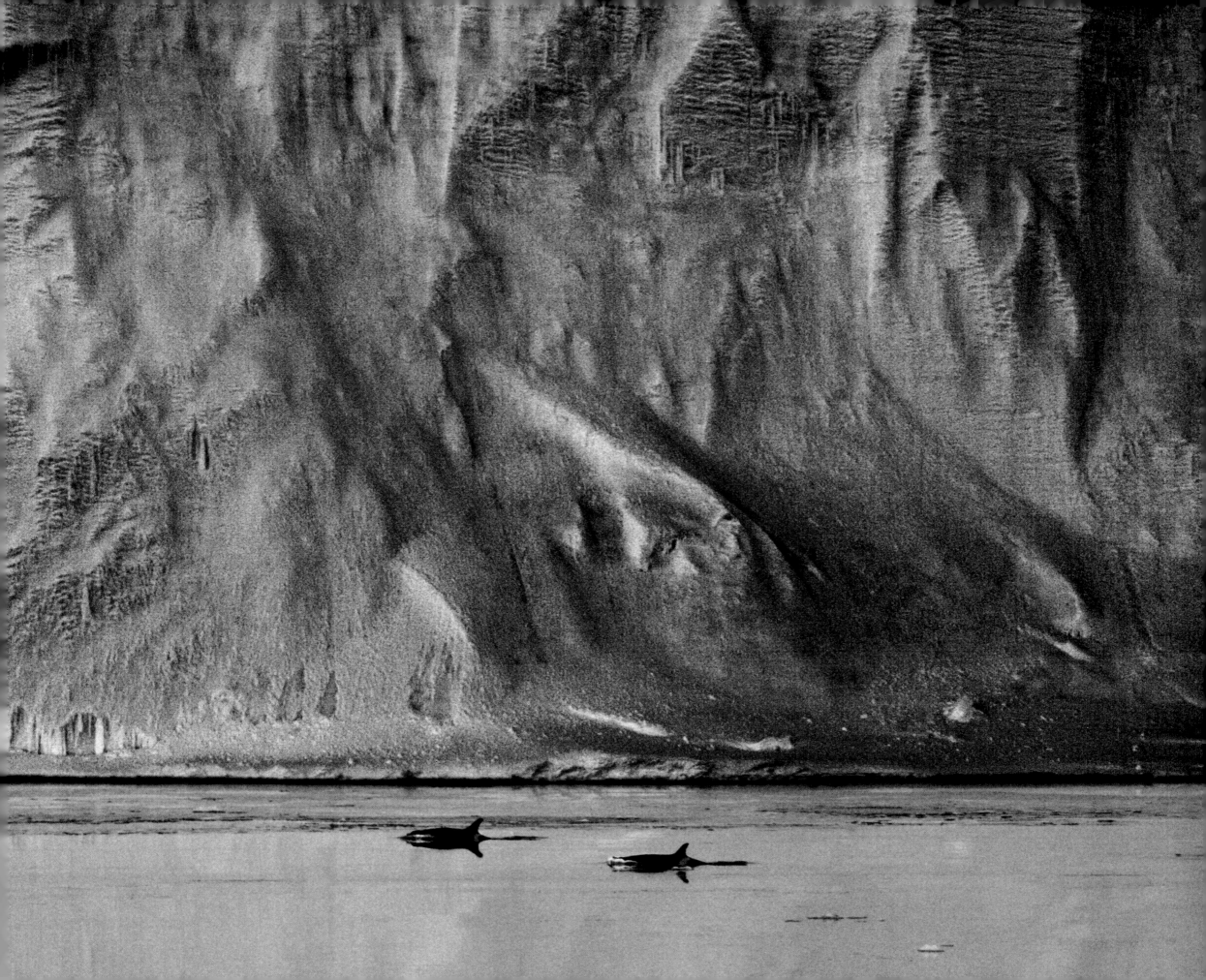

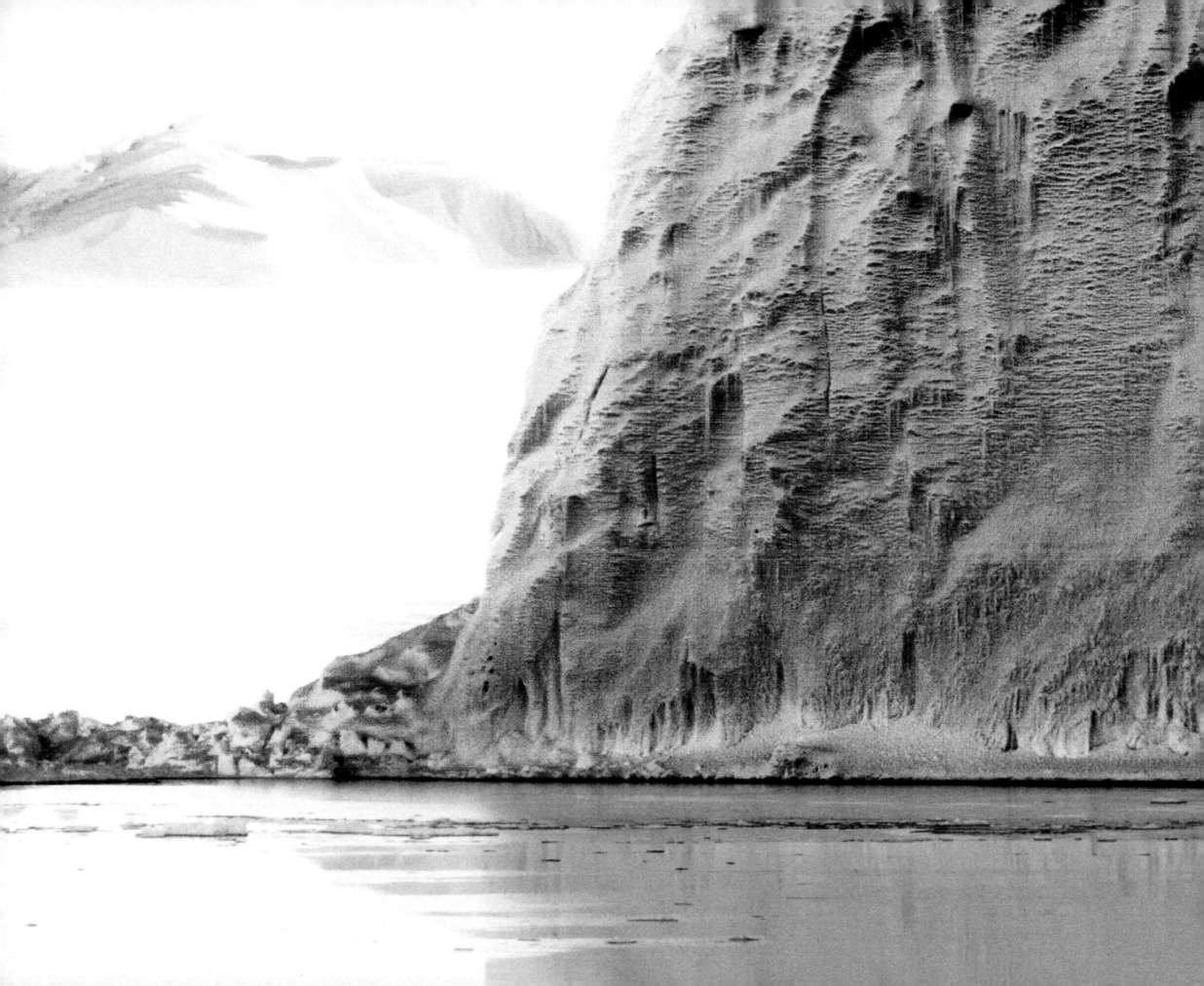

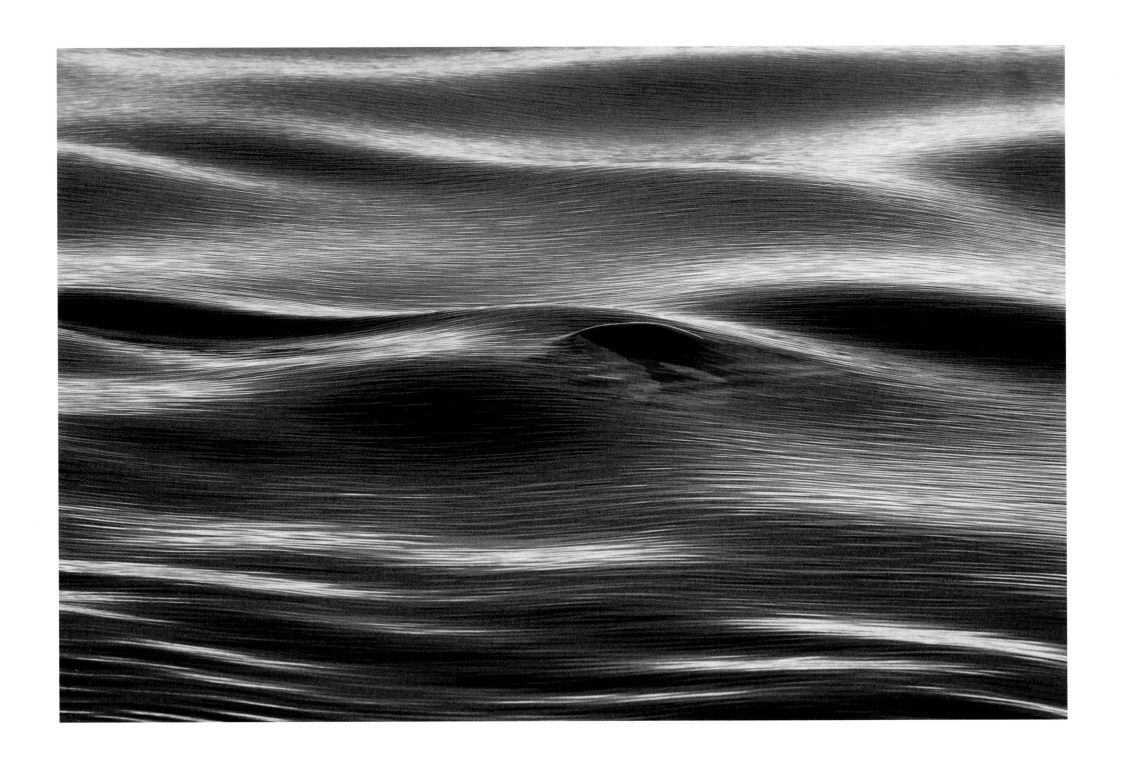

Above: **Killer whale breaking the surface** | Following Spread: **Killer whales and iceberg**

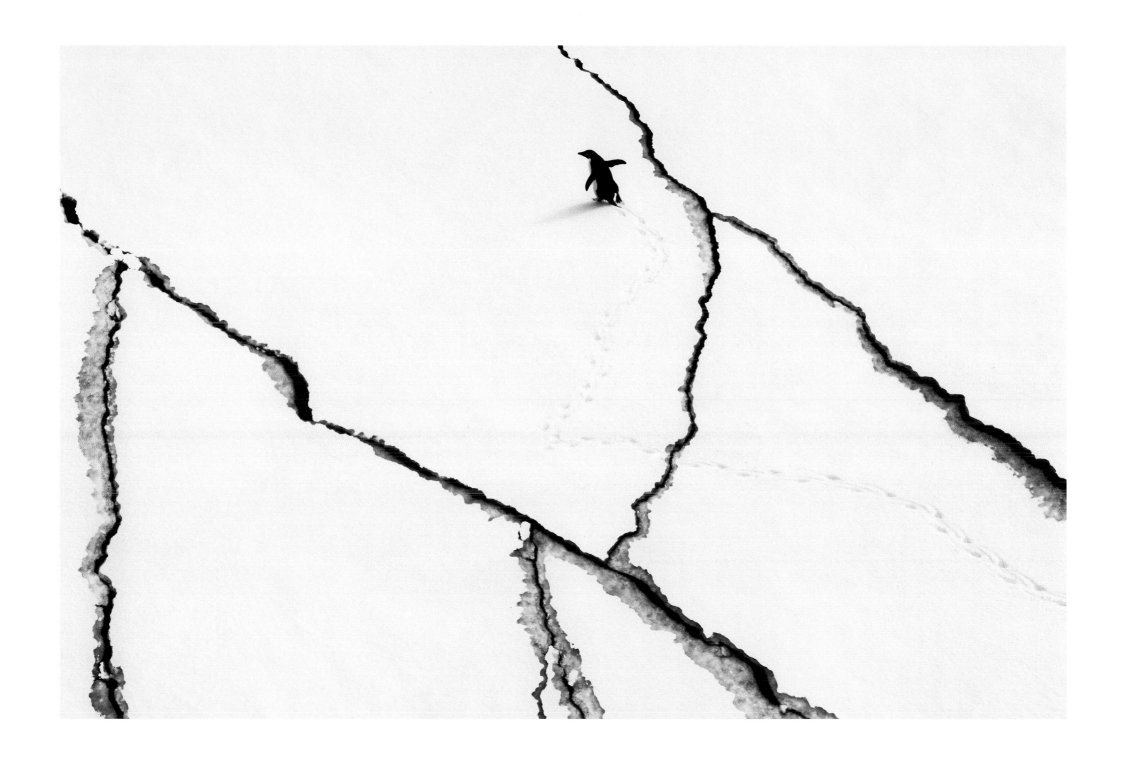

Adélie Penguin on broken ice

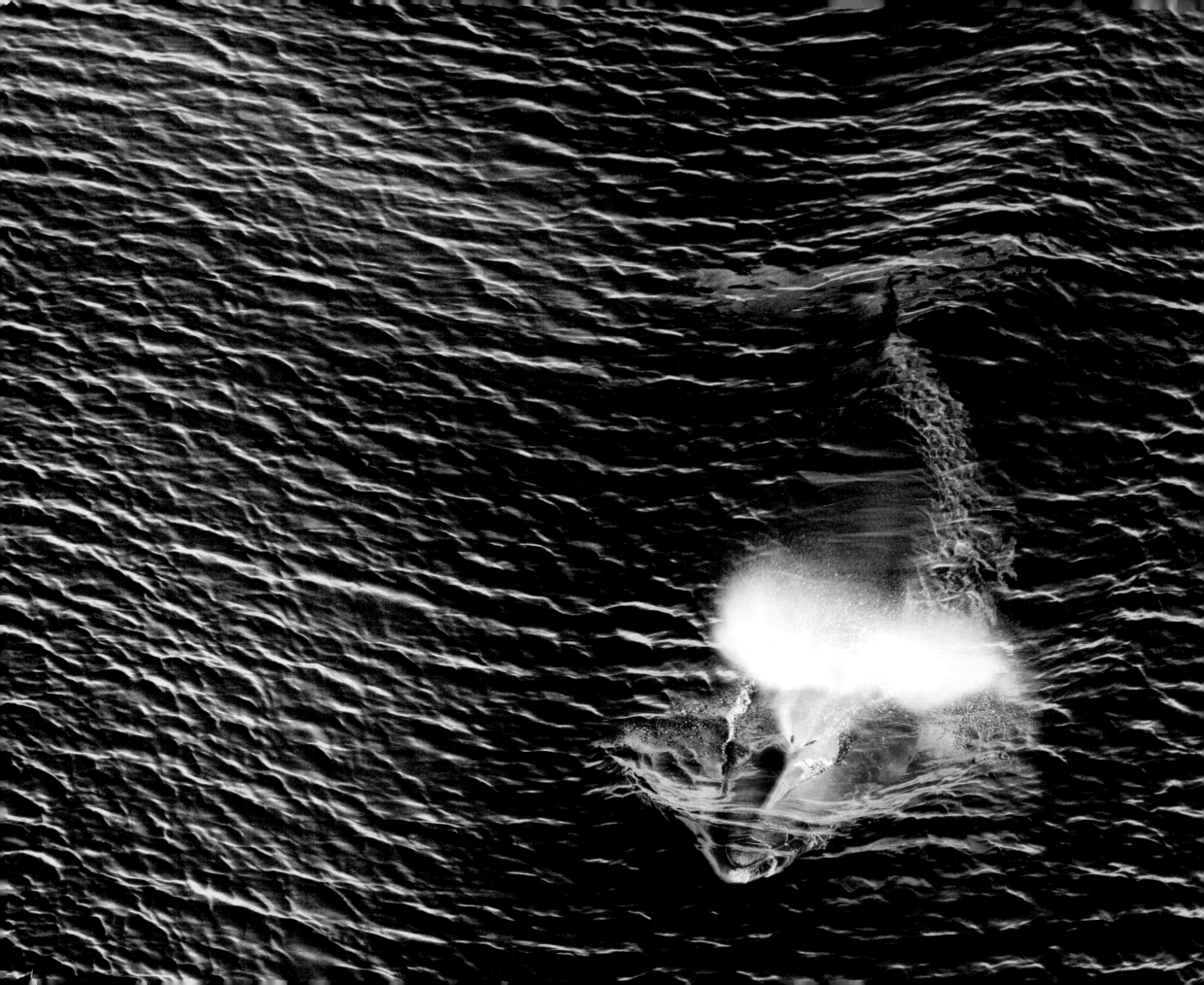

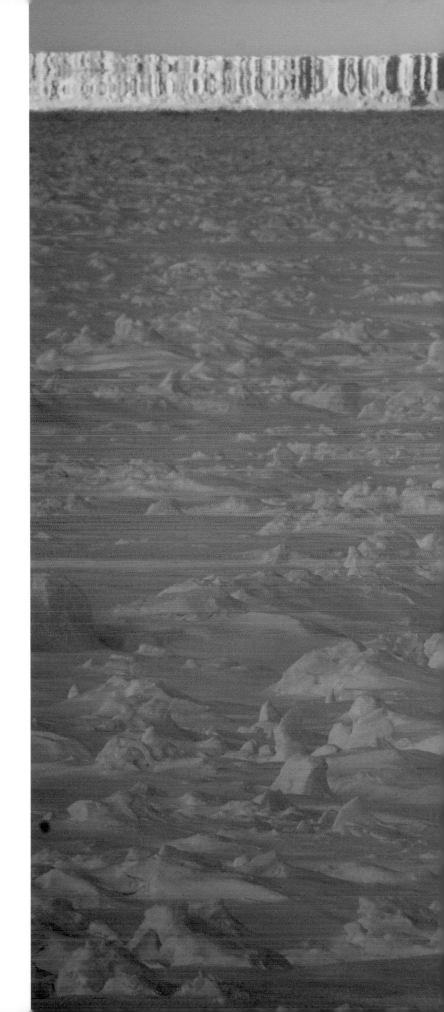

Adélie Penguins and mirage

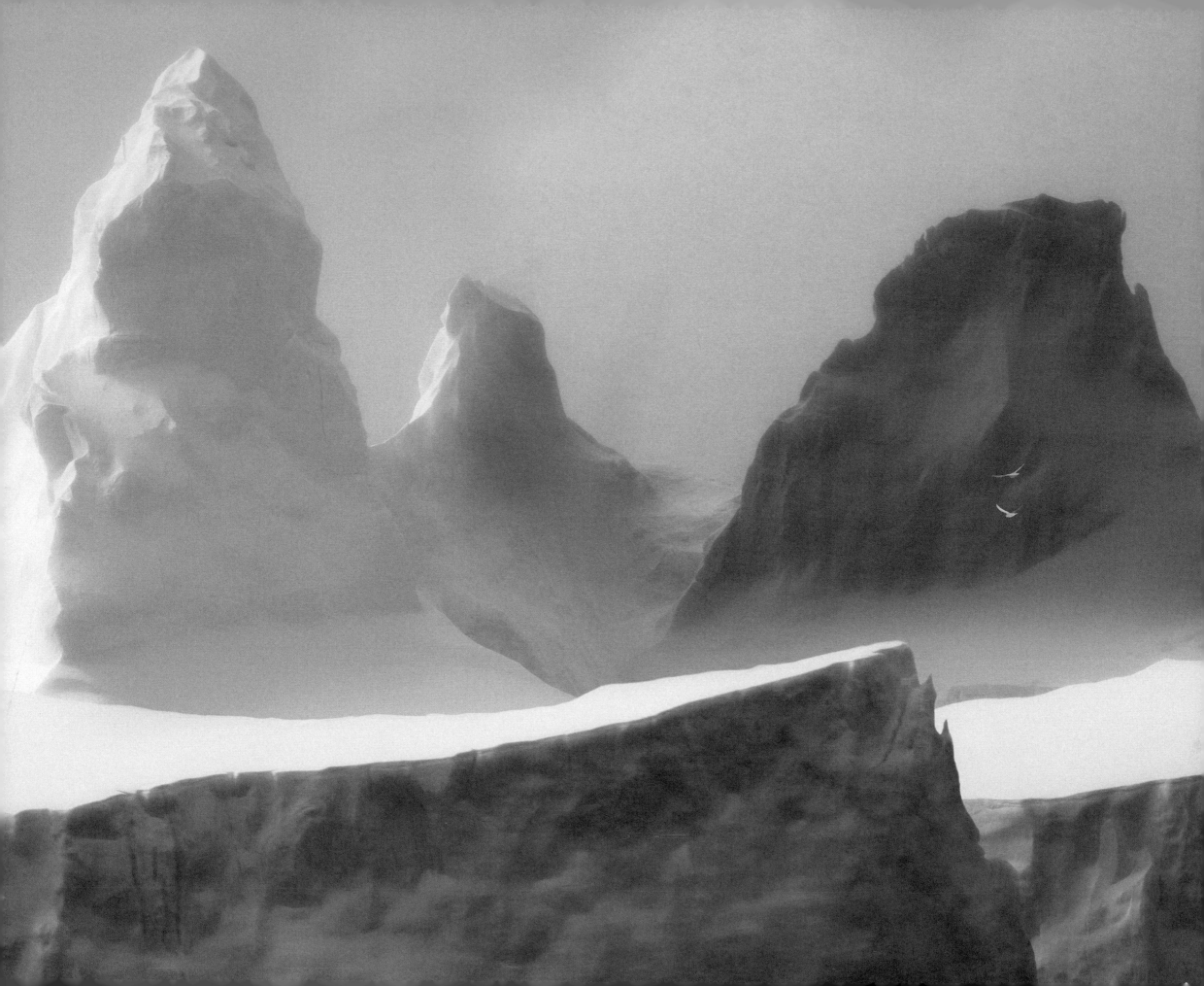